THE ROYAL HUNTER

Asia House Gallery, New York City
Dallas Museum of Fine Arts
The Cleveland Museum of Art

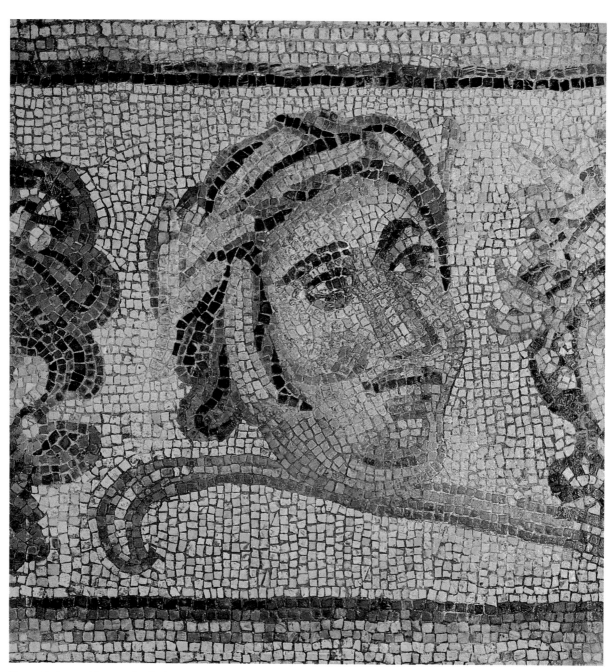

No. 87B. *Mosaic floor panel. Third century A.D. H. 38 cm., W. 36 cm. Bishapur, Iran. Musée du Louvre.*

THE ROYAL HUNTER
ART OF THE SASANIAN EMPIRE

by Prudence Oliver Harper

with contributions by Jens Kröger, Carol Manson Bier, and Martha L. Carter

The Asia Society
In association with John Weatherhill, Inc.

THE ROYAL HUNTER is the catalogue of an exhibition
shown in Asia House Gallery in the winter of 1978
as an activity of The Asia Society, to further greater understanding
between the peoples of the United States and Asia.

An Asia House Gallery Publication
© The Asia Society, Inc. 1978

This project is supported by grants from the
National Endowment for the Arts, Washington, D.C., a Federal agency,
the Andrew W. Mellon Foundation, and the Mobil Oil Corporation.

In this catalogue, fig. is used to indicate comparative illustrations
of objects not included in the exhibition.

Library of Congress Cataloging in Publication Data

Harper, Prudence Oliver.
 The royal hunter.

 Catalogue of an exhibition at the Asia House Gallery,
winter of 1978.
 Bibliography: p.
 1. Art, Sassanid—Exhibitions. I. Asia House
Gallery, New York. II. Title.
N7283.H35 709'.35 77-13082
ISBN 0-87848-050-1

CONTENTS

Foreword

In keeping with its reputation, Asia House Gallery here presents another of its carefully selected and closely focused exhibitions which elucidates a particular facet of Asian art that has escaped general recognition. The considerable artistic creations of the Sasanian dynasty are little known, and often misunderstood, wrongly dated, and improperly catalogued. In addition, numbers of objects that have been traditionally identified as Sasanian are now thought to have been made at different times and outside of the limits of the Sasanian realm.

It is not difficult to understand why such a confusing situation should exist. In the first place, we face the old and familiar problem brought about by the fact that many so-called Sasanian objects have been found in uncontrolled circumstances and nothing is known about their archaeological context. Then, because the influence of the Sasanian dynasty was so widespread and powerful, its art became equally pervasive and elements of the style appear in the art of many later cultures. Yet despite the greatness of their achievements, the accomplishments of the Sasanians remained relatively unknown. The scarcity of records from the period of Sasanian rule forced historians to rely upon foreign sources or, alternatively, to reconstruct the history of the dynasty from much later Arabic and Persian writings. Lastly, although unique stylistic characteristics can be identified, the uncertainties surrounding the date and provenance of many objects have made it difficult to arrive at an actual definition of the art of Sasanian Iran.

With this exhibition and catalogue, we seek to examine the elements of style that distinguish Sasanian art, to place them in their proper cultural and historical context, and to assemble a group of objects from the world's major collections which bring the greatness and qualities of that style to life. We realize, of course, that certain questions will remain unanswered and new ones most likely will be raised, but the function of the Gallery's programs is well served if we can continue to introduce our public to the current state of research in a particular field and present great works of art.

The idea of the exhibition was originally proposed by Richard Ettinghausen at a meeting of the Gallery's Advisory Committee in 1975. He immediately identified his colleague, Prudence Oliver Harper, Curator, Ancient Near Eastern Art Department at The Metropolitan Museum of Art, as a scholar who would be able to select such an exhibition and prepare a well written, clear, and informative catalogue for us. In this, he was absolutely correct. We have been most fortunate to have Dr. Harper as our guest director for the project. Besides having an intimate knowledge of the objects themselves and the taste to choose the best of them for this exhibition, she has published extensively on the subject of ancient Near Eastern art with particular emphasis on Sasanian metalwork. She has also supervised certain technological examinations of Sasanian silver pieces which have provided invaluable information about metal content, dating, and origin. In some cases, these analyses have helped in establishing the authenticity of a particular object. In this manner, solutions to one of the most difficult and controversial problems in this field are beginning to be found.

From Dr. Harper's acknowledgments, it is evident that this has been a wide-ranging effort, involving great collections and scholars from around the world. We thank all of them for their support and interest, and we are indebted to the lenders for sharing so many superb objects with us. In addition, it is a pleasure to acknowledge the considerable and essential financial assistance we have received. Two important grants were made by the National Endowment for the Arts: one a planning grant which enabled Dr. Harper to travel to Iran to study collections there; and the other, a generous Aid to Special Exhibitions grant for general assistance. Two grants have also been made to underwrite the costs of producing this catalogue, one from the Mobil Oil Corporation, the other from the Andrew W. Mellon Foundation as part of its continuing support for the Gallery's publication program. The Starr Foundation has made a most thoughtful contribution towards installation expenses, and a special donation from Alice Heeramaneck reflects the interest which she and her late husband, Nasli, have had in the art of the ancient Near East for many years. A grant from the National Endowment for the Humanities has enabled the Gallery to prepare educational activities complementing the exhibition, under the guidance of Cecelia Levin, as well as to produce a series of photographic panels showing some of the great rock-cut reliefs which give some idea of the monumental dynastic art of the Sasanian period.

H. E. Mehrdad Pahlbod, Iranian Minister of Culture and Arts, has supported the exhibition since its inception, and we are grateful for his assistance. We are indebted to H. E. Fereydoun Hoveyda, Ambassador of Iran to the United Nations, for his efforts to help us obtain color transparencies of loans from Iranian collections. We have also been assisted by Helmut Nickel, Curator of Arms and Armor, The Metropolitan Museum of Art, and Herbert D. Spivack of The Asia Society in translating correspondence and legal documents from German. Andrea Miller retyped the edited manuscript with thoughtful efficiency.

Once again, the small dedicated staff of Asia House Gallery has performed admirably. Sarah Bradley has been responsible for the production of the catalogue and has followed through with many other details such an exhibition entails. Terry Tegarden has supervised the care and handling of the objects and made preparations for the exhibition's tour with her usual efficiency; and Kay Bergl and Carol Lew Wang have assisted in the areas of publicity and seemingly endless correspondence. Cleo Nichols and his installation staff continue to distinguish themselves as designers and craftsmen of unique distinction. The success and continuing value of such an exhibition, its catalogue, and programs is in a large part the result of their efforts.

Allen Wardwell
Director, Asia House Gallery

Acknowledgments

The purpose of this exhibition is to present, through works of art, a picture of Near Eastern life and culture during the first half of the first millennium A.D.—the Sasanian period (A.D. 226–651). In order to achieve this aim, I have relied upon many different individuals and institutions for advice and help. Without their enthusiastic response and their support for this project, the exhibition could not have come into being. To the private collectors and museums who generously agreed to contribute works of art I extend my warm thanks.

In this country, a number of people provided assistance and information concerning objects in their care: Sidney M. Goldstein, Corning Museum of Glass; Louise W. Mackie, The Textile Museum; Arielle P. Kozloff, The Cleveland Museum of Art; Susan B. Matheson and Mrs. Fernande E. Ross, Yale University Art Gallery; Maude de Schauensee, The University Museum; Timothy Kendall, Museum of Fine Arts, Boston; Thomas S. Wragg, Devonshire Collections; Jean Gordon Lee, Philadelphia Museum of Art; Milton Sonday, Cooper-Hewitt Museum of Decorative Arts and Design; Lois Katz, The Arthur M. Sackler Collections; Bennet Bronson, Field Museum of Natural History; and Jeanny Vorys Canby, The Walters Art Gallery. At The Metropolitan Museum of Art, my colleagues were invariably cooperative: Helmut Nickel of the Arms and Armor Department; Pieter Meyers, Research Chemist; Nobuko Kajitani of the Textile Conservation Department; Vaughn E. Crawford, the Ancient Near East Department; Laurence Libin, the Musical Instruments Department; and Richard Ettinghausen, the Department of Islamic Art. Marcel G. Berard, Senior Departmental Assistant in the Department of Islamic Art, executed the drawings of the decoration on the bronze furniture support in the shape of a griffin (No. 35).

Mary A. Littauer instructed and advised on all matters concerning the representations of horses, an aspect of art history to which she has brought a high level of scholarship. She is in no way responsible for any errors which may have entered this text.

Christopher J. Brunner of the Iran Center, Columbia University, willingly offered his advice on questions concerning the Middle Persian language and literature. His translations and commentary on the inscribed objects are included in the catalogue.

My friend and colleague Martha L. Carter deserves special thanks. In our initial travels together in Iran she assisted me in every aspect of this endeavor. She has contributed to this catalogue (Nos. 18, 23, 24, 26, 88) and has read through the manuscript, offering valuable suggestions. For her help throughout the preparation of this exhibition, I am deeply grateful.

In Europe, Dr. Pierre Amiet of the Musée du Louvre allowed me, with customary generosity, to examine material in the storage reserves and acceded to requests for photographic materials with patience and speed. Roman Ghirshman, an old and valued friend, listened while I discussed the original plans for the exhibition with him in Paris. He proceeded to advise me on material from Susa and made available to me, through the

courtesy of Miriam Rosen-Ayalon, his forthcoming article on harnesses excavated at Susa. Dr. Kurt Böhner of the Römisch-Germanisches Zentralmuseum, Mainz, responded promptly and generously to a request for loans from that museum's collection.

My colleagues at The British Museum have long given support and encouragement to various endeavors and in this instance they responded again with help in practical matters and professional advice. I am grateful to Dr. Edmond Sollberger and to the Trustees of The British Museum for agreeing to the requests of Asia House for the loan of objects. Terence Mitchell provided objects and records for examination and eased my work through his courteous assistance.

In Iran, the enthusiasm of Mina Sadegh-Behnam of the National Collection and her prompt response to various requests are acknowledged with gratitude. She enabled me to see the important Sasanian objects in this collection, which is under the auspices of Her Imperial Majesty, the Shahbanou of Iran, and provided information, particularly concerning the inscription on a silver vase (No. 24). In the same office, my colleague from previous years at The Metropolitan Museum, Anita Koh, assisted me in innumerable matters of detail with customary skill and efficiency.

At the Iranian Centre for Archaeological Research, Dr. Firuz Bagherzadeh graciously reviewed the proposed exhibition with me in its initial stages and offered constructive comments. Anne Saurat helped me, as she has many other scholars, providing information and arranging for special photography of the important objects in the Iran Bastan Museum. Without the support of the Iranian Centre for Archaeological Research, this exhibition could not have achieved comprehensive form.

My work on the exhibition in Tehran and the preparations made after my return to this country were greatly facilitated by Ambassador and Mrs. Richard Helms. Their hospitality and their interest in the art and archaeology of Iran are familiar to all who were fortunate enough to be in Iran during the period in which they represented the United States. I am grateful also to Dr. William F. DeMyer, Cultural Attaché at the Embassy, for his help.

The staff of Asia House adopted the Sasanians with enthusiasm. Initially Allen Wardwell discussed the exhibition with me, and he has continued to make every possible effort to further this complex project with imagination and ability. Virginia Field supervised, in a most proficient fashion, the original arrangements for the loan of objects and, after her retirement from Asia House Gallery, Sarah Bradley continued this work while collaborating with Susan Williams O'Sullivan in preparing the manuscript of the catalogue for publication.

Many of the photographs in the catalogue were taken by Otto Nelson, a master craftsman. Tireless, cheerful, and extraordinarily generous with his time and work, he has my warm thanks.

Major portions of the text were written by Carol Manson Bier (Textiles), Jens Kröger (Stucco) and Martha

L. Carter (a selection of five objects). They provided their manuscripts promptly and the catalogue is more valuable because of their scholarly contributions. Louise W. Mackie of The Textile Museum generously made available technical notes on many of the textiles. Sidney M. Goldstein kindly described the fabrics and methods of manufacture of the glasses lent by the Corning Museum of Glass.

Friends and colleagues read this manuscript in whole or in part: Martha L. Carter, Vera K. Ostoia, Edith Porada, Sidney M. Goldstein, Christopher J. Brunner, and Ann Farkas. Jacolyn Mott ably assisted me in the initial editing.

The catalogue entries are intended to provide the reader with references to comparative materials and to explain the attribution and dating of the individual works. The collection of objects, viewed as a whole, illustrates the richness of Sasanian culture—a descendant of the great civilizations of the ancient world and a source for the art of medieval Europe and of the Near and Far East.

Prudence Oliver Harper

Lenders to the Exhibition

The Art Institute of Chicago
Ruth Blumka
Elie Borowski
The British Museum, London
Cincinnati Art Museum
The Cleveland Museum of Art
Cooper-Hewitt Museum of Decorative Arts and Design, Smithsonian Institution
The Corning Museum of Glass, Corning, N. Y.
Devonshire Collection, Chatsworth
Field Museum of Natural History, Chicago
The Guennol Collection
Iran Bastan Museum, Tehran

The Metropolitan Museum of Art, New York
Musée du Louvre, Paris
Museum of Fine Arts, Boston
National Collection, Tehran
Römisch-Germanisches Zentralmuseum, Mainz
The Arthur M. Sackler Collections
Staatliche Münzsammlung, Munich
The Textile Museum, Washington, D.C.
The University Museum, Philadelphia
Victoria & Albert Museum, London
The Walters Art Gallery, Baltimore
Yale University Art Gallery, New Haven

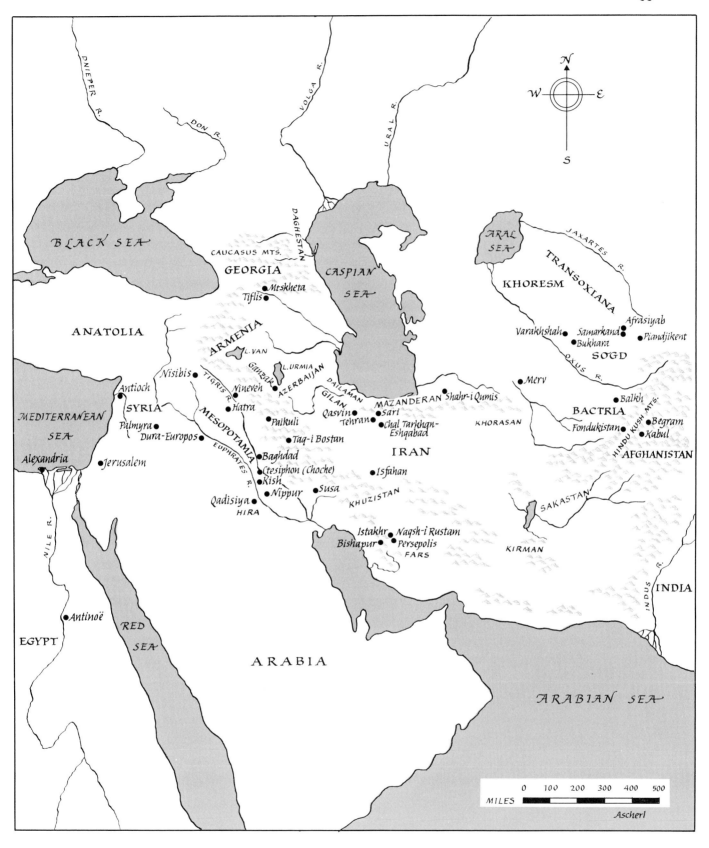

Ascherl

Introduction

I, the Mazda-worshipping lord Shapur, king of kings of Iran and non-Iran who is of the stock of the gods, son of the Mazda-worshipping lord Ardeshir, king of kings of the Iranians . . . grandson of Papak, king—of the empire of Iran, I am the lord.[1]

This formal inscription, carved on the rock surface of a sacred building at Naqsh-i Rustam near Persepolis in southern Iran, embodies the concept of Sasanian royalty. The king, "Mazda-worshipping" monarch, was above other men, possessor of *xwarrah* (the "royal glory"), supporter of the Zoroastrian faith, and worshipper of the god Ahuramazda. Shapur (literally, "son of the king," 241–272) is called the descendant of Ardeshir (224–241), the first king of the Sasanian dynasty, and of Papak, who was probably a ruler of Istakhr in southern Iran. No mention is made of the ancestor, Sasan, from whom the dynasty derived its name. Sasan was in charge of the fire-temple of the goddess Anahita at Istakhr, according to one tradition. In another legendary account he was a shepherd of Papak over whose head the sun shone, illuminating the whole world.[2]

From the third century of the Christian era until the middle of the seventh, the Sasanian kings ruled over a realm comparable to that of the emperors of Rome and Byzantium. From their predecessors, the Arsacid rulers of the Parthians, the Sasanians inherited, in the third century, a land divided into small kingdoms, at war with each other and with the royal Arsacid house. To their successors, the Arab converts to the religion of Mohammed, the Sasanians passed on the concept of a unified empire and a tradition of legendary royal power. The influence of the Sasanians extended over a vast area far greater than that of any contemporary dynasty in Central Asia, India, or China. In the throne room of his palace, Khusrau I (Anoshirwan, "of the immortal soul," 531–579) allegedly kept three golden thrones for the emperor of China, the king of the Khazars, and the emperor of Byzantium—rulers who might sit in his presence.[3]

Included in the Sasanian Empire were Iran and Iraq (Eranshahr), parts of Armenia, Georgia, Afghanistan, and southern Central Asia (see map, p. 11). At times the Sasanian kings expanded their conquests to the lands of the eastern Mediterranean seacoast, devastating Antioch and Jerusalem and establishing their suzerainty over Egypt.

Iraq (ancient Mesopotamia) was the center of the state, and the official capital was at Ctesiphon, south of Baghdad, where the ruins of the palace still known as Taq-i Kisra (arch of Khusrau) stand. Trade routes from the East and West met at Ctesiphon, and other cities in southern Iraq. This was the administrative and economic heart of the empire and a gathering place for peoples and products from all parts of the civilized world. However, Iran was the homeland of the dynasty, and the Sasanian kings spent much of their time in the royal cities and palaces of that country.

The Arab conquests in the Near East during the seventh century and the confrontation of Islam with medieval Christianity at the time of the Crusades are recognized as having had an impact on the historical and cultural development of Europe. Less widely known is the earlier relationship between the Sasanian Near East and the Romano-Byzantine West: an interaction between two cultures that influenced the character of early Islamic and medieval European life.[4] This is apparent at many different levels: in the concept of majesty, the structure and procedures of court life, as well as in the development of the arts. André Grabar has observed that the pronounced decorative character of Sasanian art led naturally to the adoption of many Sasanian forms and motifs by peoples of widely varying cultures.[5] The penetration of the Sasanians eastward into Central Asia and their control for a time of parts of the great Silk Route across Asia led ultimately to the influence of Iranian forms and designs on the art of the Far East. On the eastern borders of Iran, in the country that is now Afghanistan, the insignia of Sasanian royalty were imitated by the nomadic peoples who moved into this area during the fourth to the seventh centuries: Chionites, Hephthalites, Kidarites, and Turks. Sasanian crowns, the designs on royal Sasanian silver plates, and many other emblems of royalty were adopted by these peoples of different ethnic and religious backgrounds (see No. 17 and fig. 17b).

Original Middle Persian texts of Sasanian date are extremely rare. Hamza al-Isfahani, writing in Arabic in the tenth century, states "as regards the Persians, their dispersed [historical] accounts and reports and their scattered stories . . . were turned into verse for their kings, registered in books and permanently deposited in storehouses which were libraries. . . . Most of them were lost when their kingdom disappeared."[6] Four lengthy rock-cut inscriptions in southern Iran (two at Naqsh-i Rustam, one at Paikuli, and one at Sar Mashad) date from the beginning of the Sasanian era and provide almost the only contemporary information on the structure of the state, the classes of secular and religious society, and the boundaries of the empire.[7] Sasanian coins and gems, which were collected and published as early as the eighteenth century, have become increasingly valuable documents, as a renewed study of the inscriptions and images produces information concerning social and religious institutions as well as historical events. Otherwise the history of the Sasanian dynasty is recounted, somewhat unsympathetically, by contemporary foreign writers—Greek, Latin, Armenian, and Syrian—and, rather fancifully, by later Arab and Persian authors who relied on a variety of Middle Persian sources.[8] The religious and epic literature of the era must, to a large extent, be reconstructed from manuscripts dating to the centuries following the collapse of the empire. These works cite authorities of the Sasanian period but the texts frequently incorporate ideas that were current at the time of writing rather than during the Sasanian era. As a result, some uncertainty still exists concerning the events of the Sasanian period and the nature of Sasanian life and thought.

At the pinnacle of the Sasanian state was the king (fig. A), ostensibly a ruler of supreme authority. The Sasanian monarch Shapur II (309–379) wrote to Constantius II: "I, Shapur, king of kings, partner with the Stars,

brother of the Sun and Moon, to my brother Constantius Caesar offer most ample greeting."⁹ Beneath the king were princes of the royal family who governed some of the newly conquered parts of the empire. Other regions kept for a time their hereditary monarchs, but only as vassals of the Sasanian king. The seven great noble families of Iran (*vaspuhrān*), who were almost completely independent by the end of the Parthian period, continued to exert considerable power through the ownership of vast domains within the kingdom.

The Sasanian monarch exercised control not only as a temporal ruler but, the monuments suggest, as a spiritual guardian as well. The Zoroastrian religion had developed for a millennium in Iran before it became, under the Sasanians, the official doctrine of the state.¹⁰ This was a religion of dualism, based on the belief in the struggle, to a victorious end, of the spirit of Good, Ahuramazda (Middle Persian, Ohrmazd), over that of Evil, Angra Mainyu (Middle Persian, Ahriman). On earth, which was the creation of Ahuramazda and therefore good, this contest was an ever-present factor. Ahuramazda was the supreme deity, but a few other important divinities are represented in Sasanian dynastic art. Anahita (Middle Persian, Nahid), a goddess of waters and fertility, was closely linked to the Sasanian dynasty. Her principal sanctuary was in southern Iran, at Istakhr, the home of the clan of Sasan. On the rock reliefs and on the coins, she is occasionally represented in scenes connected with the investiture of the Sasanian king. Mithra (Middle Persian, Mihr) also appears on a rock relief in an investiture scene. He was identified with light and truth, and was revered as a wise judge and guardian of men.

The Zoroastrian priests were judges and ministers of the king. At times they wielded tremendous power and controlled the affairs of the realm while the king ruled in name only. From the end of the third century through the remainder of the Sasanian period, sporadic persecutions of the non-Zoroastrian communities—Christians, Jews, and Manichaeans—were to occur. These increased when the power of the Zoroastrian clergy grew but were controlled to varying degrees through the efforts of rulers who recognized the part played in commerce and industry by the non-believers who constituted a large segment of the population.

The penetration of Zoroastrian thought into all levels of Sasanian life is clear. A regulated daily existence was ordained by the religion, and the rules of religious practice were strictly defined. The divisions of Sasanian society, based on ancient religious traditions, were precise. In descending order were: 1) priests; 2) warriors; 3) scribes and bureaucrats; and 4) artisans and peasants. Movement between the classes was practically impossible. Those born into one level of society were not expected to rise to another as it was undesirable that the order be disturbed.

More difficult to detect is the reflection of the Zoroastrian approach to life and the universe in the arts. The tie between the official religion and the state was close. However, there is little that is specifically Zoroastrian in the figural designs decorating the works of art.¹¹ Few Zoroastrian divinities are ever actually represented (see No. 74). In spite of the absence of a religious imagery, however, it can be observed that many characteristics of

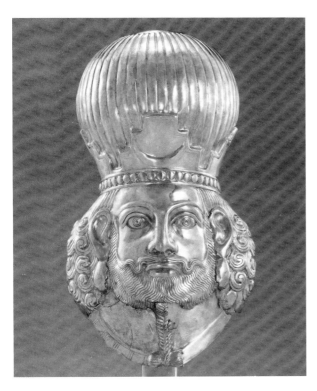

Fig. A. *Silver-gilt head of Shapur II (?). Fourth century A.D. H. 40 cm. Sasanian, Iran. The Metropolitan Museum of Art; Fletcher Fund (65.126).*

Fig. B. Ivan *of Khusrau II. Taq-i Bostan, Iran.*

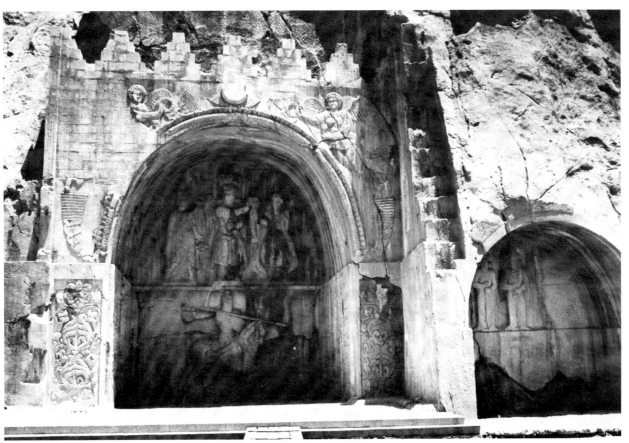

Sasanian art are consistent with Zoroastrian thought and beliefs. The representations reveal the presence of certain attitudes that governed the execution of the works of art: a concern for order and clarity; a preoccupation with the theme of contest, usually represented by humans hunting but also illustrated by struggles between certain animals and birds; and an acceptance of an established social structure which led to regulations and controls in the production and design of art objects. On an intellectual plane, similar concepts are expressed in the Zoroastrian texts. The religious writings and the art are, therefore, in harmony and provide, at different levels, a sense of the character and spirit of the Sasanian era.

In the rules governing the conduct of the orthodox Zoroastrian, the pleasures of life are not overlooked. One text, *The Counsels of Adhurbadh, Son of Mahraspand*, contains a passage urging the Zoroastrian believer "on the day of Ohrmazd to drink wine and make merry." There is a section concerning the effect of wine on the character of a good or bad man in the *Mēnōk i Khrat* ([The Book] of the Spirit of Wisdom): "For when a man of good character drinks wine he is like a gold or silver goblet."[12] The references in the designs of many Sasanian silver vessels to wine-drinking and the illustrations of the grape and leaf vine are not alien or contrary to the Good Religion. Feasting and drinking were obviously common forms of amusement at the Sasanian court. However, it is interesting that the royal monuments, at least those that have survived, do not illustrate this subject. When drinking scenes and representations of the making of wine are depicted on silver plate and on seals, there is no clear reference to royalty. Such representations may have decorated the walls of the private villas and palaces of the king, but they do not appear on the official silver plate, coins, or dynastic reliefs. Only in the early Islamic era was the drinking or feasting theme raised to the level of the hunt, and openly associated, in the arts, with the rulers.

The production of works of art by craftsmen working within the Sasanian Empire was strictly controlled. Shapur II (309–379), the first monarch to define royal authority and to curtail the rights of both the high nobility and clergy, also achieved the organization of lower levels of society. Artisans were separated into corporations according to métier. Each organization had an elected head, and over all the artisans there was a chief, *karagbed*, appointed by the king. At Karkha de Ledan in Khuzistan, where Shapur II resided with his court, a Syrian named Posi was at first chief of the court workers and later became "chief of the artisans of other regions of the empire." His duties included the direction of the royal artisans as well as the inspection of workshops in different parts of Iran.[13] An analysis of Middle Persian terms reveals the careful and reasonable division of labor. Among iron workers, silversmiths, and goldsmiths, there were some who made larger objects ("cups and crowns") and others who fashioned smaller works ("keys, bridle bits, bracelets, and earrings.")[14]

The king of kings who ruled above this hierarchy was not an isolated Oriental monarch. His embassies traveled westward to Byzantium and eastward to China. He led his armies to the Mediterranean seacoast and

into Central Asia. Among the events recorded by the sixth-century historian Procopius are references to both treasures and captives transported by invading Persians back to their homeland:

> Chosroes commanded the army to capture and enslave the survivors of the population of Antioch and to plunder all the property, while he himself with the ambassadors descended from the height to the sanctuary which they call a church. There Chosroes found stores of gold and silver so great in amount that, though he took no other part of the booty except these stores, he departed possessed of enormous wealth. And he took down from there many wonderful marbles and ordered them to be deposited outside the fortifications, in order that they might convey these to the land of Persia.[15]

Khusrau I (531–579) returned from the West to build himself a city in Iraq modeled on Antioch, Veh-Antiokh-i-Khusrau (the better Antioch of Khusrau), as Shapur I had done earlier at Veh-Antiokh-Shapur (Gundeshapur). The closing of the School at Athens in 529 brought Western scholars to the court of Khusrau I as temporary residents, and Greek artisans were sent by the Byzantine emperor Justinian (527–565) to help embellish the capital at Ctesiphon.

The most conspicuous monuments of the Sasanian Empire are the huge dynastic rock reliefs carved on the mountain cliffs of Iran with investiture, battle, and hunt scenes (fig. 4b). More familiar are the treasures of silver plate which have been for years in British, European, and Soviet museums. These works in precious metal are complemented by large collections of seals of Sasanian date that illustrate a greater range of designs. Among the subjects and motifs that are characteristically Sasanian are scenes of the king hunting; ribbons attached as symbols to specific animals, birds, and plants (Nos. 40, 43); jeweled bands placed around the necks of animals and birds (No. 55); wing and plant forms arranged beneath human and animal busts (Nos. 2, 72); and designs enclosed within a pearl roundel (No. 20). None of the separate elements of these designs is uniquely Sasanian, but their treatment by Sasanian artists is distinctive. The repetitive use of these and other decorative motifs in a wide range of materials encouraged the diffusion and influence of Sasanian artistic modes. As noted above, Sasanian designs were adopted by peoples living in areas distant from Iran. This has led to confusion in the attribution and dating of works found beyond the borders of the Sasanian Empire. Too often these "Sasanian" patterns are considered reliable evidence of direct Iranian manufacture by those who ignore the form and style of the objects on which the decoration appears.

Throughout most of the Sasanian period, the repertory of designs consists of subjects having a symbolic or religious value rather than a purely decorative or secular purpose. This is as true of representations on small seal stones as of scenes on the over life-sized rock reliefs. Many of the symbols are of ancient Near Eastern origin:

the king standing on a defeated enemy (No. 71), the king hunting (No. 7), birds of prey devouring animals (No. 14), antelopes and rams placed antithetically on either side of a tree, lions attacking bulls, and human-headed winged bulls. Other motifs were adopted from the West and achieved widespread popularity for the first time in the Sasanian period: small winged figures bearing diadems, vine scrolls with figures of animals and birds, scenes of vintaging (No. 24), female dancers with scarves (Nos. 18, 69), and themes connected in Roman art with the cult of Dionysos (No. 87), a subject that may have had, in some instances, a political significance associated with victory celebrations.[16] Although the precise meaning of these adopted motifs is not always known, it is unlikely that the subjects had the same connotations in the Near East as they had in the West.

The present exhibition includes both objects of luxury, the royal silver plate and the patterned silks of Sasanian design, as well as such minor works of art as stucco, glass, ceramics, bronzes, and seals. The intention is to recreate the spirit of the age, touching on many aspects of Sasanian life and culture. Objects made of precious metals, textiles, and royal and official gems reflect the beliefs, interests, and customs of the ruling class. To some extent their production was a matter of dynastic policy. Stucco wall plaques and mosaic pavements are the only reference in this exhibition to Sasanian architecture, a field that is still largely unexplored. Pottery, bronzes, glass, and the seals of private persons offer an insight into the lives of a segment of the population without significant authority in the affairs of state. It is interesting to observe, in this respect, that there is a uniformity in the form and design of many of these ordinary works of art corresponding to that observable in objects of luxury.

Some of the latest pieces in the exhibition illustrate changes in emphasis and meaning which occurred toward the end of the Sasanian period: sacred, cultic, and dynastic subjects lose some of their significance; an interest develops in the representation of themes from ancient epic literature; and scenes of daily life become acceptable subjects for the decoration of silver vessels. Many of these trends in the art of the late Sasanian era reflect the growth of the new nobility and the military class in the sixth and seventh centuries.

The picture is not complete. Wall paintings with historical and epic scenes originally decorated the royal palaces and the villas of the nobility. These are lost—destroyed in part by man, but more extensively by the ravages of a climate in which fragile materials do not survive. Some media were never exploited. Stone carving—architectural decoration or sculpture in the round—was not a traditional Iranian craft in the Sasanian or earlier periods. The dynastic rock reliefs are, however, a traditional form of Near Eastern monument. As political manifestos, the earliest Sasanian examples were designed to proclaim the legitimacy of the new dynasty, while the latest rock sculptures of Khusrau II at Taq-i Bostan (fig. B) testify to the concentration of religious and secular power in the person of the king.

The absence of extensive archaeological exploration at Sasanian sites makes it difficult to provide precise dates for most Sasanian works of art. Only future field work in the Near East combined with linguistic and art

historical studies will eventually establish a reliable chronological framework for objects of Sasanian manufacture. A number of objects in this exhibition illustrate the continuation of Sasanian traditions during the century of Umayyad rule from 660 to 750 (Nos. 26, 35, 61, for example). After that, the influence of contemporary art began to be felt and the style was transformed, at first subtly and later radically. All memory of the Sasanian past was not lost, however. The extraordinary prestige of the Sasanian royal house is clearly reflected in the persistence—long after the downfall of the dynasty—of symbols associated with the Persian king and his court in the cultures of both the Mohammedan Near East and Christian Europe.

Notes

1. M. Sprengling, *Third Century Iran, Sapor and Kartir* (Chicago, 1953), p. 14; A. Maricq, "Res Gestae Divi Saporis," *Syria* 35 (1958), p. 304.

2. *Kârnâmak-i Artakhshîr Pâpakân*, trans. E. K. Ântiâ (Bombay, 1900), p. 2.

3. *Fars-nameh* of Ibnu'l-Balkhi as cited in A. Christensen, *L'Iran sous les Sassanides*, 2nd ed. rev. (Copenhagen, 1944), p. 412.

4. O. Grabar, *The Formation of Islamic Art* (New Haven/London, 1973); M. Rosen-Ayalon, "Further Considerations Pertaining to Umayyad Art," *Israel Exploration Journal* 23 (1973), pp. 92–100; A. Grabar, "Le Rayonnement de l'art sassanide dans le monde chrétien" in *La Persia nel Medioevo* (Rome: Accademia nazionale dei Lincei, 1971), pp. 679–707; A. Grabar, *L'Art de la fin de l'antiquité et du Moyen Age* (Paris, 1968), II, pp. 663–668, 677–685.

5. See Grabar, "Le Rayonnement de l'art sassanide," in note 4 above.

6. S. Shaked, "Specimens of Middle Persian Verse," in *W. B. Henning Memorial Volume*, ed. M. Boyce and I. Gershevitch (London, 1970), p. 405.

7. E. Herzfeld, *Paikuli, Monument and Inscription of the Early History of the Sasanian Empire* (Berlin, 1924), I, pp. 94–119; J. Gagé, *La Montée des Sassanides* (Paris, 1964), pp. 285–291 and pp. 323–328 (Shapur and Kartir inscriptions at Naqsh-i Rustam); P. Gignoux, "L'Inscription de Kartir à Sar Mašhad," *Journal Asiatique* (1968), pp. 387–418.

8. Christensen, *L'Iran sous les Sassanides*, pp. 50–83.

9. Ammianus Marcellinus, trans. J. C. Rolfe, Loeb Classical Library (Cambridge, Mass./London, 1950), I, p. 333 (Bk. XVII. 5. 3).

10. R. C. Zaehner, *The Teachings of the Magi* (New York, 1976); G. Widengren, *Les Religions de l'Iran* (Paris, 1968); J. Duchesne-Guillemin, *La Religion de l'Iran ancien* (Paris, 1962).

11. J. Duchesne-Guillemin, "Art and Religion under the Sasanians," in *Mémorial Jean de Menasce*, ed. P. Gignoux and A. Tafazzoli (Louvain, 1974), pp. 147–154.

12. Zaehner, *The Teachings of the Magi*, pp. 107, 117.

13. N. Pigulevskaja, *Les Villes de l'état iranien aux époques parthe et sassanide* (Paris/The Hague, 1963), pp. 159–160.

14. A. Tafazzoli, "A List of Trades and Crafts in the Sassanian Period," *Archaeologische Mitteilungen aus Iran* N. F. 7 (1974), pp. 191–196.

15. Procopius, trans. H. B. Dewing, Loeb Classical Library (London/New York, 1914), I, p. 341 (Bk. II. 9. 14–17).

16. H. von Gall, "Die Mosaiken von Bishapur," *Archaeologische Mitteilungen aus Iran* N. F. 4 (1971), pp. 193ff.

Within each chapter the first reference to a publication is given in full; thereafter, publications which also appear in the Bibliography are cited in an abbreviated form.

Historical Summary

Under Ardeshir I (224–241), Shapur I (241–272), and Shapur II (309–379), the power of the Sasanian dynasty was firmly established and the boundaries of the empire—in Armenia and along the Euphrates River in the west and to Merv in the east—were set. The armies of Shapur I destroyed Antioch, in Syria, in the middle of the third century and the Roman emperor Valerian was captured and taken prisoner at Edessa in 260. This latter event forms the chief subject of the dynastic rock reliefs of Shapur at Naqsh-i Rustam and Bishapur in Iran. The Sasanian conquests of the third and fourth centuries brought a tremendous influx of prisoners into the Near East, enlarging and supplementing the labor force within the kingdom.[1] Later Roman emperors were more successful against the Sasanians. Carus and Julian reached Ctesiphon during the reigns of Bahram II (276–293) and Shapur II (309–379) respectively. In 297 Galerius defeated Narseh, capturing the royal household including the Sasanian king's wife, Arsane.

In the East, the Kushan lands in Bactria came under Sasanian domination in the third century. By the middle of the fourth century, however, a new group of peoples, the Chionites, who were Altaic-speaking Huns, had arrived in the formerly Kushan lands north of the Oxus River. Shapur II concluded a peace with them and for a time they served as his allies in wars against the Romans.

The long rule of Shapur II in the fourth century was one of relative internal stability and prosperity. The fifth century, in contrast, brought increasing disorders and hardships in Iran. After the reign of Yazdegird I (399–420), the power of the monarchy weakened and the heir to the throne was chosen not by the king but by a group comprising members of the high nobility, lay administrators, and clergy. By 400 the Sasanians had lost their lands in the East around Kabul and Peshawar to the Huns and in the middle of the fifth century another group of nomads, the Hephthalites, arrived in this region to threaten Sasanian sovereignty. Bahram V (Gur) (420–438) was successful against these invaders in the Khorasan region but the kings who followed him were less fortunate. Hephthalite armies defeated, captured, and eventually, in 484, killed in battle Peroz (459–484). For over two decades Iran was tributary to the Hephthalites, who also dominated the prosperous Sogdian centers where trade was carried on with inner Asia.

During the fifth century relations with the West remained stable since the Byzantine rulers, concerned with the Visigothic invasions of Western Europe, were fully occupied elsewhere.

The reign of Kavad I (499–531) constitutes the turning point in the history of the empire. A sign of the rising fortunes of the monarchy is the fact that Kavad was powerful enough to designate his son, Khusrau I, as heir apparent. The restructuring of the fiscal basis of government, primarily the introduction of tax reforms, was in large part the reason for the increase of prosperity within the empire. The growth of a class of lower nobility (*azatan*) to whom the king granted lands, establishing feudal ties, enlarged the base of loyal support for the monarchy.[2]

The wars of Kavad and Khusrau I (531–579) in the West have been described as a means of replenishing the treasury rather than permanently expanding the borders of the empire.[3] In the East, the arrival of the Turks in the sixth century and their alliance with the Persians brought about the collapse of Hephthalite power, and resulted in the division of the Hephthalite lands between the conquerors. From this time, the activity of Persian merchants in Central Asia increased substantially.[4]

The final great ruler of the Sasanian dynasty was Khusrau II (Parviz, "victorious," 591–628). The magnificence and luxury of his court at Dastagird is legendary. According to Arab tradition the great arched rock-cut *ivan* at Taq-i Bostan (fig. B, p. 15) was constructed at the order of Khusrau, an attribution which, in spite of considerable controversy, is probably to be accepted as accurate.

Khusrau II undertook a newly aggressive campaign against the West, expanding his territories in a short period of time. In 606–607 Syria was overrun; in 611 Antioch was captured and remained under Sasanian control until 628. Khusrau took Jerusalem in 614 and from there set out to devastate Asia Minor. With the invasion of Egypt in 616 and the capture of Alexandria in 617, the Sasanian Empire achieved its greatest expansion. The fall, however, came rapidly. During the 620's the offensive passed to the West. The Byzantine emperor Heraclius, from his headquarters in Armenia, took Ganzak in northwestern Iran in 623–624. In 626 the Persians counter-attacked, reaching Constantinople, but the end was in sight. Heraclius, with Khazar allies, defeated the Persians at Nineveh. In 628 he sacked the royal city of Dastagird and besieged the capital, Ctesiphon, events which brought about the overthrow of Khusrau by Iranian generals. Khusrau's son, Kavad II (628), made peace, evacuating Antioch and releasing Roman captives in Iran.

A period of anarchy followed the death of Khusrau II. His successors ruled only briefly and probably over only parts of the kingdom. Yazdegird III, the last ruler, came to the throne in 632. As titular head of the government until 651, he was, in actual fact, under the control of the military governors—men who had come to rule almost independently in the provinces under their care. In 626 the Arabs defeated the Sasanian army at Qadisiya and in 642 at Nihavend in Iran. Yazdegird fled eastward and his death at Merv, in 651, marks the official end of the Sasanian period.

Notes

1. N. Pigulevskaja, *Les Villes de l'état iranien aux époques parthe et sassanide* (Paris/The Hague, 1963), pp. 135ff.
2. Ibid., p. 157.
3. I. Shahid, "The Iranian Factor in Byzantium during the Reign of Heraclius," *Dumbarton Oaks Papers* 26 (1972), p. 314.
4. A. D. H. Bivar, "Trade between China and the Near East in the Sasanian and Early Muslim Periods," in *Pottery and Metalwork in T'ang China*, ed. W. Watson (London, 1970), pp. 1–8.

Chronology

Sasanian Dynasty (Iran, Mesopotamia)	East (Afghanistan, Central Asia, China)	West (Rome, Asia Minor, Armenia, Syria, Egypt)
224–241 *Ardeshir I*	220–589 Six Dynasties, China	222–235 *Severus Alexander*
241–272 *Shapur I*, son of Ardeshir	Kushan Empire in Afghanistan and northern India	235–238 *Maximinus*
260 Shapur captures Valerian at Edessa.		238–244 *Gordian III*
273 *Hormizd I*, son of Shapur	ca. 270–280 Sasanians may have annexed kingdom of Kushans at this time.	244–249 *Philip the Arab*
273–276 *Bahram I*, brother of Hormizd		253–260 *Valerian*
276–293 *Bahram II*, son of Bahram I		261–272 Palmyrene domination of Antioch.
283 Emperor Carus reaches Ctesiphon.		270–275 *Aurelian*
293 *Bahram III*. Deposed by his uncle, Narseh.		282–283 *Carus*
293–303 *Narseh*, son of Shapur I		297 Galerius defeats Sasanian army and captures family of Narseh. Treaty on Armenia with Sasanian Iran.
303–309 *Hormizd II*, son of Narseh		
309 *Adhurnarseh*, son of Hormizd II. Deposed.	ca. 320–330 According to some scholars Sasanians establish rule over Kushans.	313–337 *Constantine I (the Great)*
309–379 *Shapur II*, son of Hormizd II. Events of first thirty years, from infancy to manhood, unknown. Shapur destroys Susa following Christian revolt.	350's Chionites (Huns) arrive in eastern Iran at about this time.	313 Edict of Milan—toleration of Christianity within the empire.
	359 Chionites fight as allies of Sasanians against Roman armies.	330 Constantinople becomes capital of Roman Empire.
379–383 *Ardeshir II*, brother (?) of Shapur II.		350–361 *Constantius II*
383–388 *Shapur III*, son of Shapur II		361–363 *Julian*
388–399 *Bahram IV*, son of Shapur II or III	386–535 Northern Wei dynasty, China Arrival of Huns (Hephthalites) in eastern Iran and northwest India.	363–364 *Jovian*
399–420 *Yazdegird I*, son of Shapur III		364–378 *Valentinian* and *Valens*
420–438 *Bahram V* (Gur), son of Yazdegird I		379–395 *Theodosius I (the Great)*
424 Christian (Nestorian) Church in Iran proclaims its full independence from the West.		395–408 *Arcadius*
		408–450 *Theodosius II* Crises in West—Visigothic invasions.
438–457 *Yazdegird II*, son of Bahram V	448 War between Hephthalites and Sasanians.	
457–459 *Hormizd III*, son of Yazdegird II. Peroz, brother of Hormizd, gathers army in the east and attacks Hormizd at Rayy.	455 Sasanian delegation arrives at Northern Wei court. Sasanians allied with Hephthalites until 465–466.	453 Attila, king of the Huns, dies.
		457–474 *Leo I*
459–484 *Peroz*. Gets throne with aid of Zoroastrian clergy and Hephthalites.	461, 466 Sasanian embassies sent to China.	
484 Peroz killed in battle with Hephthalites. For 28 years Sasanian Iran tributary to Hephthalites.	476 Peroz captured in battle against Hephthalites. Ransomed by Zeno. Peroz's son Kavad remains hostage for two years.	474–491 *Zeno*
484–488 *Valash*, brother (or son) of Peroz		
488–497 *Kavad I*, son of Peroz. Deposed.		

Sasanian Dynasty	East	West
497–499 *Zamasp*, brother of Kavad		**491–518** *Anastasius I*. Peace with Sasanian Iran.
499–531 *Kavad I*. Returns and with aid of Hephthalites regains throne; marries daughter of Hephthalite king.	**510** Final subjugation of Sogd by Hephthalites.	**518–527** *Justin I*
	518, 520 Sasanian delegations to China.	**527–565** *Justinian I (the Great)*
502 War against East Roman Empire; Hephthalites in Sasanian army.		**540** Antioch destroyed by Sasanians.
528 Sasanians receive envoys from Deccan.	**558** Allied with Turks from Central Asian steppes, Sasanians defeat Hephthalites, divide territories. Large scale penetration of Sasanians in East.	
531–579 *Khusrau I*, son of Kavad		**565–578** *Justin II*
567 Chinese delegation arrives at the Sasanian court.	**567** Sasanian embassy to China.	**578–582** *Tiberius II*
579–590 *Hormizd IV*, son of Khusrau. Deposed.	**581–618** Sui dynasty, China	**582–602** *Maurice*. Khusrau, son of Hormizd IV, flees to Maurice, marries Maria. Maurice aids Khusrau in regaining throne.
590–591 *Bahram VI* (Chobin), general, member of the Mihran family		
591–628 *Khusrau II*, son of Hormizd IV. Byzantine, Armenian, and Iranian forces defeat Bahram Chobin, who flees to Turks at Balkh.		**602–610** *Phocas*
		610–641 *Heraclius I*
606–607 Syria overrun by Sasanians.		**611** Antioch captured by Sasanians, remains in their hands until 628.
615–620 Asia Minor devastated by Sasanians. Chinese delegation to Sasanian Iran before Turco-Persian War.	**616–617** Turco-Persian War	**614** Sasanians take Jerusalem, carry off piece of True Cross.
	618–906 T'ang dynasty, China	**616** Sasanians invade Egypt, take Alexandria.
622–626 Heraclius successful in offensive against Sasanians up to Media, allied with Khazars.		**626** Sasanian counteroffensive against Byzantine armies as far as Constantinople.
628 Heraclius sacks palace of Khusrau II at Dastagird and besieges Ctesiphon.		**628** Antioch evacuated by Sasanians. Roman captives in Sasanian Iran released.
628 *Kavad II*. Peace with Byzantium.		**629** True Cross returned to Jerusalem.
628–630 *Ardeshir III* (a child), son of Kavad II		
630–631 *Buran*, daughter of Khusrau II		
631–632 *Hormizd V, Khusrau III*. Period of anarchy, 628–632.		
632–651 *Yazdegird III*. Rostam is *spahbed* (general); becomes true regent of Sasanian Iran.		
636 Arabs defeat Sasanian army at Qadisiya in Mesopotamia.		**637** Arabs conquer Jerusalem, Antioch.
638 or 639 Susa taken by Muslim armies.		**641** Arabs conquer Egypt.
642 Arabs defeat Sasanians at Nihavend in Iran.		**641–668** *Constans II*. Loss of southern and eastern provinces of Byzantium to Arabs.
651 Yazdegird murdered at Merv.		**668–685** *Constantine IV*. Withstands four-year siege of Constantinople (674–678) by Arabs.

SILVER

"He [Shapur] had portrayed on a wine cup the image of [the Armenian king] mounted on a white horse, and ordinarily during the great festivities, he set the cup before him and repeated each time the same words 'May the man on the white courser take wine with me.'"

Faustus of Byzantium.[1]

Every good Zoroastrian was instructed to spend two-thirds of his days consulting the wisdom of wise men and tilling the soil. The remaining third was for eating, rest, and enjoyment.[2] The vast quantity of silver plate accumulated by the highest classes of Sasanian society indicates their concern for this third of their lives.

The most famous works of art from the Sasanian period are undoubtedly the silver vessels, notably those decorated with scenes of an equestrian king hunting. Passages in ancient texts describe gifts of silver plate from the Sasanian king to nobles or, on a more lavish scale, to contemporary rulers. One seventh-century Albanian writer, Moses Kalankatuisky, states that Shapur II (309–379) gave a cup and a flowering branch to each noble at banquets.[3] The emperor Aurelian allegedly received from Shapur I (241–272) a bowl "on which was engraved the Sun-god in the same attire in which he was worshipped in the very temple where the mother of Aurelian had been a priestess."[4]

In the East as in the West, large collections of silver vessels existed in the imperial and noble households. A taste for elaborate table settings of silver spread subsequently to the barbarians north of Iran, who apparently acquired as gifts or booty vast collections of gold and silver plate. The remains suggest that imitations of these foreign luxury wares were produced in many regions bordering on Iran and Byzantium (No. 17 and fig. 17b).

The silver of the Sasanians has not been found in archaeologically recorded hoards or treasures on Iranian soil. Vessels from Iran are for the most part accidental discoveries without a documented history. This has caused problems in establishing a precise chronology and has introduced the question of authenticity. Furthermore, the silver of Sasanian type found in Russia during the last centuries and now in the Hermitage Museum in Leningrad and in European collections (notably the Bibliothèque Nationale, the Museum für Islamische Kunst in Berlin, and The British Museum) also lacks any real archaeological context. Many of the discoveries were made in the Perm region, north of the Caspian Sea, an area the silver vessels reached as objects of trade and barter, exchanged for local products, "honey, beeswax, amber, furs, and walrus ivory."[5] Occasionally treasures of silver plate, including both Sasanian and late antique pieces, are recovered from known sites in the Soviet Union, still intact as a group, but this is the exception rather than the rule. Bewildered by the volume of undocumented material, scholars are often unable to agree on questions of cultural and chronological attribution. In recent years, however, a combination of art historical research and scientific analysis of the metal has begun to provide reliable evidence for the definition of stylistic traditions and the establishment of criteria for determining authenticity.[6]

Many of the silver objects are inscribed, sometimes with only a name, more often with indications of weight, according to the Sasanian standard.[7] The basic unit was the *drahm* (loan word from Greek *drachma*; later Arabic and Persian *dirhem*). The inscriptions and the weights, when compared with the weights of Sasanian and early Islamic *drahm* coins, provide information concerning the date of the vessels and suggest that there was a strict control of the distribution of silver. This system of controls was also extended to the ore from which the metal was extracted. Metallurgical analyses of the silver used for vessels identifiable in style as central Sasanian court products suggest that the metal came from a single source.

There is a considerable variety in the shapes of the silver vessels.[8] Most of the types are represented by objects in this exhibition. Examples in each class are remarkably uniform in size. The standardization of the royal hunting plates (Nos. 6, 7) which were part of a state production, is not surprising. It is more unexpected to find that other vessels—small hemispherical bowls, oval dishes, and vases—commissioned, in all probability, by the nobility for personal rather than official use, are so regular in design.

To some extent the shapes of the vessels have a chronological significance. Large circular bowls (No. 2) bear designs of the third and fourth centuries. Elongated lobed bowls are apparently later in date. They are represented on seventh-century Sogdian wall paintings at Piandjikent and it is probable that these Central Asian vessels are the prototypes for the Iranian examples.[9] Stylistically, the designs on the Sasanian bowls of this type confirm this late dating. The crescentic oval bowl (No. 11) may also belong to the latter part of the Sasanian period, although there is less evidence upon which to base a judgment. One such bowl, in bronze, was found in a late Sasanian or early Islamic context at Qasr-i Abu Nasr in Iran.[10] The fluted bowl with a high pedestal foot (No. 9) and the ewer (No. 18) are typologically similar to late antique vessels of the fourth or early fifth century. One opinion is that the designs on the ewers are of approximately this date; another is that they are slightly later and belong to the sixth or seventh century. The vases have late Sasanian parallels in pottery from Ctesiphon and Kish.[11]

Horn-shaped rhyta terminating in animal heads had been popular in many earlier periods in the Near East. However, only slight evidence survives of this type of vessel from Sasanian times (Nos. 5, 25). Silver vessels in the shape of complete animals with holes for filling and pouring are equally rare, but there are examples among recent finds made in Iran (No. 1).[12]

Some designs are limited to vessels of certain shapes. The royal scenes with the king hunting or enthroned occur exclusively on the interior of circular plates with low ring feet. From the time of Shapur II (309–379) until late in the sixth century, no human figures other than the kings were represented on Sasanian silver. Apparently these plates were part of an official court production. The hunting scenes retain military aspects. The hunter is always fully armed with a sword, quiver, and often a dagger, as well as his hunting weapon, generally a bow. Typically he wears a chest halter with a central boss, a form of royal dress derived from the straps and breast-

plate worn by armored figures on the rock relief of Ardeshir I (224–241) at Firuzabad.[13] It is, therefore, plausible to view these scenes as deliberate references to the warrior king. Representations of the hunt on silver plates are more than reflections of court life. They are allegories for human combats such as those carved on the rock reliefs. Many of the plates were sent to rulers and allies abroad, particularly to areas bordering on the Sasanian Empire, where as official works of art, they were expected to impress the recipient with the valor and prowess of the donor. The vessels have been discovered in Armenia, Soviet Azerbaijan, Georgia, and Afghanistan. Eventually the plates were traded as valuable objects of barter, reaching areas as remote as the Perm region. Only the presence of Middle Persian or Sogdian inscriptions testifies to the route along which they passed.

In most instances these royal hunting plates are to be dated to the time of the ruler who appears on them. He can often be identified by comparing the crown represented on the plate with those on Sasanian coins. Unfortunately, from the end of the fifth century through the early seventh, there is much repetition in the crown types. This feature does not always serve, therefore, as a precise indication of date. Friedrich Wachtsmuth suggested decades ago that by the late Sasanian period the intention was not to represent the crown of an individual monarch but only an "ideal" type.[14] On late Sasanian royal silver there is never any inscription naming the king. The image is therefore ambiguous and the emphasis is on the glory of the dynasty of Sasan rather than on a particular king.

The correspondence between subject matter and shape exists not only on the royal hunting plates but also on other types of vessels. One theme appears almost exclusively on vases and ewers. A number of dancing female figures are shown holding specific objects or attributes (No. 18). Although the significance of this subject is unknown, the fact that it occurs only on pouring vessels suggests that it had a ceremonial or cultic meaning.

Another category of subject, considerably enlarged by recent discoveries in Iran, is the genre or narrative scene. Wine-making, games, and noble banquets are among the activities of daily life depicted on small hemispherical bowls (see Nos. 14, 25). These probably belonged to the nobility and also to the new military class that achieved wealth and position under Khusrau I (531–579) and his successors.

A recent study by Pieter Meyers, research chemist at The Metropolitan Museum of Art, of Sasanian silver vessels in Soviet, European, and American collections has done much to explain the methods of their manufacture. The techniques are varied and complex. None of the Sasanian pieces examined appears to have been simply cast in its final form. They were usually hammered into shape and then decorated in a number of different ways. On the most elaborate plates and bowls, separate pieces of silver were added to provide high relief. These pieces were inserted into lips cut up from the plate. Low relief was produced by carving away the background around the design. In contrast to the plates, vases and ewers were decorated chiefly by hammering and chasing.

Many of the vessels are gilded—usually with an amalgam of mercury and gold, painted onto the surface.

This form of gilding runs easily. To prevent it from spreading beyond the chosen areas, the artists began, late in the Sasanian period, to apply it to the low background rather than to the raised design. One vessel in this exhibition, the rhyton in the shape of a horse from The Cleveland Museum, is gilded differently—with gold foil (No. 1).

Occasionally minor works, particularly the small hemispherical bowls (Nos. 14, 25), were made of silver with a high copper content. The royal court silver, on the other hand, is of a purer quality and is remarkably uniform in metallurgical composition. When analyzed, the metal offers support for the distinctions established on the basis of style, between provincial works (No. 17) and those of central Sasanian court manufacture (Nos. 6, 7, 12). These analyses reveal that the workshops outside central Sasanian control used silver extracted from a number of different ores, whereas the makers of court vessels were provided with silver from a single source.

Descriptions of hunting scenes similar to those on Sasanian silver vessels abound in the poetry and prose of Islamic Persia: onagers are hunted with lassos; stags are overcome by a hunter on foot, who grasps their horns and throws them down; crowns are snatched by royal pretenders from between snarling lions.[15] These descriptions illustrate the power of repetition in visual imagery. To a large degree, works of art shape the language and thoughts of the viewer. The hunter king of Sasanian Iran was a prestigious image familiar in the East and West and long remembered by the rulers of Islam.

Notes

1. Faustus de Byzance, Bk. 5. 3 in V. Langlois, *Collection des historiens anciens et modernes de l'Arménie*, I (Paris, 1867), p. 280.
2. R. C. Zaehner, *The Teachings of the Magi* (New York, 1976), p. 22.
3. K. V. Trever, "Novoye 'sasanidskoye' bliudtse Ermitazha," in *Istoria kultury narodov Sredney Azii* (Moscow/Leningrad: Akademia Nauk SSSR, 1960), p. 260 (Shapur II cup and branch quotation, *Istoriya Albanii*, Bk. II).
4. M. I. Rostovtzeff et al., *The Excavations at Dura-Europos, Preliminary Report of the Fifth Season* (New Haven, 1934), p. 308 (reference to the sun-god vessel given by Shapur I to Aurelian, *Scriptores Historiae Augustae* III, p. 201).
5. J. Orbeli and C. Trever, *Orfèvrerie sasanide* (Moscow/Leningrad, 1935); O. M. Dalton, *The Treasure of the Oxus*, 3rd ed. (London, 1964), pls. 36–39; K. Erdmann, *Die Kunst Irans zur Zeit der Sasaniden* (Berlin, 1943), pls. 59–80. For the trade with the Perm region see R. N. Frye, "Irano-Byzantine Commercial and Diplomatic Rivalry," *Bulletin of the Asia Institute of Pahlavi University* (1976), p. 15.
6. P. L. Meyers et al., "Major and Trace Elements in Sasanian Silver," *Symposium on Archaeological Chemistry*, 165th American Chemical Society Meeting (Dallas, 1974), pp. 22–23.
7. V. A. Livshits and V. G. Lukonin, "Srednepersidskie i sogdiyskie nadpisi na serebryanikh sosudakh," *Vestnik Drevnei Istorii* (1964), no. 3, pp. 155–176; C. J. Brunner, "Middle Persian Inscriptions on Sasanian Silverware," *Metropolitan Museum Journal* 9 (1974), pp. 109–121; R. N. Frye, "Sasanian Numbers and Silver Weights," *Journal of the Royal Asiatic Society* (1973), pp. 2–11.
8. The University of Michigan Museum of Art, *Sasanian Silver* (Ann Arbor, 1967), Introduction by Oleg Grabar, pp. 19–84.
9. A. Iu. Yakubovskiy et al., *Zhivopis drevnego Pyandzhikenta* (Moscow, 1954), pl. 7.
10. R. N. Frye, ed., *Sasanian Remains from Qasr-i Abu Nasr* (Cambridge, Mass., 1973), p. 21, fig. 22.
11. R. Ettinghausen, "Parthian and Sasanian Pottery," in *A Survey of Persian Art*, ed. A. U. Pope (London/New York, 1938), I, pp. 646–680.
12. The University of Michigan Museum of Art, *Sasanian Silver*, fig. 49.
13. W. Hinz, *Altiranische Funde und Forschungen* (Berlin, 1969), pl. 52.
14. F. Wachtsmuth, "Zur Datierung des Taq-i Bustan und der Pariser Silberschale," *Zeitschrift der Deutschen Morgenländischen Gesellschaft* 99 (1945–49), pp. 212–224.
15. W. L. Hanaway, "The Hunt in Persian Literature," *Bulletin of the Boston Museum of Fine Arts* 69 (1971), pp. 21–34.

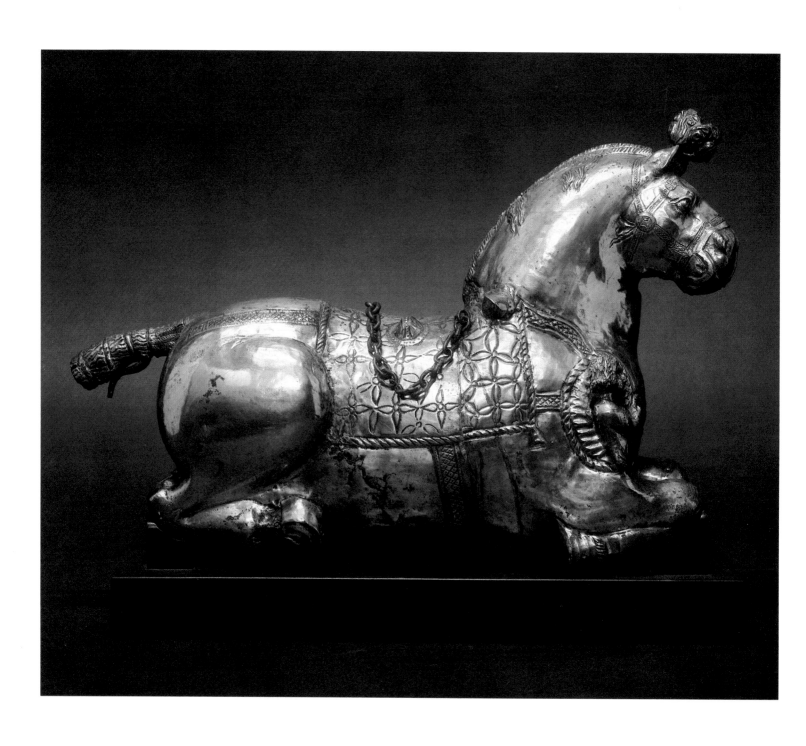

Detail of No. 1

1

Silver-gilt rhyton in the shape of a horse

Iran(?); third or early fourth century
Height 21 cm., length 26.7 cm., weight 995 grams
The Cleveland Museum of Art; Purchase, John L. Severance
Fund (64.41)

Among the most interesting Sasanian silver objects are vessels in the shape of a complete animal. One of the finest examples is this horse now in the collection of The Cleveland Museum. It consists of two large pieces (forepart and hindquarters), a removable tail, and a prominent forelock that served as a funnel. Small wires are attached to the undersurface of the elaborately bound tail, now incomplete. Between the bent forelegs, low on the chest, is a spout. Above this, on the shoulders of the horse, two fluted roundels enclose the busts of bearded male figures. The rhyton is partially gilded, with thin gold foil rather than in the typical Sasanian fashion with mercury gilding.

Originally, the two parts of the body were held together, although the means of attachment is not evident. The proportions of the animal are correct if the two cut edges of the body join but do not overlap each other. The purpose of the chains is also unclear. Since they were reattached in the process of restoration, it is useless to speculate whether they were originally intended to serve as a means of suspending or holding the vessel. However, chains for suspension exist on bronze horse-shaped vessels made in the eastern Mediterranean world in the fifth to seventh centuries.[1] The saddle blanket with bells or pendants at the corners on this horse from The Cleveland Museum is quilted in a fashion also apparent on some Sasanian silver hunting plates.

The bridle has been described by Mary A. Littauer as follows: "The horse is wearing a headstall, probably of leather and wool or hair braid. Below is a metal muzzle or 'dropped noseband.' The latter would have been held in place by attachments between its upper corners and the headstall. The deep bays of the muzzle allow room for the ends of a bit, which is not present here, but which also would have been hung from the headstall."

The horse lies in an unusual position, with both fore and hind legs folded directly beneath the body. In Sasanian art, horses are customarily represented standing or in a flying gallop. In spite of the recumbent posture, generally assumed by an animal at rest, this horse is fully saddled. The head turns slightly to the right and the appearance is one of alertness. An animal in a similar pose is represented on an earlier silver rhyton of the first millennium B.C. found in Armenia (fig. 1a).[2] On this example, there is a rider actually seated astride the horse. A second- or third-century silver-gilt vessel in the shape of a horse is closer to the Cleveland piece in date (fig. 1b). Probably the product of an eastern Mediterranean workshop, this horse, now in the Louvre, stands upright on all four legs.[3] Although more realistic in appearance, the Louvre horse would have been clumsy to handle when drinking or pouring.

The silver horse in The Cleveland Museum is heavy-set

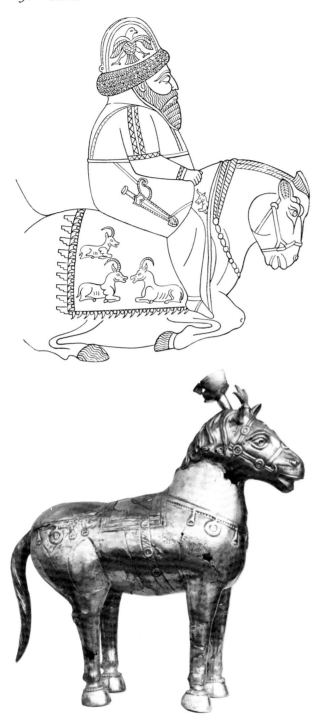

and has a mane that is cropped except for three pairs of long locks. This type of horse is consistently represented on royal Sasanian rock reliefs. It is a descendant of the royal and sacred horse of the Achaemenid Persians, the Nisean.[4] As a symbol of status and rank, it continued to be associated with royalty and nobility in Sasanian times.

The male figures within the fluted roundels on the horse in The Cleveland Museum have jeweled necklets and bands on their garments, but neither wears a crown or headdress to denote royal rank. One figure rests his left hand on a sword (?) and holds in his right a jeweled ring toward which the other figure gestures. The left hand of this second personage is covered by a long sleeve in a customary Sasanian gesture of respect. The ring symbolizes some form of contract or agreement, the precise meaning of which is unclear. On many early Sasanian reliefs, rulers of different parts of the empire are represented holding jeweled rings, which signify the authority bestowed upon them by the king. These rings differ from the royal rings of investiture because they lack ribbons.

The Cleveland rhyton was undoubtedly made for use on special occasions. It is a commemorative object, designed to celebrate an important event in the life of a princely or noble owner. This is symbolized by the presence of the male figure, possibly the original owner, who grasps in his hand the jeweled symbol of office. Finally interred in a grave, the rhyton was crushed but not destroyed. Restored in modern times, it retains its beauty —an original and, at present, unique work of Sasanian art.[5]

Selected Bibliography

E. Coche de la Ferté, "Palma et Laurus," *Jahrbuch der Berliner Museen* 3 (1961), p. 147, fig. 11; R. Ghirshman, "Notes iraniennes XI: Le rhyton en Iran," *Artibus Asiae* 25 (1962), p. 78, figs. 29, 30; R. Ghirshman, *Persian Art* (New York, 1962), p. 220; D. G. Shepherd, "Two Silver Rhyta," *The Bulletin of The Cleveland Museum of Art* 53 (October, 1966), pp. 289–315, figs. 6, 8, and back cover; H. N. Lechtman, "Ancient Methods of Gilding Silver: Examples from the Old and New Worlds," in *Science and Archaeology*, ed. R. H. Brill (Cambridge, Mass., 1971), pp. 2–18.

Notes

1. Coche de la Ferté, "Palma et Laurus," pp. 134–147.
2. B. N. Arakelyan, "Klad serebryanikh izdeliy iz Erebuni," *Sovetskaya Arkheologiya* (1971), no. 1, pp. 143–157, figs. 1–4.
3. J. Charbonneaux, "Nouvelles acquisitions du Départements des Antiquités Grecques et Romaines: Un rhyton en forme de cheval," *Revue des Arts* (1957), no. 5, pp. 229–230 (H. 31 cm.); see also note 1 above.
4. Herodotus, *History*, ed. G. Rawlinson (London, 1875), IV, p. 39 (Bk. VII. 40).
5. I am grateful to Mary A. Littauer for her description of the horse gear and for her ideas and comments.

Fig. 1a. *Drawing of a silver rhyton with the figure of a horseman. Mid-first millennium B.C. L. 42 cm. Erevan, Armenia.*
Fig. 1b. *Silver-gilt vessel in the shape of a horse. Early first millennium A.D. H. 31 cm. Eastern Mediterranean region. Musée du Louvre.*

2

Silver bowl with medallion enclosing a
male bust

Iran; late third or early fourth century
Height 7.6 cm., diameter 23.7 cm., weight 775 grams
Cincinnati Art Museum; Gift of Mr. and Mrs. Warner L.
 Atkins (1955.71)

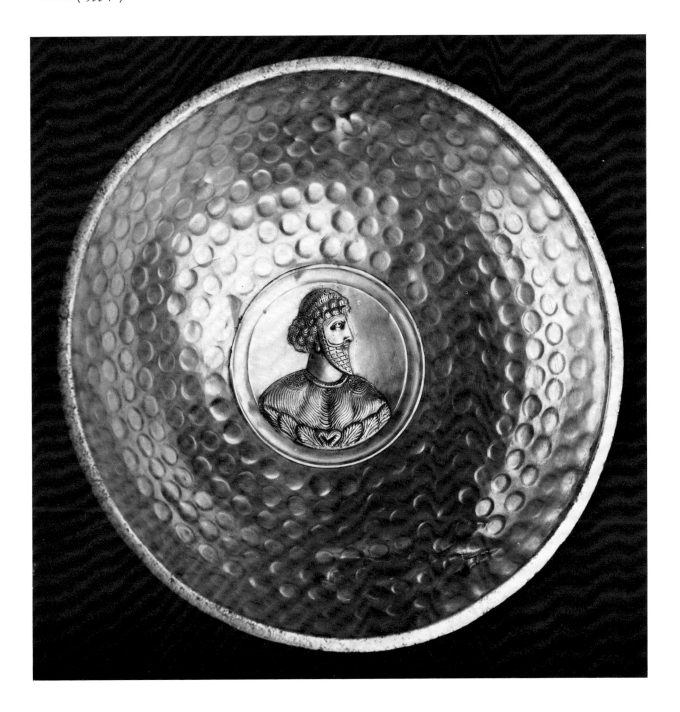

This vessel, one of four bowls allegedly found together in Iran, is a rare example of early Sasanian silver plate. All four of the bowls in this group are decorated in the same fashion: at the center of the interior on each vessel there is a circular medallion enclosing a human bust resting on a leaf base. The other three bowls are presently in The Metropolitan Museum of Art, the Freer Gallery of Art, and the Iran Bastan Museum in Tehran (the sole example with a female rather than a male bust[fig. 2a]). On the interior of the bowl included here convex discs reflect light in a fashion similar to the circular facets on the walls of Sasanian glass vessels (compare No. 78).

Only a small number of early Sasanian silver vessels have survived. Seven pieces, including the four just described, are decorated with medallions enclosing busts of human figures.[1] These figures appear to be members of the high nobility—local governors or princes, rather than the king himself. The one exception occurs on a two-handled cup from Zargveshi in Georgia (Caucasus) on which the king, Bahram II (276–293), and members of the royal family are represented within circular frames.[2]

Elaborately dressed in a garment decorated with embroidered roundels and wearing a necklace and earrings, the figure on the Cincinnati plate is a man of high rank. Nothing indicates precisely who this person is or suggests the function of the vessel. The leaf base occurs on Western sepulchral monuments but its meaning in Sasanian contexts is unknown.[3] On the stamp seals, human busts commonly appear above a row of plant leaves (compare No. 72).

The drapery and facial features of the male bust on the Cincinnati plate resemble those of Shapur on the hunting plate in The British Museum (No. 4). The clothing on the bust, however, falls naturalistically over the body, reflecting the form beneath, while the folds of the garment worn by the royal hunter are more decoratively arranged. Less natural in appearance is the almond-shaped eye of the male on this bowl, a feature executed in a much more realistic fashion on the British Museum plate. These two vessels thus illustrate the development of figural designs on Sasanian silver of the third and fourth centuries. On the one hand, there is evidence of an increasing abstraction in the drapery and, on the other, a greater naturalism in the body parts.

The Cincinnati bowl probably dates to the late third or early fourth century. Shortly after this period, the production of silver became a royal prerogative in Iran and Mesopotamia, the heart of the Sasanian Empire. Representations of human figures were then restricted solely to the image of the king and the hunting scene became the standard form of royal design on Sasanian court silver.

The decoration of silver vessels with medallion busts does not recur until the end of the Sasanian period (see No. 25).

Selected Bibliography

M. S. Dimand, "A Group of Sasanian Silver Bowls," *Aus der Welt der islamischen Kunst, Festschrift für Ernst Kühnel* (Berlin, 1959), pp. 11–14; B. Goldman, "Early Iranian Art in the Cincinnati Art Museum," *Art Quarterly* 27 (1964), p. 339; The University of Michigan Museum of Art, *Sasanian Silver*, p. 99, fig. 11; O. Grabar, "Sasanian and Islamic Art through the Ages," *Apollo Magazine* 93 (April, 1971), p. 255; P. O. Harper, "Sasanian Medallion Bowls with Human Busts," *Near Eastern Numismatics, Iconography and History: Studies in Honor of George C. Miles*, ed. D. K. Kouymjian (Beirut, 1974), p. 65, fig. 4.

Notes

1. Harper, "Sasanian Medallion Bowls with Human Busts," p. 65, fig. 4.
2. V. G. Lukonin, *Persia II* (Geneva, 1967), fig. 207.
3. H. Jucker, *Das Bildnis im Blätterkelch*, 2 vols. (Lausanne, 1961); see also P. O. Harper in *Sasanian Remains from Qasr-i Abu Nasr*, p. 68.

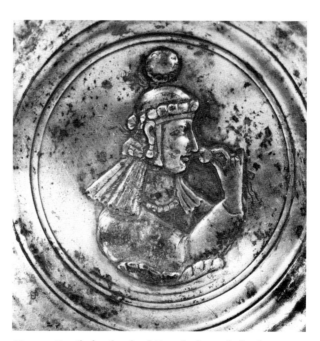

Fig. 2a. *Detail of a silver bowl. Late third or early fourth century A.D. Sasanian. Iran Bastan Museum, Tehran (1385).*

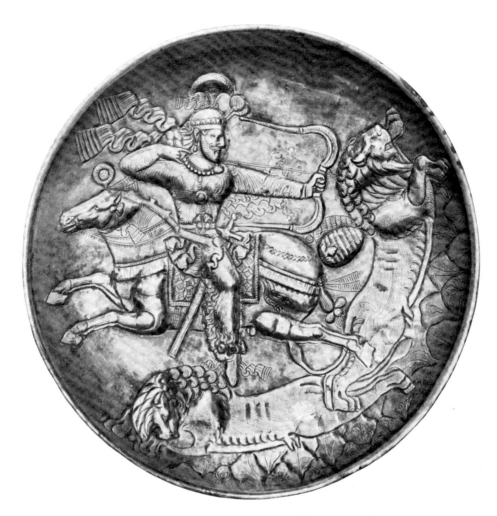

3

Silver-gilt plate with a figure hunting lions

On reverse, in center, two concentric circles and a worker's mark
Sari, northern Iran; fourth century
Height 6 cm., diameter 28.5 cm., weight 1302 grams
Iran Bastan Museum, Tehran (1275)

This plate, found by workmen in 1954 at Sari, is one of the most beautiful and possibly the earliest of all the royal Sasanian hunting vessels. Riding his horse at a gallop, the hunter draws his bow and turns back to shoot at a pair of lions. The figure sits on his horse in a contorted position. His upper torso and left leg are entirely twisted to the rear.

Before the hunting scene became associated exclusively with the Sasanian king, princes and rulers of regions within the Sasanian Empire were portrayed on silver plates in scenes of the hunt. Two examples—both in provincial Russian collections—survive with representations of such hunters, in left profile.[1] On the Sari plate, how-

ever, the figure is shown in right profile, the pose consistently adopted by the king on later hunting plates.

The Sari plate presents a problem. The beaded halter, right profile, tied beard, and the presence of both a sword and a bow imply that the hunter is a king. However, he wears a headdress unknown on Sasanian coins, a fan-shaped form similar to the headgear of royal princes rather than kings.

Lions are the quarry on the Sari plate. Does the slaying of the king of beasts signify the victory, imagined or real, of some pretender to the throne over a royal claimant? The accession to the throne of Iran was disputed many times during the third and fourth centuries. Bahram III (293) was deposed in favor of Narseh (293–303). Adhurnarseh (309), the son of Hormizd II (303–309), was replaced by Shapur II (309–379). The chosen successor of Shapur II, his son Shapur III (383–388), came to the throne only after the interregnum of Ardeshir II (379–383).

The representation of the figure on this plate is unique. The drapery, rippling naturalistically over the body, is

not similar either to the stylized parallel folds on the fourth-century British Museum plate (No. 4) or to the paired-line drapery style that characterizes the official court silver of the end of the fourth century and later (Nos. 6, 7). With the help of the images on seals and rock reliefs, however, it is possible to date this vessel in the fourth century. Dorothy Shepherd compared the drapery of the Sari figure to that of Ardeshir II on a rock relief at Taq-i Bostan.[2] It is true that the stylization of the drapery on the Sari plate is consistent with this one dynastic monument of the late fourth century. How much earlier the plate is than the relief is difficult to judge.

The Sari plate combines naturalism, in the depiction of the forms, with rich linear details. This style did not persist in Iranian metalwork. When the hunting plates became a controlled product of the state under Shapur II, the images grew increasingly stereotyped and the representations became stylized. The animals and landscape, even the vessels themselves, diminished in size.

At the beginning of this sequence of royal silver is the Sari plate—a magnificent testimonial to the ambitions of the hunter, surely an aspirant to the Sasanian royal throne, perhaps a successful one.

Selected Bibliography

R. Ghirshman, "Notes iraniennes VI: Une coupe sassanide à scène de chasse," *Artibus Asiae* 18 (1955), pp. 5–19. The weight given in this publication is cited in the entry; L. vanden Berghe, *L'Archéologie de l'Iran ancien* (Leiden, 1959), p. 7, pl. 7a; D. G. Shepherd, "Sasanian Art in Cleveland," *The Bulletin of The Cleveland Museum of Art* 51 (April, 1964), p. 70, fig. 5.

Notes

1. S. Fajans, "Recent Russian Literature on Newly Found Middle Eastern Metal Vessels," *Ars Orientalis* 2 (1957), p. 61, pl. 5, fig. 11; V. G. Lukonin, *Iran v epokhu pervykh sasanidov* (Leningrad, 1961), pl. 11 (a plate from Krasnaya Polyana). Another found near Shahmahah in Soviet Azerbaijan is unpublished. I am grateful to V. G. Lukonin for bringing this plate to my attention.
2. S. Fukai and K. Horiuchi, *Taq-i-Bustan*, II (Tokyo, 1972), pls. 81–83.

4

Silver plate with a hunting scene

Allegedly from Anatolia, purchased in Iran; fourth century
Height 4.5 cm., diameter 18 cm., weight 394.7 grams
The British Museum, Department of Western Asiatic
 Antiquities (BM 124091)

In no sense is this a typical Sasanian hunt. The king, astride a stag, stabs his quarry in the neck. Beneath the royal hunter lies another (perhaps the same) stag in the characteristic pose of death—legs folded, head raised, and blood pouring from the nostrils.

The plate can be dated to the fourth century on the basis of style and dress (notably the beaded halter partly visible on the figure's left shoulder and the raised globe above and in the center of, rather than enclosed within and toward the front of, the stepped crenellations of the crown).[1] At this time Shapur II (309–379) ruled over the Sasanian Empire but the crown in this scene lacks the characteristic details of the two crowns of Shapur II: a beaded band beneath the stepped crenellations (fig. 4a) or, alternatively, a row of curls above an unbeaded band. The possibility exists, therefore, that this is a deliberate representation of a royal ancestor, Shapur I, who is depicted on rock reliefs wearing the crown appearing on this plate (fig. 4b).

Shapur II (309–379) became king at his birth and during the period that he was a child his mother governed the country with members of the great families of Iran. As a subject for the court silver made at the time of the king's infancy and early youth, Shapur I, the illustrious namesake of the young king, would have been a natural choice. On this plate in The British Museum, the deceased ancestor, Shapur, was perhaps deliberately likened to Mithra, who is shown as a hunter, pursuing stags and other animals, in the third-century wall paintings of the Mithraeum at Dura-Europos.[2]

It is clear that the British Museum's vessel is the type that served as a model for some later provincial silver plates (No. 17). The drapery falls in parallel lines over the

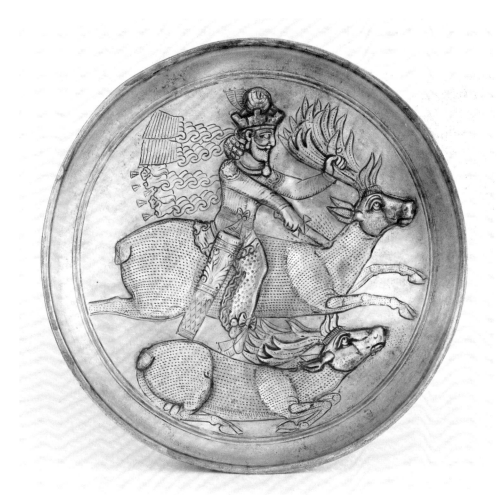

Fig. 4a

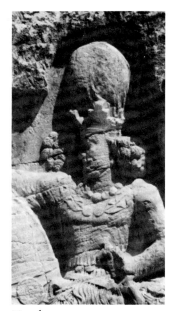

Fig. 4b

body. The animals are covered with hatched hair patterns. Blood spurts from their wounds. The design is partly cut off by the molding and is spot-gilded. In the late fourth century, these features disappear from the silver commissioned within the Sasanian kingdom, and it is evident that another style developed. This is apparent on a few vessels in this exhibition (Nos. 6, 7). Only outside of Iran is the earlier tradition preserved.

The British Museum plate is unique in many respects. Important as an example of the type of hunting scene that must have been well-known in some provincial, eastern lands, it is also a rare and beautifully conceived illustration of a Sasanian scene with a particular symbolic meaning.

Selected Bibliography

L. Bachhofer, "Sasanidische Jagdschalen," *Pantheon* 11 (1933), p. 65; K. Erdmann, "Die sasanidischen Jagdschalen," *Jahrbuch der Preuszischen Kunstsammlungen* 57 (1936), pp. 199–200; E. Herzfeld, "Khusrau Parwēz und der Tāq-i Vastān," *Archaeologische*

Mitteilungen aus Iran 9 (1938), pp. 125–126; J. F. Haskins, "Northern Origins of 'Sasanian' Metalwork," *Artibus Asiae* 15 (1952), p. 328; Dalton, *The Treasure of the Oxus*, p. 60, pl. 36.

Notes

1. B. I. Marshak and Ya. K. Krikis, "Chilekskie Chashi," *Trudy Gosudarstvennogo Ermitazha* 10 (1969), p. 63.
2. A. Perkins, *The Art of Dura-Europos* (Oxford, 1973), pl. 16; K. V. Trever, "Otrazhenie v iskusstve dualisticheskoi Kontseptsii Zoroastrizma," *Trudy Otdela Vostoka* 1 (1939), p. 248; The University of Michigan Museum of Art, *Sasanian Silver*, p. 54.

Fig. 4a. *Coin of Shapur II. The American Numismatic Society.*
Fig. 4b. *Detail of rock relief of Shapur I commemorating the defeat of two Roman emperors. Third century A.D. Naqsh-i Rustam, Iran.*

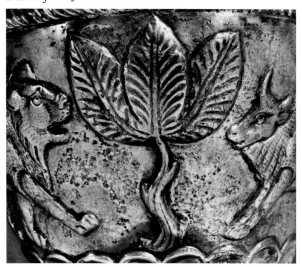

Details of No. 5

5
Silver-gilt rhyton

Iran(?); ca. fourth century
Height (from the fluting on the base of the drinking horn to the rim) 12.7 cm., diameter at rim 14.2 cm., weight 598.5 grams
The Arthur M. Sackler Collections

Horn-shaped vessels terminating in animal heads were produced over a long period of time in the pre-Islamic Near East. The most spectacular Iranian examples are made of gold and silver and can be attributed to the first millennium B.C. The rhyton in the Sackler collection is one of the few surviving horn-shaped vessels of Sasanian date.[1] The profile is crescentic, the drinking horn rising only slightly above the animal's head. At the rim, below a row of repoussé discs, there is a broad band decorated with antelopes and a lion and bull approaching a central tree. Beneath this band, a portion of the horn is longitudinally fluted.

The primal bull, in Zoroastrian texts, embodied "animal life and prosperity." As an artistic motif, the bull probably also stood for the zodiacal sign of Taurus. The lion "represented royalty and may have possessed an astral symbolism beyond that of the zodiacal constellation, Leo."[2]

Between the two animals on this vessel is a tree, possibly a general symbol of fertility and renewed life. In one Pahlavi text, however, the *Shikand Gumānī Vazār*, the Good Religion is compared to a tree with a single trunk, two boughs, and three branches, "the famous triad of good thoughts, good words, good deeds."[3] Interpretations of the figural designs on this rhyton are hypothetical, but it is evident that the separate motifs had a beneficent and significant meaning and were, therefore, appropriate for the decoration of a luxury vessel.

A close parallel for the Sackler rhyton, in shape, is a small agate vessel recently discovered in a seventh-century Chinese hoard (fig. 5a).[4] The naturalistic modeling of the animal head has led some scholars to date this piece to the third or second century B.C. However, the date remains open to question. In silhouette, the agate rhyton resembles this example as well as a representation of another horn-shaped vessel on a late Sasanian bowl in the Sackler collection (No. 25).

The animal and plant designs on the rhyton under consideration have certain features found only in the third and fourth centuries on Sasanian silverware: the overall hair pattern of the animals and the technique of spot-gilding (parts of the animal bodies and the tree on the relief band, the discs at the rim, and certain sections of the

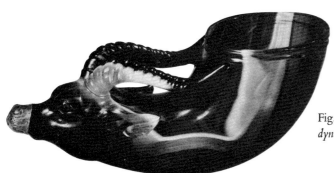

Fig. 5a. *Agate rhyton decorated with an antelope head. T'ang dynasty hoard. L. 15.3 cm. Shensi Province, China.*

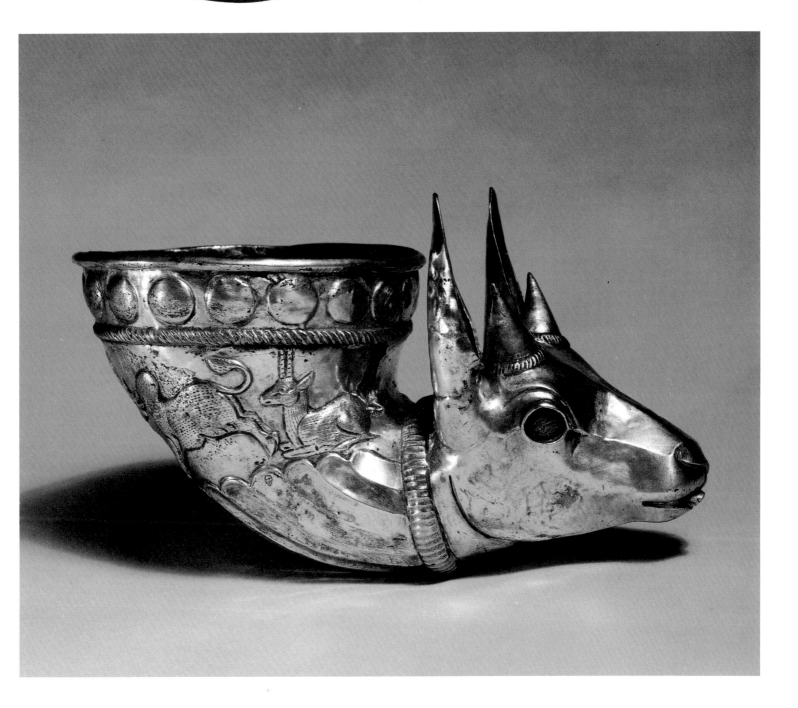

fluting). By the fifth and sixth centuries, however, these details are characteristic of works of art made in the lands east of Iran. On provincial silver plates that imitate the royal Sasanian hunting silver and on a "Bactrian" vessel from Veroino in the Perm region, dated to the fourth or fifth century, there are parallels for the particular tree on the Sackler rhyton.[5] This plant differs in species and therefore in appearance from those customarily illustrated on Sasanian works of art.

The animal head on this vessel shares some details with the saiga antelope in a private collection (No. 16): the exaggerated upright ears and the ribbed band around the neck. However, the rendering of the eyes (probably inlaid originally) and nostrils of the animal head on the Sackler rhyton is more naturalistic than that of the saiga antelope.

The source of the rhyton in the Sackler collection is said to be Iran and the presence of elements uncommon in later Sasanian art suggests that it is datable to the beginning of the fourth century. After this period, during the reign of Shapur II (309–379) there is a standardization in the form of the designs on silver vessels. In style and in the elemental composition of the metal, the Sackler rhyton can be distinguished from the central Sasanian court products of the late fourth to the seventh century. The similarity of the tree to that on the eastern silver bowl is a sign of influence from an outside area, either the Bactrian lands that had, in the fourth century, come under Sasanian domination, or elsewhere. The rhyton is a striking example of an early Sasanian silver vessel, the prized possession of some Iranian prince or king.

Selected Bibliography

D. G. Shepherd, "Two Silver Rhyta," *The Bulletin of The Cleveland Museum of Art* 53 (October, 1966), p. 300, fig. 11.

Notes

1. I am grateful to Dr. Pieter Meyers for the results of a neutron activation analysis of the metal which places this piece in close association with the silver bowl from Cincinnati (No. 2) and clearly differentiates it from provincial eastern silver and from the Sasanian court production of the time of Shapur II and later monarchs.
2. C. J. Brunner, in M. Noveck, *The Mark of Ancient Man* (Brooklyn: The Brooklyn Museum, 1975), pp. 79, 82.
3. Zaehner, *The Teachings of the Magi*, p. 85.
4. *Cultural Relics Unearthed in China* (Peking: Wenwu Press, 1972), pl. 70; K. Parlasca, "Ein hellenistisches Achat-rhyton in China," *Artibus Asiae* 37 (1975), pp. 280–286.
5. Y. I. Smirnov, *Vostochnoe Serebro* (St. Petersburg, 1909), pl. 39, no. 68 (Bactrian vessel—dated to the fourth–fifth centuries by B. I. Marshak and Ya. K. Krikis, in "Chilekskie Chashi," p. 71).

6

Silver-gilt plate with a king hunting lions

Inscribed: Gugāy. 32 [stēr] and 1 drahm[1]
Iran(?); fifth or sixth century
Height 4.4 cm., diameter 20.8 cm., weight 546 grams
The Cleveland Museum of Art; Purchase, John L. Severance Fund (62.150)

The rider turns backward to execute what is generally called a "Parthian" shot—a subject occasionally depicted on Sasanian silver plates (compare No. 3). This feat of archery was much admired in the West. Procopius, a historian of the reign of Justinian (527–565), exclaimed on the prowess of Roman bowmen of his own time. He stated that they were expert horsemen who could shoot an opponent whether in pursuit or flight.[2]

The king on this plate wears an accurately portrayed Sasanian crown. It is that of Hormizd II (303–309) (fig. 6a). The scene is laid out and executed in normal Sasanian fashion. However, this vessel could not have been manufactured at the beginning of the fourth century. Details of the royal dress and the saddle—beaded halter, no leg guard—are not consistent with those on the early Sasanian rock reliefs and seals. The shape of the bow, with a pronounced ridge at the base of the ear, or outermost section (added protection against the taut bowstring),[3] and the position of the bowstring hand with bent little finger are features that do not appear on Sasanian monuments before the fifth century. The folds of the drapery where it falls free of the body have a linear quality characteristic of sixth-century Sasanian silver plate.

Is this a representation made in the fifth or sixth century of a long dead ancestor or, if this is not Hormizd II, is the royal hunter some other personage? Hormizd III (457–459) was the legitimate ruler of Iran for slightly less than two years. During that time, he struggled to hold his throne in the face of attacks by his brother Peroz. The crown of Hormizd III is unknown, because he minted no coins. However, it was customary in the Sasanian period for rulers to adopt the crowns of earlier kings of the same name. Hormizd III may have hoped that, by imitating the crown type of Hormizd II, he could underscore the legitimacy of his disputed claim.

The subject of the Cleveland plate is appropriate if the king is Hormizd III. Lions are traditionally a symbol of royalty. Furthermore, they are a form of quarry not often represented on Sasanian silver vessels. David Bivar interprets a rock relief in which the Sasanian king Bahram II (276–293) kills two lions as a commemoration of the king's defeat of two royal enemies, the Roman emperor

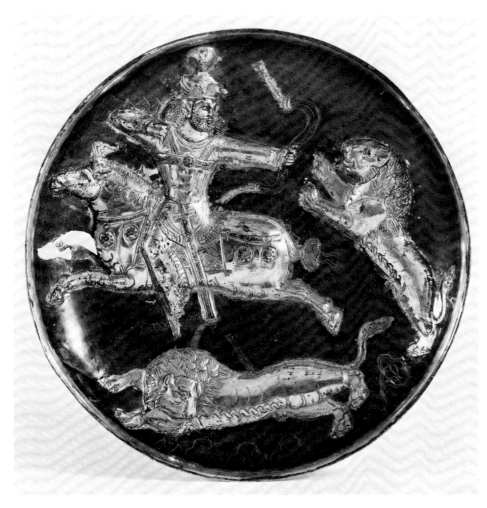

Fig. 6a. *Coin of Hormizd II. The American Numismatic Society.*

Carus and Bahram's own brother who attempted to usurp the throne.[4] In the *Shah-nameh*, Bahram V (420–438) proves his legitimacy by taking the crown from the jaws of lions.

If the king on the Cleveland plate is not Hormizd II, perhaps he is the legitimate fifth-century ruler Hormizd III overcoming the royal pretender Peroz. Hormizd III may have commissioned a number of silver vessels for use as gifts either to win allies to his cause or to reward them in his battle against Peroz.

Without inscriptional or numismatic evidence, the interpretation of this plate and the identification of the figure as Hormizd III remains hypothetical. The vessel illustrates the problems that traditionally surround the dating of Sasanian court silver on which the official crown type cannot be accepted without question as reliable evidence.

Selected Bibliography

D. G. Shepherd, "Sasanian Art in Cleveland," *The Bulletin of The Cleveland Museum of Art* 51 (April, 1964), pp. 66–95; Lukonin, *Persia II*, fig. 151; H. N. Lechtman, "Ancient Methods of Gilding Silver: Examples from the Old and New Worlds," in *Science and Archaeology*, ed. R. H. Brill (Cambridge, Mass., 1971), pp. 2–18.

Notes

1. C. J. Brunner, "Middle Persian Inscriptions on Sasanian Silver-ware," *Metropolitan Museum Journal* 9 (1974), p. 115.
2. Procopius, trans. H. B. Dewing, Loeb Classical Library (London/New York, 1914), I, pp. 5–9 (Bk. I. 1. 9–15).
3. F. E. Brown, "A Recently Discovered Compound Bow," *Seminarium Kondakovianum* 9 (1937), pp. 1–9. William Trousdale states his belief that the Cleveland Museum plate must be later than Hormizd II because of the rosette slide and the bow shape: *The Long Sword and Scabbard Slide in Asia*, Smithsonian Contributions to Anthropology, no. 17 (1975), p. 283, n. 363.
4. A. D. H. Bivar, "Cavalry Equipment and Tactics on the Euphrates Frontier," *Dumbarton Oaks Papers* 26 (1972), p. 281.

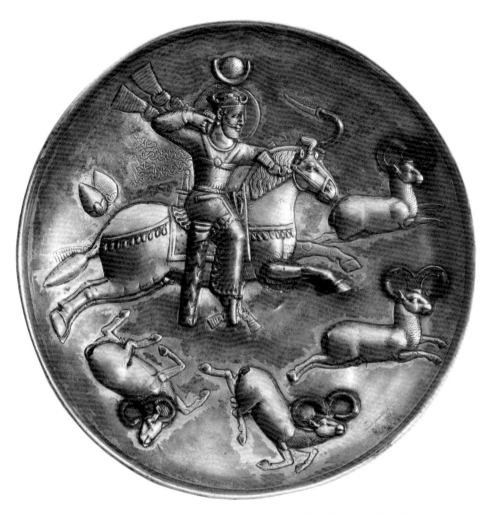

7
Silver plate with a hunting scene

Allegedly found at Qazvin, northern Iran; fifth century
Height 3.5 cm., diameter 22 cm., weight 721 grams
The Metropolitan Museum of Art; Fletcher Fund (34.33)

During the reign of Shapur II (309–379), the hunt became the standard motif on royal Sasanian silver plate. It symbolized the king's prowess and invincibility and was predominant on donative court silver from the fourth century until the collapse of the dynasty in the seventh century.

In antiquity, Sasanian vessels were sent to neighboring rulers and allies as gifts from the Iranian king. Many have been discovered in countries that share a common border with Iran—chiefly the Soviet Union. A substantial collection of Sasanian silver is presently in the Hermitage Museum in Leningrad.

This plate comes from Iran. When it was acquired in 1933 by The Metropolitan Museum it was one of the few Sasanian silver vessels known to have been discovered in Iran. Since then, chance finds of Sasanian silver have greatly increased the number of vessels of Iranian provenance, but regrettably there is still no scientific archaeological information concerning the circumstances of discovery.

The king represented on this plate sits astride his horse, in right profile, and aims with bow and arrow at two rams fleeing before him. Another pair of animals of the same species lies dead beneath the horse. The king has all the customary insignia of royalty: crown and fillet, covered globe above the head, and beaded chest halter. Surrounding his head is a halo of light signifying the "royal fortune," the attribute of all true Sasanian kings.

During the three centuries in which the royal silver plate was manufactured, fairly rigid restrictions governed the form of the scenes. Consequently only minor changes in detail occur. Because the vessels are products of different workshops, however, the quality of the representa-

tions varies. The Metropolitan Museum plate is one of the finest to have survived. Perfectly designed and executed, rich in color through the application of niello and gilding, the excellence of the plate suggests that it was made by craftsmen at the royal court. The pieces of silver that have been added to provide high relief are joined almost invisibly to each other and to the background shell.

Comparison with Sasanian coins shows that the king's crown is that of Peroz (459–484) or Kavad I (488–497, 499–531). Only a small detail—a single rather than a double line of beading on the forehead band—differentiates this crown type from that of another crown of Kavad I, Khusrau I (531–579), and a number of other late Sasanian rulers.[1] Our knowledge of the chronology of royal Sasanian silver is not sufficiently exact to permit us to distinguish the products made during the reign of Peroz or Kavad I from those made in the following century. There is, moreover, no way of knowing whether the silversmiths were obliged to follow strictly the iconography of the coins. Because both the coins and the royal silver plate were official state productions, however, the form of the crown must have been considered an important detail and the chronological evidence it provides cannot be ignored.

The modeling of the niello in relief on the horns of the moufflon rams is distinctively Iranian. In contemporary Western art, niello, with few exceptions, fills in areas cut out of the silver, remaining level with the surface of the vessel. This latter technique is used on the high-footed bowl in the Sackler collection and the hemispherical bowl in the Borowski collection (Nos. 9, 15).

In comparison with other Sasanian hunting scenes, the Metropolitan Museum plate has details that indicate a late date: the position of the bowstring hand with the little finger bent down, the representation of a belt buckle with a movable tongue, and the pronounced ridge on the upper arm of the bow. None of these features appears on a Sasanian work of art earlier than the fifth century.

In general, this hunting scene repeats the form that had been established by the mid-fourth century for royal vessels. The design is gilded, with the exception of the human flesh. The scene fits within a circular frame. The vertical position of the king and the placement of the two living animals, one above the other, is balanced by the horizontal line of the horse's body and the two dead animals below. Many details of dress and equipment that appear on this example are also illustrated without variation on others made in the central Sasanian workshops a century before and after this period. The regimentation of the design and details over a long period of time makes the precise dating of individual vessels extremely difficult.

The rule of Peroz was one of political, social, and economic disaster in Iran. After battling for years with nomadic invaders on Iran's eastern borders, Peroz was finally killed in combat against the Hephthalites in 484. His son Kavad I ruled only briefly before being deposed. This superb silver plate is difficult to view in such a setting. One is tempted to consider it a product of the Sasanian renaissance that occurred with the accession to the throne of Khusrau I (531–579).[2] There is, however, no real justification for assigning the vessel to the later period and it is, therefore, attributed here, on the basis of the crown type, to Peroz or Kavad I.

Selected Bibliography

Erdmann, "Die sasanidischen Jagdschalen," p. 210; Herzfeld, "Khusrau Parwēz und der Tāq-i Vastān," p. 126, pl. 8; Erdmann, *Die Kunst Irans zur Zeit der Sasaniden*, fig. 63; J. F. Haskins, "Northern Origins of 'Sasanian' Metalwork," *Artibus Asiae* 15 (1952), p. 246; E. Porada, *The Art of Ancient Iran* (New York, 1965), p. 219; The University of Michigan Museum of Art, *Sasanian Silver*, p. 93, fig. 2; Marshak and Krikis, "Chilekskie Chashi," p. 64.

Notes

1. R. Göbl, *Sasanian Numismatics* (Braunschweig, 1971), Tables 9, 11.
2. A. D. H. Bivar, "Cavalry Equipment and Tactics on the Euphrates Frontier," *Dumbarton Oaks Papers* 26 (1972), p. 285.

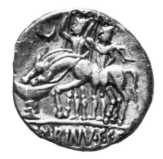

Fig. 8a. Far left. *Reverse of a coin of A. Postumius Alginus with an image of the Dioscuroi. First century B.C. The American Numismatic Society.*

Fig. 8b. Left. *Reverse of a coin of Maxentius with an image of the Dioscuroi. Fourth century A.D. The American Numismatic Society.*

8

Silver-gilt plate with youths and winged horses

Iran(?); fifth or sixth century
Height 5.2 cm., diameter 21 cm., weight 572 grams
The Metropolitan Museum of Art; Fletcher Fund (63.152)

On this unusual plate in The Metropolitan Museum, a pair of winged horses are represented standing in profile, their reins in the hands of youths who also carry spears. The groups are antithetically arranged, so that the heads of the horses, bending to drink water flowing from a vase, meet at a point just below the center of the plate. The youths are in a three-quarters position and look slightly outward. In the field between the wings of the horses is a seated musician. The horses stand on plinths or bases and beneath these is a half-figure of a female who supports the vase. She rises from a plant form and is surrounded on either side by other leaves.

When first published, this plate was attributed to the Sasanian period. The subject was identified as a representation of the constellation Do-Paktar ("Two Figures") of Middle Persian astronomical texts, and parallels for the figures were found among the images of the Dioscuroi in late antique art. Not all scholars accepted this view. Some argued that the plate was Parthian,[1] and others that the Sasanian scene was of Pegasus and Bellerophon.[2]

The two youths, each wearing only a cloak, are unquestionably modeled on Western rather than Iranian prototypes. Parallels for their nudity, beardlessness, curled hair style, and cloak exist in late Roman art, but are rare on Parthian and Sasanian monuments (compare Nos. 13, 66). However, the small dot on the forehead of each youth is probably an imitation of the Buddhist *urna*. In the depiction of the youths this is the only detail taken directly from an Eastern source. Other Sasanian divine or mythological figures have the dot on their foreheads (compare Nos. 13, 18), but it never occurs on humans. In contrast to the youths, the winged horses are typically Sasanian.

The beaded band on the wings appears in Kushan art earlier than in Sasanian art, but by the second half of the Sasanian period it is fairly common.

The plate itself is a characteristically Sasanian work of art. It resembles the court silver (Nos. 6, 7, 12) in method of manufacture, details of design, style, and elemental composition of the metal. An attribution to the Parthian period cannot, therefore, be accepted. Few silver vessels of Parthian date have survived. None resembles this silver plate in any of the aspects mentioned above. The subject matter is, admittedly, unusual for a Sasanian work of art, but this does not outweigh the stylistic and technical evidence for a Sasanian date.

What is the meaning of the scene on this plate and what is its specific Western source? Opposition to the theory that the twins and their mounts are modeled on images of the Dioscuroi has centered on one particular point: the Sasanian horses are winged, those of the Dioscuroi are not. In Sasanian art, there is some evidence that horses associated with divinities have wings. A seal, once in Berlin, showed the sun-god in a chariot drawn by winged horses.[3] On a silver plate in the Hermitage Museum, winged horses support the throne of the Sasanian king, perhaps as a deliberate reference to the sun-god.[4] The artist who executed the design on this plate from The Metropolitan Museum adhered to a Sasanian tradition, rather than to the Roman one. Knowing that the youths were superhuman, he gave their horses wings.

Pegasus is represented in late antique art drinking from the spring, Peirene, where he was first caught and tamed by Bellerophon.[5] Scholars have cited these images as the specific source for the scene on the Metropolitan Museum plate. However, a legend associated with the Dioscuroi describes their miraculous appearance, with their horses, at a spring in the Forum in Rome.[6] On Roman coins of the first century B.C. (fig. 8a), the image on the reverse depicts this event. The Dioscuroi also appear on Roman coins of the fourth century A.D. (fig. 8b) and continue to be represented on both pagan and Christian monuments in the West. Thus the pose of the animals on the silver

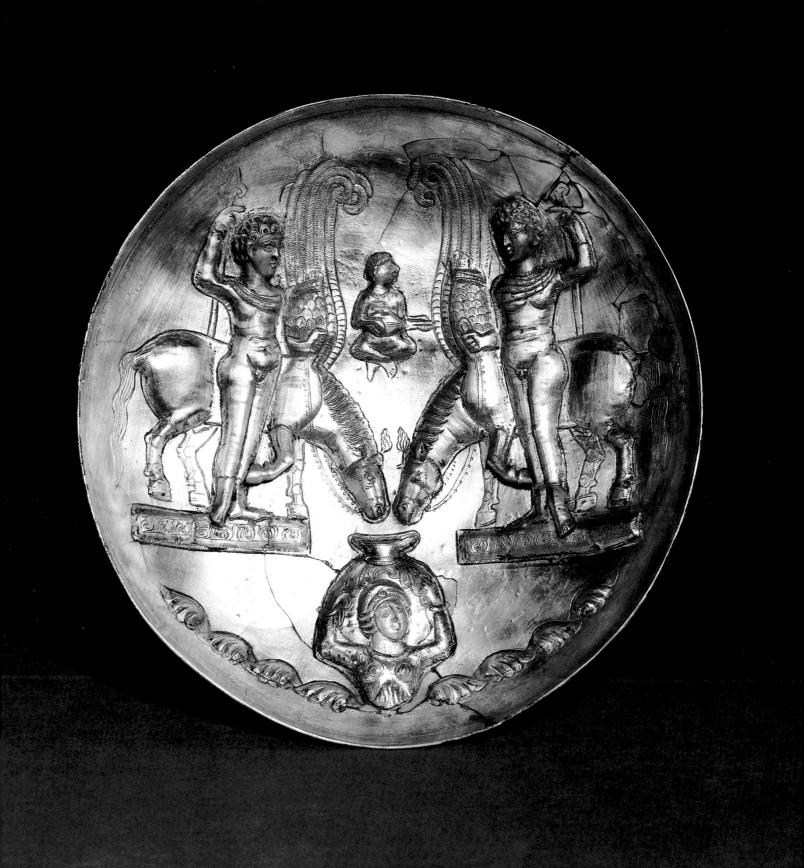

plate could have developed from illustrations of either the Dioscuroi or Pegasus on late Roman monuments.

Whatever the source of the Sasanian motif, there is one particularly strong argument against interpreting it as an Iranian adaptation of Pegasus and Bellerophon. The duplication of motifs for purely decorative purposes, to achieve a balanced composition, is not customary in Sasanian art (see Textiles, introduction). In executing the design on this silver plate, the artist surely intended to depict two identical figures. If the twins are not the Do-Paktar, then another interpretation must be found to explain the fact that there are two youths and two horses.

As the creations of the supreme spirit of good, Ahuramazda, the constellations were an appropriate decoration for court silver plate. The constellation, Do-Paktar, a sign of the zodiac (Gemini), may have commemorated the birth of some royal personage. Christopher Brunner has suggested that certain seal motifs were chosen because they were the nativity sign of the owner (scorpion, ram, lion, goat, fish, crab).[7] In the West the Dioscuroi were the patrons of music as well as dance and poetry. Perhaps this explains the presence of the small seated musician on the silver plate. The female supporting the flowing vase may be a personification of the fountains of Anahita, located on "top of a mythical mountain in the star region."[8]

The Metropolitan Museum plate illustrates the problems that arise when an attempt is made to trace, and interpret, images on Sasanian works of art. At the time the Zoroastrian religion was adopted by the Sasanian state, there was almost no established iconography. Consequently, artists borrowed a variety of subjects from foreign, chiefly Western, sources. Although the form of the images did not change, they had a new significance. Their meaning accorded with the beliefs and practices of the Iranian, rather than the Roman world. Whatever the significance of this scene, the plate in The Metropolitan Museum is a tribute to the skill of an unknown Iranian silversmith who designed and executed a spectacular work of art.

Selected Bibliography

P. O. Harper, "The Heavenly Twins," *The Metropolitan Museum of Art Bulletin* n.s. 23 (1964–65), pp. 186–195; G. A. Koshelenko, "Serebryanaya 'vaza s Dioskurami'," *Sovetskaya Arkheologiya* (1968), pp. 266–269; R. Ettinghausen, *From Byzantium to Sasanian Iran and the Islamic World* (Leiden, 1972), pp. 11–16; R. Ghirshman, "Les Dioscures ou Bellerophon?" in *Mémorial Jean de Menasce*, ed. P. Gignoux and A. Tafazzoli (Louvain, 1974), pp. 163–167; D. Thompson, Review of R. Ettinghausen, *From Byzantium to Sasanian Iran and the Islamic World*, in *Journal of Near Eastern Studies* 35 (1976), pp. 199–201.

Notes

1. Koshelenko, "Serebryanaya 'vaza s Dioskurami'," pp. 266–269.
2. Ettinghausen, *From Byzantium to Sasanian Iran*, pp. 11–16; Ghirshman, "Les Dioscures ou Bellerophon?", pp. 163–167; Thompson, Review of Ettinghausen, *From Byzantium to Sasanian Iran*, pp. 199–201.
3. Pope, *A Survey of Persian Art*, IV, pl. 255 EE.
4. Erdmann, *Die Kunst Irans zur Zeit der Sasaniden*, pl. 67.
5. The British Museum, *Masterpieces of Glass*, comp. D. B. Harden et al. (London, 1968), p. 72.
6. C. Daremberg and E. Saglio, *Dictionnaire des antiquités grecques et romaines* (Paris, 1892), II, pt. 1, pp. 249–265.
7. C. J. Brunner, in M. Noveck, *The Mark of Ancient Man* (Brooklyn: The Brooklyn Museum, 1975), p. 88.
8. *The Zend Avesta*, trans. J. Darmesteter, pt. 2 (Oxford, 1883), p. 52.

9
Silver high-footed bowl

Iran(?); ca. sixth century
Height 9.5 cm., diameter 17.9 cm., weight 496.5 grams
The Arthur M. Sackler Collections

Bowls of this shape with a fluted exterior and a high foot are rather common in the Sasanian period. One example comes from the excavations of Jacques de Morgan at Susa in southwestern Iran.[1] However, prototypes for this form of vessel are found not in Iran but in the West. Almost identical silver bowls have come from Roman North Africa and Europe (fig. 9a).[2] These can be dated to the fourth and fifth centuries, earlier than any of the Sasanian vessels.

No comprehensive study has been made of the designs on the interiors of this class of Sasanian bowl. Nevertheless, it is evident that the images do not include figures of the king. The decoration of the Sackler vessel is particularly fine. A deeply carved pattern of a guinea fowl within a circular frame is filled with niello so that it stands out vividly against the silver background.

In Sasanian art, these bowls are frequently represented as containers for food at both secular and cultic occasions (see No. 25).[3] This varied use probably explains the extensive production and, consequently, the survival of so many examples in modern times.

Notes

1. P. Amiet, "Nouvelles acquisitions: Antiquités parthes et sassanides," *La Revue du Louvre* 17 (1967), nos. 4–5, p. 278, fig. 9.
2. D. E. Strong, *Greek and Roman Gold and Silver Plate* (London, 1966), pl. 66A.
3. P. O. Harper, "Sources of Certain Female Representations in Sasanian Art," in *La Persia nel Medioevo* (Rome: Accademia nazionale dei Lincei, 1971), p. 511.

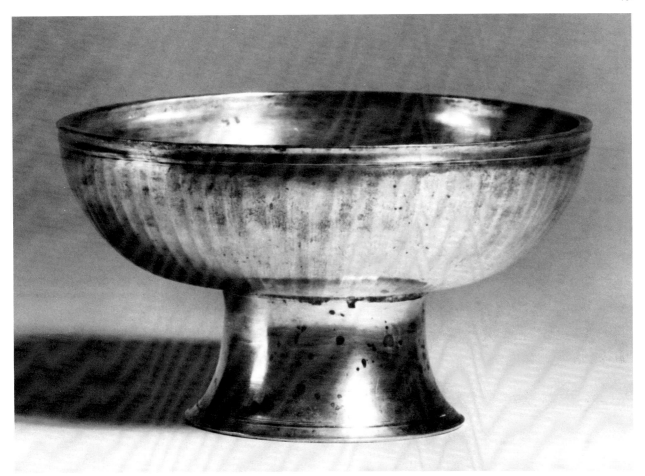

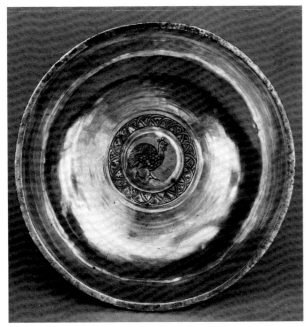

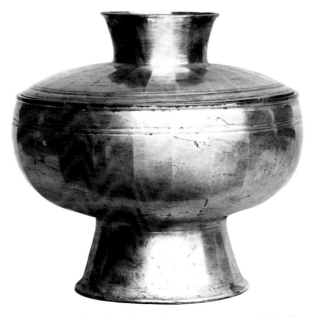

Detail of No. 9

Fig. 9a. *Silver bowl from the Carthage Treasure. Late third–early fourth century A.D. H. 11.4 cm. The British Museum.*

10
Silver oval bowl

Susa, Iran; sixth or seventh century
Length 19.4 cm., width 11.2 cm.
Musée du Louvre, Antiquités Orientales (Sb 6728)

Although fragmentary, this vessel has the distinction of being one of the few pieces of silver found during an official excavation of a Sasanian site. It was unearthed at Susa at the beginning of this century during the time when Jacques de Morgan was director of the French Mission. Disguised by a thick encrustation, the bowl was recently revealed to be silver, through the diligence of Pierre Amiet, chief curator of the Department of Oriental Antiquities at the Louvre.

The design of the interior is misleadingly simple. The small raised bosses were initially stamped from the outside, and then all traces of this process were carefully removed by carving and burnishing the exterior. A crane within an oval medallion has been chased onto the surface in the center of the bowl. The interior rim, the crane, and the border of the central medallion are gilded.

A long-necked bird holding a plant in its beak is a fairly common textile motif (see No. 57). The same subject also occurs against a field of raised bosses on the interior of an oval bowl in The Metropolitan Museum of Art.[1] The exterior of the Metropolitan Museum bowl has an elaborate, inhabited grape vine scroll. The dotted background on these vessels, combined in both instances with a water bird, may represent rain, which was associated in Iranian literature with fertility and the growth of plants. A design that signifies abundance and life is appropriate for an object of luxury that may have been used at banquets or as an offering deposited in a tomb. Regrettably, no record is preserved concerning the exact circumstances of the find.

Selected Bibliography

Amiet, "Nouvelles acquisitions: Antiquités parthes et sassanides," p. 277, fig. 8; P. Amiet, "Orfèvrerie sassanide au Musée du Louvre," *Syria* 47 (1970), p. 52, fig. 1.

Notes

1. *The Metropolitan Museum of Art Bulletin* n.s. 18 (1959–60), p. 267, fig. 32; for a similar design see also: S. Fajans, "Recent Russian Literature on Newly Found Silver Vessels," *Ars Orientalis* 2 (1957), pl. 6, fig. 15.

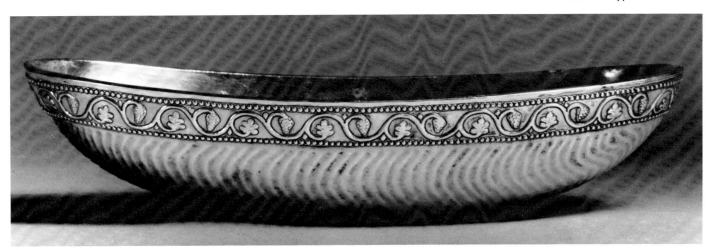

11
Gilded oval bowl

Iran(?); fifth to seventh century
Height 5.7 cm., length 25 cm., weight 464.5 grams
Collection of Ruth Blumka

Hammered into a graceful crescent, the narrow ends of this oval vessel rise above the central portion. The interior is undecorated. A grape and leaf vine scroll runs beneath the rim on the exterior. The low relief has been achieved by carving away the background. A chased pattern of rippling lines covers the rest of the exterior surface. These waves are probably a deliberate reference to water, as the vine scroll undoubtedly represents wine. The two motifs occur together on a nearly contemporary Indian bowl, which was influenced in many details by Sasanian works of art (fig. 11a).[1] Appropriately, a wine-drinking scene decorates the center of this Indian bowl, now in The British Museum.

Judging from the details and style of the decoration, most Sasanian oval bowls can be dated in the second half of the Sasanian period. The fragmentary example from Susa (No. 10) and a much corroded bronze bowl from Qasr-i Abu Nasr[2] are the only Sasanian examples of known provenance. The circumstances of their discovery are unclear. However, the material from Qasr-i Abu Nasr is largely late Sasanian and early Islamic. Oval vessels made of a high-tin bronze alloy (compare No. 33A) are fairly common, but these pieces are always undecorated and consequently difficult to date. The chased designs on the surface of the Blumka bowl are derived from those on late antique silver vessels. A pair of circular plates from the fourth-century Mildenhall Treasure is decorated with similar vine scrolls, beaded bands, and softly modeled rippling lines.[3]

Fig. 11a. *Silver bowl. Fourth or fifth century A.D. Diam. 25.1 cm. Punjab, India. The British Museum (OA 1937-3-19,1).*

Mercury gilding was sparingly applied to the background of the rim decorated with the vine scroll. Rather than uniformly covering the surface, it has been used to emphasize the plant design, drawing the eye to this area through the use of contrasting colors.

Notes
1. Dalton, *The Treasure of the Oxus*, no. 204, pl. 33, p. 58.
2. Frye, *Sasanian Remains from Qasr-i Abu Nasr*, p. 21, fig. 22.
3. J. W. Brailsford, *The Mildenhall Treasure* (London, 1955), no. 11.

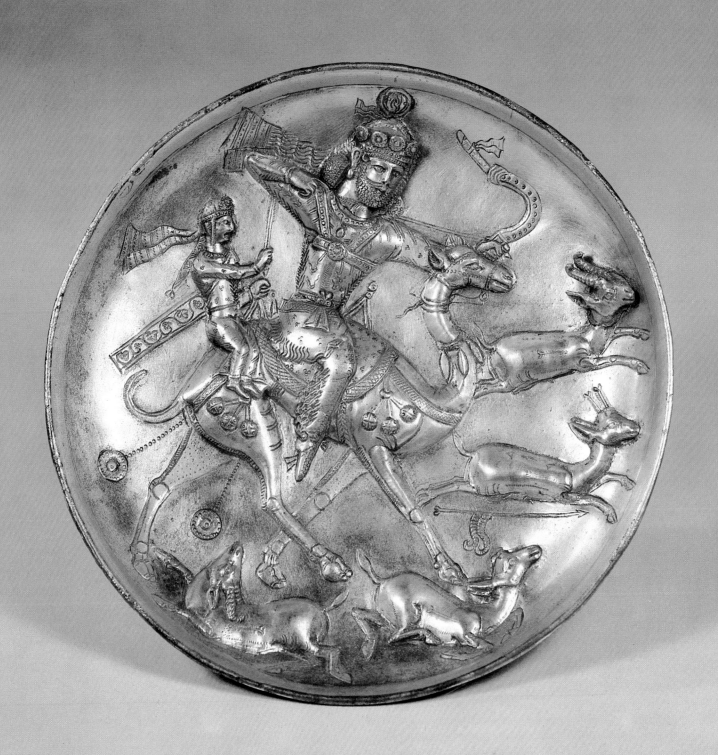

12

Silver-gilt hunting plate

Inscribed: Tahmagdast ("having a mighty hand"), 42 s[tēr]
Allegedly from northwest Iran; fifth or sixth century
Height 4.12 cm., diameter 20.1 cm., weight 647 grams
The Guennol Collection

In the *Shah-nameh* the following story is told of the Sasanian king Bahram V (Gur):

It happened one day that he went out hunting accompanied by the lyre-player and without his retinue. The Greek girl's name was Azada and the colour of her cheeks was that of coral. . . . [Bahram Gur] had asked for a racing-camel, the back of which he adorned with brocade. . . . Suddenly there came running towards them two pairs of gazelles. . . . [Azada said to Bahram Gur] "My lion-hearted prince, men of war do not go in chase of gazelles. Convert yonder female into a buck with your arrow and with another arrow let the old buck become a female. . . ." Bahram Gur ("The Wild Ass") strung his bow and raised a shout in that silent waste. In his quiver he had an arrow with two heads, which he kept for hunting on the plain. As soon as the gazelles were in flight the prince shot away the horns on the head of the fleeing buck, using the arrow with the double head, whereat the girl was filled with amazement. The buck's head being shorn of its black horns at once came to look like a doe. Then the hunter shot two arrows at the doe's head at the place where horns might grow. Instead of horns there were now two arrows, the doe's blood reddening its breast.[1]

This event, which is supposed to have taken place while Bahram V (420–438) was still a prince, is depicted with some frequency in Islamic art (fig. 12a).[2] However, only one Sasanian object—this silver vessel from The Guennol Collection—has a subject that can be interpreted as a scene from the tale recorded in the *Shah-nameh*.

Who is the hunter on this plate? He wears a crown that is not known on Sasanian coins of Bahram V (Gur) (fig. 12b) or of any other ruler. Beaded discs, wings, and a crescent appear on the crown of a Sasanian queen, Buran (630–631), and circular discs occasionally decorate the headbands of other females, but none of these headdresses resembles the crown worn by the hunter on the silver plate. It is clear from the pose and attire of this figure that he is intended to be a royal personage: the hair is drawn up above the head and covered by a silken cloth; a beaded halter is strapped around the chest; the hunter is equipped not only with a bow but with a sword (the hilt projects above the saddle, just in front of the female rider).

The small female riding behind the king appears to be Azada, the companion in the *Shah-nameh* legend. She is distinguished from other representations of Sasanian females by the arrangement of her hair. A bunch of tight curls rises above the forehead and a braided pigtail hangs down behind the neck. An almost identical hair style appears on a contemporary Indian silver bowl in The British Museum (fig. 11a). Less close but perhaps related is a style current in Rome in the second century.[3] Part of the hair was curled up above the forehead and the rest was braided and wound in a bun behind the head. Only occasionally did a long twist of hair hang down behind the neck. On the reliefs of Khusrau II (591–628) at Taq-i Bostan and on Sasanian seals of the fourth century and later there are females with plaits of hair.[4] The curled arrangement of the hair over the forehead, however, is lacking in these representations. It is possible that the distinctive hair style on this plate is intended to characterize the woman as a foreigner. In the *Shah-nameh* account, Azada is a Greek.

There is nothing in the scene to indicate that the main personage is a divinity. His dress and the narrative form of the hunting scene suggest that this is a royal legend, part of some Iranian epic. The identity of the ancient hero was apparently forgotten in Islamic times and the story was assimilated into the fictional description of the life of Bahram V (Gur).

A few details suggest a date for this plate late in the fifth or early in the sixth century: the bent little finger of the bow-string hand; the pronounced ridge on the arm of the bow; the gilding of the design rather than the background; and the stylized linear drapery folds. It is possible, therefore, that the vessel was actually made during the reign of Bahram V, the king with whom this tale was associated in later times.

The scene on the Guennol plate illustrates the interest that developed toward the end of the Sasanian period in the legendary history of Iran, and provides us with a rare glimpse of an important literary tradition which is almost completely unrepresented in the art of the Sasanian period. The growing interest in early Iranian legends is reflected in the adoption of names from Iranian epic literature by the rulers of the sixth and seventh centuries: Kavad and Khusrau. By the reign of the last Sasanian king, Yazdegird III, a Book of Kings (*Khvadhaynamagh*) had been compiled, a work which served as a source for the later *Shah-nameh*.

One characteristic of both the Zoroastrian and genre literature of pre-Islamic Iran is the presence of riddles or verbal contests. In the Bahram Gur tale, the original hero was doubly skilled: he was successful not only in the hunt but also in responding correctly, and therefore with "truth," to a challenge of words.

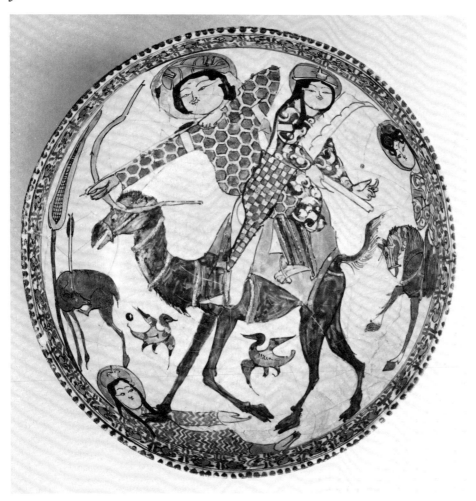

Fig 12a. Left. *Glazed bowl, Mina'i ware. Late twelfth–early thirteenth century A.D., Seljuq period. Diam. 22.1 cm. Iran. The Metropolitan Museum of Art; Fletcher Fund (57.36.2).* Fig. 12b. Below. *Coin of Bahram V. The American Numismatic Society.*

Note on the inscription:

The inscription is found at the center of the plate, on the reverse within the raised foot. The epigraphic style is that of late and post-Sasanian cursive script (Pahlavi). The letters are executed in the normal manner found on silverware—as a series of discontinuous punched holes. The first line reads: thmk'dst. *tahmagdast* ("having a mighty hand"). This term is reminiscent of the epithet commonly applied to the great hero Rustam in the Iranian epic, the *Shah-nameh*, i.e., *tahmtan*, "having a mighty body." The epic also uses such heroic terms as *cērdast* ("having a bold hand") and *carbdast* ("having a skilled hand"). The term occurring on the plate is probably an honorific name of the owner. Honorific names were, in Sasanian as in Islamic times, a means of bestowing distinction upon nobles. The second line of the inscription is more difficult, because the writing is extremely cursory. It is certainly a designation of the weight of silver used in making the object. A tentative reading of the irregular orthography is: s xl ii, "42 s[tēr]." If this reading is valid, then the weight standard represented by the plate (which is 647 grams) would be 3.8 grams per *drahm*. This is the normal standard for the Sasanian period. (For the *stēr* and *drahm*, see p. 71.) *Christopher J. Brunner*

Selected Bibliography

The University of Michigan Museum of Art, *Sasanian Silver*, pp. 92–93, no. 3. See also Introduction by O. Grabar, pp. 51–53; I. E. Rubin, ed., *The Guennol Collection*, I (New York, 1975), pp. 103–106.

Notes

1. *The Epic of the Kings, Shāh-nāma*, trans. R. Levy (London, 1967), pp. 299–300.
2. Orbeli and Trever, *Orfèvrerie sasanide*, pls. 11, 12 (two early Islamic silver plates with representations of Bahram Gur and Azada).
3. G. M. A. Richter, *The Engraved Gems of the Greeks, Etruscans and Romans*, Pt. II: *Engraved Gems of the Romans* (London, 1971), nos. 533, 543a, 548a.
4. Fukai and Horiuchi, *Taq-i-Bustan*, I, pls. 68, 69.

13

Silver-gilt vase with four youths subduing animals

Iran; sixth or seventh century
Height 17.8 cm., diameter of rim 5.3 cm., weight 519 grams
National Collection, Tehran (579)

Framed by an arch, each of the four principal scenes represented on this vase shows a youth mastering an animal, apparently without effort. The short-haired male figures are nude except for a cloak (compare No. 8). They stride or dance—legs in profile, the remainder of the torso fully frontal—a characteristic Sasanian pose. A small dot is placed in the center of the foreheads of the youths as a sign of their superhuman nature (compare No. 8). This attribute is also evident on dancing females, frequently represented on this type of vase and on ewers (see No. 18).

Roman Ghirshman considers that the "heros" on this vase are images of the Zoroastrian god of victory Verethragna (Middle Persian, Wahram), a divinity similar to the Greco-Roman Heracles. In a recent article, Ghirshman presented comprehensive evidence for the appearance of Heracles-Verethragna in the arts of Iran during the Seleucid, Parthian, and Sasanian periods. He observed that after the third century, this Iranian divinity in the guise of the Western "hero" disappears from Sasanian art. In his opinion, therefore, this Iranian vase should be dated to the beginning of the Sasanian era.

The only third-century Sasanian representation of a figure who may be Heracles-Verethragna is on a rock relief of Ardeshir I (224–241) at Naqsh-i Radjab in southern Iran.[1] Two details relate the rock carving to Western images of Heracles: the figure holds a club and is nude except for a cloak pinned high on the shoulder. In contrast, the figures on this silver vase do not follow Western models so closely. They have no clubs, and in two instances their cloaks are fastened at the center rather than the side of the chest.

Because there are no parallels for the main subject—the youths and their quarry—it is difficult to date the vase precisely. No other Sasanian vessel of this specific shape has a design which can be dated, on the basis of style, earlier than the fifth century. Some designs are certainly of the sixth or seventh century (Nos. 22, 24). The only excavated example of this type of silver vase comes from the tomb of a seventh- to eighth-century Slavic chief in the Ukraine.[2]

Ghirshman is surely correct in assuming that the Iranian scenes on this vase are to some extent derived from images associated with Heracles. However, representations simi-

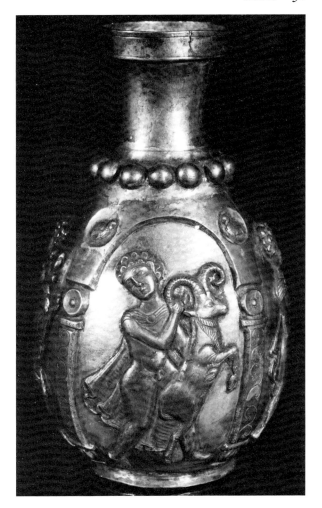

Fig. 13a. Left. *Silver vase. Third century A.D. H. 22.5 cm. Dura-Europos, Syria. Yale University Art Gallery (1931.585).*

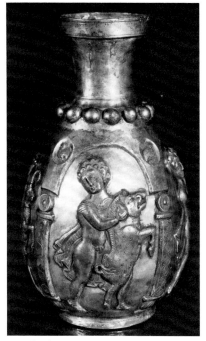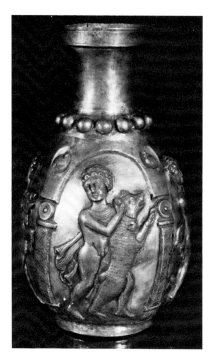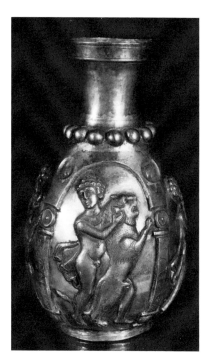

Details of No. 13

lar in appearance to these particular Sasanian figures are
not easy to find in late antique art. Kurt Weitzmann, in a
recent article on eighth-century ivory plaques with carv-
ings of the Labors of Heracles, contrasts the dramatic
poses of the Carolingian figures with the Heracles on a
Coptic textile of the sixth or seventh century.[3] The latter
is a small dancing *putto*, a Heracles close in spirit to the
figures on the silver vase. Possibly the Iranian artist was
influenced by Coptic textile designs when he portrayed
the classical hero as a dancing figure, effortlessly over-
coming his quarry.

The figural motifs on the silver vase, the arcades fram-
ing the pairs, and the shape of the vessel itself (compare
fig. 13a) are ultimately derived from the West. It does not
follow that the Sasanian design must have the same mean-
ing as the subject from which it developed. The presence
of the scenes on a silver-gilt vase argues in favor of their
having a particular significance but the true sense of the
"labors" and the identity of the Iranian "heros" remain
unknown.

Selected Bibliography

R. Ghirshman, "Notes iraniennes XVII: Un bas-relief parthe de
la collection Foroughi," *Artibus Asiae* 37 (1975), pp. 229–239, pl. 4.

Notes

1. Hinz, *Altiranische Funde und Forschungen*, p. 125, pl. 59.
2. A. T. Smylenko, *Glodoski Skarbi* (Kiev: Akademia Nauk
 Ukrainskoy RSR, Institut Arkheologii, 1965), fig. 37. I am

grateful to Vera K. Ostoia for bringing this article to my
attention.
3. K. Weitzmann, "The Heracles Plaques of St. Peter's Cathe-
 dra," *The Art Bulletin* 55 (1973), p. 7, fig. 9. This textile is one
 of a pair. The other is in The Metropolitan Museum of Art
 (acc. no. 89.18.244); see V. K. Ostoia, *The Middle Ages, Treas-
 ures from The Cloisters and The Metropolitan Museum of Art*,
 (New York, 1969), p. 32, no. 10.

14

Silver-gilt hemispherical bowl

Iran(?); ca. seventh century
Height 5.1 cm., diameter 13.3 cm., weight 399.5 grams
The Cleveland Museum of Art; Purchase from the J. H. Wade Fund (66.369)

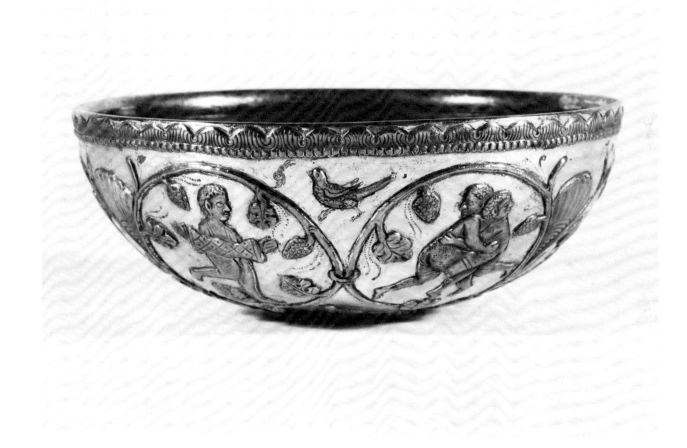

Drinking vessels with scenes of noble and court life, music, dance, and the hunt comprise one class of late Sasanian silver plate. However, the nudity of the youths on this bowl and their arrangement within a grape and leaf vine scroll place them outside the context of daily life. Genre scenes are more realistically portrayed on a vessel in the Sackler collection (No. 25).

The bird of prey grasping an animal in the central medallion is a common motif in ancient Near Eastern art.

More closely related to Western imagery is the scene with a youth pointing his spear toward a hunting net behind which there is a bear. A net is depicted in the same fashion on a Byzantine plate in the Hermitage Museum.[1] Other scenes around the vessel include figures playing double hornpipes, a waisted lute, and a double-headed drum. The association of drum music with a scene of wrestling, depicted within the final scroll, is not unusual. From early times in the Near East, wrestling and other

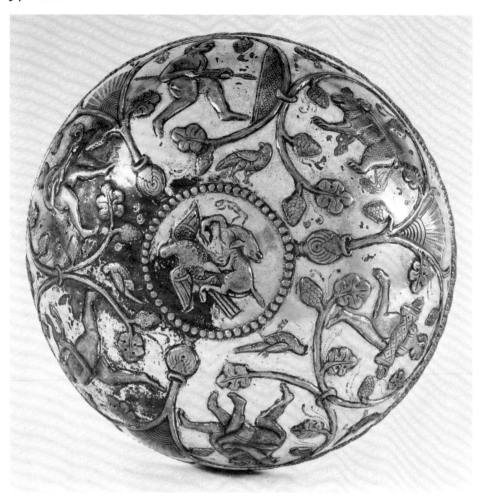

Exterior of No. 14

forms of exercise have taken place to the accompaniment of music. In present-day Iran, ". . . in the *zurkhane* (house of force) groups of men engage in strenuous and specialized gymnastic exercises directed by a drummer who sometimes also chants extracts from the *Shah-nameh* of Firdausi; the stages of the exercise are punctuated with cymbals."[2] This custom is believed to derive from pre-Islamic practices, which may have had "a partly chivalrous, partly religious character." The scenes on the Cleveland bowl probably also have both these levels of meaning.

Selected Bibliography

"Annual Report," *The Bulletin of The Cleveland Museum of Art* 54 (June, 1967), pp. 177–178.

Notes

1. L. Matzulewitsch, *Byzantinische Antike* (Berlin/Leipzig, 1929), p. 2, no. 1, pl. 1.
2. J. Rimmer, *Ancient Musical Instruments of Western Asia in The British Museum* (London, 1969), p. 25.

15

Silver bowl with gilding and niello inlay

Reported to be from Iran; sixth or seventh century
Height 5.3 cm., diameter 13.2 cm., weight 432 grams
Collection of Elie Borowski

A running wave pattern at the rim, compass-drawn rosettes, and circles decorate the exterior of this hemispherical bowl. These geometric designs were familiar throughout the first millennium in the Roman West, the Near East, and Central Asia. On this example, the combination of mercury gilding, on the background and on the rosettes, with niello produces a rich and colorful effect. The interior of the vessel is plain.

Hemispherical bowls with medallions enclosing figural and plants motifs are particularly common east of Iran. Bactrian and Indian examples are generally dated from the fourth to the seventh century A.D.[1] There are a few early Sasanian bowls with portrait busts in circular frames

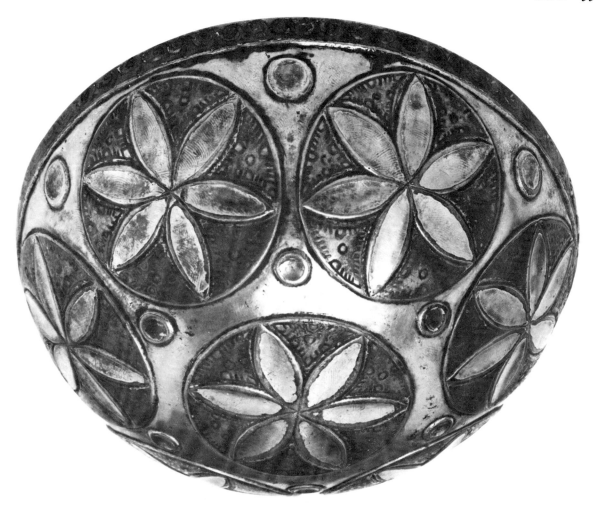

(see No. 2). Otherwise, small hemispherical bowls with medallions are rare until the sixth or seventh century (compare No. 25). The bowl in the Borowski collection differs from these vessels in the purely abstract decoration.

The rosette and running wave patterns are too common to suggest either a particular provenance or date for this vessel. The hatched lines and circles surrounding the rosettes within the medallions are not characteristically Iranian. Precisely the same designs are employed on late antique and early Christian silver vessels of the fifth and sixth centuries. The combination of gilding and niello also occurs on Roman silver plate of the fourth and fifth centuries.[2] The artist who made the bowl was almost certainly influenced by a Western model.

The significance of the design is unclear, but it is probably not without meaning. An eight-lobed silver vessel in the Tenri Sankokan Museum in Japan has a rosette pattern combined with plant, water, and bird motifs.[3] This suggests that the rosette and the running wave bor-

der on the Borowski bowl were associated with water, fruitfulness, and prosperity—an appropriate form of decoration for a drinking bowl.

Selected Bibliography

Musée Rath, *Trésors de l'ancien Iran* (Geneva, 1966), cat. 723, fig. 81. The weight cited in this publication is given in the entry.

Notes

1. Marshak and Krikis, "Chilekskie Chashi," pp. 71ff.
2. D. E. Strong, *Greek and Roman Gold and Silver Plate* (London, 1966), pp. 194–195.
3. S. Fukai, *Study of Iranian Art and Archaeology* (Tokyo, 1968), pls. 42–48.

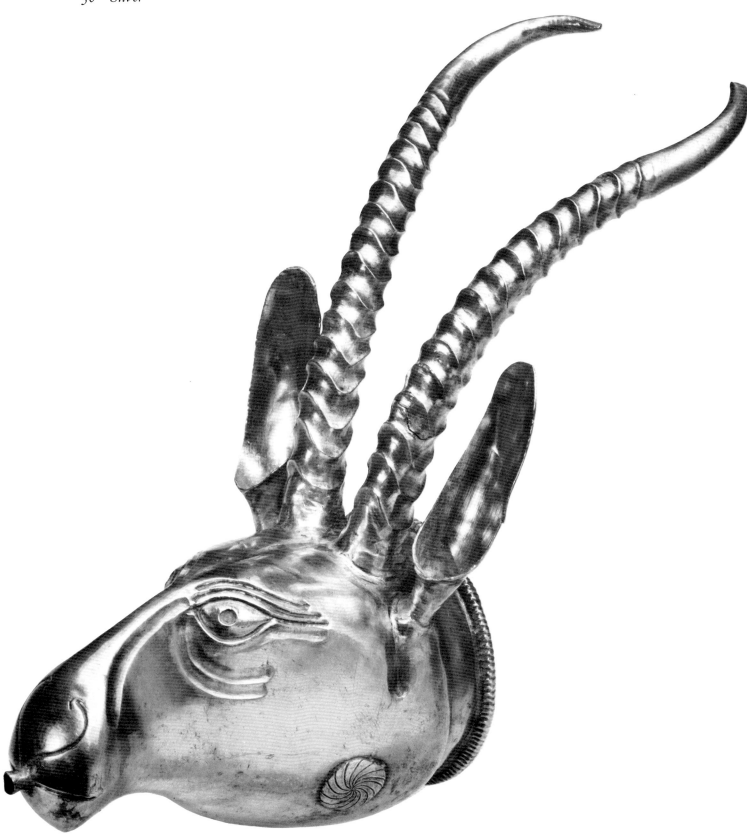

Detail of No. 16

16

Silver-gilt saiga antelope head rhyton

Inscribed: 55 s[tēr]
Iran(?); sixth or seventh century
Height (base of head to tip of horns) 23.4 cm., length 17.6 cm.,
 weight 867 grams
Private collection

This striking head of a saiga antelope is not primarily a sculpture in the round but rather a vessel. Filled through the hole behind the horns, then plugged to prevent the liquid from escaping through the small spout between the lips, this spectacular work of art was undoubtedly used only at special banquets or ceremonies. It is probably a vessel of this kind that is represented on the British Museum seal showing a male and female figure banqueting (No. 73). In that scene a saiga antelope head is placed on the ground beside a bowl of food. Some object rises between the horns, perhaps a silver stopper or a funnel (see fig. 1b) for the opening in the head.

The distinctive features of the saiga antelope (*saiga tatarica*) are lyre-shaped horns and downward directed nostrils. In antiquity, the saiga roamed the steppe country from Poland to western Mongolia. The Iranian artist who made this rhyton may, therefore, have had only a vague idea of the animal's actual form. Perhaps this explains the unrealistically elongated and upright ears. Two other silver saiga heads, both of which come from Poland, a region to which the saiga was native, are missing their ears.[1] This is regrettable since the vessels were probably locally produced and the ears may, therefore, have been

accurately rendered by an artist who knew the appearance of the saiga antelope.

The horns of the living animal are the color of amber and were greatly treasured by the Chinese for their medicinal properties. Some equally important, if imagined, quality undoubtedly caused the Iranians to prize the saiga antelope and to reproduce the head and magnificent horns in gilded silver.

This saiga head can probably be dated to the end of the Sasanian period because of the stylized form of the head and eyes. This is distinctive and closely resembles the treatment of animal heads on one class of eighth-century silverware from Sogd in Central Asia.[2] The decorative rosette on the back plate provides no indication of date, as this motif was common throughout the Sasanian period (compare No. 51).

Selected Bibliography

R. Ghirshman, "Notes iraniennes XI: Le rhyton en Iran," *Artibus Asiae* 25 (1962), p. 78, fig. 28; Ghirshman, *Persian Art*, p. 221, fig. 263; C. J. Brunner, "Middle Persian Inscriptions on Sasanian Silverware," *Metropolitan Museum Journal* 9 (1974), p. 112, fig. 2; I. E. Rubin, ed., *The Guennol Collection*, I (New York, 1975), pp. 107–112.

Notes

1. S. Przeworski, Review of P. Bienkowski, *Skarbie srebrnym z Choniakowa na Wolyniu*, in *Syria* 12 (1931), pp. 291–292. The heads are in The Metropolitan Museum of Art (acc. no. 47.100.82) and, at the time of the publication in *Syria*, in a Lithuanian private collection.
2. B. Marshak, *Sogdiyskoe Serebro* (Moscow, 1971), p. 156, figs. 6, 7; Pope, *A Survey of Persian Art*, IV, pls. 219–220.

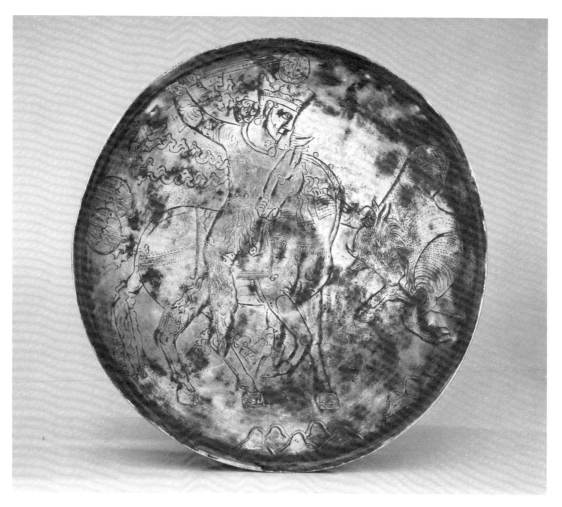

17

Silver plate with a hunting scene

Inscribed: 30 [stēr]
Provenance unknown; sixth or seventh century
Height 4.6 cm., diameter 23.4 cm., weight 432 grams
Ex. coll. Fabricius
Collection of Ruth Blumka

Sasanian royal silver plate was highly valued in Mesopotamia, Iran, and the regions bordering those countries. Because of the prestige of the Sasanian king, the theme of the royal hunter became synonymous with imperial power. Therefore, Sasanian vessels were soon imitated by local rulers of neighboring lands. Evidence for the provincial production of silver based on Sasanian models comes mostly from the East, present-day Afghanistan, and the Soviet Union, although there are examples from Georgia (Caucasus) in the West. Vessels of this type are in the Hermitage Museum and The British Museum.[1]

The source of this plate, previously in the Fabricius collection, is unknown. It has all the characteristics of the hunting plates made in imitation of Sasanian silverware. The crown worn by the "king" is similar to those of the Sasanian rulers Yazdegird II (438–457) (fig. 17a), Valash (484–488), and Ardeshir III (628–630). Nevertheless, there are important differences: the unbeaded forehead band, the curls above this band, and the crescent divided at the center so that it appears to be a pair of bull's horns. The same details occur on the crown represented on a provincial vessel in The British Museum, acquired in Afghanistan (fig. 17b).

On this plate from the Blumka collection, the king, in right profile, is mounted on horseback. The horse raises one foreleg and turns its head back across the chest. The horse's pose is common in late antique art, but it differs from the standard Sasanian profile view. A humped bull (zebu) emerges from the right side of the plate. The king grasps one of the bull's horns in his left hand and raises his right, sword arm behind him in a typical Roman gesture

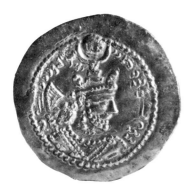

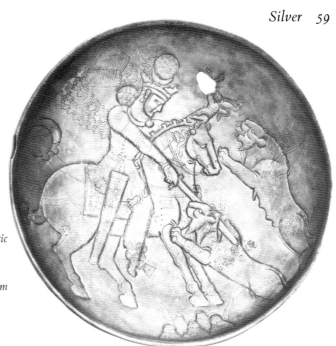

Fig. 17a. Above. *Coin of Yazdegird II. The American Numismatic Society.*
Fig. 17b. Right. *Silver-gilt plate. Fifth to seventh century A.D. Ex. coll. General Sir Alexander Cunningham. The British Museum* (*WAA 124092*).

of victory. Two groups of hills are depicted in the lower quadrant.

The scene is executed in the simplest fashion: chased lines follow a dotted pattern, which must have been previously laid out for the craftsman's guidance. This method is typical of provincial works. Spot-gilding on the design, inaccurately rendered Sasanian crowns, elements of the design cut off by the rim of the plate, and certain details of dress and equipment also distinguish provincial vessels from the central Sasanian court silver. These imitations are difficult to date precisely, but some evidence is provided by the Sasanian crown type that served as a model. In this instance, the crown resembles one adopted by a number of Sasanian kings from the fifth to the seventh century.

This plate is related in style to a provincial Sasanian vessel recently found at Chilek, near Samarkand, in Soviet Uzbekistan.[2] The archaeologists who examined the site after the find was made believe that the Chilek plate comes from a level not later than the early seventh century. Christopher Brunner places the inscription on the Blumka plate sometime between the reign of Peroz (459–484) and the beginning of the Islamic era.

The precise significance of the scene on the Blumka plate, apart from the standard parallelism between the hunt and war, is difficult to determine because nothing is known of the local ruler who commissioned this work— of his religion or epic literature. On Sasanian silver vessels, the bull is not a quarry in the royal chase. A recent study of early Islamic bull hunting scenes in ninth-century paintings at Samarra in Mesopotamia and at Aghthamar in Armenia has led to the proposal that this type of hunt reflects the ritual practices of the pre-Islamic Turks.[3] These peoples occupied the area east of Iran during the final centuries of the Sasanian period. The image on the Blumka plate may belong to a similar tradition. If so, it is further removed in meaning than in appearance from Sasanian Iran.

Selected Bibliography

K. Erdmann, "Eine unbekannte sasanidische Jagdschale," *Jahrbuch der Preuszischen Kunstsammlungen* 59 (1938), pp. 209ff; K. Erdmann, "Die Entwicklung der sāsānidischen Krone," *Ars Islamica* 15–16 (1951), p. 104, fig. 13; C. J. Brunner, "Middle Persian Inscriptions on Sasanian Silverware," *Metropolitan Museum Journal* 9 (1974), p. 115, fig. 3.

Notes

1. Orbeli and Trever, *Orfèvrerie sasanide*, pl. 14; Dalton, *The Treasure of the Oxus*, p. 61, no. 207.
2. Marshak and Krikis, "Chilekskie Chashi," pp. 55–81.
3. J. P. Roux, "Le Taureau sauvage maîtrisé, recherches sur l'iconographie médiévale du Proche Orient," *Syria* 48 (1971), pp. 187–201.

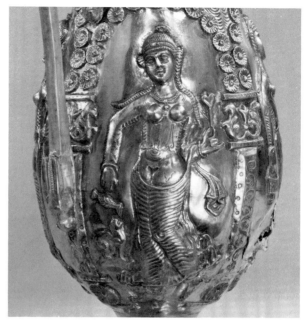

Detail of No. 18

18

Silver-gilt ewer with female figures

Inscribed: Wastarčīn, son of Ardānaf
Iran(?); sixth or seventh century
Height 34.2 cm., greatest diameter 13.3 cm., weight 1541.2
 grams
The Metropolitan Museum of Art; Mr. and Mrs. C. Douglas
 Dillon Gift and Rogers Fund (67.10)

The form of this elegant silver-gilt ewer appears to have been favored in Sasanian workshops during the late period of the dynasty. The neck is tall and slender, tapering to a spouted rim above an ovoid body. The base is a hollow flaring foot. A similar vessel is represented in the hand of the goddess Anahita on the rock relief of Khusrau II (591–628) at Taq-i Bostan. This general shape, derived from late antique forms, was widespread in the late first millennium A.D. It occurs in Sogdian silverwork and is echoed in the phoenix-headed metal and ceramic ewers of T'ang dynasty China.

The vessel has a single handle with an onager head at each end and a ball at the top of the arm, level with the rim. The gilded silver lid, decorated with a female figure holding a bird and grapevine stalk, is held on by a twisted circlet of wire. A running grape and leaf pattern occurs on a raised ridge below the neck and is repeated just above the flaring base. Below the upper vine scroll a stylized foliate motif serves to edge the main decoration. This consists of four arches on low pilasters, each containing

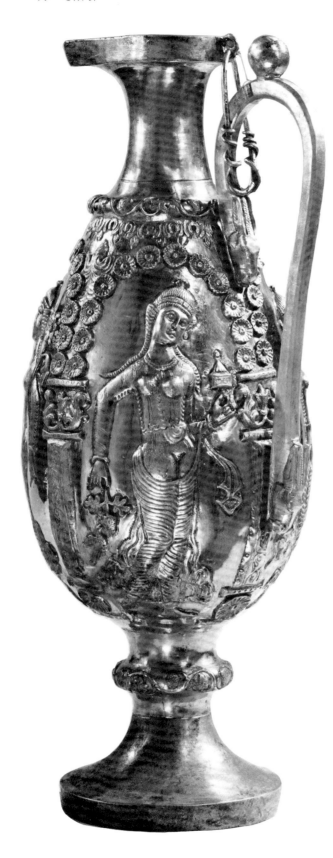

the representation of a dancing female figure who holds an object in either hand. The pilasters are decorated with a running vine motif, a half-palmette capital, and a rosette base. The arches are formed by embossed rosettes. Mercury gilding has been applied to the ball atop the handle, the animal heads on the terminals of the handle, and the background of the body of the vessel.

The dancing ladies are dressed in long-sleeved, tight-fitting costumes of diaphanous material. Another piece of drapery encircles the body below the thighs. Each female wears bracelets, anklets, a necklace, and a jeweled diadem. The hair appears to be dressed in long plaits and a small topknot drawn up above the head. The attributes held by each of the four figures include: a heart-shaped flower and a ewer from which a tiny panther drinks; a bird and a long-stemmed flower; a small bucket and a mirror; and a bird pecking at a grape cluster and a small lidded pyxis. The motif of dancing girls holding a particular group of attributes was one of the most popular in the Sasanian repertory. It occurs on a large number of vessels, most commonly ovoid or bulbous silver vases. The females, usually four in number, are shown either with or without arched frames.

There has been much speculation concerning the precise meaning of these so-called "bacchantes." Are they representations of the Zoroastrian goddess Anahita or her priestesses? Are they votaries of a vestigial cult of the Asiatic Dionysos, or are they secular subjects without particular significance?[1] The answer to these questions may lie somewhere between the two extremes: sacred and purely secular. Since the dancers hold symbols of bounty, they may have a function similar to that of Personifications in the Greco-Roman world. It has been suggested that they are related to the seasons and months, and that they are intended to personify popular seasonal festivals celebrated in Sasanian Iran. This would explain the limited repertory of attributes associated with them, and the secular rather than strictly religious appearance of the scenes. The Bacchic symbolism can be explained by the popularity of a wide range of Dionysiac motifs in the late antique world, ranging from Byzantium to China. This repertory of designs was believed to have a generally festal or auspicious meaning and was consequently assimilated by many different cultures.

It is likely that the silver vessels decorated with "bacchantes" were intended to hold wine for special court celebrations. The most illustrious of these was the festival of Nāurūz, celebrated in the spring, at the beginning of the year in the Sasanian calendar. In this celebration, which lasted several days at the court, the king was the central figure, since his reign was renewed with the onset of each year. At this occasion he drank and feasted with his assembled courtiers, and presented lavish gifts of precious objects wrought of silver and gold to the assembled company. *Martha L. Carter*

Selected Bibliography

"Reports of the Departments (1966–1967)," *The Metropolitan Museum of Art Bulletin* n.s. 26 (1967–68), p. 52; P. O. Harper, "Sources of Certain Female Representations in Sasanian Art," in *La Persia nel Medioevo* (Rome: Accademia nazionale dei Lincei, 1971), no. 160, pp. 503ff; C. J. Brunner, "Middle Persian Inscriptions on Sasanian Silverware," *Metropolitan Museum Journal* 9 (1974), p. 118.

Notes

1. D. G. Shepherd, "Sasanian Art in Cleveland," *The Bulletin of The Cleveland Museum of Art* 51 (April, 1964), pp. 66–95; Harper, "Sources of Certain Female Representations in Sasanian Art," no. 160, pp. 503ff; M. L. Carter, "Royal Festal Themes in Sasanian Silverwork and Their Central Asian Parallels," *Acta Iranica, Commemoration Cyrus I* (Leiden, 1974), pp. 171–202; Y. Godard, "Bouteille d'argent sassanide," *Athar-e-Iran* 3 (1935), pp. 291–300; R. Ettinghausen, *From Byzantium to Sasanian Iran and the Islamic World* (Leiden, 1972), pp. 3–10; J. Duchesne-Guillemin, "Art and Religion under the Sasanians," in *Mémorial Jean de Menasce*, ed. P. Gignoux and A. Tafazzoli (Louvain, 1974), pp. 147–154.

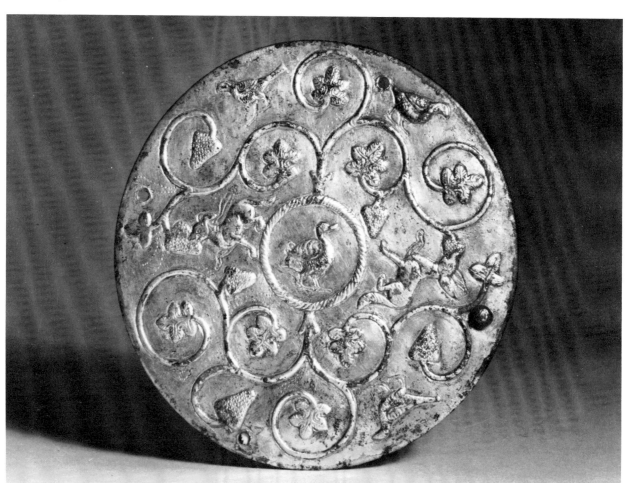

19

Silver-gilt roundel with a vine scroll

Iran(?); sixth or seventh century
Height 7.0 mm., diameter 12.3 cm., weight 136 grams
The Arthur M. Sackler Collections

It is difficult to ascertain the function of this circular disc with a small vertical rim. It resembles a shallow lid, and the surface is pierced in four places. One hole retains a small bronze rivet that once held some material to the interior. Another roundel, also decorated with a populated vine scroll, is in the Iran Bastan Museum in Tehran.[1]

A plant design, stylized leaves and fruit, covers the obverse surface. Winding sinuously over the disc, the scroll divides the circle into two parts, which are almost mirror images. Within this rigid decorative pattern, the rather naturalistic animals and birds seem out of place.

The design was executed in customary Sasanian fashion. Relief was achieved by carving away the back-

ground. The undecorated surface was then covered with mercury gilding.

Inhabited vine scrolls are common in the arts of the first millennium A.D. over a large part of the civilized world—in Europe and the Mediterranean lands, in Central Asia and China. The significant feature of the Iranian representation is the rigidity of the stylization. The perfect balance of the design reflects an abiding love of order, both human and divine, characteristic of Sasanian Iran.

Notes
1. Pope, *A Survey of Persian Art*, IV, pl. 215 A.

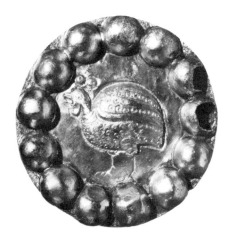
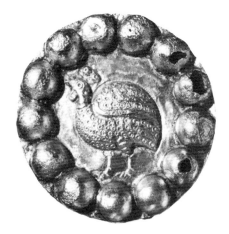

20
Silver-gilt roundels

Allegedly from northwest Iran; sixth or seventh century
Diameter 5.3 cm.
Römisch-Germanisches Zentralmuseum, Mainz

Metal roundels with loops on the reverse for attachment are common in Iran and the steppe country north of Iran from the late second through the first millennium B.C.[1] They appear to have been an important article of dress or equipment, but their precise function remains unclear. For no particular reason, Sasanian roundels are generally referred to as horse trappings, but they could be appliqués for belts or clothing.

The early Iranian and Sarmatian roundels often, but not always, come in pairs. One group found on human skeletons in tombs of the last centuries B.C., northwest of the Caucasus, are thought to be belt decorations. The archaeological context of the Sasanian examples is unknown, but they may well be a continuation of the earlier Iranian and Sarmatian types.

These roundels are decorated with a chased representation of a guinea fowl enclosed within a repoussé beaded border. There is an identical pair in Berlin (also allegedly from northwest Iran).[2] A fifth roundel, decorated with a boar's head, is now in the Museum of the Instituto per el Medio e Estreme Oriente in Rome.[3] These objects, particularly the example in Rome, are closely related in design to textiles in this exhibition (Nos. 53, 59).

Birds in the Zoroastrian religion were "creations of Ohrmazd (the power of good)" and had "the function of opposing the 'vermin' creation of Ahreman (the spirit of evil)."[4] Their benevolent aspect made them an obvious choice for the decoration of the equipment of a Sasanian noble.

Selected Bibliography

K. Böhner, D. Ellmers, and K. Weidemann, *Das frühe Mittelalter* (Mainz, 1972), p. 42.

Notes

1. A. Farkas, "Sarmatian Roundels and Sarmatian Art," *Metropolitan Museum Journal* 8 (1973), pp. 77–88.
2. *Museum für Islamische Kunst Berlin, Katalog* (Berlin-Dahlem, 1971), p. 37, no. 87.
3. ISMEO, Rome. The roundel, a gift of M. Aaron, is unpublished.
4. C. J. Brunner, *Catalogue of the Sasanian Seals in The Metropolitan Museum of Art* (New York: The Metropolitan Museum of Art, forthcoming).

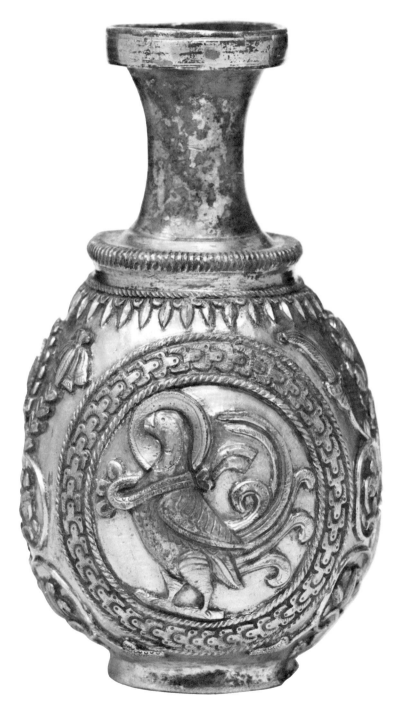

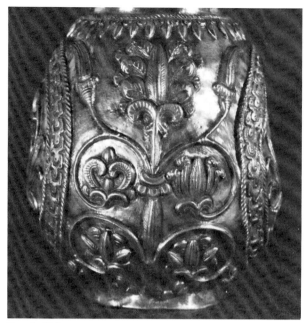

Detail of No. 21

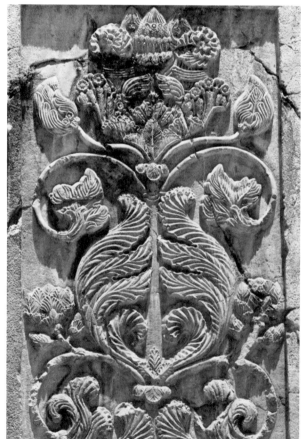

Fig. 21a. *Detail, facade of the ivan of Khusrau II. Taq-i Bostan, Iran.*

21
Silver-gilt vase with cocks

Iran(?); seventh century
Height 17.2 cm., greatest diameter 10.2 cm., weight 535 grams
Museum of Fine Arts, Boston; Holmes Collection, Gift of
* Mrs. Edward Jackson Holmes (58.94)*

Two cocks, within roundels, and a pair of elaborate "trees" decorate this silver-gilt vase. Allegedly found in northern Iran, the vessel differs from the standard Sasanian shape (compare Nos. 13, 22, 24). The tall narrow neck and spherical body give the vase a distinctive profile.

The birds are distinguished by two features: the halo of light encircling the head and the necklace with three oval pendants (probably pearls). Both the halo and the necklace are symbols of royalty, specifically associated in Sasanian art with kings. The triple-pendant necklace appears on late Sasanian coins and reliefs, as well as on the coins of the Umayyad governors of Iran. A similar necklace with three pendants hangs from the neck of the cock on an eighth-century bowl from Mazanderan, in northern Iran (No. 26), and another example of this motif occurs on a textile in this exhibition (No. 61).

The "trees" on the vase consist of a central trunk with two pairs of downward curling branches on either side. On the uppermost pair, two additional stems curve up toward the rim of the vessel. In the layout of the design the "trees" resemble those represented on the *ivan* of Khusrau II (591–628) at Taq-i Bostan (fig. 21a).[1] There, however, the plants are more naturalistic and luxurious. The simplification of the design on the silver vessel may indicate a slightly later date.

In Sasanian art, cocks occur on small seal stones, on silver vessels, and on the garments of figures riding elephants and seated in boats in the royal boar hunt relief at Taq-i Bostan (fig. J, p. 121).[2] In the Avesta, the cock is a companion of Sraosha, the angel who defends mankind from demons. The cock, when he proclaims the arrival of the day, awakens men to their prayers.[3] Thus, on this silver-gilt vase of late Sasanian or early Islamic date, the cock is a symbol both of royalty and of true religion.

Selected Bibliography
L. vanden Berghe, *L'Archéologie de l'Iran ancien* (Leiden, 1959), p. 6, pl. 6. The University of Michigan Museum of Art, *Sasanian Silver*, p. 118, fig. 32; Museum of Fine Arts, *Romans and Barbarians* (Boston, 1976), p. 190, fig. 220.

Notes
1. Fukai and Horiuchi, *Taq-i-Bustan*, I, pls. 12 (tree), 39, 57 (cocks).
2. R. Pfister, "Coqs sassanides," *Revue des arts asiatiques* 12 (1938), pp. 40ff.
3. Brunner, *Catalogue of the Sasanian Seals in The Metropolitan Museum of Art.*

22
Silver-gilt vase with hunting scenes

Iran; ca. seventh century
Height 17.5 cm., diameter of rim 5.5 cm., weight 575 grams
National Collection, Tehran (577)

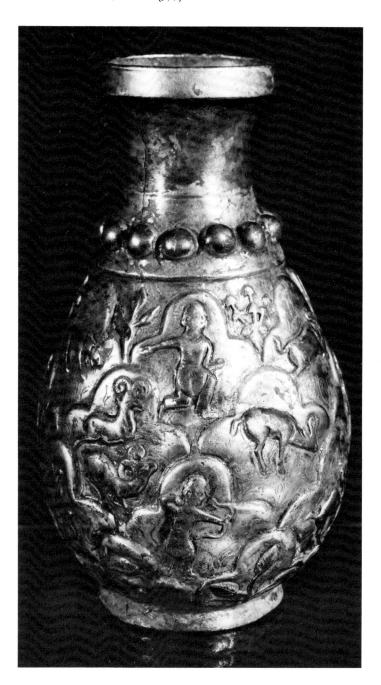

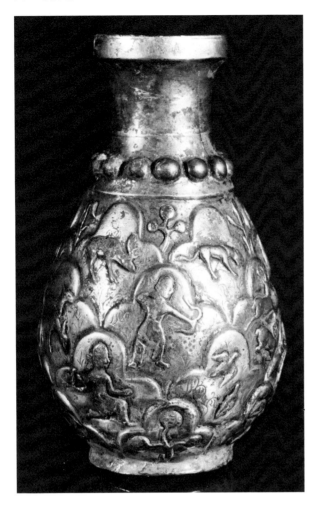

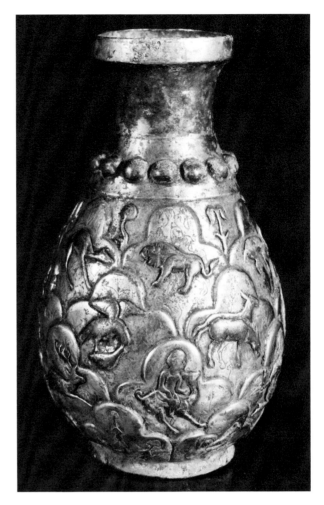

Scenes of a hunt in a mountainous landscape cover the entire body of this silver vase. Figures dressed as Sasanian courtiers, in a style current between the late fourth and seventh centuries, appear against a background of triple hills. The landscape, animals, and humans are hammered in repoussé relief. Plants are chased onto the surface of the hills. The theme on this vase is courtly life, the pastimes of the nobility.

It is unusual for a vessel of this shape to be decorated with an uninterrupted figural pattern. Customarily the figures are arranged in pairs or groups of four and six within circular or arched frames (see No. 13). A few late Sasanian and early Islamic vases have overall geometric designs. The decoration of an early Islamic bronze ewer in The Metropolitan Museum illustrates the development from a figural to a geometric style (fig. 22a). The lobed forms are stylized representations of mountains and the vertical lines surmounted by bud-like shapes are probably plants.

The small hunting scenes on this silver vase have considerable charm. Figures ride camels. Archers shoot at camels and goats. A standing male lassos a wild bull. A kneeling hunter prepares to loose a falcon. Scattered in the field are birds of prey, onagers, an antelope, a lion confronting a camel, and a stag. The spirit is far removed from the formal hunting scenes on the royal silver plates.

Only late in the Sasanian period is there any evidence of the production of silver vessels depicting persons other than the king in scenes taken from daily life. The restrictions placed on the manufacture of silver plate under Shapur II in the fourth century were apparently lifted sometime late in the sixth century. Members of the high nobility were then free to commission silver vessels with images of themselves and their families (see No. 25). It is to this period, probably in the seventh century, that the vase from the National Collection belongs.

The arrangement of the design on the vase—triple hillocks framing single figures, plants, or birds—is reminis-

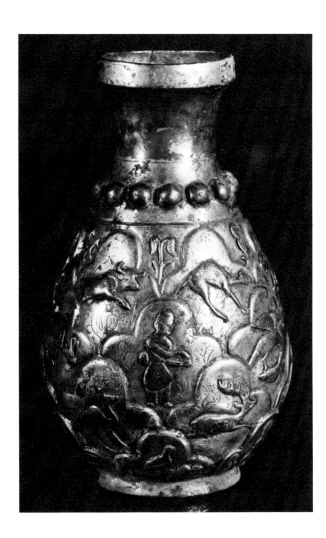

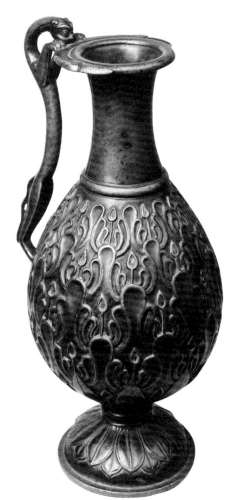

Left. *Details of No. 22*

Fig. 22a. *Bronze ewer. Seventh century A.D. H. 46.4 cm. The Metropolitan Museum of Art; Fletcher Fund (47.100.90).*

cent of the painted scenes in the Buddhist caves at the oasis of Kucha in Central Asia, an area into which Sasanian influence expanded in the sixth century.[1] The paintings, however, are narratives, illustrating the life and teachings of the Buddha. In contrast, Sasanian work generally lacks a recognizable narrative content. The scenes recall descriptions of the Persian "paradise" or game park. Ammianus Marcellinus, the historian who accompanied the Roman emperor Julian on his campaign in the East, describes a park near Ctesiphon in a region with "groves and fields rich with the bloom of many kinds of fruit." In this area was an extensive tract "containing the wild beasts that were kept for the king's entertainment."[2]

Notes

1. A. Grünwedel, *Alt-Kutscha* (Berlin, 1920), figs. 44, 45.
2. Ammianus Marcellinus, trans. J. C. Rolfe, Loeb Classical Library (Cambridge, Mass./London, 1950), II, pp. 449–451 (Bk. XXIV. 5. 1–3).

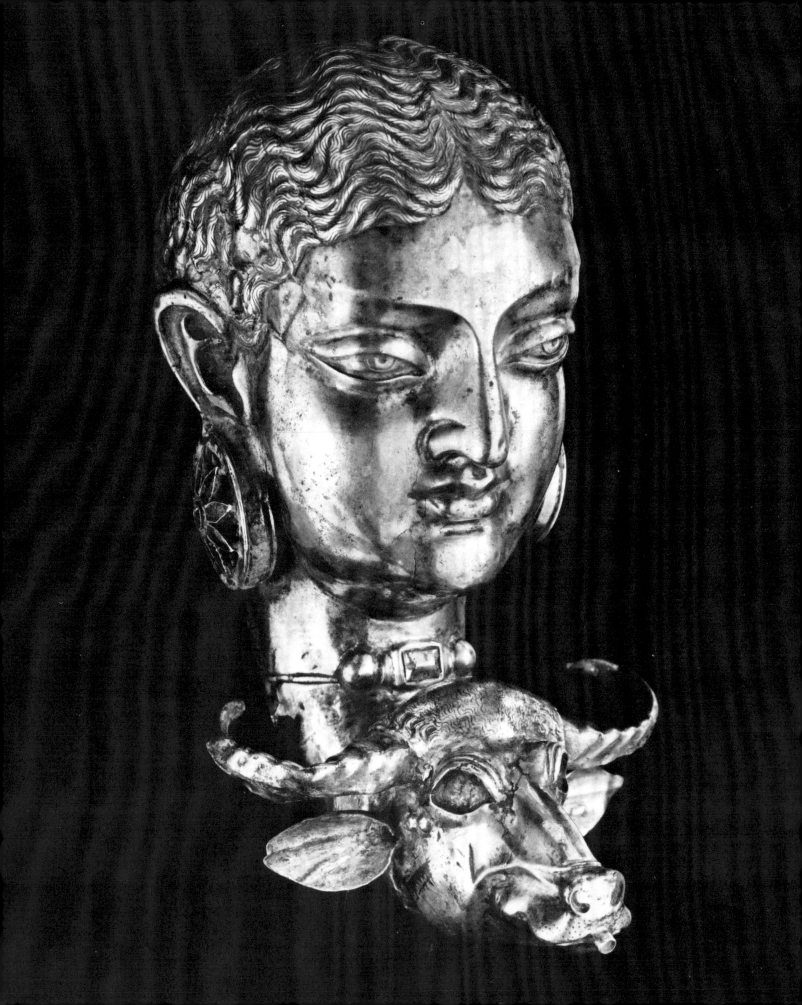

23

Silver-gilt rhyton decorated with the heads of a female and a buffalo

Inscribed (see note below)
Iran(?); ca. seventh century
Height 19.4 cm., overall length 20 cm., width across horns
 12.5 cm., weight 702 grams
The Cleveland Museum of Art; Purchase, Leonard C.
 Hanna Jr. Bequest (64.96)

This vessel, combining a female head with that of an Indian buffalo, derives from a shape known in both Iran and Central Asia. Another version of the human-headed, animal-spouted rhyton form is a clay vessel, No. 84 in the exhibition. The upper and lower halves of the silver rhyton, worked in repoussé and joined by a collar soldered inside one rim, unite as a single object displaying an extraordinary complexity in technique of manufacture. Additional elements attached by solder include a spout in the buffalo's mouth, the horns and ears of the buffalo, a collar inside the opening at the top of the female's head, and the large circular earrings decorated with open lotus flowers, the petals of which still retain bits of green glass paste inlay. The eyes of the animal are recessed to accommodate similar inlays. Mercury gilding has been applied to the earrings, the bezel of the central jewel in the necklace, the twin beauty marks on the lady's cheeks, the crescent device on her forehead, and also on the horns, bristly pate, eyelids, and muzzle of the buffalo. The ribbon of the necklace is shown knotted at the back of the neck and terminates in a pair of symmetrically fluttering ends. Just above this is a Pahlavi inscription giving the weight of the silver.

From a stylistic viewpoint this vessel does not belong to the mainstream of Sasanian artistic tradition, but rather to the eastern periphery of its influence. Here Iranian elements mixed with those of Gupta India and Central Asia to form a syncretic style. Although the rhyton was found in the Dailaman region of Iran near the Caspian Sea, it was almost certainly brought there from elsewhere. After

the piece reached Iran it was weighed and inscribed according to a system of measurement current until around A.D. 700, thus providing a *terminus ante quem* for the period of manufacture. In order to investigate its provenance we must look to the Indo-Iranian borderlands for comparable material. The lady has widely-set, heavy-lidded "lotus eyes," a small receding chin, and a small mouth with a short upper lip and a full lower lip, all of which suggest late or post-Gupta Indian facial types. A close resemblance can be found in the elegant visages of divinities and worshippers discovered at the Buddhist site of the Fondukistan monastery near Kabul in Afghanistan,[1] and at Ashkur and Akhnur in Kashmir.

Sasanian and Arab-Sasanian coins found at the Fondukistan excavation indicate that the monastery flourished in the seventh century, at a time when the surrounding regions were controlled by the so-called Turki Shāhis who ruled the Kabul Valley, Gandhara, and the upper Indus region to the borders of Kashmir. The dynasty gained power after the destruction of the empire of the Hephthalite Huns by the Sasanians and Turks in the mid-sixth century, and may well have formed an important cultural and artistic link interconnecting Iran, India, and Sogd in the seventh and eighth centuries. The style seen at Fondukistan, often called Indo-Sasanian or Buddhist "rococo," marks the final chapter in a development that began with the Kushans in the first and second centuries A.D. Although it would be impossible at present to pinpoint the exact origins of the silver rhyton, it probably belongs to a seventh-century atelier somewhere in or around the Afghan realm of the Shāhis.

The vessel's imagery is not identifiably Buddhist, but may have some associations with the Indian cult of Śiva. The combination of the head of an Indian buffalo with that of an auspicious female, probably a goddess, brings to mind the spouse of Śiva, Durgā, in her role of Mahiṣāsuramardinī, slayer of the buffalo demon. Representations of this goddess, riding on her lion while stabbing or decapitating a buffalo, are known as early as the Kushan era in northwest India, and have also been found in fragmentary marbles datable to the Shāhi period in

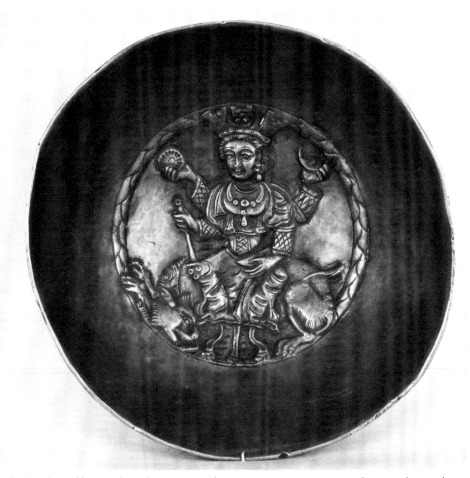

Fig. 23a. *Silver bowl with a goddess seated on a lion. Ca. seventh century A.D. Diam. 12.7 cm. Khoresm. The British Museum (WAA 124089).*

Afghanistan.[2] Recently at Tapa Sardar near Ghazni, an eighth-century Buddhist sanctuary has been uncovered containing the remains of a monumental sculpture of a buffalo-slaying goddess of the Mahiśāsuramardinī type.[3]

On the brow of the rhyton's female is a painted gilt crescent with a triangular or trilobate motif in its center. Although the Durgā head from Tapa Sardar and a similar Durgā or Śiva marble head from nearby Gardez have a third eye on the forehead, the Gardez head also has a crown displaying a triangular device on a crescent. The upturned crescent, an emblem frequently adorning the hair or headdress of Indian Śiva images, is also found on the crowns of small stone representations of Pārvatī from Gandhara datable to the seventh and eighth centuries. Hsüan-tsang, the seventh-century Buddhist monk who traveled through Gandhara when it was under Shāhi rule, noted in his journal the extreme popularity of the goddess Bhimā Devī (Durgā) there. Many of her devotees came from great distances to her shrine near Pushkalāvatī where an image of the goddess was supposed to exist in the living rock on a mountainside.

The invincible Durgā (also called Umā or Ambā) appears to have had deep roots in this region of the former Kushan empire. A kindred goddess, the lion-riding Nana of Kushan coinage, frequently is shown with a lunar crescent on her head.[4] On some coins she appears with Oesho (Śiva) as her consort. A number of Central Asian silver bowls of the seventh century show lion-riding goddesses who may be related to Nana or Durgā.[5] One goddess on a bowl in The British Museum displays a distinct lunar crescent and three-lobed emblem on her mural crown (fig. 23a). Since paintings of similar goddesses and of a god who closely resembles Śiva have been found at Piandjikent, it is possible that elements of a syncretic Śiva cult had penetrated Sogd by the seventh century, if not before.[6] In this case it would not be unreasonable to suggest that the goddess associated with the buffalo might have been known there too. In an Iranian context, the

image was probably associated with the cult of Nana, as rhytons of earlier date (Nos. 83, 84) indicate that this goddess was represented on pouring or drinking vessels. Since the goddess Nana was known to the Sasanians, the image of the Indo-Afghan Durgā Mahiśāsuramardinī on the silver-gilt rhyton would probably have been recognized by them as this deity.　　　　*Martha L. Carter*

Note on the inscription:

The inscription on the Cleveland Museum rhyton is written in late Sasanian cursive script (Pahlavi), which was current from the early sixth century A.D. on. This inscription has two unusual features. It is rendered in incised lines, like a graffito, whereas normal silverware inscriptions represent the ductus of the script with a series of discontinuous punched holes. Secondly, the numeral "10" shows a unique ornamental stroke at its upper end. Hence the inscription cannot be called typical, although in other respects the writing is in an ordinary late Sasanian style. The three lines read: gwḥlk' / xl-x / ZWZN *iii*, "[the] material [is] 50 [stēr and] 3 *drahm*." A *stēr* (loanword from Greek "stater") equaled 4 *drahm* ("drachma"). The *drahm* was the standard measure of weight and determined the silver monetary unit (the *drahm* coin). Thus a total of 203 *drahm*-weight of silver went into the making of the rhyton. The present weight of the object, after losses and repairs, is 702 grams. If this were regarded as the original weight of the object, then a standard of about 3.5 grams per *drahm* would be indicated. This value roughly approximates the revised Islamic *drahm* weight.　　　　*Christopher J. Brunner*

Selected Bibliography

D. G. Shepherd, "Two Silver Rhyta," *The Bulletin of The Cleveland Museum of Art* 53 (October, 1966), pp. 289–317; B. Rowland, *The Art of Central Asia* (New York, 1974), p. 60, color plate.

Notes

1. J. Hackin, "Le Monastère bouddhique de Fondukistan," in *Diverses recherches archéologiques en Afghanistan, 1933–1940*, Mémoires de la délégation archéologique française en Afghanistan VIII (Paris, 1959).
2. D. Barrett, "Sculptures from the Shāhi Period," *Oriental Art* (1957), pt. 3, pp. 54–58.
3. M. Taddei, "The Mahisasuramardini Image from Tapa Sardar, Ghazni," in *South Asian Archaeology*, ed. N. Hammond (New Jersey, 1973).
4. J. Rosenfield, *The Dynastic Arts of the Kushans* (Berkeley/Los Angeles, 1967), pp. 83ff; B. N. Mukherjee, *Nanā on Lion* (Calcutta, 1969).
5. G. Azarpay, "Nine Inscribed Choresmian Bowls," *Artibus Asiae* 31 (1969), pp. 186ff.
6. P. Banerjee, "A Siva Icon from Piandjikent," *Artibus Asiae* 31 (1969), pp. 73–80.

24
Silver-gilt vase with scenes of vintaging

Inscribed (see note below)
Iran; ca. seventh century
Height 17.2 cm., diameter of rim 4.8 cm., diameter of base
* 5.84 cm., weight 529 grams*
National Collection, Tehran (578)

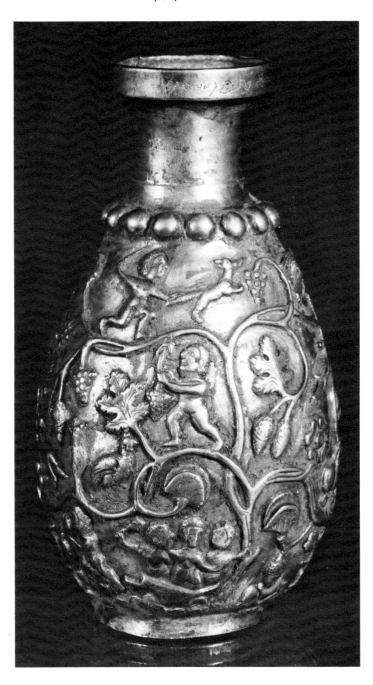

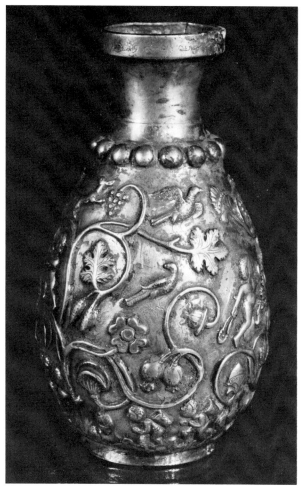

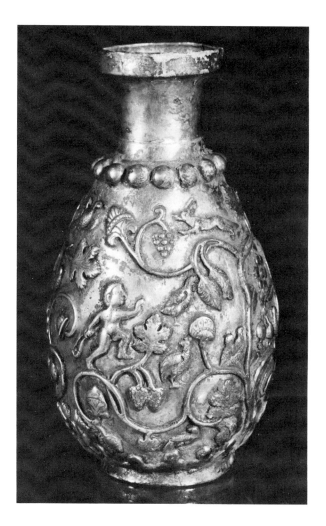

Details of No. 24

Typically Sasanian in form, this ovoid silver-gilt vase is similar to several others in the exhibition (compare Nos. 13, 21, 22). The surface of the body is covered by branches of two inhabited vine trees growing from a ground plane made up of a series of trilobate mounds symbolizing a hilly landscape. At the base of one vine, three small seminude vintagers tramp grapes in a vat while a fourth pours the juice into amphorae. On the other side of the tree trunk, two more vintagers carry baskets of harvested grapes on their backs. Above, in the branches, a naked child tugs at a vine stem, while nearby another one chases a fox that is about to feast on some grapes. On the opposite side of the vessel a second vine tree is filled with similar representations of birds and small figures, including a nude boy with a sling who stalks a pair of game birds.

Although the growing vine appears on many Sasanian silver objects, the decoration on this vase closely resembles that on a silver vessel with a pierced base in The British Museum (fig. 24a).[1] There, too, the trees are in-

habited by birds, small animals, and playful diminutive figures who frolic or take part in vintaging activities. There are a number of stylistic differences between the two works, however. In the British Museum example, the simple vine trees produce only flat blunt-tipped leaves and grape clusters; whereas on this vase from the National Collection in Tehran the vines are fantastic. They produce not only naturalistic grape leaves and grapes, but also pomegranates, flowers, acorn-like fruits, and lotiform elements.

Doubtless, the inspiration for this work derives from the late classical repertory of Dionysiac motifs which had spread by the third century A.D. throughout the east Roman Empire as far as Kushan India. At the core of this symbolism was the pious hope that participants in the mysteries of Dionysos might enjoy an afterlife of eternal felicity as Bacchic cherubs in the immortal *thiasos* of the vine god.[2] The grapevine thus became the ubiquitous symbol of eternal life and fruitfulness, an image meaning-

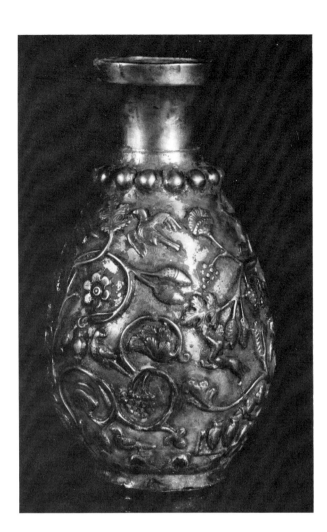

in Jerusalem. These produce pomegranates and grapes, as well as a wealth of floral motives.

An inscription around the mouth of the silver vessel gives its weight in a standard of measurement current in Iran until around A.D. 600. From the evidence of the shape and style of decoration, it is probable that the piece was made in the later sixth or the seventh century.

Martha L. Carter

Note on the inscription:

The inscription reads: [. . . gw] (šn) sp NPŠH s-*xx-x i* ZWZN iii, which can be translated as "Property of . . . Gušnasp; 31 *s* [*tēr*], 3 *drahm*." The weight is probably according to the classical Sasanian (and immediately post-Sasanian) standard. 127 *drahm* would thus equal approximately 508 grams. On the revised, Islamic standard, it would equal approximately 381 grams. For a very similar weight inscription, see Brunner, "Middle Persian Inscriptions on Sasanian Silverware," p. 112, no. 5.

Christopher J. Brunner

Notes

1. Dalton, *The Treasure of the Oxus*, no. 209.
2. R. Ettinghausen, *From Byzantium to Sasanian Iran and the Islamic World* (Leiden, 1972), pp. 3–10; M. L. Carter, "Royal Festal Themes in Sasanian Silverwork and Their Central Asian Parallels," *Acta Iranica, Commemoration Cyrus I* (Leiden, 1974), pp. 171–202.

ful to Christians in the West and to Buddhists in the East. On Sasanian works of art the vines' playful inhabitants—vintagers, foxes, birds, etc.—are similar in form and concept to figures in the Constantinian mosaics on the vaults of the Mausoleum of Sta. Costanza in Rome. In the East this imagery spread to China where inhabited grapevines appear on bronze mirrors and silver vessels of the T'ang dynasty.

The vine trees on this silver vase have a distinctly Sasanian appearance, displaying a wide assortment of floral and vegetal motifs commonly seen in Sasanian stucco ornament. The lotiform elements are influenced by Indian tradition where the growing lotus vine was depicted as a miraculous source of plenty, producing jewels and fine fabrics from its pods and calyxes. The foliage of the vine trees on this vase may be compared to that of the fantastic acanthus trees carved on either side of the Taq-i Bostan *ivan* (fig. 21a), and to that of the gem-encrusted acanthus scrolls in the mosaics of the Umayyad Dome of the Rock

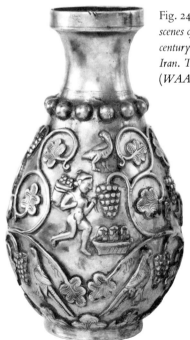

Fig. 24a. *Silver-gilt vase with scenes of vintaging. Sixth–seventh century A.D. H. 18.5 cm. Sasanian, Iran. The British Museum (WAA 124094).*

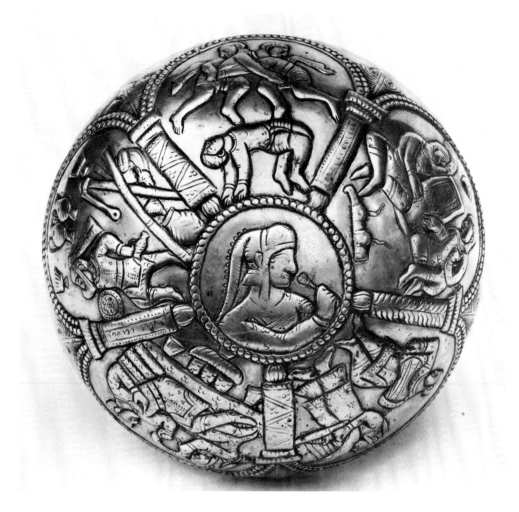

25

Silver-gilt hemispherical bowl with a ceremonial scene

Iran(?); seventh century
Height 5.5 cm., diameter 14.3 cm., weight 481 grams
The Arthur M. Sackler Collections

Late in the Sasanian period, the state relaxed its controls on the production of silver plate. Persons other than the king became free to commission silver vessels with images of themselves and their families. The exterior of this hemispherical bowl is decorated in low relief with scenes of court life, enclosed within arches. The bust of a woman appears in the center of the base within a beaded roundel. Mercury gilding has been applied to the background of the design.

Presumably the principal scene, to which all the others are related, is the one showing a male and a female seated on a couch and holding up between them a large jeweled ring. Similar representations, in which a male and a female grasp a ring, appear on seal stones. They are generally interpreted as celebrating a marriage contract (see No. 73).[1] This is probably also the meaning of the scene on the Sackler bowl. The band around the head of the male indicates that he is a man of rank, possibly a member of the landed nobility (*azatan*).

Beneath the arch to the right of the male banqueter are vessels and containers, a ladle, and high footed bowls for food (compare No. 9). In the corner, to the side of the stand in which the beverage is held and strained, is a rhyton. It has a beaded rim and ends in an animal head. The horn-shaped body of the vessel is fluted (compare No. 5). A servant approaches the seated couple. He wears a cloth over his mouth, a custom that was observed among the Sasanians and represented on other silver vessels.[2]

The next arch encloses a wrestling scene, a common sport in the Near East and in the Greco-Roman world. Beneath the two contestants the artist has, in characteristic

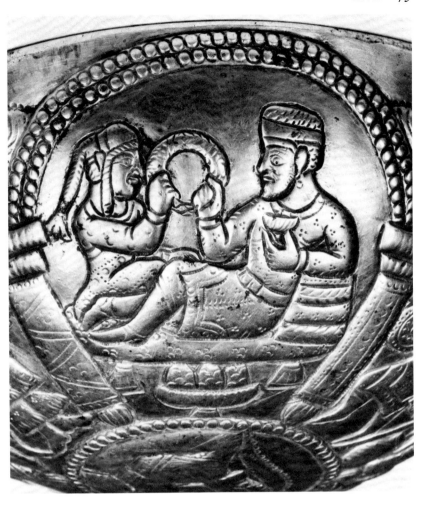

Detail of No. 25

Sasanian fashion, portrayed the final outcome of the match, by showing the fallen figure of the defeated wrestler.

In the third arch a different form of entertainment is depicted: backgammon, the Persian *nard*. The winner is clearly the figure on the viewer's left. He raises his hand in victory, while the loser makes the gesture of respect, forefinger pointing toward his opponent. In the field are the cap and perhaps the weapon of the loser—stakes he may already have lost. According to Persian legend, the Sasanians adopted chess from India and offered in return a game they found more challenging, backgammon (see No. 89). Backgammon boards similar to the one on the Sackler bowl are represented in the seventh- and eighth-century paintings at Piandjikent in Central Asia[3] and later in Islamic miniatures.[4]

The final scene includes two musicians. One, a male, plays a drum, as is customary. The other, a female, plucks the strings of an arched harp (compare No. 87A).

Genre scenes of this sort are rare in Sasanian art, in which a formal imagery, remote from the activities of daily life, prevails. The costumes, tableware, instruments, and games represented on the Sackler bowl provide a wealth of information about court life. Wall paintings and mosaics in royal and noble residences probably illustrated similar scenes, but none has yet been recovered.

This hemispherical vessel was undoubtedly made in honor of the woman represented on the banqueting couch and again in the central medallion. Was it a gift from the Sasanian ruler to a loyal subject, from a husband to his wife or to noble guests who attended the ceremony? These are questions that cannot be answered. A date late in the Sasanian period or at the beginning of the Islamic era is assured by many details: the forms of dress, which are similar to those of courtiers on the reliefs at Taq-i Bostan (fig. J, p. 121);[5] the shape of some of the vessels, particularly the ewers; the attachments on the short sword (compare No. 28); and the gilding of the background

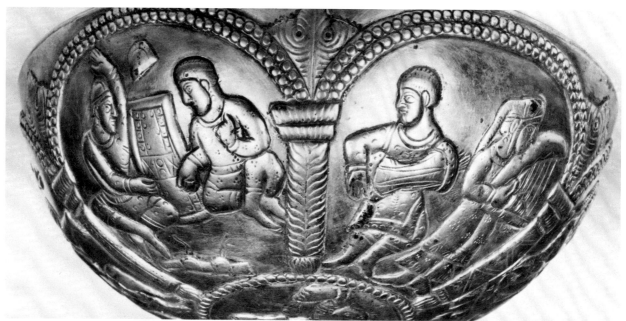

Details of No. 25

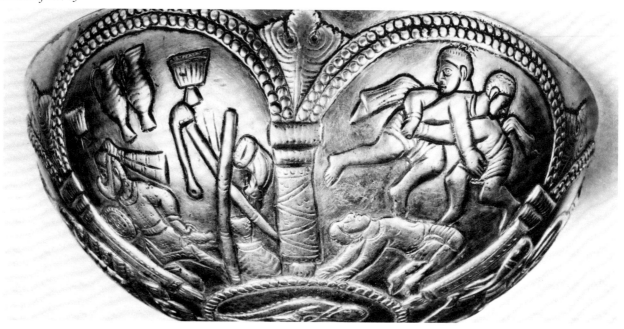

rather than the design. It is interesting that the design on the Sackler bowl includes a medallion with the bust of a figure holding a flower. This form of decoration recalls the earliest Sasanian royal and princely vessels (compare No. 2).

Notes

1. A. Christensen, *L'Iran sous les Sassanides*, 2nd ed. rev. (Copenhagen, 1944), pp. 322–330; B. Staviskiy, "O datirovke i proiskhozhdeniya Ermitazhnoy serebryanoy chashi c izobra-zheniem venchaniya tsarya," *Soobshcheniya Gosudarstvennogo Ermitazha* 17 (1960), pp. 67–71; R. Ghirshman, "Notes iraniennes V: Scènes de banquet sur l'argenterie sassanide," *Artibus Asiae* 16 (1953), pp. 51–70.

2. Erdmann, *Die Kunst Irans zur Zeit der Sasaniden*, fig. 68.

3. M. Bussagli, *Painting of Central Asia* (Geneva, 1963), p. 46.

4. The Metropolitan Museum of Art, *Chess: East and West, Past and Present* (New York, 1968), p. xiii.

5. See also Fukai and Horiuchi, *Taq-i-Bustan*, I, pl. 34.

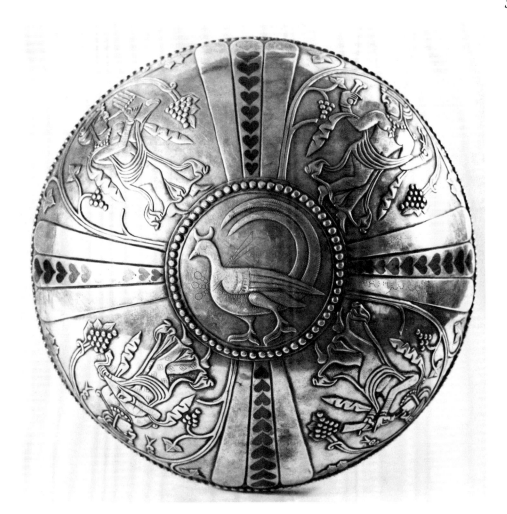

26

Silver bowl with female musicians

Inscribed: Property of Windad Ohrmazd of the Karens.
 Of 306 drahm by weight.[1]
Mazanderan, Iran; eighth century
Height 8 cm., diameter 23.5 cm.
Iran Bastan Museum, Tehran (1333)

This bowl belongs to a group of three similar vessels discovered by chance in the province of Mazanderan near the Caspian Sea. Its exterior is decorated with a central medallion containing a long-tailed crested bird with a jeweled ribbon tied around its neck (compare Nos. 21, 61). Surrounding this motif, the hemispherical surface of the bowl is divided into equal segments by four series of triple petals, the central elements of which are decorated with rows of niello hearts. Both the rim of the bowl and the central medallion have a raised pearl border. In the four open sections of the design are representations of

female musicians, each under an identical vine tree terminating in a large bunch of grapes. One plays a short-necked lute, similar to the *'ud* popular in Islamic times. Another holds a pair of clappers, and a third plays an oboe-like reed instrument. The fourth is shown playing an elaborate mouth-organ resembling an instrument known in T'ang China as the *yu*, which was fitted with bamboo pipes of varying length. These were often played in China by orchestras from Kucha, which introduced so-called Iranian modes of music from Central Asia.

The simple shape of the bowl and the form of decoration that appears on the exterior surface are not common in Sasanian metalwork, but recall a group of Central Asian vessels made under strong Hellenistic influence which are thought to come from Bactria.[2] This does not necessarily mean that the bowl itself is a Central Asian product, only that it was made at a time when Iran was particularly open to influences from that area.

The representation of female musicians is interesting

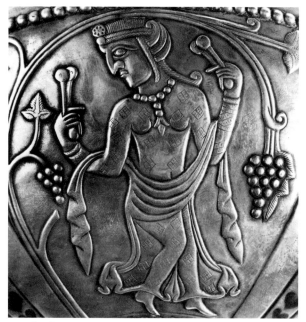

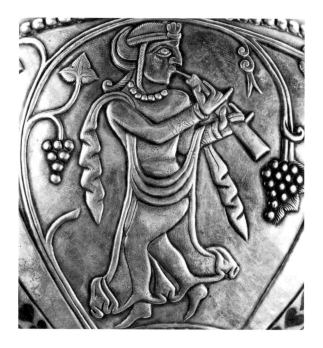

Details of No. 26

because it follows a Sasanian tradition of showing four similar female figures on silver vessels. The basic difference here is that, unlike the so-called Sasanian "bacchantes" (compare No. 18), the females do not hold auspicious symbols or attributes, but play musical instruments, a modification that may indicate a change in their significance.

The style of the representations is flat, linear, and highly schematic. The head and legs are in profile, the shoulders and chest frontal. The lines of the drapery and the vine trees form a complex abstract design. This style was further developed in medieval Islamic art. On the bowl the body and its clothing are turned into an arbitrary set of rhythmic patterns comparable to those evident in a floor painting with musicians in the Umayyad Palace at Qasr al-Hayr al-Gharbi in Syria (ca. 730).[3] The dancing girls in the well-known wall painting found at the Jausak Palace at Samarra and dated to the early ninth century are also depicted in a similar manner.[4]

The Pahlavi inscription written on the outside petals of one of the dividing elements tells us a great deal about the bowl's history. According to the translations of W. B. Henning and Christopher Brunner, the bowl was the property of Windad Ohrmazd of the Karens, Ispahbad of Tabaristan in the late eighth century. Islamic histories record that this prince expelled the Arabs from his ancestral domains and temporarily restored Zoroastrianism as the official religion. The weight standard noted in the inscription is an early Islamic rather than a Sasanian one. It was introduced under the Caliph Abd al-Malik in 695.

The bowl can thus be dated to the later part of the eighth century. It is an important work since it shows that artisans of the post-Sasanian era were in the process of transforming the old Sasanian motifs into a new artistic idiom. The bowl appears to anticipate the style of Buyid metalwork, notably that of a silver plate in the Hermitage Museum showing a ruler seated on a dais surrounded by attendants and musicians.[5] This work has been dated to the tenth century. The Buyid dynasty originated near the Caspian Sea in the same region where the bowl of the Ispahbad probably was found. The persistence of traditions maintained by the Kāren-wand dynasty of Tabaristan probably influenced the later Buyids who attempted to continue the traditions of Sasanian court luxury.

Martha L. Carter

Selected Bibliography

R. Ghirshman, "Argenterie d'un seigneur sassanide," *Ars Orientalis* 2 (1957), pp. 76–82, pls. 1–3; W. B. Henning, "New Pahlevi Inscriptions on Silver Vessels," *Bulletin of the School of Oriental and African Studies* 22 (1959), pp. 132–134; C. J. Brunner, "Middle Persian Inscriptions on Sasanian Silverware," *Metropolitan Museum Journal* 9 (1974), p. 119, no. 34.

Notes

1. Read by C. J. Brunner.
2. K. Weitzmann, "Three Bactrian Silver Bowls with Illustrations from Euripides," *Art Bulletin* 25 (1943), pp. 289–324.
3. D. Schlumberger, "Deux fresques omeyyades," *Syria* 25 (1946–48), pp. 86–102.
4. F. Sarre and E. Herzfeld, *Die Ausgrabungen von Samarra*, III: *Die Malereien* (Berlin, 1927), pls. I, II.
5. F. Sarre, *Die Kunst des alten Persien* (Berlin, 1922), fig. 109.

GOLD

Gold, the noblest of metals, is poorly represented among objects dating from the period of Sasanian rule in the Near East. There was rarely a gold coinage in the Sasanian era. The primary medium of trade and the precious metal most frequently used was silver, from which both the coinage and much of the royal plate was manufactured.[1] One explanation for the scarcity of Sasanian gold objects is that no rich source of gold existed in the lands that were permanently under Sasanian rule. Although the Iranians acquired this precious commodity as tribute and booty, they were unable to control its extraction from the earth in quantity, except at certain periods.

The gold objects that have survived in the greatest number are weapons and belts, the equipment of horsemen and warriors. Thin gold foil was often applied over the wooden scabbards and around the hilts of swords. On an elaborate example in The Metropolitan Museum (No. 28), the metal is enhanced by colored stones and glass. Similarly, a magnificent gold plate in the Bibliothèque Nationale (fig. C, p. 80) is inlaid with medallions of rock crystal and colored glass.

The use of gold foil and mercury gilding to enrich a surface, rather than to give an overall appearance of gold, seems to have been characteristic of Sasanian taste. The gilding provides an attractive contrast to the silver of the vessels. A similar effect was achieved by applying gold foil to the iron noseband and bit of a bridle (No. 27) and to the mount of a small rock crystal bowl found at Susa (No. 29).

Literary sources describe golden vessels as part of the tableware of Sasanian kings and princes, and it would be misleading to think of the Sasanian court without the presence of golden plate. The property of kings, however, rarely survives the vicissitudes of time and war. During the plundering of the palace of Khusrau II (591–628) at Dastagird, the army of the Byzantine emperor Heraclius (610–641) carried off vast quantities of loot, including silver, embroidered carpets, silks, spices, and aromatic woods.[2] Following the invasion of Heraclius, Arab conquerors descended on Mesopotamia and Iran. Procopius, the sixth-century Byzantine historian who recorded the wars of Justin I and Justinian I against the Persians, described the Arabs as: "unable to storm a wall, but the cleverest of all men at plundering."[3] In view of this history of invasion and pillage, it is hardly surprising that the golden treasures of the Sasanian kings have disappeared.

Notes

1. D. Sperber, "Silver as a Status Symbol in Sasanian Persia," *Persica* 5 (1970–71), pp. 103–105; J. Orbeli and C. Trever, *Orfèvrerie sasanide* (Moscow/Leningrad, 1935), pls. 61, 63.
2. A. Christensen, *L'Iran sous les Sassanides*, 2nd ed. rev. (Copenhagen, 1944), p. 469 (reference to the ninth-century Byzantine chronicle of Theophanes).
3. Procopius, trans. H. B. Dewing, Loeb Classical Library (London/New York, 1914), I, p. 421 (Bk. II. 19. 12).

Fig. C. *Gold, rock crystal, and glass plate. Sixth-seventh century A.D. Cabinet des Médailles, Bibliothèque Nationale (379).*

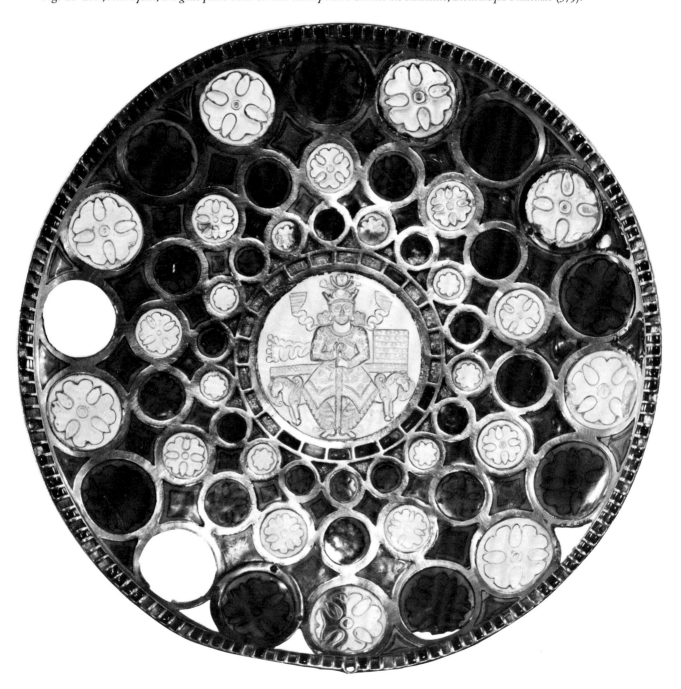

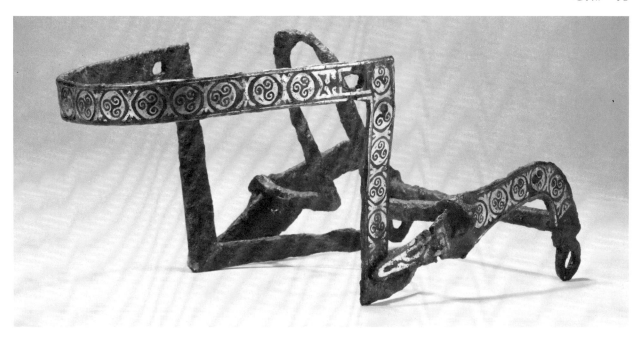

27

Iron bridle decorated with gold foil

Iran (?); third to fifth century
Noseband: height 20.2 cm., length 12.2 cm.
Bit: height 15.4 cm., length 17.2 cm.
The Metropolitan Museum of Art; Gift of Mrs. Vladimir S.
 Littauer (1971.223)

Although the origin of this iron bridle is unknown, on
the basis of its form and decoration it is attributed here to
Sasanian Iran. The bridle consists of two parts, a noseband
and a bit with a brutally high porte (see fig. 27a for its
placement). The gold foil decoration, arranged so that
the design is in positive (gold) and negative (iron) silhou-
ette, includes four motifs: circles enclosing *triskele*, or
triple-armed whorls; half palmettes; lotuses; and running
vine scrolls with grape clusters.

 Illustrations of horses harnessed with bridles of this type
are provided by a number of early Sasanian rock reliefs.
They are also seen on silver vessels that range in date from
the third to the seventh century (see No. 7). Actual exam-
ples are much rarer. Part of an iron bridle—a bit with a
high porte—was discovered in a tomb of late Parthian or
early Sasanian date excavated by a Tokyo University
expedition at Noruzmahale in northwestern Iran.[1] Other
iron and bronze bridle pieces were found in fourth-
century levels at Susa.[2] Two of the Susa bits are iron and
have a high porte and curving sides similar to this exam-
ple. The noseband found at Susa, however, resembles that
on The Cleveland Museum's horse rhyton (No. 1).

Fig. 27a. *Drawing of the bridle, No. 27. Anita Koh.*

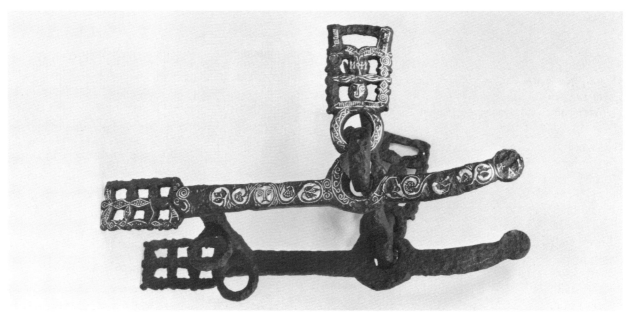

Fig. 27b. *Iron bridle. Late seventh–early eighth century. Visigothic. Spain. The Metropolitan Museum of Art; Fletcher Fund (47.100.24).*

The beautifully executed plant and geometric designs provide further support for the attribution of this bridle to an Iranian workshop. The *triskele* is the most important component of the decoration. This motif appears on Achaemenid coins and on those of the pre-Sasanian kings of the province of Persis. It occurs on one of the crowns of the first Sasanian king, Ardeshir (224–241).[3] Later, it continues in use as the *nishan*, or sign, of one branch of the Sasanian royal family.[4] Christopher Brunner explains the *triskele* on the crown of Ardeshir I as a symbol of celestial movements and a reminder of their beneficence to man.[5] Such insignia were probably placed as a sign of ownership on the equipment, weapons, and horse trappings of members of the king's entourage and those of his immediate family.

The grape and leaf pattern was commonly used to embellish weapons, armor, and horse trappings in the first millennium A.D. It decorates a Visigothic bridle in The Metropolitan Museum (fig. 27b), typologically related to this example, and occurs on an Ostrogothic helmet in the museum's collection.[6] The vine motif also appears on the king's quiver on a hunting plate in The Guennol Collection (No. 12). On late Sasanian seals, a grape and leaf scroll is often accompanied by the inscribed word *pwzn'*, an expression having a general meaning of prosperity.

The comparison of this bridle with the equipment of the Goths illustrates the extent to which shapes and designs passed from one part of the world to another during the first millennium after Christ. Without a known provenance, the bridle in The Metropolitan Museum cannot be attributed with certainty to a particular culture. The form and appearance suggest, however, that it is a product of a Sasanian workshop, and the rich decoration surely indicates that it was made for a royal or princely patron.[7]

Selected Bibliography

Sotheby's Catalogue (July 12, 1971), pp. 10, 11, lot 22B.

Notes

1. N. Egami et al., *Dailaman II* (Tokyo, 1966), pl. 17.
2. R. Ghirshman, "Le Harnais de tête en Iran," *Mélanges à la mémoire de Gaston Wiet* (University of Jerusalem, forthcoming).
3. R. Göbl, *Sasanian Numismatics* (Braunschweig, 1971), Table I.
4. W. Hinz, *Altiranische Funde und Forschungen* (Berlin, 1969), pl. 74.
5. C. J. Brunner, *Catalogue of the Sasanian Seals in The Metropolitan Museum of Art* (New York: The Metropolitan Museum of Art, forthcoming).
6. Museum of Fine Arts, *Romans and Barbarians* (Boston, 1976), p. 134, no. 159.
7. I am grateful to Mary A. Littauer for references to comparable material and for her advice.

28

Sword with gold hilt and scabbard

Allegedly from northwest Iran; seventh century
Length 100.3 cm., width at guard 7 cm.
The Metropolitan Museum of Art; Rogers Fund (65.28)

The sword was a symbol of rank and authority in the Sasanian period. Whether hunting on horseback or enthroned in majesty, the king is always depicted armed with a sword. Coins commemorating royal investitures show the king standing with his sword by his side or held in both hands before his body.[1]

The wooden scabbard and the hilt of this elegant sword are covered with gold foil. A delicately worked feather pattern decorates the scabbard and the surfaces of both hilt and scabbard have been further enriched with designs in granulation and inlays of garnets and glass. The blade is iron and the cross guard, also covered with gold foil, is bronze.

Although the commonly represented Sasanian sword either hangs from a slide attached to the center of the scabbard or is attached to the belt by straps passing through loops on both sides, the sword shown here has distinctive P-shaped mounts on one side of the scabbard. These are designed to keep the weapon, suspended from belt straps, at an oblique angle to the body. Only in a hunting scene on the side of the large rock-cut *ivan* of Khusrau II (591–628) at Taq-i Bostan does a presumably royal hunter wear the type of sword represented here—the so-called "sword of the Huns."[2]

In all probability the hunting scenes at Taq-i Bostan are contemporary with Khusrau II or not much later. The site, which lies on a main road between Mesopotamia and Persia, was surely occupied immediately by Arab invaders in the seventh century. It is not likely that these conquerors would have added hunting scenes to a monument commemorating the accession and victory of an enemy.

Many swords with gold or silver scabbards and P-shaped mounts have been found in the last decade, allegedly in northwestern Iran.[3] Less numerous are matching short swords (fig. 28a). Although weapons with P-shaped mounts are certainly not typically Sasanian in design, they were probably adopted by the Sasanians sometime in the sixth century. A Central Asian wall painting of the late fifth or sixth century from Piandjikent, a site northeast of Iran in Soviet Tadjikistan, shows a figure wearing a sword hanging from two hemispherical mounts arranged along one side of the scabbard.[4] Another sword similar to the one in The Metropolitan Museum was

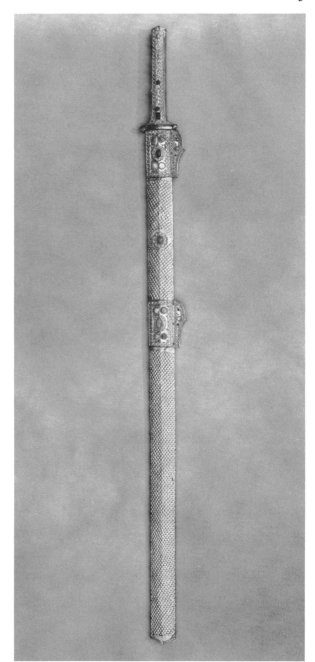

found in an early seventh-century grave in Soviet Azerbaijan, northwest of Iran. The same grave contained a gold ring inscribed with two Iranian names, indicating that in all probability the deceased warrior was Iranian.[5]

A sword suspended from the belt at an angle is particularly convenient for mounted warriors. The Sasanians must have adopted this sword from the peoples east and west of Iran who commonly wore their weapons in this way. The tenth-century Muslim historian Tabari records

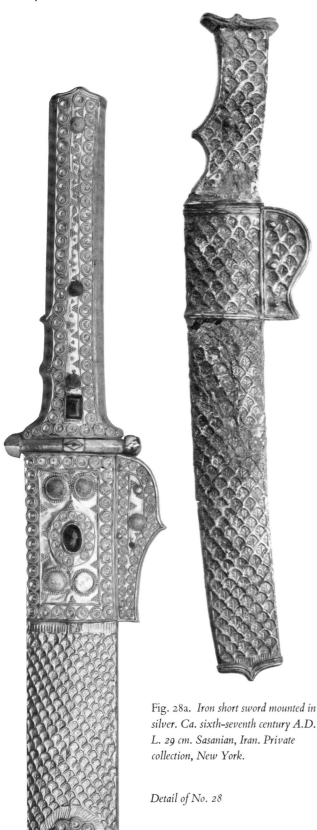

Fig. 28a. *Iron short sword mounted in silver. Ca. sixth–seventh century A.D. L. 29 cm. Sasanian, Iran. Private collection, New York.*

Detail of No. 28

that Khusrau I (531–579), having attacked the Khazars and Alans who invaded Iran and Armenia, captured 10,000 prisoners and transported them to Azerbaijan and neighboring regions.[6] Almost certainly these defeated warriors carried swords with P-shaped mounts.

In accordance with the conservative nature of Sasanian dynastic art, the standard Sasanian sword with a scabbard slide probably continued to be depicted long after it had disappeared from actual use. A similar conservatism is observable in jewelry and belts shown on rock reliefs.

The pattern of overlapping feathers that covers this scabbard is also evident on a Sasanian helmet (No. 31). Ghirshman interprets the feather pattern as a symbol of the *Varagn* bird, one of the forms of Verethragna, the Zoroastrian god of victory.[7] Sasanian warriors bearing this symbolic decoration on their arms doubtless felt well protected against all enemies, including those nomads of the steppes from whom they had inherited this sword.

Selected Bibliography

H. Nickel, "About the Sword of the Huns and the 'Urepos' of the Steppes," *Metropolitan Museum Journal* 7 (1973), pp. 131–142, figs. 1–3.

Notes

1. R. Göbl, *Sasanian Numismatics* (Braunschweig, 1971), pls. 11, 12, 14.
2. S. Fukai and K. Horiuchi, *Taq-i-Bustan*, I (Tokyo, 1969), pl. 81.
3. R. Ghirshman, "Notes iraniennes XIII: Trois épées sassanides," *Artibus Asiae* 26 (1963), pp. 293–311; P. Amiet, "Nouvelles acquisitions: Antiquités parthes et sassanides," *La Revue du Louvre* 17 (1967), nos. 4–5, p. 280, fig. 15.
4. A. Belenitskiy and B. Marshak, "Stennye rospisi obnaruzhen-nye v 1970 godu na gorodishche drevnego Pendzhikenta," *Soobshcheniya Gosudarstvennogo Ermitazha* 36 (1973), p. 61.
5. G. Gropp, "Der Gürtel mit Riemenzungen auf den sasanidi-schen Reliefs in der grossen Grotte des Taq-e Bostan," *Archaeologische Mitteilungen aus Iran* N.F. 3 (1970), p. 279. William Trousdale believes that the Sasanians may first have become familiar with this form of scabbard suspension from the Hephthalites in the mid-fifth century. The latter would have acquired it from the Turkic peoples of the steppes: *The Long Sword and Scabbard Slide in Asia*, Smithsonian Contributions to Anthropology, no. 17 (1975), p. 94. The large bronze male figure of Parthian date found at Shami in southern Iran wears two swords, each suspended from attachments on one side of the scabbard. According to the monuments, however, this form of sword attachment was not adopted by the early Sasanians.
6. Christensen, *L'Iran sous les Sassanides*, p. 369.
7. Ghirshman, "Notes iraniennes XIII," p. 310. The feather of the *Varagn* bird brought help to man and is related in this sense to the feather of the *simurgh* (*senmurw*, see No. 34). As it is described in the *Shah-nameh*, the *simurgh* feather had the power to heal wounds; for commentary see *The Zend-Avesta*, trans. J. Darmesteter, pt. 2 (Oxford, 1883), p. 241. Helmut Nickel (see Selected Bibliography above) refers to the feather pattern on this sword as symbolic of the eagle, the tribal image of the Huns.

29
Rock crystal bowl in gold mount

Susa, Iran; ca. seventh century
Height 1.7 cm., length 8.9 cm., width 6.6 cm.
Musée du Louvre, Antiquités Orientales (Sb 3795)

Rock crystal, a colorless quartz that can be highly polished, was used through the millennia for objects of luxury. Because its hard surface withstands scratching, rock crystal was valued above glass.[1]

The small size of this oval bowl and the elaborate setting give it a jewel-like appearance. On the exterior of the rock crystal, a simple design of an oval surrounded by plant forms and cross-hatched lines is carved in low relief. The wide gold mount has an openwork pattern of wavy lines radiating outward from the center. Originally this gold sheathing enclosed some other material. Only traces of a substance, said to be bitumen, now remain. The interior of the bowl and its mounting are undecorated.

Other miniature bowls of glass and rock crystal exist from the late Sasanian and early Islamic periods.[2] Their alleged provenance is Iran or Egypt. The source of this bowl from the Louvre is Susa, where it was found during the excavations made in the late nineteenth and early twentieth centuries by Jacques de Morgan. Inhabited in the beginning of the Sasanian era, Susa was destroyed by Shapur II (309–379) following a Christian rebellion. By the end of the Sasanian period, however, the city was once again populated.

Cross-hatched patterns such as those seen here occur on Assyrian glass of the early first millennium B.C. found at Nimrud in northern Mesopotamia.[3] The pattern becomes common again in the first millennium A.D. on Roman and, later, on Islamic glasses. Although the leaves on this bowl from the Louvre resemble those on ninth- and tenth-century Islamic rock crystal vessels, the greater naturalism of the Susa plant design may indicate a late Sasanian rather than an early Islamic date. Another small oval bowl from Susa, made of jadite, has an almost identical design carved in relief on the exterior.[4] The repetition of certain patterns on vessels made from rock crystal and other valuable stones also occurs in the Islamic era and may be typical of the decoration of objects in these precious materials.

How this bowl from Susa was used is unknown, since no record of the archaeological context in which it was found has been preserved. An undecorated sardonyx bowl of approximately the same proportions was discovered in a late second- or early third-century tomb at Mtskheta in Georgia (Caucasus).[5] The excavators be-

lieved that it once contained material for a woman's toilet, perhaps rouge. Pierre Amiet has offered a similar explanation for the Susa bowl, suggesting that it held some precious material to be used only in small quantities.

Selected Bibliography

M. Pézard and E. Pottier, *Les Antiquités de la Susiane* (Paris, 1913), p. 175, no. 403; Amiet, "Nouvelles acquisitions: Antiquités parthes et sassanides," p. 277, figs. 10, 11.

Notes

1. A. Oliver, "Rock Crystal Vessels in Antiquity," *Muse* no. 7 (1973), pp. 29–35.
2. C. J. Lamm, *Mittelalterliche Gläser und Steinschnittarbeiten aus dem Nahen Osten* (Berlin, 1929), I, p. 188; II, pl. 14 (no. 1), pl. 52 (no. 7), pl. 65 (no. 3).
3. M. E. L. Mallowan, *Nimrud and its Remains* (London, 1966), II, p. 631, fig. 591.
4. Amiet, "Nouvelles acquisitions: Antiquités parthes et sassanides," pp. 277–278.
5. A. M. Apakidze et al., *Mtskheta*, I (Tiflis, 1958), p. 92, pl. 74, fig. 43.

BRONZE

Beginning in the late third millennium B.C., bronze was widely used throughout the Near East for a variety of purposes. During the Sasanian period, jewelry, articles of dress, mirrors, vessels, pieces of furniture, weapons, and small sculptures were made of this copper-tin alloy. The elaborate furniture supports in the shape of griffins (Nos. 32, 35) are particularly striking works of art. They may originally have been embellished with gold, but no traces remain. There are, in fact, few gilded bronzes of Sasanian date. This is surprising because bronzes decorated with gilding are common both in the Roman West and in China at periods contemporary with and earlier than the Sasanian era.

In the latter part of the Sasanian period and in the Islamic era, bronze made with a high percentage of tin (at least 20 percent) became increasingly popular.[1] The shapes of bowls and vessels in this golden-hued alloy imitate those of the silverware (compare Nos. 11 and 33A). Apparently, high-tin bronze provided a less costly form of luxury plate for persons who could not afford silver.

Pewter, an alloy of lead and zinc, was another substitute for silver. Common in the West, it was rare in the pre-Islamic Near East. The pewter vessels from Iran (figs. D, E) are similar in shape to sixth and seventh-century

Fig. D. Left. *Pewter high-footed bowl. Sixth-seventh century A.D. H. 5.7 cm. Iran. The Metropolitan Museum of Art; Gift of Martha L. Carter (1977.233).*
Fig. E. Right. *Pewter ewer. Seventh century. H. 21.3 cm. The Metropolitan Museum of Art; Rogers Fund (1972.6.1).*

Sasanian silver plate and it is probable that pewter was only used for tableware during the final decades of the Sasanian era. The existence of vessels in these alloys—high-tin bronze and pewter—undoubtedly reflects the increased prosperity of the lower levels of society by the end of the Sasanian period.

Chinese sources state that brass came from Sasanian Iran.[2] This is not supported by the artifacts that survive from Sasanian times. However, no metal analyses have been made of the specific kinds of minor objects (belt buckles and needles) to which the Chinese refer. There is, nevertheless, nothing comparable to the Islamic production of luxuriously decorated brass vessels, candlesticks, and objects with copper and silver inlays.

The recent discovery of a group of stucco molds at Choche in southern Mesopotamia has contributed significantly to our knowledge of the minor arts in the first half of the Sasanian period.[3] The molds were used for the manufacture of models, probably in terracotta. These, in turn, may have been exported to different metalworking centers, enabling artisans in widely separated areas to produce objects of similar design and quality (see No. 35).

Sasanian bronzes are covered with a patina that varies from green to brown or black. The effect is often pleasing to our eyes. However, there is no evidence that it was intended to be part of the original appearance of the objects and was artificially induced as was often the case on Chinese bronzes. As far as we know, bronzes of the Sasanian period were polished and gleaming. Although not as precious as silver or gold, bronze was a material from which luxury wares as well as common, functional objects were produced.

Notes

1. A. S. Melikian-Chirvani, "The White Bronzes of Early Islamic Iran," *Metropolitan Museum Journal* 9 (1974), pp. 123–152.

2. H. E. Wulff, *The Traditional Crafts of Persia* (Boston, 1966), p. 12; E. H. Schafer, *The Golden Peaches of Samarkand* (Berkeley/Los Angeles, 1973), pp. 256–257.

3. M. Negro Ponzi, "Some Sasanian Moulds," *Mesopotamia* 2 (1967), pp. 57–92.

30
Bronze male figure

Provenance unknown; third century
Height 12.4 cm.
Musée du Louvre, Antiquités Orientales (AO 22134)

It is difficult to determine the identity of this solid-cast bronze male figure. He stands in a fully frontal pose, his left hand grasping a sword and his right arm raised upward. Regrettably, the right hand is missing. The dress of the figure is characteristically Sasanian: long trousers, short tunic, heavy mantle joined at the chest by a clasp, and a sword slung on a scabbard slide. A long moustache curls up across his cheeks and his wavy beard is neatly trimmed. The back of the figurine is simple, with no indication that it was ever elaborately modeled or decorated. Almost certainly the piece was made to be viewed from the front.

In the Sasanian period, few persons except the king were represented standing in this hieratic fashion, fully frontal with a sword centered on the body. The use of the left hand to grasp the sword hilt must indicate that a more important object was once held in the favored right hand or, alternatively, that the gesture of the right hand was particularly significant. On Sasanian monuments a spear (compare No. 71) or a ring denoting investiture to some high office is occasionally depicted in the raised right hand.[1] Equally relevant is the fact that male figures on late Parthian rock reliefs are shown making a gesture with the arm raised above the head in a position similar to that of this bronze.[2]

Strangely, the bronze figurine has no cap or fillet. The absence of any headgear denoting rank is unusual, although a few noble personages on early Sasanian silver vessels (see No. 2) and the small male busts on both sides of the Cleveland horse rhyton (No. 1) also lack the tall cap or simple diadem customarily worn by Sasanian officials, nobles, and princes.

The function of this figurine is as difficult to determine as the identity. A comparable bronze male in Berlin (fig. 30a) must have served as a handle but there is nothing to indicate how the piece in the Louvre was used. It may have been an object complete in itself or it may have formed part of some larger group.

John Rosenfield has compared this small figure to Kushan sculptures of the second century A.D.[3] The simple wavy beard with its broadly curving outline resembles some of the Mesopotamian sculptures from Hatra of approximately the same date. In none of these regions, however, is there a parallel for the facial features and the

Fig. 30a. *Bronze male figure. Ca. third century A.D. H. 11.5 cm. Iran. Museum für Islamische Kunst, Staatliche Museen Preussischer Kulturbesitz, Berlin (West) (I3643).*

overall appearance of the figure. Rather, the pose and dress suggest that this is a rare example of a minor work of art in bronze from the early Sasanian period.

Selected Bibliography

J. David-Weill, "Une Nouvelle salle d'art oriental au Musée du Louvre," *Bulletin des Musées de France* 12 (1947), pp. 7–8; P. Amiet, "Nouvelles acquisitions: Antiquités parthes et sassanides," *La Revue du Louvre* 17 (1967), nos. 4–5, p. 278; J. Rosenfield, *The Dynastic Arts of the Kushans* (Berkeley/Los Angeles, 1967), fig. 133.

Notes

1. R. Ghirshman, *Bîchâpour*, I (Paris, 1971), pls. 14, 15, 19; W. Hinz, *Altiranische Funde und Forschungen* (Berlin, 1969), pls. 78, 101.
2. R. Ghirshman, *Persian Art* (New York, 1962), figs. 65, 68.
3. Rosenfield, *The Dynastic Arts of the Kushans*, p. 178.

31

Helmet

Iran(?); ca. fifth century
Height 24 cm., width 20 cm.
The Metropolitan Museum of Art; Rogers Fund (62.82)

A small number of helmets constructed of iron plates riveted to broad bands of bronze come from Mesopotamia and Iran. One example in the Iraq Museum, Baghdad, was found at Nineveh in northern Mesopotamia.

On this helmet the iron plates are covered with a thin layer of silver, bearing a stamped feather pattern. Within the helmet there was originally a leather lining. A hole at the top must have held a crest or some other decorative or symbolic device. Chain mail hanging from the holes on the lower rim of the helmet obscured and protected the warrior's head, giving him an appearance similar to that of the mail-clad horseman in the *ivan* of Khusrau II (591–628) at Taq-i Bostan (fig. 31a).[1] There too the dome of the helmet, almost hidden behind the beaded diadem and foliated headdress, is composed of separate plates.

Although helmets of this segmented type are depicted on Roman monuments,[2] where they are worn by foreign troops, there are few Sasanian representations of battles and consequently little is known of the equipment worn by Sasanian troops.[3] Helmets do appear in Sasanian rock reliefs of the third and fourth centuries, but they are of a different type.

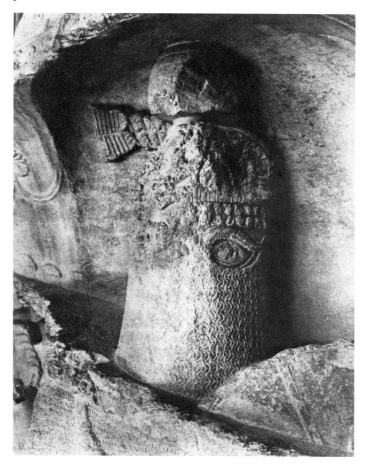

Fig. 31a. *Detail of the mail-clad horseman. Ivan of Khusrau II, Taq-i Bostan, Iran.*

There are slight variations in shape and design among the existing Sasanian segmented helmets: the example found at Nineveh; others, of unknown provenance, in The British Museum; and this one from The Metropolitan Museum. In the absence of a series of securely dated finds, however, the significance of these variations is uncertain and no precise chronology can be established.[4] The resemblance of the stamped feather pattern on the Metropolitan Museum helmet to that on the late Sasanian gold sword (No. 28) does not indicate that the two objects are necessarily contemporary. This form of decoration was widely used on objects of precious metal for a long period in the first millennium A.D.

The application of silver to the surface of the helmet and the excellent state of preservation suggest that it was used only on special occasions. It is probable that this piece, the gold sword (No. 28), and the iron and gold bridle (No. 27) were buried in tombs and, for that reason, have survived almost intact to the present day.

Selected Bibliography

S. V. Grancsay, "A Sasanian Chieftain's Helmet," *The Metropolitan Museum of Art Bulletin* n.s. 21 (1962–63), pp. 253–262 (includes illustrations of the Sasanian helmets in Baghdad and London).

Notes

1. S. Fukai and K. Horiuchi, *Taq-i-Bustan*, II (Tokyo, 1972), pl. 36.
2. S. V. Grancsay, "A Barbarian Chieftain's Helmet," *The Metropolitan Museum of Art Bulletin* n.s. 7 (1948–49), pp. 272–281; J. Werner, "Zur Herkunft der frühmittelalterlichen Spangenhelme," *Praehistorische Zeitschrift* 34–35 (1949–50), pp. 178–193.
3. A. D. H. Bivar, "Cavalry Equipment and Tactics on the Euphrates Frontier," *Dumbarton Oaks Papers* 26 (1972), pp. 273–291.
4. Another type of "Sasanian" helmet is published by K. Böhner, D. Ellmers, and K. Weidemann, *Das frühe Mittelalter* (Mainz, 1972), p. 41.

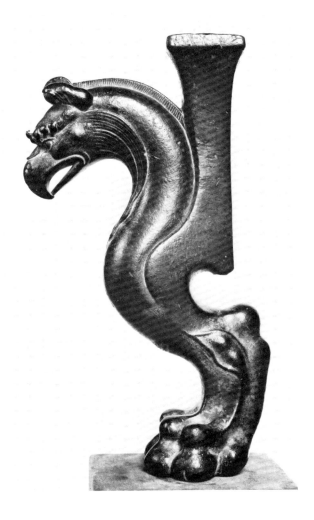

Fig. 32a. Below. *Gold armlet. Fifth century B.C. H. 12.3 cm. Oxus Treasure. The British Museum (WAA 124017).*

32

Bronze furniture leg with the forepart of a griffin

Provenance unknown; fifth to seventh century
Height 32 cm.
Musée du Louvre, Antiquités Orientales (AO 22138)

The diminutive size of this griffin support suggests that it served as the foot for a low piece of furniture. The pose of the griffin, with head down and ears forward, gives an impression of contained power, as if the creature were about to spring. This is particularly apparent when the stance of this griffin in the Louvre is compared with the pose of stationary alertness and watchfulness of the griffin on the furniture leg in The Metropolitan Museum (No. 35). In antiquity the significance of the griffin varied but the creature was, in the Sasanian period, believed to be the protector of men, a concept reflected in the pose of both bronze figures.

The chief similarities between these two furniture supports are the method of construction and the general form—a griffin protome decorating a vertical rectangular element. In detail, the objects vary considerably. The piece from the Louvre has, instead of a ruff projecting beneath the head, chest fur falling in naturalistic, wavy strands against the front of the body, as on late Roman examples.[1] Unlike the Metropolitan Museum piece, no part of the creature is decorated with plant designs. Between the ears, at the end of the crest, is a small curl. This detail has precedents in Near Eastern representations of griffins in the first millennium B.C. (fig. 32a)[2] and the convention persists, east of Iran, on a Central Asian griffin in a fifth- or sixth-century wall painting from Piandjikent (fig. 32b).[3] The stylization of the leg of the Louvre griffin, with prominent veins and accentuated knobs on the paw, is reminiscent of Achaemenid representations, a millennium earlier.

In its pose and overall appearance, the Louvre griffin is closer to Western art than to works of oriental origin.

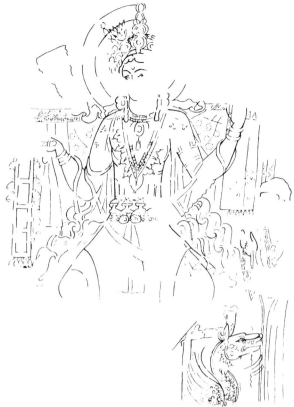

Fig. 32b. *Drawing of a Sogdian wall painting. Fifth–sixth century A.D. Piandjikent, Tadjikistan.*

The naturalism of the form may indicate an early Sasanian date, when captive Western artisans worked in Iran. There was, however, a recurrence of late antique influence in Near Eastern art in the seventh and eighth centuries, following the conquest of the eastern Mediterranean lands by the Arabs. It is possible, therefore, that the griffins in The Metropolitan Museum and the Louvre are not far apart in date. They are, however, products of different traditions, the former reflecting Near Eastern modes, the latter those of the Greco-Roman world.

Selected Bibliography

Amiet, "Nouvelles acquisitions: Antiquités parthes et sassanides," p. 279, fig. 16; *L'Islam dans les collections nationales* (Paris: Grand Palais, 1977), p. 56, no. 24.

Notes

1. T. Kraus, *Das römische Weltreich*, Propyläen Kunstgeschichte II (Berlin, 1967), fig. 159; D. E. Strong, *Greek and Roman Gold and Silver Plate* (London, 1966), pl. 43B.
2. O. M. Dalton, *The Treasure of the Oxus* (London, 1964), no. 116.
3. G. Azarpay, "Iranian Divinities in Sogdian Painting," *Acta Iranica* (1975), pl. 6.

33

Three bronze vessels

Iran(?); sixth or seventh century

A. Oval bowl

Height 5.3 cm., length 23.2 cm.
The Metropolitan Museum of Art; Rogers Fund (49.112.1)

B. Circular bowl

Height 4 cm., diameter 18.6 cm.
The Metropolitan Museum of Art; Rogers Fund (58.101)

C. Vase

Height 13 cm., diameter 9.5 cm.
The Metropolitan Museum of Art; Anonymous gift
(1973.338.10)

These three vessels are distinctive because they are made of an alloy of copper and tin in which the tin makes up 21.9 to 22.1 percent of the composition—an unusually large proportion. The vessels originally had a golden color but are now covered by an even black patina. The long oval bowl is absolutely plain, without any form of decoration on the interior or exterior surface. The circular vessel has a sharp carination on the interior, just below the rim. A single circular line and shallow indentation decorate the center of the inner surface. Most elaborate is the vase with vertical fluting around the neck.

Although large numbers of bronzes with a high tin content now exist in public and private collections, their provenance and the actual circumstances of discovery are usually unknown. However, a few of these bronzes have been discovered in late Parthian or early Sasanian tombs in northwestern Iran and this area is also the alleged source of the vessels that have appeared on the market in recent years.

The shapes of these three bronzes indicate that they belong to the end of the Sasanian or to the early Islamic period. Similar oval and circular bowls, in silver, are decorated with late Sasanian figural and plant motifs (see Nos. 11, 25). Roger Moorey has compared the faceted surface of a high-tin bronze vase of the same type as this example to the wheel-cut patterns on Sasanian glass.[1] This accurate observation does not, however, provide a precise date for the piece, since faceted glasses were popular throughout the Sasanian period.

The simple appearance of these bronzes is misleading. Considerable technical skill was required for the manufacture of vessels in this alloy. The metal can be worked only at high temperatures and all three objects had to be

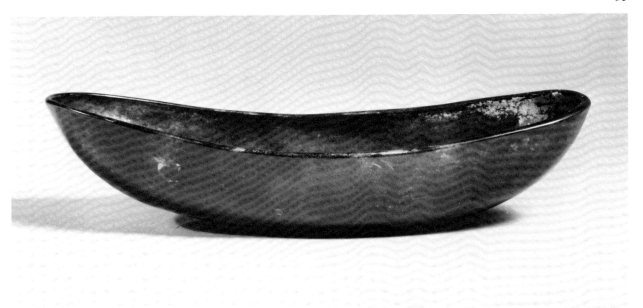

A

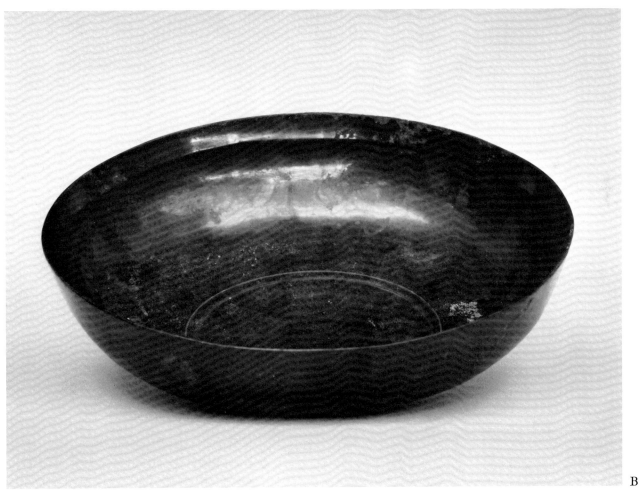

B

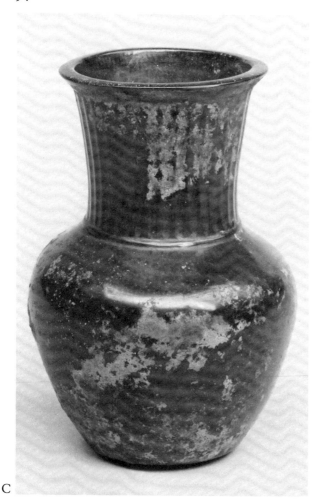

C

hammered into their present form. In their original state these gold-colored vessels were undoubtedly handsome objects produced for those who could not afford the gilded silver plate of the Sasanian court.

Selected Bibliography
Melikian-Chirvani, "The White Bronzes of Early Islamic Iran," pp. 149–151.

Notes

1. P. R. S. Moorey, "Parthian and Sasanian Metalwork in the Bomford Collection," *The Burlington Magazine* 118 (June, 1976), p. 358.

34

Bronze plate with a *senmurw*

Iran(?); ca. seventh century
Height 3 cm., diameter 36.8 cm.
The Metropolitan Museum of Art; Fletcher Fund (60.141)

The creature decorating the center of this shallow bronze plate has been identified as the mythical *senmurw* (*simurgh* of Persian legend and *saêna* of Avestan texts). This fantastic creature is variously described in the ancient literature as a griffin of three natures, a griffin bird, or an eagle.[1] In the religious book of the Zoroastrians, the Avesta, Verethragna, the god of victory, is compared to "that great bird the *saêna*; he is like the big clouds full of water that beat the mountains."[2] The *senmurw* has his resting place upon the "tree of all seeds." When he wanders from this tree, he scatters the dry seed "into the water and it is rained back to the earth with the rain."[3] Obviously the function of the *senmurw*, the largest and foremost of all flying creatures, was a beneficent one and closely tied to the "prosperity of mankind."[4]

From the descriptions quoted above, it is evident that the *senmurw* was thought to have the form of a griffin or eagle rather than that of the hybrid creature appearing on the plate in The Metropolitan Museum of Art: a long-eared head with wrinkled nose ending in a small protuberance, and a body with wings, lion's paws, and a plumed tail. This type of composite being, first convincingly identified by Camilla Trever as a *senmurw*, appears only rarely in Sasanian art.[5] All known Sasanian examples of this *senmurw* are datable to the last century of the era. They occur on the garments of the kings depicted on the back and side walls of the large rock-cut *ivan* of Khusrau II (591–628) at Taq-i Bostan (figs. 34a, b),[6] and on a silver ewer of the seventh century.[7] The monuments suggest that this *senmurw* was, at the end of the Sasanian period, a significant royal motif associated almost exclusively with the monarchy.

A comparison between the late Sasanian *senmurw* on the Metropolitan Museum plate and those represented at Taq-i Bostan, reveals that the images are not identical. The *senmurw* on the plate has the heavy, substantial form of the creature on the back wall of the Taq-i Bostan *ivan*, but the wing feathers curl at the tip toward the tail, not toward the neck. The tail feathers are luxurious, freely curving plumes rather than small patterns enclosed within a rigidly defined curvilinear outline, a tail typical of Sasanian peacocks. On both the reliefs and this bronze plate, the *senmurw* has curling locks of hair on the back of the neck, but there is no ruff beneath the jaw of the *senmurw*

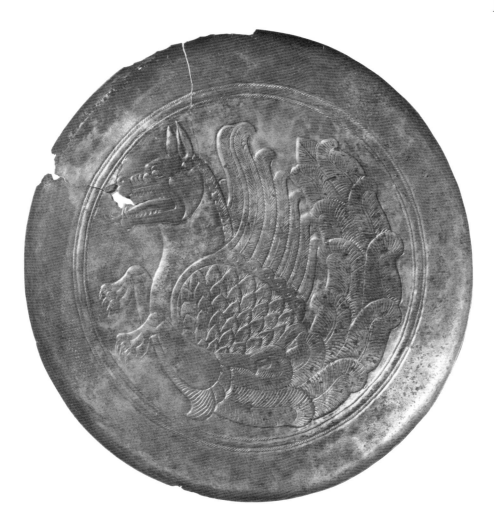

on the Metropolitan Museum vessel. His paws are bent down at the joints, whereas the paws reach out aggressively at Taq-i Bostan.

What do these variations in design suggest? This question is difficult to answer because there are so few representations of the *senmurw* in this late Sasanian form. However, there are elements in the design of the *senmurw* on the bronze plate that suggest an association with works of art made in the lands east of Iran. In Sogdian paintings of the seventh century from Varakhshah and on silver vessels of the eighth century,[8] fantastic beings have wings with freely curving plumes related in form to those of the *senmurw* on the bronze plate. In some Sogdian representations, there is a scalloped edge at the base of the wing feathers, similar to the one shown here.[9] A single animal, enclosed within a twisted rope border, is also a common motif on eighth-century Sogdian silver vessels.[10] Some Hunnish coins of this period (from modern-day Afghanistan) have the *senmurw* as a countermark.[11] In spite of the

minute size of the representations, one can observe the long wavy feathers—their tips turned backward toward the tail—and the undulating plumes of the tail itself. The tongue of the *senmurw* in these images is in the form of a serpent, while on the Metropolitan Museum plate the reptilian character is indicated only by a forked tip.

In contrast to the *senmurw* on the bronze plate, those represented on the Sasanian rock reliefs at Taq-i Bostan and on the late or possibly post-Sasanian silver ewer lack the undulating plumes of the tail and wing feathers characteristic of the works of art described above from lands east of Iran. The *senmurw* of the Sasanian stone reliefs and the silver vessel is the type imitated in the West, on Syrian stuccos, wall paintings, and on the rock-carved panels at Mschatta,[12] as well as on Byzantine textiles. It is also the form that persists, for a time, in post-Sasanian Iran (see No. 50).

The alleged source of the Metropolitan Museum bronze vessel is Iran. The material is a high-tin bronze

alloy, which was used for many vessels of late Sasanian and early Islamic date (see No. 33). The presence of Central Asian influences in the design of the bronze vessel indicates that it may date from the sixth or seventh century when Persian expansion into Central Asia brought closer contacts with the art and culture of Sogd. Alternatively, the date of the plate could be as late as the eighth century, following the Arab conquest of Sogd. Only in the final decades of the Sasanian era and in Islamic times did Sasanian royal motifs begin to appear on relatively simple objects made for persons who were probably not members of the highest classes of society.

The source of this fantastic creature, the late Sasanian *senmurw*, remains obscure, but clearly its significance as an attribute of royalty was widely understood. It is remembered in at least one version of the great Iranian Book of Kings, the *Shah-nameh*. There, a creature with wings like a *simurgh* and having a tail of a peacock is described as the "royal fortune" following the future founder of the Sasanian dynasty, Ardeshir, in his flight from the Parthian monarch, Ardavan.[13]

Selected Bibliography

P. O. Harper, "The Senmurv," *The Metropolitan Museum of Art Bulletin* n.s. 20 (1961–62), pp. 97ff.

Notes

1. *The Zend-Avesta*, trans. J. Darmesteter, pt. 2 (Oxford, 1883), p. 173; see notes 2 and 3 below.
2. Ibid., p. 242.
3. *Pahlevi Texts*, trans. E. W. West (Oxford, 1880), I, p. 176 (*Zad-sparam* VIII, 4).
4. C. J. Brunner, in M. Noveck, *The Mark of Ancient Man* (Brooklyn: The Brooklyn Museum, 1975), p. 81; C. J. Brunner, *Catalogue of Sasanian Stamp Seals in The Metropolitan Museum of Art* (New York: The Metropolitan Museum of Art, forthcoming).
5. C. Trever, *The Dog-Bird, Senmurv-Paskudj* (Leningrad, 1938); C. Trever, "Tête de senmurv en argent des collections de l'Ermitage," *Iranica Antiqua* 4 (1964), pp. 165–166; K. Riboud, "A Newly Excavated Caftan from the Northern Caucasus," *Textile Museum Journal* 4, no. 3 (1976), pp. 21–42.
6. Fukai and Horiuchi, *Taq-i-Bustan*, I, pl. 50; II, pl. 46.
7. J. Orbeli and C. Trever, *Orfèvrerie sasanide* (Moscow/Leningrad, 1935), pls. 25, 26, 49.
8. F. Sarre, *Die Kunst des alten Persien* (Berlin, 1922), figs. 120–121.
9. A. Belenitsky, *Central Asia* (Geneva, 1968), pls. 135, 140.
10. See note 7 above.
11. R. Göbl, *Dokumente zur Geschichte der iranischen Hunnen*, I (Wiesbaden, 1967), Em. 216, p. 148; Em. 245, p. 168.
12. D. Schlumberger, "Les Fouilles de Qasr el-Heir el Gharbi (1936–38)," *Syria* 20 (1939), p. 355; N. Thierry, "Mentalité et formulation iconoclastes en Anatolie," *Journal des Savants* (April–June, 1976), pp. 115ff.

13. *Le Livre des rois V*, par Abou'l Kasim Firdousi, trans. J. Mohl (Paris, 1877), p. 233; *The Epic of the Kings, Shāh-nāma*, trans. R. Levy (London, 1967), pp. 260–261. This reference to the *senmurw* as the "royal fortune" was apparently not in the original version of the *Shah-nameh* since it does not appear in E. E. Bertel's edition, *Firdousi Shah-Nameh: Kriticheskiy Text* (Moscow: Akademia Nauk, 1960–71), VII, p. 127, chap. 8. I am grateful to M. Shreve Simpson for providing this information at the request of Marie L. Swietochowski on my behalf.

Fig. 34a. *Detail of a royal garment. Back wall of the* ivan *of Khusrau II. Taq-i Bostan, Iran.*

Fig. 34b. *Detail of the king's garment. Side wall of the ivan of Khusrau II. Taq-i Bostan, Iran.*

35

Bronze furniture leg with the forepart of a griffin

Allegedly from western Iran; seventh to eighth century
Height 57 cm., width (beak to back of strut) 18.7 cm.
The Metropolitan Museum of Art; Joseph Pulitzer Bequest
(1971.143)

In Sasanian Iran the majestic griffin was a beneficent creature associated with royalty. It is represented here without wings. The head and chest surmount an over-sized lion's paw. Descriptions of this piece often note the solidity of form and vitality of expression. Less attention has been paid to the delicate plant motifs on the head, breast, and leonine paw (fig. 35a). In its original state, this floral decoration, particularly the chased design on the head, must have caught the viewer's eye and softened the rather formidable aspect of the creature.

This bronze leg is cast over a ceramic core. The semiquantitative elemental analysis made by Pieter Meyers indicates that this is a leaded bronze (in addition to the copper, approximately five percent tin and fifteen percent lead). A heavy strut, square in section, rises from behind the griffin's neck. The strut supported the original piece of furniture and still contains the remains of two iron rods. The leg was formerly in the David-Weill collection and is allegedly one of a pair.

The use of animals, birds, and fantastic hybrids to support royal or divine thrones is an ancient tradition in the Orient. The Sasanian examples of throne legs include lion's legs, winged horse protomes, griffins, and possibly eagles.[1] The throne resting on lion's legs is the earliest Sasanian type. It is represented on coins, combined with the fire altar (fig. 35b),[2] and appears on a relief of Bahram II (276–293) at Naqsh-i Bahram in southern Iran.[3] This leonine throne leg is derived from earlier, Achaemenid supports in the shape of a lion's leg and paw which rest on a base consisting of cushion-shaped moldings and palmette leaves.

Stucco molds with impressions of griffins' heads and lions' paws have been excavated at Choche in southern Mesopotamia.[4] They provide the only evidence for the use of griffins as furniture legs in the early Sasanian period. No Sasanian representation of a throne that rests on griffin legs has survived. However, a silver plate in The British Museum, probably made somewhere in present-day Afghanistan, shows a royal bench supported by complete figures of griffins.[5] The style of this plate and the dress of the people on it reflect Sasanian influence while the small griffins are similar to those carved on Sasanian

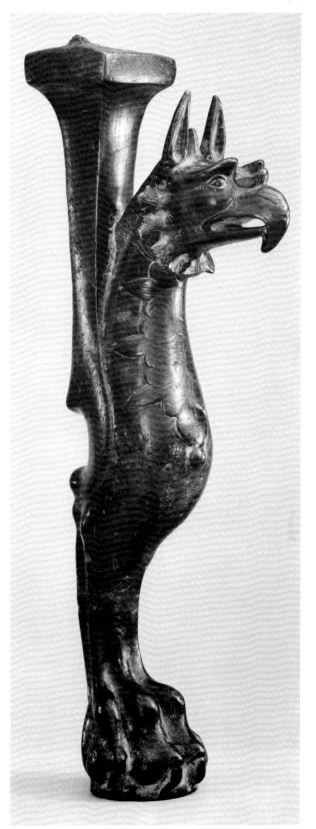

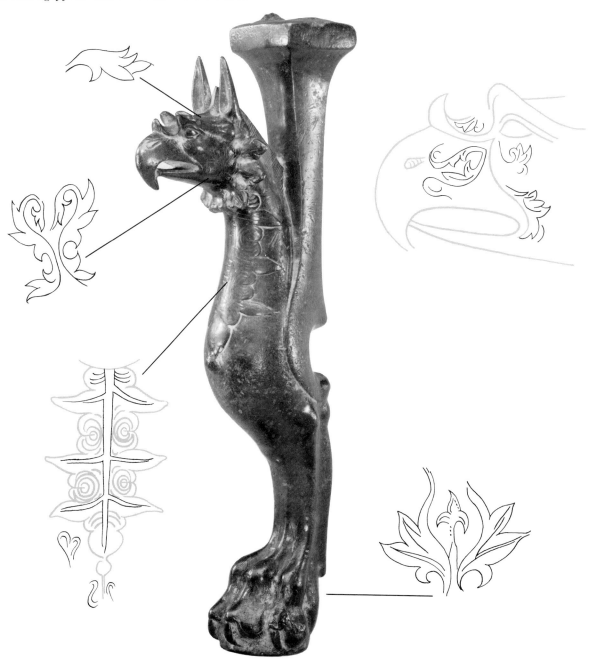

Fig. 35a. *Drawing of floral details on No. 35. Marcel G. Berard.*

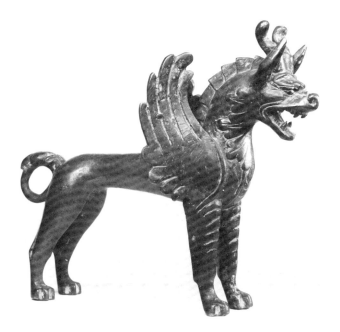

Fig. 35b. *Reverse of a Sasanian coin with a fire altar. The American Numismatic Society.*

Fig. 35c. *Bronze horned lion-griffin support. Seventh-eighth century A.D. H. 24.9 cm. Allegedly from the Helmund River region. The British Museum (WAA 123267).*

seal stones. It is probable, therefore, that this eastern throne is modeled on an unknown Sasanian prototype.

Closest in appearance to the Metropolitan Museum griffin is a pair of griffin supports, one of which is in the Hermitage Museum in Leningrad, the other in the Nizami Museum in Baku.[6] The resemblances between this pair and the griffin-decorated leg from The Metropolitan Museum are sufficiently striking to suggest that models for the various parts (produced from molds such as those found at Choche) existed in the workshops where these objects were produced. The Baku and Hermitage examples are rather squat, however, compared to the Metropolitan Museum piece, and the treatment of the foliated pattern on the chest of the latter is not identical to that on the Russian examples. These variations in design indicate that the supports were probably made in two different workshops.

Other parallels for decorative details on the Metropolitan Museum leg can be found in a painting of the late fifth or sixth century discovered in one of the buildings at Piandjikent in Soviet Tadjikistan, an area that lay on the boundaries of Sasanian Iran.[7] In this painting (fig. 32b), a divine figure sits upright on a throne supported by a creature with a griffin-like head. This fantastic animal has a snout (compare the *senmurw* on No. 34), rather than a bird's beak, and a pair of wings, but the decorative foliation of the body is essentially the same as that on the Metropolitan Museum griffin. The ruff under the chin and the fur on the chest are formed by leaf patterns, and a simple rosette is placed on the side of the head. The

goddess seated on the Piandjikent throne wears a long necklace with leaf-shaped pendants, resembling those on the chest of the creature supporting her and on the Metropolitan Museum griffin. Each leaf element on the necklace terminates in a tiny circle, perhaps a pearl. This may explain the presence of a small knob at the base of the foliated chest fur on the Metropolitan Museum griffin. The pattern on the chest may, therefore, be interpreted as a jeweled necklet—a royal and divine attribute.

The decoration of the body of an animal with plant designs is not common in the Sasanian period. It is, however, a characteristic feature of Umayyad art. On the Metropolitan Museum, Baku, and Hermitage griffins and on a fantastic animal support in The British Museum (fig. 35c),[8] the leaf patterns blend with the creature's appearance only on the chest, where they replace the fur. A subtle modeling of this surface in concentric, curving lines is apparent on the Metropolitan Museum griffin and is related to the patternization of leaves on some late Sasanian silver vessels (see No. 18).

The Piandjikent painting described above provides an illustration of foliation ornamenting an animal form in Sogdian art as early as the sixth century. A taste for this type of decoration could have developed in Iran, therefore, during the last century of the Sasanian period, when contacts with Sogd increased substantially. However, it is only on objects dating to the Islamic era that plant motifs are commonly found embellishing the surface of animal bodies.

The convoluted leaf pattern on the side of this bronze

griffin's head is more elaborate than the simple rosette in the Piandjikent painting. Similar highly stylized plants, turning back on themselves in S-shaped curves to form new leaves, cover a ewer from Daghestan (Caucasus) datable to the seventh or early eighth century.[9] This pattern also decorates Syrian stone capitals of the mid-eighth century[10] and Central Asian stucco from Varakhshah of approximately the same date.[11] As a floral design, however, it has a long history—there are second- or third-century examples in Gandharan art and others of the fifth century in northern China.[12] The motif does not provide a precise date for the Metropolitan Museum support.

It is difficult to locate with certainty the area in which this griffin support was produced. The parallels for the form and decoration, cited above, range from Central Asia to southern Mesopotamia, Syria, and the Caucasus. The two comparable examples come from Soviet Azerbaijan. The Metropolitan Museum griffin is allegedly from western Iran and there is certainly no reason why this should not be the correct provenance.

Although the griffin leg probably belongs to the early Islamic period, it retains a Sasanian identity. Arab princes continue to decorate their couches with animal figures, but the lion, an ancient symbol of majesty, becomes the exclusive attribute, and the griffin ceases to be the guardian of royal thrones.

Selected Bibliography
Royal Academy of Arts, *Persian Art* (London: Burlington House, 1931), p. 8, no. 11; J. Orbeli, "Sāsānian and Early Islamic Metalwork," in *A Survey of Persian Art*, ed. A. U. Pope (London/New York, 1938), I, p. 719; IV, pls. 240 B, C. It is possible that both illustrations show the same, rather than two different pieces. Ghirshman, *Persian Art*, p. 214, fig. 255; *D. David-Weill Collection*, Sale Catalogue (Paris: Hôtel Drouot, June 16, 1971), Lot 49; R. Ettinghausen, "Outstanding Recent Accessions," *The Metropolitan Museum of Art Bulletin* n.s. 30 (1971–72), p. 94.

Notes
1. H. von Gall, "Entwicklung und Gestalt des Thrones im vorislamischen Iran," *Archaeologische Mitteilungen aus Iran* N.F. 4 (1971), pp. 207–236; A. S. Melikian-Chirvani, "Studies in Iranian Metalwork V: A Sasanian Eagle in the Round," *Journal of the Royal Asiatic Society* (1969), pp. 2–9.
2. R. Göbl, *Sasanian Numismatics* (Braunschweig, 1971), pl. 1.
3. Hinz, *Altiranische Funde und Forschungen*, pl. 128.
4. Negro Ponzi, "Some Sasanian Moulds," pp. 67–73, figs. 105–108.
5. Dalton, *The Treasure of the Oxus*, pl. 38.
6. L. S. Bretanitskiy and B. V. Veimarn, *Iskusstvo Azerbaidzhana, IV–XVIII vv. n.e.* (Moscow: Iskusstvo, 1976), p. 40 (Nizami Museum throne leg).
7. A. Belenitskiy and B. Marshak, "Stennye rospisi, obnaruzhennye v 1970 godu na gorodishche drevnego Pendzhikenta," *Soobshcheniya Gosudarstvennogo Ermitazha* 36 (1973), p. 59; G. Azarpay, "Iranian Divinities in Sogdian Painting," *Acta Iranica* (1975), pl. 6.
8. Dalton, *The Treasure of the Oxus*, pl. 25.
9. Orbeli and Trever, *Orfèvrerie sasanide*, pl. 71 (Daghestan ewer, plant motif as on lion paw); pl. 73 (Daghestan ewer, plant motif as on griffin head).
10. M. Dimand, "Studies in Islamic Ornament," *Ars Islamica* 4 (1937), p. 30, figs. 15, 16.
11. V. A. Shishkin, "Arkhitekturnaya Dekoratsiya Dvortsa v Varakhshe," *Trudy Otdela Vostoka* 4 (1947), p. 243.
12. H. Ingholt, *Gandhāran Art in Pakistan* (New York, 1957), fig. 376; S. Bush, "Floral Motifs and Vine Scrolls in Chinese Art of the late Fifth and Early Sixth Centuries A.D.," *Artibus Asiae* 38 (1976), pp. 49–83.

STUCCO

Although the Sasanian Empire lasted roughly four hundred years, little is known about architecture and its decoration during this phase of Near Eastern history. Only a few sites have been excavated, most of them by chance and not in a scientifically controlled manner. Thus the provenance of a considerable body of surviving material is unknown.

In Mesopotamia only two Sasanian sites have been studied seriously. At Kish, a few miles to the east of Babylon, a number of important buildings, presumably palaces of local noblemen, as well as some less imposing houses were excavated. All seem to have belonged to a city of unknown dimensions. The second site of importance is the Sasanian capital, Ctesiphon, where archaeologists have uncovered parts of the famous royal palace and several houses in its vicinity. Little evidence is available from Iran. In the homeland of the Sasanian dynasty major investigations have been confined to the royal palace at Bishapur and, in the northern part of the country, the famous religious center of Takht-i Sulaiman, the regional seat of a nobleman in Damghan, and three similar seats in the vicinity of the town of Rayy, near modern Tehran. In most cases these excavations were carried out in the 1930's, with assistance from American scholars.

The use of stucco (gypsum plaster) as a form of architectural decoration in Sasanian times was a heritage from the preceding Parthian period. It is reasonable to believe that this technique was introduced to the Parthians through contact with the Greco-Roman world. The popularity of stucco was mainly due to the fact that the traditional building materials used in the Sasanian Empire, namely bricks in Mesopotamia and rubble masonry in Iran, both had to be masked by some form of coating. Stucco provided a particularly versatile solution to this problem.

It has often been argued that stucco was used widely from Parthian times onwards because it was less costly than other forms of decoration. It is doubtful that this is true, because stucco required skilled craftsmen. Not only were they responsible for applying the material, but they also had to design the patterns and give the finished surface a coat of color. Thus it is probable that a whole group of workmen was necessary. The best argument for the use of stucco probably lies simply in the fact that after its introduction no need was seen to use a different material.

It is quite obvious that the remains surviving from excavated sites together with the objects of unknown provenance are not representative of the whole range of architectural decoration in the Sasanian Empire. Nevertheless it is possible to draw some conclusions from the limited evidence available. In the first place, a general division between ornamental and figural themes will be made for convenience, although in one building both were used together.

The principal designs appearing in ornamental stucco include a variety of plants, either alone or in different combinations, and abstract patterns such as interlacing circles or meanders. The designs are repeated in order to

Fig. F. *Drawing of stucco decoration. Ctesiphon, Iraq. Gerhild Kröger-Hachmeister.*

cover large areas, so that the single element becomes secondary. Neither the full extent nor the exact manner in which walls were covered is, however, known with certainty. The number of abstract designs was apparently limited. Plant themes may therefore be considered as particularly characteristic of Sasanian stucco decoration. Good examples are provided by pieces from Kish showing part of a band of palmettes (No. 36), a winding stem with palmette leaves branching off (No. 37), and four pomegranates (No. 40). Evidently the most common plant motifs were palmettes, pomegranates, vine scrolls, pine cones, and blossoms of various types. Frieze plaques from the region of Ctesiphon show, among a variety of designs, palmettes alternating with fan-shaped blossoms (fig. F) and bush-like plants (fig. G). Due to the lack of extensive material, the plant motifs from Kish are of considerable importance for our knowledge of the nature of Sasanian ornamental stucco. Some of the more important motifs from this site have additional symbolic features such as flying ribbons (No. 40) or a pair of wings (No. 39). It is very likely that these were more than mere decorative conventions. Plant motifs were probably not only decorative, but also iconographically meaningful. This is a typical Sasanian feature, since the symbolic use of plant motifs is not evident in the arts of the preceding Parthian or the following Islamic period.

The figural repertory in stucco must have been richer than is hitherto known, but the existence of a large number of different types is already certain. On the whole it may be assumed that most major themes appearing on the seals (Nos. 65–74) were also used in figural stucco decoration. Particularly important were the busts of kings, of which fine examples were found in Kish (No. 41) as well as at other sites. Their meaning is not altogether clear, since they were apparently not intended to be depictions of the reigning monarchs but rather symbols of sacred kingship. Besides representations of kings, those of the goddess Anahita (No. 42) or of beings associated with her seem to have played an important role in the standard repertory. Representations in stucco of the king hunting animals, a theme illustrated on the hunting plates (see Nos. 4, 6, 7), may have been quite common although this has not yet been clearly demonstrated. The small figured plaque with this theme included here (No. 46) belongs not to the Sasanian but to the early Islamic period. It is, however, possible that it follows an unknown Sasanian prototype. Such small figured scenes with a strong narrative interest (Nos. 46–48) could well have been typical of a transitional phase in early Islamic Iran when Sasanian influence was still strong.

In addition to the main group of representations of the king and his goddess, a second large group of stucco fragments shows different types of animals (Nos. 43, 44, 49). In spite of their repetitive use, these motifs did not belong to either purely ornamental or narrative compositions. Instead they were probably symbolic representations, perhaps intended to depict in a visual form certain abstract qualities of a god. This is very clear from one of the Kish finds, namely the plaque with the forepart of a ram framed within outspread wings (No. 43)· In other cases such as the lion plaque (No. 44), the symbolic implications are not as obvious at first sight. The well-known plaque with a boar (fig. H) from the house Umm az-Zaʿatir, two kilometers to the east of the royal

Fig. G. *Drawing of stucco decoration. Ctesiphon, Iraq. Gerhild Kröger-Hachmeister.*

palace at Ctesiphon, suggests that there may have been a hunting scene in this building. However, the excavators had reasons to believe that the boars covered the right half of the vault of an *ivan*, while the left half was adorned with plaques showing bears. Therefore it is reasonable to suppose that the boar in a repetitive scheme such as this represented the god Verethragna. The possibility exists, nevertheless, that both boar and bear were used as abbreviations for a hunt and signified the victorious power of the king. Of considerable importance were birds (No. 49) (some of them again possibly linked to the goddess of fertility) and mythical creatures such as the *senmurw* (No. 50).

A survey of the buildings to which the stucco architectural decoration belongs shows that only the more important ceremonial areas were accentuated by the application of this material. In the larger houses and in the more elaborate seats of noblemen, stucco was applied to the most important rooms—the *ivans* or three-aisled halls. It is reasonable to assume that these were audience halls, since the decoration usually served to stress the might and wealth of the owner, as well as his direct dependence on the monarch and the gods. Because the stucco was painted in a wide range of colors, with red and blue playing an important role, it originally had a very different appearance.

A certain importance may be attached to the techniques of manufacture, since it is possible to distinguish between different methods. While carved stucco was mainly used in Parthian times, one of the important characteristics of stucco from the Sasanian age is the use of pattern blocks to form a mold from which it was possible to make an infinite number of identical plaques (Nos. 36–38, 43, 44). These pattern blocks are usually quite thick, allowing room for lifting slots at the sides. In contrast, most molded plaques are relatively thin so that they may be applied easily to the walls. Only in some houses in the vicinity of Ctesiphon is the presence of identical patterns from the same mold evident. In the early Islamic period the technique of molding was gradually given up in favor of carved work.

The question of dating is a most difficult one due to the lack of inscriptions and the fact that representations of kings with their identifying crowns are not necessarily contemporary with their actual reigns. Technical and, more important, stylistic criteria are therefore the principal means for establishing a chronology. Changes in style are evident if one compares designs which are common to all sites, such as pomegranates or pairs of wings. In my opinion the stucco from Kish (Nos. 36–43) is datable to the fifth century, that from the region of Ctesiphon (figs. F–H) to the sixth century, that from Damghan to the very end of the Sasanian period, and the material from the vicinity of Rayy, to which Chal Tarkhan (Nos. 46–50) belongs, to the second half of the seventh century or possibly the first half of the eighth century. Since changes were not rapid, only a large body of material will allow more precise solutions to questions of dating.

Sasanian architectural decoration in stucco is significant for several reasons. Firstly, nearly all the material

Fig. H. *Drawing of stucco decoration. Ctesiphon, Iraq. Gerhild Kröger-Hachmeister.*

from the different sites is of a high quality, although there is some variation in workmanship. Not enough material has survived to illustrate the existence of local provincial traditions, but it must be assumed that these existed and varied considerably from those of the major urban centers. In general, the workmanship in stucco was not inferior to that of the rock reliefs.

The development of a distinctive Sasanian style is not yet altogether clear, since the largest body of early material, namely the finds from Kish, illustrates a style which is already fully developed. The homogeneity of this style, the result of the merging of different artistic and iconographic traditions, is certainly impressive. After a phase of strong Mediterranean influence, a style developed which reveals an indebtedness to an artistic vocabulary of Greco-Roman origin as well as a dependence on the heritage of the ancient Near Eastern cultures. It is one of the more interesting points to see how the Greco-Roman features slowly recede and the artistic and aesthetic principles of the ancient Near East assert themselves. This process of amalgamation differed in various regions across the empire. The stucco from the area of the capital of Ctesiphon, a region open to Mediterranean influences at all times, shows fewer changes in the Greco-Roman vocabulary than the material from Kish, where there is a stronger connection with what may be called Near Eastern features. This can be seen by comparing the lion plaque (No. 44), possibly from the Kish area, and a boar plaque from Ctesiphon (fig. H). The former shows the stylizations usual in Near Eastern art, and tends to stress the spiritual aspect, while the boar from the area of Ctesiphon is more naturalistic in appearance.

The uniqueness of Sasanian art as illustrated by the architectural decoration lies in the combination of different traditions and the creation of a clearly recognizable artistic style which reveals the strong Near Eastern cultural heritage of the Sasanian age despite the absorption of manifold influences from the Greco-Roman world. A large number of characteristic themes common in architectural decoration may also be found in other media, especially on seals, suggesting that Sasanian art was strongly repetitive in character, employing a limited number of themes. The works of stucco form an impressive and important body of material. Together with the works in other media, they provide a deeper insight into the culture of the Sasanian age, which exercised a strong influence not only on the art of the Islamic period but also on other cultures of the early Middle Ages.

Jens Kröger

36
Stucco pattern block with palmettes

Kish, Palace I; fifth century
Height 13.5 cm., width 21 cm., depth 8 cm.
Field Museum of Natural History (228830)

The pattern on this stucco block combines a five-petaled palmette with two half-palmettes above a raised border. Typically Sasanian are the sharply downward curving lower petals and the design of the full palmette which looks as if it had been formed by two separate halves. The pattern block was used to mold a number of plaques that could then be joined together, forming a continuous band of palmettes. This type of pattern is common in Sasanian art, although usually different motifs alternate with each other. The Sasanian versions are derived from both Western and ancient Near Eastern sources.

Selected Bibliography
J. Baltrusaitis, "Sāsānian Stucco, A. Ornamental," in *A Survey of Persian Art*, ed. A. U. Pope (London, 1938), I, pp. 611ff., fig. 188 A, B; J. Kröger, "Sasanidischer Stuckdekor" (Ph.D dissertation, Freie Universität Berlin, 1977), pp. 474ff., 575ff., 588ff., pl. 177, 2.

37
Stucco pattern block with a winding stem

Kish, Palace I; fifth century
Height 25.5 cm., width 25.5 cm., depth 5.5 cm.
Field Museum of Natural History (228842)

This stucco pattern block is one of the more interesting types. The design consists of a winding stem from which palmette leaves branch off in various directions, four reaching into the corners of the plaque. Judging from ancient Near Eastern practice, and from the tree form decorating the facade of the *ivan* of Khusrau II (591–628) at Taq-i Bostan (fig. 21a), it is reasonable to assume that plaques such as this were arranged vertically to form a continuous tree-like design. It is possible that this design was influenced by comparable plant forms used in the architectural decoration of Palmyra in the Syrian desert.[1] The motif may be related to the ancient Near Eastern concept of the "sacred tree." No real comparison in Sasanian art can be cited, but in addition to the trees at Taq-i Bostan, there are plaques from the region of Ctesiphon and Takht-i Sulaiman with similar vertical trees, probably belonging to this tradition.

Selected Bibliography
Baltrusaitis, "Sāsānian Stucco, A. Ornamental," pp. 612ff., fig. 194 A; Kröger, "Sasanidischer Stuckdekor," pp. 474ff., 588ff., pl. 181, 3.

Notes
1. H. Seyrig, "Antiquités syriennes, Ornamenta Palmyrena antiquiora," *Syria* 21 (1940), pp. 282ff., pls. 31, 32.

38
Stucco roundel with a grape leaf

Kish, Palace I; fifth century
Diameter 14 cm., depth 3 cm.
Field Museum of Natural History (228828)

The design of this little roundel consists of a single grape leaf of a very characteristic type with upturned, pointed lobes. The veins cover the lobes except for the tips in a rather schematic way. This pattern block for molding single leaves may have been used to create simple rows of grape leaves or for some other unknown composition. Comparable small roundels are not known from other sites, so that the exact use of this block must remain open to speculation. The type of leaf is typical of the stuccoes from Kish and differs, in the form of the lobes, from those of other places. Only a few examples of this motif are known in architectural decoration, but it appears that Sasanian grape leaves became stylized more slowly than other motifs. Characteristic of pieces later than those from Kish are leaves with sharply downward curving lower lobes and upward curving upper lobes. These appear in the *ivan* of Khusrau II (591–628) at Taq-i Bostan and on the stuccoes from the vicinity of Rayy.[1] These late stylized grape leaves approach the form which is usual for palmettes. It is generally true in the Sasanian period and is evident at Taq-i Bostan that there is a trend away from the naturalistic Greco-Roman type of vine scroll toward a stylization in pattern and detail.

Selected Bibliography
Baltrusaitis, "Sāsānian Stucco, A. Ornamental," pp. 606ff., fig. 185; Kröger, "Sasanidischer Stuckdekor," pp. 599ff., pl. 182, 3.

Notes
1. D. Thompson, *Stucco from Chal Tarkhan-Eshqabad near Rayy* (Warminster, 1976), pp. 58ff.

39
Stucco plaque with a trefoil framed by a pair of wings

Kish, Palace I; fifth century
Height 15.5 cm., width 26 cm., depth 4 cm.
Field Museum of Natural History (228870)

On this frieze plaque a pair of wings surround a trefoil. A plain band runs along the lower edge of the plaque. Wings and trefoil are tied together by a pair of flying ribbons that spread out symmetrically to each side, giving the theme an additional emphasis. The absence of a border at the upper edge suggests that this molded plaque was used in a frieze of some sort. Usually archivolt or crowning friezes, standing out from the wall at varying angles, were treated in this way.

The design is one of special significance since this is the clearest instance in which a plant is surrounded by the sacred motif of a pair of wings.[1] In some contexts wings may symbolize the god Verethragna, or the goddess Anahita, but they may also have been understood simply as a general sacred symbol. It is probable that the motif on this plaque, which is typically Sasanian, played a specific symbolic role in the decoration of the building.

Selected Bibliography
Baltrusaitis, "Sāsānian Stucco, A. Ornamental," pp. 608ff., fig. 187 A; Kröger, "Sasanidischer Stuckdekor," pp. 575ff., pp. 605ff., pl. 177, 5.

Notes
1. A. Roes, "The Trefoil as Sacred Emblem," *Artibus Asiae* 17 (1954), pp. 61–68; Thompson, *Stucco from Chal Tarkhan-Eshqabad*, pp. 26ff.; Kröger, "Sasanidischer Stuckdekor," pp. 300ff., pp. 516ff.

40

Stucco plaque with pomegranates

Kish, Palace I; fifth century
Height 20.5 cm., width 29.5 cm., depth 6 cm.
Field Museum of Natural History (228832)

This rectangular plaque has a pattern created by the repetitive use of a single motif: a pomegranate of rather flat shape wholly surrounded by a split palmette that is tied together at the base by symmetrically arranged flying ribbons. This motif is repeated four times on the plaque, and a pair of pierced pearls divides the composition into two vertical units. Although the pomegranate motif is found in a number of variations at nearly all Sasanian sites including Kish, this is the only known example of pomegranates tied together by ribbons. Pomegranates are among the more widely used decorative elements in ancient Near Eastern art, but the motif combining the pomegranate fruit and the split palmettes seems to have been created in the Sasanian era. Toward the end of the Sasanian period the split palmettes resemble pairs of wings. In the early Islamic period pomegranates were integrated into overall patterns of types unknown in Sasanian times.[1] Plaques such as this one may have been arranged in a manner stressing the simple repetitive character of the decoration. As is the case with the trefoil (No. 39), the pomegranate was widely used because of its significance as a sacred emblem of the goddess of fertility.

Selected Bibliography

Baltrusaitis, "Sāsānian Stucco, A. Ornamental," fig. 186 B; Kröger, "Sasanidischer Stuckdekor," pp. 595ff., p. 626, pl. 181, 2.

Notes

1. Thompson, *Stucco from Chal Tarkhan-Eshqabad*, pp. 75ff., pl. XIX, 3.

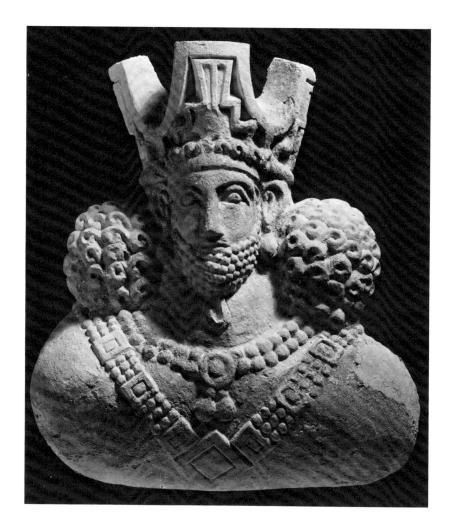

41

Stucco bust of a king

Kish, Palace II; fifth century
Height 51.5 cm.
Field Museum of Natural History (236400a)

This is one of several seemingly identical busts of a king found in Palace II at Kish. The bearded king is shown frontally, his small head symmetrically framed by two large clusters of curls that rest on his broad shoulders. He wears a crown of Sasanian type, earrings with large pearls, a pearl necklace, and two bands with pearls and jewels which meet on the lower bust and are part of the royal form of dress. The crown is composed of a simple band with curls, above which there are stepped crenellations. Between the one complete and the two half crenellations, parts of large crescents remain. Although this crown was once thought to be that of Shapur II (309–379), it resembles, but is not identical to the crown worn by Bahram V

(420–438) (fig. 12b). Unfortunately this does not mean that the busts and the decoration of Palace II are necessarily to be dated to the reign of this monarch. The crown type only suggests a date *post quem* for the sculptures— sometime in the fifth century. Stylistically it is possible that the piece belongs in the fifth century. Busts such as these, which adorned the courtyard of the building, should not be seen as portraits of individual kings. They are primarily manifestations of the Sasanian concept of sacred kingship.

Selected Bibliography

L. C. Watelin, "Sāsānian Architecture, C. The Sāsānian Buildings near Kish," in *A Survey of Persian Art*, I, pp. 587ff., fig. 172; A.U. Pope, "Sāsānian Stucco, B. Figural," in *A Survey of Persian Art*, I, p. 634, fig. 211; A. U. Pope, *Masterpieces of Persian Art* (New York, 1945), p. 67, pl. 35; Kröger, "Sasanidischer Stuckdekor," pp. 474ff., fig. 117, pl. 187.

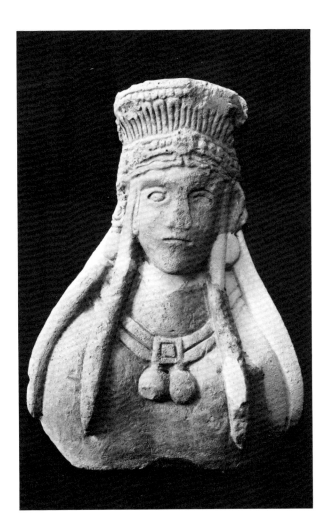

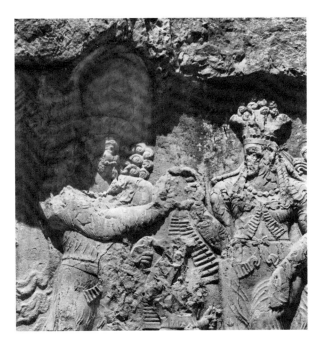

Fig. 42a. *Detail of rock relief of Narseh. Naqsh-i Rustam, Iran.*

42

Stucco bust of a woman

Kish, Palace I; fifth century
Height 28.5 cm.
Field Museum of Natural History (236322)

The bust shows a frontally presented female with a relatively small face, staring eyes, and a small mouth. Her head is topped by a large crown from under which four thick braids fall over her shoulders, covering her breasts. She wears large earrings and a necklace with two heavy pendants. The crown consists of borders of pearls framing a concave band of loop forms. This crown is the most important feature of this piece since it is the only part which suggests an identification. The row of loops may be interpreted as a stylized garland of leaves, a feature common to a number of crown types in Asia Minor associated with the cult of Cybele and Artemis.[1] Similar headgear appears in Achaemenid Persepolis and the Sasanian king Narseh (293–302) wears such a crown on his rock relief at Naqsh-i Rustam (fig. 42a). The goddess Anahita represented in the rock relief at Taq-i Bostan is shown with a row of palmettes on her crown. The interpretation of the characteristic crown leaves little doubt that this bust represents Anahita, not only in her function as goddess of abundance but also as the kings' goddess.

Selected Bibliography

Illustrated London News (March 7, 1931), p. 369, fig. 5; Kröger, "Sasanidischer Stuckdekor," pp. 174ff., pl. 183, 3.

Notes

1. H. von Gall, "Persische und Medische Stämme," *Archaeologische Mitteilungen aus Iran* N.F. 5 (1972), pp. 261–283.

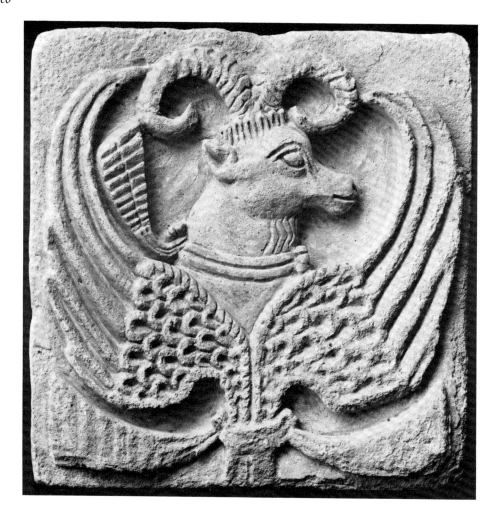

43

Stucco pattern block with the forepart of a ram above wings

Kish, Palace I; fifth century
Height 33 cm., width 33 cm., depth 13.5 cm.
Field Museum of Natural History (228840)

This pattern block shows the right profile of a ram's head above a pair of wings. The ram's strongly curved horns are presented frontally, a convention inherited from ancient Near Eastern art, and he wears a collar from which small transversely ridged ribbons fly upward. Although all the characteristic features of the animal are rendered, there is little modeling in the relief. The ram's head is almost completely surrounded by a large pair of wings tied together by flying ribbons.

The ram is one of the animals frequently depicted in Sasanian art, for example on seals and textiles. Rams in high relief were also common in stucco architectural dec-

oration.[1] A composition similar to the one in this plaque occurs in mosaics from Antioch, the result of Sasanian influence.[2] The ram was considered to be a manifestation of the god Verethragna and was also a symbol of the *xwarrah*, the "royal glory," to which the collar with ribbons on this example may allude.

Selected Bibliography

Pope, "Sāsānian Stucco, B. Figural," pp. 637ff., fig. 214; The University of Michigan Museum of Art, *Sasanian Silver* (Ann Arbor, 1967), no. 70; Kröger, "Sasanidischer Stuckdekor," pp. 474ff., 605ff., pl. 185.

Notes

1. Thompson, *Stucco from Chal Tarkhan-Eshqabad*, p. 23, pl. V, 6 and pl. VII, 1.
2. D. Levi, *Antioch Mosaic Pavements* (Princeton, 1947), II, pl. 134.

44

Stucco pattern block with a lion

Mesopotamia; fifth century
Height 24 cm., width 32.1 cm.
Musée du Louvre, Antiquités Orientales (AO 26172)

The lion shown in profile on this pattern block appears poised to spring at his prey. All his characteristic features are strongly stylized. Notice, for example, the related semicircular forms of his mane and tail. This sort of stylization, which brings out the ferocity of the beast rather impressively, is distinctly Near Eastern and has antecedents in the glazed brick panels of Achaemenid Susa.

Since the original context of this plaque is unknown, many questions must remain open. Possibly the animal shown here was derived from a scene, not unusual in Near Eastern and Sasanian art, illustrating the lion and his prey. This is suggested by the pose of the lion. The lion could have symbolized the sun, as he did in certain other con-

texts in Iranian art, or he may have had yet another meaning which explains the inclusion of this design in the decoration of some unknown building belonging to a Mesopotamian dignitary.

Selected Bibliography
Pope, "Sāsānian Stucco, B. Figural," p. 643, fig. 215; Kröger, "Sasanidischer Stuckdekor," p. 520, pl. 220, 2 b.

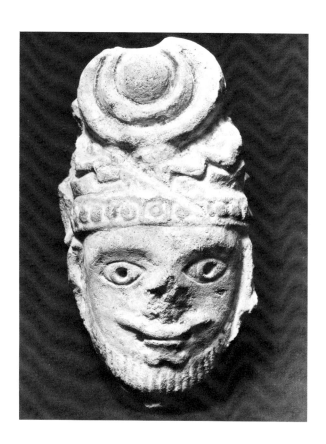

45

Stucco head of a king

Provenance unknown; seventh century
Height 11 cm.
The Art Institute of Chicago; Logan-Patten-Ryerson
 Collection (1927.442)

This small, rather roughly modeled head represents a bearded man wearing an imposing crown. The deeply pierced eyes hold the viewer's attention so completely that one is almost unaware of the damaged nose. Drill holes also accentuate the corners of the small mouth below a sweeping moustache. The prominent mural crown has a band of pearls around the forehead and above this band two symmetrically arranged halves of stepped crenellations. Between them is a large crescent surrounding a rather small globe.

Of unknown provenance, this head was once thought to represent the Sasanian king Kavad I (488–497; 499–531), who is depicted with a similar crown. There are, however, stylistic reasons for dating the piece somewhat later (compare No. 41). It is very probable that this is a fragment of a small figured plaque similar to the one from Chal Tarkhan which shows a boar hunt (No. 46). Such stucco plaques depicting the reigning monarch are still unknown from the Sasanian period. Judging from compositions in other media, it is probable that the crown represented here belongs to a standard type simply designating the figure as a Sasanian ruler, without indicating a specific king.

Selected Bibliography
N. C. Debevoise, "A Portrait of Kobad I (488–531)," *Bulletin of the Art Institute of Chicago* 24 (1930), p. 10; K. Erdmann, *Die Kunst Irans zur Zeit der Sasaniden* (Berlin, 1943), pp. 79, 82, pl. 37; Kröger, "Sasanidischer Stuckdekor," pp. 57ff., 518ff., pl. 220, 1.

46
Stucco plaque with a boar hunt

Chal Tarkhan-Eshqabad, Main Palace; second half of the
seventh century or first half of the eighth century
Height 35 cm., width 34 cm.
Museum of Fine Arts, Boston (39.488)

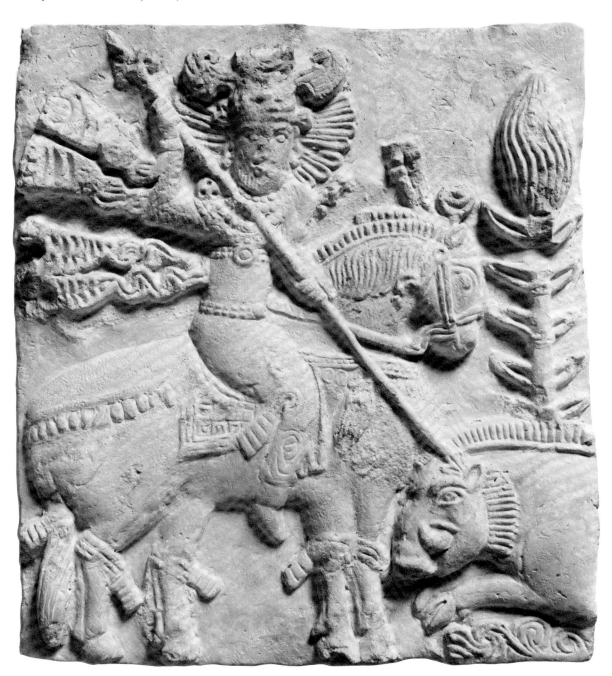

This small-figured relief plaque shows a king on horseback spearing a boar. He is characterized by a large but unfortunately badly damaged crown, a nimbus, and two different types of fluttering ribbons. Numerous ribbons as well as a crescent and globe attached to his bridle indicate that the rather sturdy horse is a royal mount. The king thrusts his spear into a boar which rushes toward him. The landscape setting for the hunt is indicated by spiral designs below the boar, representing water, and a large reed placed directly in front of the horse. It is unusual that the boar is only partially shown, but this reconstruction of the plaque has been suggested by the fragments. As plaques of this type were molded in large numbers, they must have been used in some sort of repetitive composition that decorated the large audience hall of this small palace.

The king wears a crown in which a crescent and globe are placed between a symmetrically arranged pair of wings. At one time this type of crown was believed to indicate that the king was Peroz (459–484). It is evident, however, from stylistic aspects of the plaque and other finds from this palace, that this was probably intended to symbolize the concept of the sacred Sasanian kingship, not to represent a specific king. Awareness of this concept did not disappear with the advent of Islam. In addition to the crown, the sacredness of Sasanian royalty is indicated by the nimbus of stylized flames which surrounds the king's head, symbolizing his power as sun-king. The killing of an animal also belongs to the standard formulas for illustrating sacred kingship in the ancient Near East.

Selected Bibliography
Pope, "Sāsānian Stucco, B. Figural," pp. 632ff., pl. 176 C; Thompson, *Stucco from Chal Tarkhan-Eshqabad*, pp. 9ff., p. 114; Kröger, "Sasanidischer Stuckdekor," pp. 441ff., 502ff., pl. 208, 1–2.

47

Stucco plaque with Bahram Gur and Azada

Chal Tarkhan-Eshqabad, Main Palace, Hall; second half of the seventh century or first half of the eighth century
Height 35 cm., width 50 cm.
Museum of Fine Arts, Boston (39.485)

A hunt of a different nature is represented on this plaque. The reassembled fragments show two persons riding on a camel toward a group of three gazelles in different poses. Undoubtedly the scene illustrates the legend of the Sasanian king Bahram V (Gur) (420–438) hunting from a camel while his favorite, Azada, rides behind him playing a lute. As many illustrations show, this was a widely known legend in Islamic times and different versions of the scene are known. According to the legend, at Azada's request the king shot one gazelle in a peculiar way, pinning its near hind leg to its right ear.

This is the only rendering of the theme known in architectural decoration. As Deborah Thompson was able to show, the plaque has none of the details of true Sasanian style evident on the royal boar hunt plaque (No. 46) from the same site. This may indicate a formulation of the theme at the very end of the Sasanian era, if not possibly somewhat later. The theme is also represented on a seal and on silver objects (see No. 12) but the form of the designs in these different media varies. Apparently more than one rendering of the theme was employed.

This plaque provides an important contribution to the understanding of ideas prevalent in the period immediately following the downfall of the Sasanian dynasty. It illustrates the "heroic" qualities of the god-king, and shows the lasting veneration of the Sasanian rulers.

Selected Bibliography
Thompson, *Stucco from Chal Tarkhan-Eshqabad*, pp. 18ff., pl. II, 3.

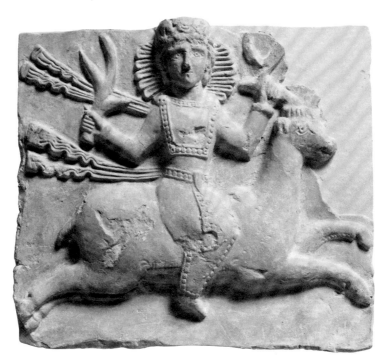

48

Stucco plaque with a rider on a stag

Chal Tarkhan-Eshqabad, Subsidiary Palace; second half of
* the seventh century or first half of the eighth century*
Height 32 cm., width 38 cm.
Museum of Fine Arts, Boston (39.490)

Several fragments of this type of plaque with a person shown riding a stag were found at Chal Tarkhan-Eshqabad.[1] The rider is depicted in a pose typical of the stucco found at this site. He does not wear a royal crown of the usual type, although stepped crenellations and a crescent remain. The hunter has a nimbus around his head and two pairs of identical ribbons streaming out behind him. These details differentiate this piece from the boar hunt plaque (No. 46). The scene shown is quite unusual. The rider grasps one of the stag's antlers in his left hand, while in his right he holds the other antler, which has been broken off. There is no precedent for such a scene in Sasanian art. The stylized form of the representation does not obscure the fact that the stag has been overcome by the rider. Symbolic of this victory are the antlers in the hands of the hero and his pose, astride the animal's back.

A traditional theme in ancient Near Eastern art is the "Master of the Beasts," a hero fighting with wild beasts. In Achaemenid times the hero was usually placed between two symmetrically arranged animals. Such scenes are not known in the art of the Sasanian period. Another theme, a stag being killed by a lion (the "Lion and His Prey"),

was, however, rather common in both the Mediterranean world and the Sasanian Empire.[2] Since the lion is a symbol of the sun in certain Iranian contexts, perhaps on this stucco plaque the lion, a royal beast, has been exchanged for an equivalent, namely the king. Sun rays surround the head of the king. In this sense he is linked to the god Mithra who is often represented in Roman art slaying a bull in a manner similar to the stag slayer shown here.

The hero on this stucco plaque holds an antler in each hand, which relates the subject to the "Master of the Beasts." At the same time, the halo of sun rays suggests the tradition of the "Lion and His Prey." The scene on the plaque may thus be the result of a mixture of different iconographic schemes.[3] Since the crown of the hero is not a characteristic Sasanian one, it is probable that this is not a specific Sasanian monarch. Nor does the hunter appear to be a specific god. An interpretation of the "king" as the hero of some legend is at present the most plausible one.

Notes

1. Thompson, *Stucco from Chal Tarkhan-Eshqabad*, pp. 50ff., pl. X, 1.
2. A. D. H. Bivar, "A Persian Monument at Athens and Its Connections with the Achaemenid State Seals," in *W. B. Henning Memorial Volume*, ed. M. Boyce and I. Gershevitch (London, 1970), pp. 43–61.
3. W. F. Volbach, *Early Christian Art* (New York, 1962), pls. 106, 180, 250, 251. A more detailed study on the iconography of this plaque is being prepared by J. Kröger.

49

Stucco plaque with a scroll and bird above grapes

Chal Tarkhan-Eshqabad, Main Palace or Subsidiary Palace; second half of the seventh century or first half of the eighth century
Height 37 cm., width 18 cm.
Museum of Fine Arts, Boston (39.489)

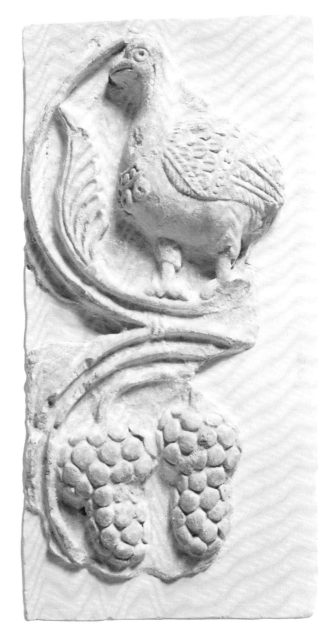

On this plaque two branches of a vine scroll divide to encircle a standing partridge in profile above and two bunches of grapes below. The upper branch ends in a palmette before the bird. Fragmentary plaques with this pattern were found in a number of rooms in both palaces at Chal Tarkhan-Eshqabad. It is possible that on the original plaque there was a symmetrical composition with a mirror image. The sturdy partridge stands on pedestal-like feet. Prominent features are the large wing and the pearl collar with pearl-like pendants. The collar was fastened at the back of the neck by two short and rather stiffly rendered ribbons.

Birds wearing or holding necklets are a common feature in Sasanian art, especially in the last phase. They appear mainly on metalwork (No. 21), textiles, and seals. Single birds in roundels are more characteristic of the Sasanian style, however, than birds framed by a circular scroll as on this plaque. This and a number of other stylistic features make a date in the decades following the end of the Sasanian dynasty reasonable for this plaque. In the Sasanian period, only certain species of birds, those associated with the *xwarrah* ("royal glory") or the goddess of vegetation, were represented. The partridge as it is shown on this plaque may have been understood in a different way.

Selected Bibliography

Thompson, *Stucco from Chal Tarkhan-Eshqabad*, pp. 56ff., pl. X, 4; Kröger, "Sasanidischer Stuckdekor," pp. 133ff., pl. 210, 4.

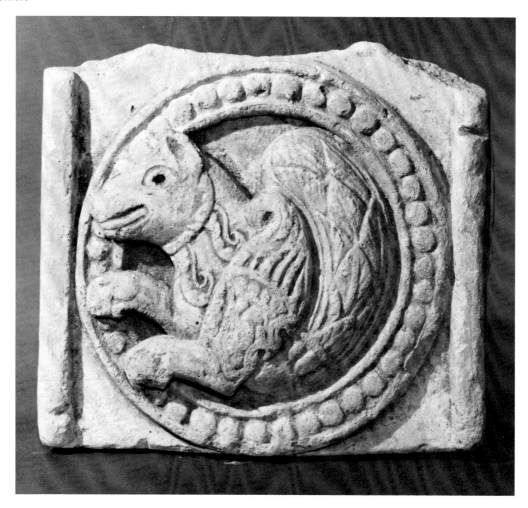

50

Stucco plaque with a *senmurw*

*Chal Tarkhan-Eshqabad, Main Palace; second half of the
 seventh century or first half of the eighth century*
Height 16.9 cm., width 19.3 cm.
*The British Museum, Department of Western Asiatic
 Antiquities (BM 135913)*

A *senmurw* in profile within a pearled roundel decorates
this fragment of a molded stucco plaque. Originally two
medallions were arranged vertically on one plaque with
a frame on each side suggesting that the plaque formed
part of a vertical border element.[1] The fierce creature
inside and partly overlapping the roundel has a large dog-
like head with outstretched tongue, and a long feathery
tail. Its two paws stretch forward, while stubby wings
protrude from its shoulders. The *senmurw*, a mythological
bird of Pahlavi texts, was a beneficent character and
served as a distributor of the seeds of plants to mankind.

On a different level the *senmurw* may have been under-
stood as a protector of man.[2] Although the *senmurw* oc-
curs in other media, such as metalwork (No. 34) and
textiles (No. 60), it has not yet been discovered in stucco
of Sasanian date. As the *senmurw* appears on the garment
of the king at Taq-i Bostan (see fig. K, p. 121), it evidently
had an important link with the ruler. This is perhaps the
reason for its inclusion in the architectural decoration of
the seat of a nobleman, although its use in a vertical
border ornament stresses the decorative rather than the
symbolic aspect of the motif.

Notes

1. For other examples see: Pope, "Sāsānian Stucco, B. Figural,"
 p. 633, pl. 177ff.; Thompson, *Stucco from Chal Tarkhan-
 Eshqabad*, pp. 29ff., pl. IV, 3, pl. XXIII, 1; Kröger, "Sasani-
 discher Stuckdekor," pp. 446ff., pl. 209, 3–4.
2. P. O. Harper, "The Senmurv," *The Metropolitan Museum of
 Art Bulletin* n.s. 20 (1961–62), pp. 95–101.

TEXTILES

The identification of Sasanian textiles has engendered controversy ever since the middle of the nineteenth century when it was first recognized that certain patterned silks in European church treasuries resembled textile patterns carved on Sasanian rock reliefs at Taq-i Bostan in Iran. This recognition contributed to the growing awareness of the "Orient" and its influence in the development of medieval art.

Approximately one hundred textile fragments, mostly silks, have been ascribed in the past century to Sasanian production, although there is no evidence for their precise date or place of manufacture. With the exception of one group of wool and cotton fragments excavated in Iran, of which several are now in The Metropolitan Museum,[1] all of the so-called Sasanian textiles have survived in lands beyond the central Sasanian domain. Many are preserved in European church treasuries; others have been retrieved in the excavation of tombs in Egypt, Central Asia, and Chinese Turkestan.[2] The Sasanian attribution thus predicates a thriving textile industry and export in antiquity.

A cursory examination of textiles which have been attributed to Sasanian manufacture reveals that they do not comprise, in any sense, a homogeneous group. The one common factor, perhaps, is the derivation of designs from the art of Sasanian Iran. It is becoming increasingly evident, however, that Sasanian royal iconography survived long after the fall of the dynasty and that Sasanian art exerted a strong influence upon the art of neighboring cultures. This situation, combined with a paucity of historical documentation, raises fundamental questions regarding the nature of the evidence. What basis does exist for the identification of Sasanian textiles, and which criteria may be used to distinguish their characteristics?

The absence of actual textiles in Sasanian contexts restricts the study of Sasanian textiles to information which can be derived from literary references and the representations of patterned textiles in Sasanian art. Western writers were impressed with the bright colors of Persian textiles; they note the opulent use of gems and pearls, but they make no mention of patterns.[3] Procopius, the court chronicler of Justinian and a contemporary of Khusrau I (531–579), describes at length the role of Persia in the silk wars.[4] He even cites the high price of silk demanded by the Persians as the primary stimulus for the deterioration of Persian-Byzantine relations. But he presents the Persians as traders, not as producers of silk, and he too does not mention textile patterns.

That richly decorated garments were worn by peoples to the east of Iran is attested by the accounts of pilgrims who traveled from China in the sixth and seventh centuries in search of their Buddhist heritage.[5] They comment upon the patterned textiles used by Turkish tribes for clothing and the interior furnishings of their felt tents. Persian weavers (not strictly Sasanian) were praised by the famous Chinese pilgrim Hsüan-tsang for their skill in weaving figured silks and carpets. Hsüan-tsang made a journey from China in the early seventh century and reached the area of present-day Afghanistan.

Fig. I. *Boar-hunt relief. Ivan of Khusrau II. Taq-i Bostan, Iran.*
Fig. J. *Detail of boar-hunt relief. Ivan of Khusrau II. Taq-i Bostan, Iran.*
Fig. K. *Detail of a royal garment in the boar-hunt relief. Ivan of Khusrau II. Taq-i Bostan, Iran.*
Fig. L. *Detail of a textile design in the boar-hunt relief. Ivan of Khusrau II. Taq-i Bostan, Iran.*

After the destruction of the palace of Khusrau II at Dastagird by the Byzantine armies in 627, large quantities of silk garments and decorated textiles were listed as booty, including tapestries, embroideries, brocades, and carpets.[6] A splendid wall-hanging, called the "Spring of Khusrau," was found in the palace at Ctesiphon which was taken ten years later by an Arab army. It was described by the tenth-century Arab historian Tabari as depicting a bountiful garden made of silk, gold and silver, rock crystal, emeralds, and other precious stones.[7] Whether it was embroidered, woven in tapestry, appliquéd, or studded with jewels is not explained.

The establishment of a Sasanian weaving industry has been attributed to Shapur I (241–272), who reportedly settled Roman prisoners as weavers in the province of Khuzistan in Iran after his conquests in Syria and northern Mesopotamia. The account is preserved in several sources of the tenth century which were compiled to explain the origins of Islamic textile factories (*tiraz*) in Iran.[8] Their historical value is therefore limited.

In general the surviving literary references clearly reflect the high cultural value placed on textiles in Sasanian times. Yet there is no explicit reference to the production of pattern-woven silks in Sasanian Iran, or to their export. Written sources do not make clear whether Sasanian craftsmen, producers, and exporters were, in fact, involved in the extensive East-West trade in textiles during the four centuries prior to the Arab conquests, or whether the Persians served more crucially as merchants who accumulated their wealth in the transport to the Christian West of patterned textiles and other luxury objects from lands further east. Archaeological evidence available at this point is also insufficient to reconstruct with confidence the role of Sasanian Iran in the manufacture and export of textiles.

The contribution of Sasanian art to this study is limited because the representation of patterned textiles is rare. The major source is provided by the rock reliefs at Taq-i Bostan (fig. B, p. 15).[9] In the larger of two rock-cut *ivans*, carved textile patterns decorate the garments of the king and his courtiers in the boar hunt relief (fig. I), as well as those of the two gods who attend his investiture at the back of the grotto.

The variety of patterns and the care with which decorated garments are rendered is exceptional. Hems, cuffs, collars, closures, and seams are clearly shown so that the textiles may be seen as yard goods, cut up and sewn to form the garments represented. These details indicate the precision of the craftsmen in transferring textile patterns to carved stone. The layout of the patterns may thus be used to determine, in many instances, the decorative technique (embroidery, appliqué, tapestry-weaving, pattern-weaving). The interruption of a repeat pattern by a seam or border, where a unit of the design is shown incompletely, conforms to the appearance of a pattern-woven fabric, cut and sewn to form a garment (fig. J). An embroidered or appliqué design would not be represented this way since these decorative techniques are carried out on finished garments. Similarly, the overlapping of an allover repeat pattern by a single motif (fig. K) suggests an embroidered design, a metal bracteate, or a fragment of a secondary woven fabric sewn onto the garment.

Fig. I

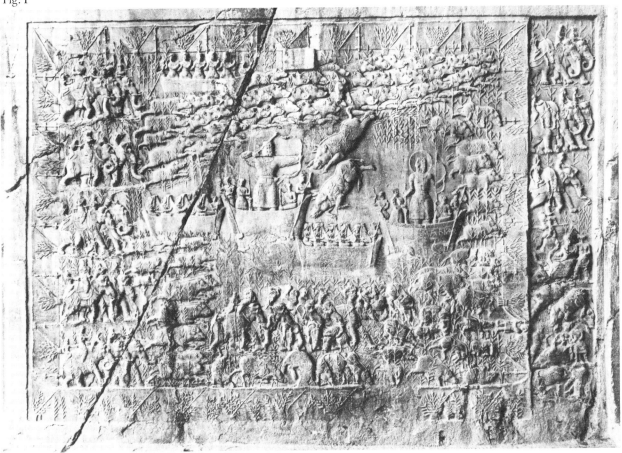

Fig. J

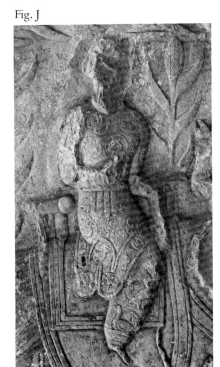

Fig. K

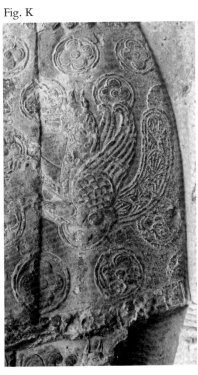

Fig. L

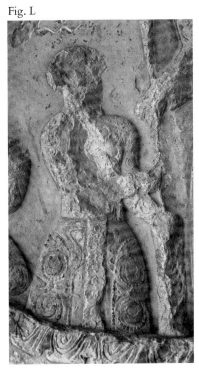

Patterned textiles at Taq-i Bostan may be divided into three categories according to the arrangement of primary motifs which are repeated to form the pattern:

1. repeat patterns of isolated or discrete primary motifs (e.g. rows of birds)
2. repeat patterns of discrete framing devices bearing primary motifs (e.g. rows of disks bearing birds)
3. repeat patterns of primary motifs, either discrete or within framing devices, arranged within a pattern framework (e.g. discrete motifs of birds arranged within a lozenge pattern framework)

Two components of a textile pattern are thus distinguished: primary motifs and the system of repeats. Together these form a consistent compositional scheme which is the nature of pattern-woven fabrics.

The systems of pattern repeats represented at Taq-i Bostan are varied, indicating several weaving sequences. The primary motifs are uniformly spaced, each forming an isolated design unit which is repeated laterally from right to left, or left to right, to face the same or opposite directions. As weaving progresses, the design units are repeated in staggered or aligned rows. Only one pattern includes a primary motif (lotus) which is repeated to form a symmetrical design unit (fig. L). The pairs of lotuses alternate with crescents in pearl roundels. They are shown on the robe of one of the king's oarsmen who appears twice. Single instances of a pearl roundel bearing a crescent also occur on the cuffs of the same figure. Since this is the only example of a textile pattern with pearl roundels in Sasanian art, it is significant that the roundels are not joined to form an overall pattern.

There are only three patterns at Taq-i Bostan that are arranged within a framework. A lozenge framework with a border of hearts occurs with two different patterns (ducks, and ducks alternating with quatrefoils) carved on the garments of four figures in the boar hunt. The third example is unique among the representations of textiles in Sasanian art. It consists of composite floral elements arranged to form a rectangular framework enclosing rows of *senmurw* in roundels with a border of trefoils (fig. M). In this pattern the carving of floral elements as a series of concentric forms may be a way of indicating color shading in the textile represented.

It is significant that textile patterns in Sasanian art prior to the reign of Khusrau II (591–628) consisted almost exclusively of the repetition of elementary geometric configurations which rarely suggest the nature of Sasanian textiles and give scarcely any indication as to fiber, color, structure, or decorative technique. Some of the patterns represented are related to their counterparts in Parthian art, which correspond in general appearance to extant textiles excavated at several sites of Parthian date (see for example, Nos. 51 and 52 from Dura-Europos). These archaeological fragments provide invaluable information regarding textiles in use in the early years of the Sasanian dynasty. The most prevalent method of decoration was tapestry-weave, a technique with a long history in the ancient Near East. The most frequently used fiber was wool.

 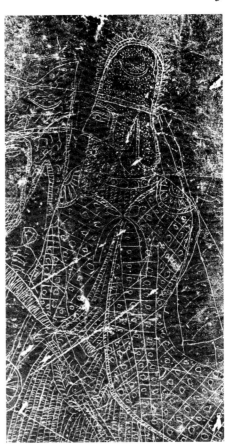

Fig. M. Left. *Detail of a royal garment.* Ivan *of Khusrau II. Taq-i Bostan, Iran.*
Fig. N. Right. *Sasanian graffito. Third century A.D. Persepolis, Iran.*

Despite the limitations of the evidence, certain characteristics of decorated Sasanian textiles may be recognized throughout the four centuries of imperial rule. There is a fascination with repeat patterns evident in the monuments, from the graffiti at Persepolis engraved in the early years of the dynasty (fig. N) to the final flourish in the rock reliefs at Taq-i Bostan executed during the reign of Khusrau II. The dress of certain individuals associated with the royal court combined several garments with different patterns. Metalwork also illustrates various patterned textiles that were used for interior furnishings.

The variety of patterns probably also reflects the use of many bright colors recorded in the surviving descriptions of Sasanian dress. Red is the most frequently mentioned; all of the Sasanian kings are said to have worn red boots, and red was the main color of the tunic or trousers of most Sasanian kings, according to a list preserved in Arab sources.[10] The predominance of red is evident in many textiles whose motifs and style rely strongly on Sasanian traditions (see Nos. 55, 57–59, 61, 62).

Contrasts between light and dark are noted in the stripes and checkerboard patterns of the textiles excavated at Shahr-i Qumis now in The Metropolitan Museum; a similar alternation is evident in the textiles from Dura-Europos, especially in the interchangeable foreground and background of the wave motif (see No. 52).

As for subject matter, there is no evidence of the representation of human beings in Sasanian textiles. Scenes

from the hunt are characteristic in Sasanian art, but they are notably absent from the representation of patterned textiles at Taq-i Bostan. In early Sasanian art, textile patterns are rendered schematically and composed of the repetition of basic geometric elements. The heart, ubiquitous in late antique ornament, is also the most prevalent decorative element at Taq-i Bostan. It occurs repeatedly as an isolated motif, or combined in groups to form rosettes, quatrefoils, and borders for a lozenge framework. Pearls are also used frequently in a variety of repeat patterns, borders, and roundels. They are considered to be elements of royal iconography because of their association with attributes of the king's dress, such as his crown, diadem, and jewelry.

Figural designs occur only at Taq-i Bostan and are restricted to units of single animals, of which birds are the most frequent (cocks, eagles, ducks, peacocks, and long-legged water birds). Except for the boar's head, other animals are fantastic creatures (winged rams and the *senmurw*). These and other mythical beasts appear on Sasanian seals, but winged horses and winged lions are notably absent from the representations of patterned textiles in Sasanian art. However, they, as well as the *senmurw*, winged ram, and boar's head, occur on textiles in the wall-paintings at Afrasiyab in Sogd (see Nos. 56, 60).

Several salient characteristics of style may also be recognized at Taq-i Bostan. There is a striking contrast between the naturalism apparent in the representations of animals and the formal stylization of floral patterns. The birds and mythical beasts are shown with an attempt to render anatomical details so as to give a sense of depth, whereas the floral motifs are formalized and symmetrical, depicted as ornament far removed from their natural appearance. Extant textile fragments similar to examples from Taq-i Bostan retain elements of naturalism in the representation of birds and animals; stylizations are carefully designed to emphasize natural features such as a long snout, chest hairs and a neck ruff, leg musculature, facial markings, and the forms of horns and ears (see Nos. 53, 55).

This duality, the contrast between the representation of animal and floral motifs, may perhaps be seen as a characteristic of Sasanian art in general. It becomes even more pronounced in certain monuments of early Islamic art, but there is a greater tendency toward more formal decorative ornament and the reduction of form to a series of flat patterns which may be seen in metalwork, glassware, and stucco, as well as textiles (see Nos. 61, 62). This is evident also in the dissolution of sculptural form as a result of progressive geometric stylization.

Because Sasanian art offers limited evidence for the identification of patterned textiles, attributions of textiles to Sasanian workshops must be considered as tentative. The lack of evidence for elaborately patterned textiles in early Sasanian art has wide-ranging implications. There is no substantial evidence to support the existence of complex woven patterns in Sasanian textiles until at least the late sixth century, a conclusion which has important ramifications for the dating of textiles attributed to Sasanian manufacture. Earlier representations of patterned textiles in Sasanian art are restricted to the repetition of small-scale elements rendered schematically.

Do these rudimentary patterns correspond to contemporary textiles or are they abbreviated versions of more elaborate designs, which simply were not recorded in their full complexity by craftsmen until the late sixth or early seventh century?

Sumptuous textiles with complicated woven patterns were luxury objects, probably confined to royal usage. Patterned textiles figure prominently in the descriptions of the court of Khusrau II (591–628), and they are recorded in the reliefs of the larger rock-cut *ivan* and the carved stone capitals at Taq-i Bostan.

The monuments of Taq-i Bostan provide an extraordinary amount of information regarding late Sasanian textiles current in the royal court. They show the prevalence of woven patterns as well as the persistence of more ancient traditions of textile decoration. The traditions of patterned textiles, however, cannot be traced in surviving monuments on the Iranian plateau. The decorated garments shown there are related to the fashions of Central Asia.[11] The patterned textiles illustrated at Taq-i Bostan may also be a southwestern extension of these traditions, particularly in view of the absence of representations of patterned textiles in Sasanian art prior to the late sixth century. The production of patterned textiles at several centers in Central Asia and their export is attested in Islamic sources for the period after the fall of Imperial Iran.[12] Perhaps the products of these local industries are illustrated in the wall-paintings excavated at Sogdian sites which depict a variety of textile patterns utilizing Sasanian motifs and indicate a strong dependence upon the art of Sasanian Iran.

Carol Manson Bier

Notes

1. J. Hansman and D. Stronach, "A Sasanian Repository at Shahr-i Qumis," *Journal of the Royal Asiatic Society* 2 (1970), pp. 142–156. Metropolitan Museum acc. no. Inst. 1969.1.7-13.
2. O. von Falke, *Kunstgeschichte der Seidenweberei* (Berlin, 1913), presentation of silks from European church treasuries and attributions to Sasanian manufacture; A. Stein, *Innermost Asia* (Oxford, 1928), excavations of "Sasanian" silks in Central Asia; E. Guimet, *Les Portraits d'Antinoé au Musée Guimet* (Paris, 1912); R. Pfister, "Le Rôle de l'Iran dans les textiles d'Antinoé," *Ars Islamica* 13–14 (1948), pp. 46ff; R. Pfister, "Les Premières soies sassanides," in *Etudes d'Orientalisme, publiées par le Musée Guimet à la mémoire de Raymonde Linossier* (Paris, 1932), pp. 461–479.
3. Ammianus Marcellinus, trans. J. C. Rolfe, Loeb Classical Library (Cambridge, Mass./London, 1950), II, p. 397 (Bk. XXIII. 6. 84).
4. Procopius, trans. H. B. Dewing, Loeb Classical Library (London/New York, 1914), I.
5. R. Grousset, *In the Footsteps of the Buddha* (New York, 1971). See also, C. L. Boulnois, *The Silk Road* (New York, 1966).
6. Cited by A. Christensen, *L'Iran sous les Sassanides*, 2nd ed. rev. (Copenhagen, 1944), p. 469.
7. Tabari, *Annales*, trans. M. H. Zotenberg (Paris, 1871), III, p. 417.
8. Islamic references to textiles have been compiled by R. B. Serjeant, "Material for a History of Islamic Textiles Up to the Mongol Conquest," *Ars Islamica* 9–15/16 (1942–1951), indexed in 15/16 (1951), pp. 273–306.
9. Detailed photographs showing textile patterns are presented by S. Fukai and K. Horiuchi, *Taq-i-Bustan*, 2 vols. (Tokyo, 1969–72).
10. Cited and translated in F. Sarre, "Sasanian Stone Sculpture," in *A Survey of Persian Art*, ed. A. U. Pope (London/New York, 1938), I, pp. 595–596, n. 1.
11. See E. H. Peck, "The Representation of Costumes in the Reliefs of Taq-i Bustan," *Artibus Asiae* 31 (1969), pp. 101–146; A. Geijer, "A Silk from Antinoë and the Sasanian Textile Art," *Orientalia Suecana* 12 (1963), pp. 3–36.
12. D. G. Shepherd and W. B. Henning, "Zandaniji Identified?" in *Aus der Welt des Islamischen Kunst: Festschrift für Ernst Kühnel*, ed. R. Ettinghausen (Berlin, 1959), pp. 15–41. See also note 8.

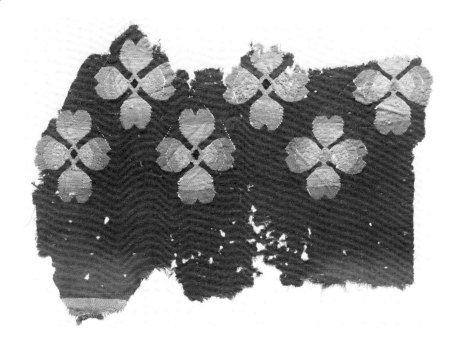

51
Textile fragment

Syria (excavated at Dura-Europos); early third century
Size: warp 22.9 cm., weft 33 cm.; rosettes 6.4–7.2 cm. by
 6.3–6.6 cm.
Technical information (lwm): tapestry weave, slit; warp—
 wool s-spun; weft—wool both s-spun and z-spun; warp
 edge finish[1]
Colors: green ground with red, three shades of pink, three
 shades of beige, blue; orange warp edge finish
Pattern description: staggered rows of quatrefoil rosettes
Yale University Art Gallery (1933.487) on loan to The
 Textile Museum, Washington, D.C.

This fragment and No. 52 were recovered during the excavations at the Syrian city of Dura-Europos, a commercial center and a Roman border post until it was conquered by Shapur I in the middle of the third century. Numerous woven textiles, mostly undecorated, were found in the debris which had accumulated inside the city's defense wall. Their significance lies in the valuable information they provide regarding the state of the textile arts and weaving technology at the time of the Sasanian conquest. Several centuries later Arab historians, in explaining the origins of government textile factories (*tiraz*) in Iran, attributed the establishment of the industry to the resettling of weavers after the campaigns of Shapur in Syria.

The simple overall repeat pattern, executed here in tapestry-weave, prefigures the rudimentary textile patterns in Sasanian art, represented, for example, on metalwork and in the graffiti at Persepolis (fig. N, p. 123). The quatrefoil rosette is pervasive in Sasanian art (see No. 15); the heart quatrefoil, its variant, occurs frequently in the textile patterns at Taq-i Bostan.

Selected Bibliography

R. Pfister and L. Bellinger, *The Excavations at Dura-Europos, Final Report IV, Part II: The Textiles* (New Haven, 1945), p. 39 (cat. no. 140); frontispiece and pl. XXI; A. Weibel, *Two Thousand Years of Textiles* (New York, 1952), p. 75 (no. 2), pl. 2.

Notes

1. Here and in other textile entries, the designation (lwm) indicates that the technical information was provided by Louise W. Mackie, The Textile Museum, Washington, D.C.

52

Textile fragment

Syria (excavated at Dura-Europos); early third century
Size: warp 24 cm., weft 12 cm.
Technical information (lwm): tapestry weave, slit; warp—
undyed wool s-spun (loose); weft—wool s-spun (loose)
Colors: white, two shades of blue, three shades of red
Pattern description: shaded stripes with five bands of decorative
ornament
Yale University Art Gallery (1933.488) on loan to The
Textile Museum, Washington, D.C.

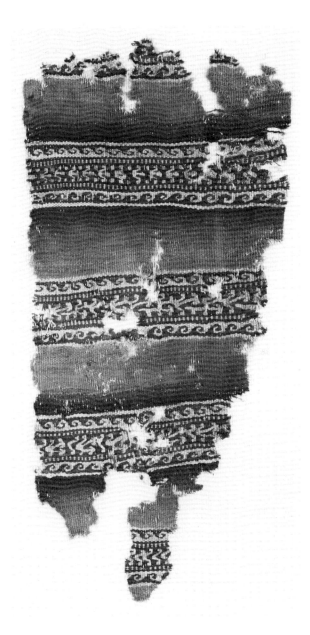

The decorated textiles excavated at Dura-Europos, with only a few exceptions, were executed in tapestry weave. The use of color shading is characteristic, and the decorative elements are derived from Hellenistic art. The deliberate variation in design—the alternation of ornamental bands and stripes and the use of patterns with interchangeable foreground and background—is also evident in the textile patterns rendered schematically in early Sasanian art. Color shading in later Sasanian textiles is perhaps indicated in the patterns at Taq-i Bostan by the carving of concentric decorative elements.[1]

Dura was located on a main east-west trade route, but its textiles were probably not as sumptuous as those of the capital cities of Antioch to the west or Seleucia to the southeast. Nonetheless, they give an indication of the fibers, colors, weaves, and decorative techniques in use at the time of Shapur's conquests in Syria.

Selected Bibliography
R. Pfister and L. Bellinger, *The Excavations at Dura-Europos, Final Report IV, Part II: The Textiles* (New Haven, 1945), pp. 36–37 (cat. no. 128), pl. III.

Notes
1. Fukai and Horiuchi, *Taq-i-Bustan*, I, pl. 65; II, pl. 47.

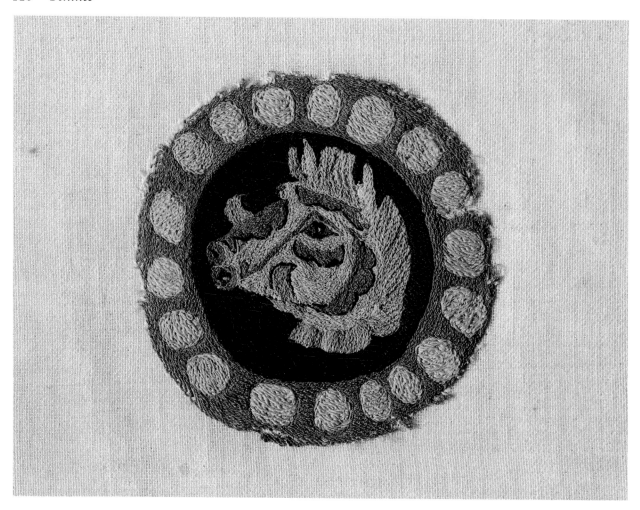

53

Textile fragment

Iran or Iraq; sixth or seventh century
Size: warp 8 cm., weft 8.5 cm.; roundel 8 by 8.5 cm.
Technical information (lwm): embroidered with chain stitch
* and stem stitch in wool—two z-spun yarns s-plied; plain*
* weave linen ground—warp and weft both z-spun and s-spun*
Colors: blue field with red, white, yellow, tan, blue green;
* brown outlines*
Pattern description: pearl roundel enclosing a boar's head
The Textile Museum, Washington, D.C. (3.304)

The boar's head is an emblem that occurs on representations of the crowns of Sasanian princes, on seals of Sasanian and Central Asian origin,[1] and on objects in silver and stucco. This example is comparable to a boar's head in a roundel carved as a textile pattern on the garment of an oarsman in the boar hunt relief at Taq-i Bostan.[2] There are also pearl roundels at Taq-i Bostan on the garments

of attendants of the king in the boar hunt. The embroidered design combines a frontal view of the snout, a three-quarters view of the tusks and ears, and a profile view of the head and ruff. This manner of presentation allows maximum visibility and permits the boar's head to be seen in three dimensions without the use of perspective. The stylizations on the face emphasize natural details and enhance the three-dimensional quality.

A parallel for the motif occurs on a pattern-woven silk from Astana in which the pearl roundel is part of a pattern-woven framework and the style of the boar's head is entirely two-dimensional with details rendered by flat geometric shapes.[3] This style may be attributed in part to the structural requirements of weaving and the rectilinear alignment of warp and weft in contrast to embroidery. The Astana silk and other extant textiles with this motif are closer in style to the textile patterns with boars' heads represented on wall-paintings at Afrasiyab and Toyuq Mazar in Central Asia and Chinese

Turkestan than to this embroidered roundel from The Textile Museum.[4]

Although no extant examples of embroidery have previously been attributed to Sasanian manufacture, there is evidence at Taq-i Bostan for embroidered plaques. Few embroidery roundels are published; the closest parallels are three roundels in The Brooklyn Museum which bear two birds of different species and a container of fruit.[5]

Notes

1. A. D. H. Bivar, *Catalogue of the Western Asiatic Seals in the British Museum. Stamp Seals*, II: *The Sassanian Dynasty* (London, 1969), pl. 20 (GC 1, 2, 3).
2. Fukai and Horiuchi, *Taq-i-Bustan*, I, pl. 67.
3. A. Stein, *Innermost Asia* (Oxford, 1928), III, pl. 76 (Ast. i.5.03).
4. L. Albaum, *Zhivopis Afrasiyab* (Tashkent, 1975); E. Herzfeld, *Am Tor von Asien* (Berlin, 1920), pl. 64.
5. D. Thompson, *Coptic Textiles in The Brooklyn Museum* (Brooklyn, 1971), no. 11 a–c, p. 32 and pl. VIII. Another example of embroidery that may be Sasanian bears a leaf scroll with a hare and a double border of pearls (The Textile Museum, Washington, D.C., 71.82). The composition corresponds to the textile shown folded over the boat of the harpists at Taq-i Bostan. See Fukai and Horiuchi, *Taq-i-Bustan*, I, pl. 69A. The vine scroll also shares certain stylistic details with a stucco rinceau which was excavated at Bishapur.

54

Textile fragment

Iran or Iraq; sixth or seventh century
Size: warp 60 cm., weft 8 cm.; width of lozenge ca. 8 cm.
Technical information: a compound structure, a weft-faced twill weave with inner warps and complementary wefts; warp—silk; weft—silk
Colors: blue ground with tan, dark orange, and white
Pattern description: pendant pearls within a lozenge pattern framework composed of double rows of pearls
Victoria & Albert Museum (2189.1900)

Staggered rows of pendant pearls, similar in form to those on this fragment, are carved in high relief on the garments of Khusrau II (591–628) in the investiture scene at Taq-i Bostan and on carved stone capitals which bear his image. The hems of the king's garments have borders with double rows of pearls. These are also indicated at the junctures between repeat patterns on the garments of the king's attendants in the boar hunt relief, and a lozenge pattern framework composed of hearts is shown on the garment of an oarsman in the king's boat. Thus each of the elements of this textile pattern are present at Taq-i Bostan.[1]

Detail of No. 54

The woven pattern renders in two dimensions the famous pearls of Sasanian kings, frequently described in Western accounts of the splendor of the Persian royal court.[2] The lozenge pattern framework composed of double rows of pearls also occurs in Byzantine silks and wool textiles in tapestry weave from Egypt.[3]

Selected Bibliography

A. F. Kendrick, *Catalogue of Textiles from Burying Grounds in Egypt*, III (London, 1922), pl. 29 (833).

Notes

1. Fukai and Horiuchi, *Taq-i-Bustan*, I, pl. 64; II, pls. 12–13.
2. For example in Ammianus Marcellinus, trans. J. C. Rolfe, Loeb Classical Library (Cambridge, Mass./London, 1950), II, p. 397 (Bk. XXIII. 6. 84).
3. See Dumbarton Oaks, *Handbook of the Byzantine Collection* (Washington, D.C., 1967), p. 107 (360) and plate. A fragment of a silk textile with a pattern similar to the Victoria & Albert example is described by P. Ackerman, in *A Survey of Persian Art*, I, p. 711 (no. 7); Berlin, Stoffsammlung no. 87.772.

55

Textile fragment

Iran or Iraq; sixth to eighth century
Size: warp 37.5 cm., weft 27 cm.
Technical information: tapestry weave, slit and dovetailed;
warp—undyed wool s-spun; weft—wool two s-spun yarns
z-plied
Colors: red ground with yellow, green, dark blue, light blue,
pink, white, brown
Pattern description: a recumbent mountain goat with pearl
neckband and fluttering ribbons; traces of quatrefoil
roundel (?)
Yale University Art Gallery; Hobart Moore Memorial
Collection, gift of Mrs. William H. Moore (1937.4604)

The pearl neckband with fluttering ribbons probably
signifies that this mountain goat is a motif associated with
royalty. A similar neck ribbon appears on a stag in a royal
hunt on a rock relief at Taq-i Bostan. The form of the
neckband corresponds to those worn by winged horses
and rams on silks from Antinoë (see for example No. 56),
and to the royal diadem which is carved on the facade of
the larger rock-cut *ivan* at Taq-i Bostan.

The recumbent position of the animal also occurs on
Sasanian seals. The rendering of the mountain goat is
naturalistic. Leg musculature, cloven hoofs, and anatomi-
cal details of the ears, horns, chest hair, beard, nose, and
neck ruff are indicated. The geometric stylization of the
shoulder and back contradict the sense of natural form
and contribute elements of a flat style which is more
apparent in textiles from Central Asia. The stepped pat-
tern on the mountain goat may be compared, for exam-
ple, with that on the boar's head on a silk excavated at
Astana in a tomb of the mid-seventh century.[1] Similar
stepped patterns are also evident in the textiles shown on
the wall-paintings at Afrasiyab.[2]

The floral forms which project from the front of the
goat's body are presented in a flat style characteristic of

floral ornament in Sasanian art. Their function and asso-
ciation are unclear.

Selected Bibliography
P. Ackerman, "A Sassanian Tapestry," *American Institute for
Persian Art and Archaeology, Bulletin* 4 (1935), no. 1, pp. 2–4;
P. Ackerman, "Textiles through the Sāsānian Period," in *A Sur-
vey of Persian Art*, I, p. 708; fig. 249; R. Pfister, "Le Rôle de l'Iran
dans les textiles d'Antinoé," *Ars Islamica* 13–14 (1948), p. 72, fig.
75; A. Weibel, *Two Thousand Years of Textiles* (New York, 1952),
p. 85 (no. 30), fig. 30; The University of Michigan Museum of
Art, *Sasanian Silver* (Ann Arbor, 1967), pp. 144ff. (no. 66).

Notes
1. A. Stein, *Innermost Asia* (Oxford, 1928), pl. 76 (Ast. i.5.03).
2. L. Albaum, *Zhivopis Afrasiyab* (Tashkent, 1975).

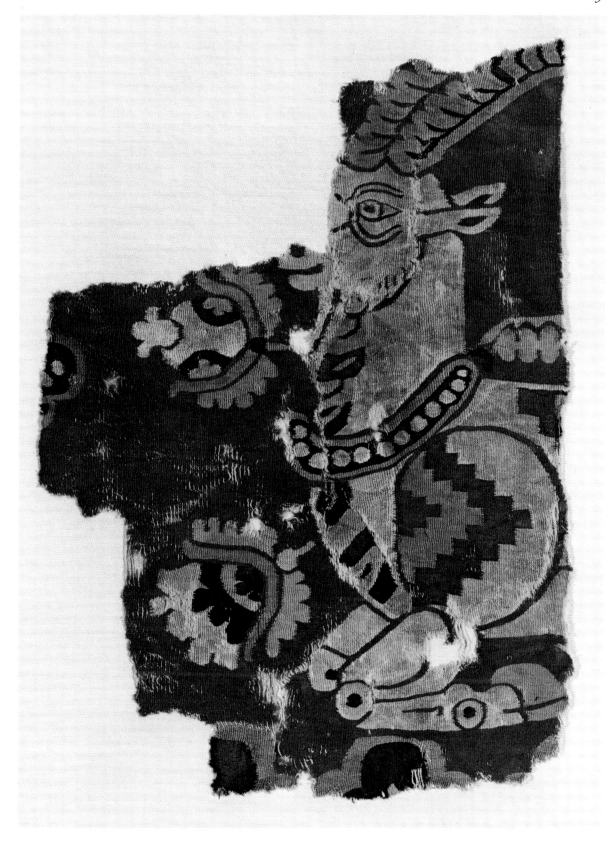

56
Textile fragments

Iran or Transoxiana (excavated at Antinoë, Egypt); seventh century

Size: warp 12.5 cm., weft 17 cm.; warp 17 cm., weft 17 cm.

Technical information: a compound structure, a weft-faced twill weave with inner warps and complementary wefts; warp—silk; weft—silk

Colors: white ground with dark blue, brown

Pattern description: a pattern framework of joined pearl roundels bearing winged horses; composite floral interstitial motif

Musée du Louvre, Antiquités Egyptiennes, Section Copte (Gu. 1138)

These fragments were excavated at Antinoë in Egypt, where the dry climate and sandy soil permit the preservation of fragile textile fibers. Numerous fragments re-trieved from graves at Antinoë belonged to garments that must have been imported in antiquity because they do not reflect the fashions or weaving traditions of Egypt.[1] The style and iconography of this example relate it to the art of Sasanian Iran, but its compound structure and weft-faced twill are characteristic of many silks with complex patterns woven in diverse locations from the eastern Mediterranean to China during the early Middle Ages.

The horse with wings outspread, one before the chest and the other placed alongside the body, is a familiar motif on Sasanian seals. Pearl neckbands with fluttering ribbons, ankle fillets, and a knotted tail are also details which are seen in Sasanian art. The neckband with flut-tering ribbons may be compared to that on a mountain goat executed in tapestry weave (No. 55). The ball and crescent supported by a shaft which projects from the horse's head is derived from crown types appearing on the coins of late Sasanian kings.

A textile pattern with discrete pearl roundels occurs at Taq-i Bostan; however, there are no Sasanian examples in which the pearl roundels are joined to form a pattern framework. In the pattern framework of this textile, the large pearl roundels are joined by smaller pearl roundels bearing crescents, a detail which is present in pattern-woven silks excavated in Central Asia, and on others pre-served in European church treasuries (see No. 60). This scheme, as well as the motif of a winged horse, occurs in the wall-paintings of the seventh or eighth century exca-vated at Afrasiab in Sogd.[2] Stylistic details on the wall-paintings are so similar to those on this textile that they must be of contemporary date. Additional fragments of this textile are located in Lyons, Musée Historique des Tissus.

Selected Bibliography

E. Guimet, *Les Portraits d'Antinoé au Musée Guimet* (Paris, 1912), pl. Va; R. Pfister, "Les Premières soies sassanides," in *Etudes d'Orientalisme, publiées par le Musée Guimet à la mémoire de Raymond Linossier* (Paris, 1932), pp. 461–479, pl. LXII; P. Ackerman, "Tex-tiles through the Sāsānian Period," in *A Survey of Persian Art*, I, p. 712 (no. 16), pl. 202 B.

Notes

1. See for example, Geijer, "A Silk from Antinoë and the Sasa-nian Textile Art," pp. 3–36.
2. V. Shishkin, "New Monuments in the Art of Sogd," (in Russian), *Iskusstvo* (1966), pp. 62–66.

57
Textile fragment

Iran or Iraq; seventh or eighth century
Size: warp 38 cm., weft 18 cm.; diameter of roundel
 (reconstructed) ca. 40 cm.
Technical information (lwm): a compound structure, a weft-
 faced twill weave with inner warps and complementary
 wefts; warp—undyed wool s-spun; weft—wool s-spun
 and cotton s-spun
Colors: red ground with white
Pattern description: a pearl roundel bearing confronted long-
 legged birds and a central tree
The Textile Museum, Washington, D.C. (73.623)

A long-legged bird is perched above the spread lower
branches of a stylized tree which terminates in a palmette
blossom and two fruit-laden branches. The bird holds one
of the branches in his beak. Traces of a pearl roundel with
square gems are preserved in the upper left and at the
bottom. Several fragments of similar textiles in other col-
lections suggest the reconstruction of a pattern frame-
work of pearl roundels bearing a symmetrical composi-
tion: confronted birds on either side of a central tree.[1]

Textiles of this group share certain features of style and
technique (see No. 59). The ground is red wool and the
pattern is delineated in white cotton. The design reper-
tory usually consists of birds, including cocks, eagles,
ducks, and long-legged water birds (cranes or herons).
They are arranged either singly or in pairs, within a pat-
tern framework of pearl roundels or in rows. The style
corresponds in many details to the textile patterns with
birds carved on the reliefs at Taq-i Bostan, but the use of
a pattern framework of pearl roundels suggests a later
date for the entire group. Most of the fragments are so
badly worn that the design is more easily seen on the
reverse, as in this example.

Reverse

Notes

1. L. Ashton, "A New Group of Sassanian Textiles," *The Burling-
ton Magazine* 66 (1935), pp. 26–30; C. J. Lamm, *Cotton in
Medieval Textiles of the Near East* (Paris, 1937), pp. 45, 50–52,
figs. 26–27. Additional parallels include Dumbarton Oaks
Collection, 33.43 (*Handbook of the Byzantine Collection* [Wash-
ington, D.C., 1967], no. 369); The Cleveland Museum of Art, 50.511 (A. Weibel, *Two Thousand Years of Textiles*, [New
York, 1952], p. 87, pl. 36); The Metropolitan Museum of Art
1974.113.11 and 1974.113.12 (unpublished); The Brooklyn
Museum L64.13.1 (unpublished); and The Textile Museum
73.174, 73.382, 73.383, 73.385, and 72.87 (unpublished).

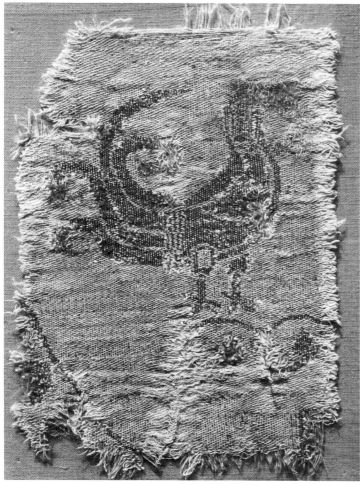

Reverse

58
Textile fragment

Iran or Iraq; seventh or eighth century
Size: warp 27 cm., weft 20 cm.; diameter of roundel
(reconstructed) ca. 52 cm.
Technical information (lwm): a compound structure, a weft-
faced twill weave with inner warps and complementary
wefts; warp—undyed wool s-spun; weft—wool s-spun
and cotton s-spun
Colors: red ground with white
Pattern description: a pearl roundel bearing confronted cocks
and a central tree
The Textile Museum, Washington, D.C. (73.554)

Traces of a circular pearl border in the lower left permit
the reconstruction of a roundel bearing a symmetrical
composition of confronted cocks perched above the vine-

like lower branches of a central tree. The style of the bird
is related to the cocks appearing at Taq-i Bostan. The
detail presenting the greatest similarity is the tail, which
is composed of four feathers. The two back feathers curl
downwards. The next one rises and curls slightly for-
ward, while the last feather turns inward. Similar tails
appear on the cocks represented on the leggings of an
elephant rider in the boar hunt relief.[1]

This is one of several related textile fragments, the style
of which suggests that they were woven in Sasanian do-
mains.[2] The pattern framework of joined pearl roundels
in some of the examples, however, signifies a date after
the Arab conquests, as this pattern is not documented in
Sasanian art.

Notes
1. Fukai and Horiuchi, *Taq-i-Bustan*, I, pl. 39.
2. For references and parallels, see No. 57, notes.

59
Two textile fragments

Iran or Iraq; seventh or eighth century

A. *Size: warp 47 cm., weft 35.5 cm.; diameter of roundel*
ca. 16 cm.
Technical information (lwm): a compound structure, a weft-
faced twill weave with inner warps and complementary
wefts; warp—undyed wool s-spun; weft—wool s-spun
and cotton s-spun
Colors: red ground with white
Pattern description: a pattern framework of joined pearl
roundels bearing long-legged birds facing opposite directions

B. *Size: warp 40 cm., weft 23.5 cm.; diameter of roundel*
ca. 13.5 cm.
Technical information (lwm): a compound structure, a weft-
faced twill weave with inner warps and complementary
wefts; warp—undyed wool s-spun; weft—wool s-spun
and cotton s-spun
Colors: red ground with white
Pattern description: a pattern framework of joined pearl
roundels bearing long-legged birds facing opposite directions

The Textile Museum, Washington, D.C. (73.341 and
73.555)

These two fragments belong to a group of textiles which
share technical as well as stylistic features indicating that

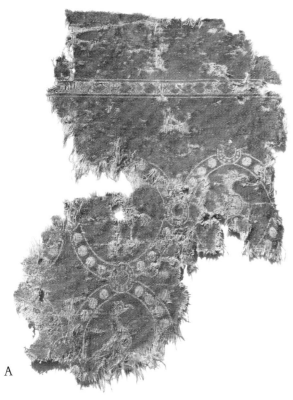

A

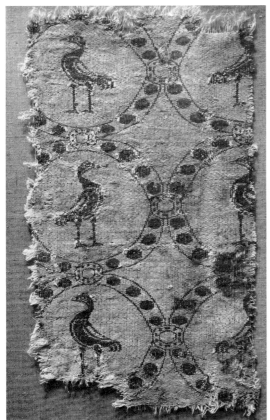

B

Reverse

they were probably woven in the same textile workshop (see also No. 57).[1] They all bear repeat patterns woven in twill with a compound structure. The wool warps are undyed, and the wefts are red wool and white cotton. The primary motifs are usually birds, either singly or in pairs, frequently arranged within a pattern framework of pearl roundels. The style is characterized by a minimum of detail, but the essential features of anatomy are clearly indicated.

The placement of birds facing opposite directions relates these two fragments to the textile patterns with birds at Taq-i Bostan. However, the pattern framework of pearl roundels, joined by smaller pearl roundels, seems to be characteristic of works of art created after the fall of the Sasanian dynasty.

Most of the fragments of this group were acquired in Egypt, but they bear no resemblance to textiles of local production. The two sets of warp and weft make the design reversible, and the pattern is best viewed today from the back because the obverse shows signs of heavy wear. The dimensions of the warp and weft yarns, and the compound structure, create a very strong fabric, suitable for wall-hangings, cushions, or floor coverings. That textiles supplied the essential furnishings of private dwellings and played a major role in the interior decoration of palaces is known from numerous descriptions in Islamic sources.

Notes

1. For references and unpublished parallels, see No. 57, notes.

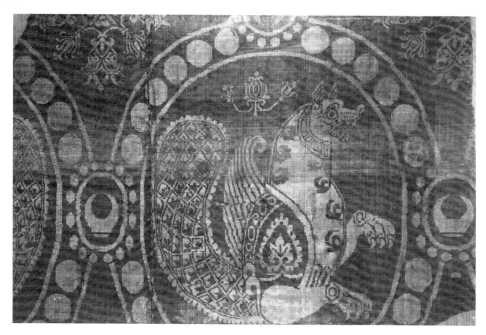

60
Textile fragment

Iran or Transoxiana; seventh to ninth century
Size: warp 34 cm., weft 50 cm.; diameter of roundel ca. 37 cm.
Technical information: a compound structure, a weft-faced
* twill weave with inner warps and complementary wefts;*
* warp—silk; weft—silk*
Colors: green ground with yellow
Pattern description: a pattern framework of joined pearl
* roundels bearing senmurws; composite floral interstitial*
* motif*
Victoria & Albert Museum (8579.1863)

The *senmurw*, a mythical winged creature with a dog's head, leonine paws, and a peacock's tail, is familiar in Sasanian art (see No. 34). As a textile motif it is shown on garments of the king at Taq-i Bostan. The naturalistic features of the *senmurw* on this textile, such as the snout, teeth, and claws, give it a sense of vigor that is also present in the *senmurw* textiles at Taq-i Bostan. Certain aspects, however, distinguish this *senmurw* pattern from those on the rock reliefs and indicate that this textile is probably a product of post-Sasanian manufacture. The tripartite wing division and the form of the outer feathers are details which also occur on the Antinoë silk with winged horses (No. 56). These textiles both bear a pattern framework of joined pearl roundels, an arrangement which is not documented in the textile patterns represented in Sasanian art. This arrangement corresponds to that on wool and cot-

ton textiles acquired in Egypt (see No. 59), and on silks excavated in Central Asia. Joined pearl roundels frequently form a pattern framework in the wall-paintings at Afrasiyab and other Sogdian sites dated to the seventh or eighth century.[1] Details shared by all of these examples place them in a contemporary milieu, probably no earlier than the seventh century.

A silk caftan bearing an almost identical *senmurw* pattern has been recovered from the tomb of a local chieftain in the northern Caucasus.[2] The *senmurw* is a motif which also occurs on textiles of Islamic and Byzantine origin, several of which have been preserved in European church treasuries and are now located in various museums.[3]

Selected Bibliography

A. F. Kendrick, *Catalogue of Early Medieval Woven Fabrics* (London: Victoria & Albert Museum, 1925), pp. 12–13, pl. 1; P. Ackerman, "Textiles through the Sāsānian Period," in *A Survey of Persian Art* (London/New York, 1938), I, p. 711 (no. 5), pl. 200.

Notes

1. L. Albaum, *Zhivopis Afrasiyab* (Tashkent, 1975).
2. A. Yerusalimskaya, "Novaya nokhodka tak nazievaemogo Sassanidskogo shelka s senmurvami," *Soobshcheniya Gosudarstvennogo Ermitazha* 34 (1972), pp. 11–15; K. Riboud, "A Newly Excavated Caftan from the Northern Caucasus," *Textile Museum Journal* 4, no. 3 (1976), pp. 21–42.
3. F. Guicher and G. Vial, "Dossiers de recensement," *CIETA Bulletin de Liaison* 15 (1962), pp. 42–50; J. Dupont, "Le Linceul de Saint-Remi," *CIETA Bulletin de Liaison* 15 (1962), pp. 38–41; D. G. Shepherd, "Hispano-Islamic Textiles," *Chronicle of the Museum for the Arts of Decoration of the Cooper Union* 1, no. 10 (1943), pp. 357–396; H. Peirce and R. Tyler, "Three Byzantine Works of Art," *Dumbarton Oaks Papers* 2 (1941).

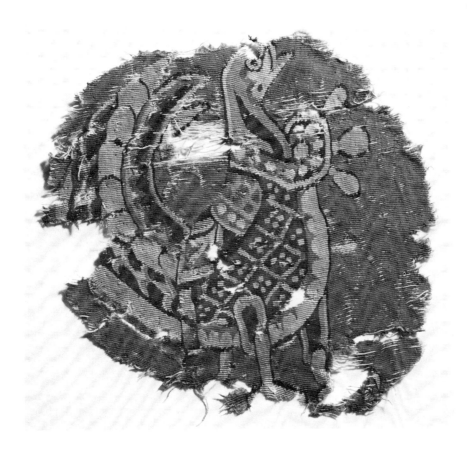

61

Textile fragment

Iran or Iraq; eighth century
Size: warp 18 cm., weft 17 cm.
Technical information (lwm): tapestry weave, slit and (some)
dovetailed; warp—wool two z-spun yarns s-plied; weft—
wool z-spun
Colors: red ground with dark blue, light blue, dark green, light
green, brown, tan
Pattern description: cock, wearing a pearl neckband with three
pendant pearls; possibly in roundel
The Textile Museum, Washington, D.C. (73.724)

This fragment belongs to a group of wool textiles in tapestry weave with the warps perpendicular to the primary motifs, usually birds with rich plumage on a red ground (see No. 62).[1] The rendering of anatomical details has been restricted to patterns of scallops, lozenges, and dots. The rather naturalistic treatment of the eye, beak, neck, and feet, and the two drooping feathers at the base of the tail, retain elements of a Sasanian style evident in the various species of birds carved on the garments of figures at Taq-i Bostan.

The rendering of the pearl neckband combines a frontal and profile view, which affords maximum visibility (see also No. 21). Necklaces with three pendants are worn by Sasanian kings on coins of the fifth and sixth centuries, but the form of this necklace, with three ovoid pendant pearls in a horizontal row, first occurs on the coins of Ardeshir III (628–630).

The pearl band which divides the wing, and the floral stylization of the outer wing feathers, are details which frequently occur on objects made after the Arab conquests. The motif and style of this fragment are similar to those of a wool textile in tapestry weave inscribed in Arabic with the name of an Umayyad caliph, Marwan,[2] thus confirming a post-Sasanian attribution.

Notes

1. R. Pfister, "Coqs sassanides," *Revue des arts asiatiques* 12 (1938), pp. 40–47.
2. E. Kühnel and L. Bellinger, *Catalog of Dated Tiraz* (Washington, D.C., 1952), pp. 5–6, pl. 1 (TM 73.524); F. Day, "The Tiraz Silk of Marwan," in *Archaeologia Orientalia in Memoriam Ernst Herzfeld*, ed. G. C. Miles (Locust Valley, New York, 1952), pp. 39–61.

62

Textile fragment

Iran or Iraq; eighth century
Size: warp 65 cm., weft 12.5 cm.
Technical information (lwm): tapestry weave, slit and dove-
 tailed; warp—undyed wool two z-spun yarns s-plied; weft
 —wool z-spun
Colors: red ground with light blue, dark blue, green, light
 green, orange, tan, brown, and white (undyed wool)
Pattern description: roundels of composite floral elements
 bearing alternately a cock and an eagle
The Textile Museum, Washington, D.C. (73.550)

This fragment is similar to several wool textiles in tapestry weave in which the pattern is woven sideways (see No. 61). The red ground is also characteristic.[1] The designs consist of birds and floral motifs related in style to those on a textile of the eighth century which has an inscription in Arabic with the name of the Umayyad caliph, Marwan.[2]

The cock in profile with four curled tail feathers, the eagle shown frontally with outspread wings, and the forms of palmettes have parallels at Taq-i Bostan. The repetition of flat patterns, apparent in the stylization of the eagle and in the composite floral designs, is particularly distinctive of early Islamic art. Elements of naturalism, however, are retained in the cock's neck markings.

The borders of the roundels vary and the primary motifs are not repeated. This freedom of design results from the technique of tapestry weaving, in which the wefts are discontinuous and a new weft is added for each color change.

Notes
1. R. Pfister, "Coqs sassanides," *Revue des arts asiatiques* 12 (1938), pp. 40–47.
2. E. Kühnel and L. Bellinger, *Catalog of Dated Tiraz* (Washington, D.C., 1952), pp. 5–6, pl. 1 (TM 73.524).

63

Textile fragment

Sogd; eighth or ninth century
Size: warp 15.5 cm., weft 27.5 cm.; diameter of roundel
 ca. 26 cm.
Technical information: a compound structure, a weft-faced
 twill weave with inner warps and complementary wefts;
 warp—silk z-twist; weft—silk no twist
Colors: tan ground with dark blue, light green, cream, beige
 (probably all faded)
Pattern description: a roundel with a composite border of
 chevrons and squares, bearing confronted lions and a central
 tree
Cooper-Hewitt Museum of Decorative Arts and Design,
 Smithsonian Institution; Gift of J. P. Morgan
 (1902.1.211)

This fragment is related to a group of textiles characterized by pairs of highly stylized animals enclosed in roundels.[1] A split palmette, the remains of which are visible beneath the lions on this fragment, and a central tree, now faded, are also hallmarks of this group of textiles. One of the examples bears an inscription giving the name of Zandanah, a town near Bukhara in Central Asia which was famous for the production and export of patterned textiles.[2] A date of about A.D. 700 is suggested by the epigraphy of the inscription, which is written in ink. The faded coloring of Zandaniji textiles has been attributed to fugitive dyes which were not prepared with the proper mordants, perhaps because the secrets of fixing the colors were retained by Chinese craftsmen more familiar with the production and weaving of silk.

The distinctive style of this group is related to the horizontal and vertical alignment of warp and weft, exaggerated by the angular outlines of the design. Although the design is rendered in a style that indicates almost no sense of depth, elements of naturalism are suggested by the smaller scale and darker coloring of the legs on the far

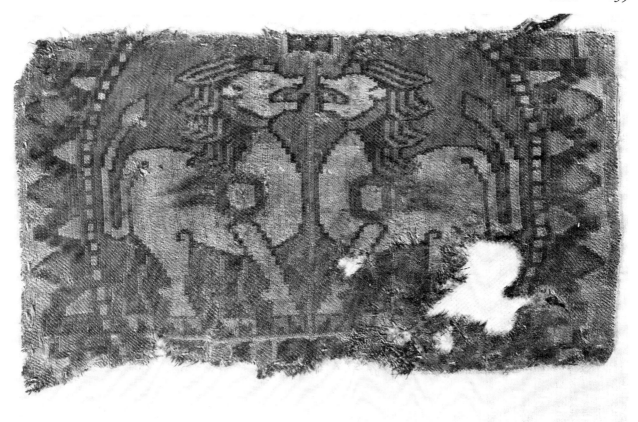

side of the animals. In contrast, the geometrized, segmented wings are barely recognizable and appear to be stylizations of the shoulder. The mane, rendered in parallel angular lines, may be compared to that of the winged horses from Antinoë (No. 56).

The style and iconography of Zandaniji textiles derives from Sasanian art, but pairs of confronted animals are not documented in the repertory of Sasanian textile patterns. At Taq-i Bostan, the only source for a knowledge of figural patterns, animals in roundels appear singly (bird, boar's head, and *senmurw*). The symmetrical arrangement on Zandaniji fabrics is probably an indication of a development in the application of drawloom weaving which allowed for the mechanical repeat of patterns in reverse (sometimes called "point-repeat" or "reverse repeat").[3]

Many Zandaniji textiles known today have been preserved in European church treasuries where they were used to wrap the relics of saints.

Selected Bibliography

R. Meyer-Riefstahl, "Early Textiles in the Cooper Union Collection," *Art in America* (October and December, 1915), p. 253 and fig. 4.

Notes

1. O. von Falke, *Kunstgeschichte der Seidenweberei* (Berlin, 1913), pp. 98ff., figs. 138–145.
2. D. G. Shepherd and W. B. Henning, "Zandaniji Identified?" in *Aus der Welt des islamischen Kunst: Festschrift für Ernst Kühnel*, ed. R. Ettinghausen (Berlin, 1959), pp. 15–41.
3. L. Bellinger, "Repeats in Silk-weaving in the Near East," *Textile Museum Workshop Notes* 24 (1961).

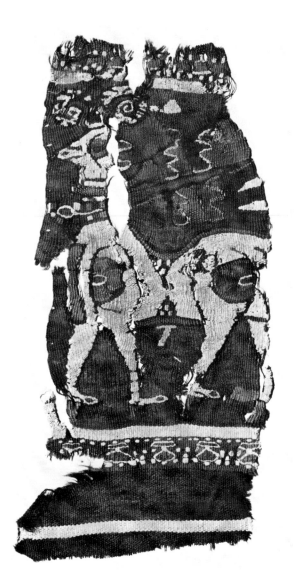

64
Textile fragment

Egypt or Iran; seventh or eighth century
Size: warp 21.8 cm., weft 10.5 cm.
Technical information: tapestry-weave, slit and dovetailed;
warp—wool s-spun; weft—wool s-spun and cotton s-spun
Colors: red ground with white (cotton), blue, yellow, green,
and brown
Pattern description: a walking ram with neckband and fluttering
ribbons; traces of an enclosing border
The Metropolitan Museum of Art; Anonymous gift
(1977.232)

It is difficult to determine with certainty the precise date and origin of this textile fragment which was acquired in Egypt. Its style as well as the technique have affinities with wool textiles of Coptic manufacture, but the beribboned ram is clearly of Sasanian inspiration. The gait of the animal and certain stylistic details such as the horns, shown frontally, and the neckband and fluttering ribbons are characteristic features of this motif as it occurs on Sasanian seals and stucco.

Like the textile bearing a mountain goat (No. 55), presumably woven in Iran or Iraq, this textile has a red ground and has been woven with both slit tapestry and dovetailing.[1] This ram may also be compared with the beribboned rams on pattern-woven silks excavated at Antinoë,[2] which probably share the same origin as the winged horse silk (No. 56). The naturalistic folds of ribbons shown on the silks have been reduced here to a static sequence of solid colors without any attempt to indicate depth or movement. The musculature and shading of the shoulders of the rams from Antinoë have been transformed in this textile into a floral design; other anatomical details are rendered as tiny geometric patterns, but the fetlocks and dewlap, as well as the facial features, are carefully marked.

The proliferation of Sasanian motifs in the arts of neighboring lands and the diffusion of Sasanian art after the fall of the dynasty contribute to the inherent difficulties of identifying the origins of ancient textiles bearing Sasanian designs such as this fragment.

Notes
1. See also R. Pfister, "Le Rôle de l'Iran dans les textiles d'Antinoé," *Ars Islamica* 13–14 (1948), fig. 76.
2. R. Ghirshman, *Persian Art* (New York, 1962), figs. 273, 277, p. 229.

SEALS

The carved designs on seals preserve, more completely than any other medium, the motifs of ancient Near Eastern art. These small stones are an invaluable source of information, illustrating in detail subjects that were part of a well understood and widely used language of imagery.

Some of the stamp seals of the Sasanian period are superb miniature works of art. Elaborate designs are carved on stones of spectacular color. The range of motifs is wide, in spite of the fact that subjects with a symbolic meaning were generally chosen. Recent studies[1] have reaffirmed earlier theories[2] concerning the astrological significance of many seal designs. Still, it is only in rare instances that a divinity can be identified, as on the seal from the Staatliche Münzsammlung in Munich that has an image of the moon god in his bull-drawn chariot (No. 74).

Frequently the seals have Middle Persian inscriptions carved around the borders. The legends—often abbreviated and difficult to decipher—give the names and occasionally the ranks of the owners, as well as pious exclamations. Regrettably, they provide few clues to the interpretation of the animal and plant designs. Although disappointing in this respect, the legends are an important aid to the art historian. Because the letters of the Middle Persian script changed in shape during the Sasanian period, inscribed seals can be dated with some accuracy. Subjects, seal shapes, glyptic styles, and details in the representations can be arranged with confidence in a broad chronological sequence. This is a valuable contribution to the study of Sasanian art, a field sadly lacking in securely dated monuments.

The ownership of seals during the Sasanian period was not limited to officials and wealthy property owners. The minute size and poor quality of vast numbers of Sasanian seals show that the owners were not always persons of means. In the increasingly bureaucratic Sasanian government, there must have been occasions when almost everyone was obliged to leave his or her mark on some document.

This selection of seals does not attempt to cover a wide range of motifs, shapes, or styles. The seals have been chosen because of their relationship to other objects in this exhibition and because, in some instances, they are rare and beautiful examples of the art of Sasanian seal carving.

Notes

1. A. D. H. Bivar, *Catalogue of the Western Asiatic Seals in the British Museum, Stamp Seals,* II: *The Sassanian Dynasty* (London, 1969); A. Ia. Borisov and V. G. Lukonin, *Sasanidskie Gemmy* (Leningrad, 1962); C. J. Brunner, *Catalogue of Sasanian Stamp Seals in The Metropolitan Museum of Art* (New York: The Metropolitan Museum of Art, forthcoming).

2. P. Ackerman, "Sāsānian Seals," in *A Survey of Persian Art*, ed. A. U. Pope (London/New York, 1938), I, pp. 784–815.

65

Amethyst seal with Bahram, the Kirmanshah

Inscribed: Bahram Kirmānshah, son of the Mazda-
worshipping god Shapur, king of kings of Iran and
non-Iran, the offspring of the gods[1]
Third century
Height 3.2 cm., width 2.6 cm. Modern setting
Devonshire Collection, Chatsworth

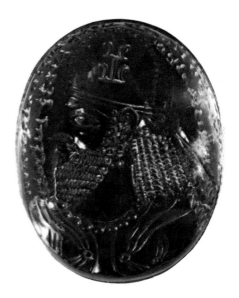

During the Sasanian period, various parts of the empire were ruled by princes of the royal family. Some were kings of Sakastan; others, of Armenia, Kirman, and Gilan. Many of their titles are known from the early dynastic, rock-cut inscriptions in southern Iran.

The subject of this famous amethyst seal is Bahram, king of Kirman. Once thought to be Bahram IV (388–399), the prince is now recognized as an earlier ruler, probably the future Bahram I (273–276).[2] His image on this seal resembles those of members of the royal family on early Sasanian rock reliefs. The tall cap bears a device or hereditary sign commonly found on the headgear of Sasanian royalty and nobility.

The seal is characteristic of the earliest period of Sasanian glyptic. The pupil is placed high in the almond-shaped eye and the beard is marked into neat horizontal divisions. By the fifth century, there was a distinct change in style. On the seal of the official Vehdin-Shapur (No. 72), the uneven hatching of the beard and the treatment of the locks of hair, the ear, and the surface of the cap give the figure a decorative appearance totally different from that of Bahram on this gem.

The inscription on the seal in the Devonshire Collection is unusual in its length, although the elaborate wording of the legend is typical of royal Sasanian monuments. The carver of the inscription started on the inner of the two concentric lines, continued on the outer rim, and finally, having run out of space, was forced to put the last phrase close to the image behind the cap and hair. Obviously he lacked the skill and experience of the artisan who carved the image of the Kirmanshah.

The execution of this beautiful amethyst seal is purely Iranian. The gem is representative of the finest early Sasanian seals on which human subjects are depicted with naturalism and delicacy. This is a formal image rather than a portrait. Appropriately, the subject is not an ordinary man but a prince of the royal house, the son of the Sasanian king.

Kushano-Sasanian Coins: Sasanian Seals in the British Museum, ed. A. D. H. Bivar (London, 1968), p. 21, pl. XXX.

Selected Bibliography
Pope, *A Survey of Persian Art,* IV, pl. 255 C; *Corpus Inscriptionum Iranicarum,* Pt. III, vol. VI: *Kushan and Kushano-Sasanian Seals and*

Notes
1. For advice on the inscription, I am grateful to Christopher J. Brunner.
2. P. O. Harper, "Sasanian Medallion Bowls with Human Busts," *Near Eastern Numismatics, Iconography, Epigraphy and History, Studies in Honor of George C. Miles,* ed. D. K. Kouymjian (Beirut, 1974), p. 69.

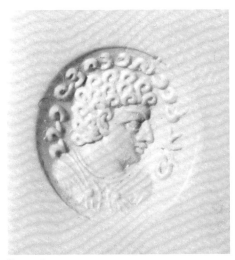

Impression

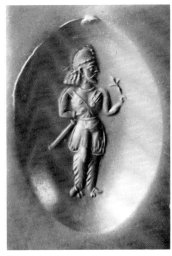

Impression

66

Carnelian seal with a male bust

Inscribed: M. the scribe
Third century
Height 1.3 cm., width 1.2 cm.
The British Museum, Department of Western Asiatic
 Antiquities (BM 120195)

The male portrayed on this seal is probably the owner, a
scribe. Although the carefully delineated curls and the
absence of a beard are not typical of male figures on Sasa-
nian seals, there are a few parallels. Christopher Brunner
has observed that similar types appear on Roman coins
and seals and has suggested that the scribe is from Meso-
potamia or Syria, the western part of the Sasanian Empire,
rather than Iran.[1]

Two silver vessels, from the second half of the Sasanian
period (Nos. 8, 13), have representations of heroic or
divine persons who are beardless and whose hair is ar-
ranged in clearly defined short curls. In both instances,
the figures are derived from Western mythological pro-
totypes—the Dioscuroi and Heracles. Their non-Iranian
appearance reflects their Western origin and indicates
that they are foreign to Iran, as is the scribe on this seal.

Selected Bibliography
P. O. Harper, "The Heavenly Twins," *The Metropolitan Museum
of Art Bulletin* n.s. 23 (1964–65), p. 191, fig. 6; Bivar, *Stamp Seals*,
II, p. 44, pl. 1, AA5; Brunner, *Catalogue of Sasanian Stamp Seals*.

Notes
1. Brunner, *Catalogue of Sasanian Stamp Seals*.

67

Onyx seal with a standing noble or prince

Third or early fourth century
Height 3.3 cm., width 2.2 cm.
The Metropolitan Museum of Art; Rogers Fund (22.139.41)

No inscription accompanies this image of a Sasanian
nobleman or prince of the royal family, and his identity
remains unknown. On Sasanian seal stones, full-length
figures are rare unless they are depicted taking part in
some action or ceremony. This example shows the figure
simply standing, grasping a plant in one hand and holding
the hilt of his sword in the other. The dress and pose are
comparable to those of male figures on early Sasanian
rock reliefs.

The seal is made of the same stone—onyx—as the Brit-
ish Museum seal of Bahram IV (388–399) (No. 71). The
Metropolitan Museum seal is simpler in design, and the
carving is less fine and precise. The two dots, supposedly
clasps holding a cloak on the chest, are represented askew
and there is no cloak hanging behind or around the body.
The flower is sketchily drawn. These signs of carelessness
or inexperience in workmanship contrast with the quality
and beauty of the stone.

Selected Bibliography
H. H. von der Osten, "Ancient Seals from the Near East in The
Metropolitan Museum," *Art Bulletin* 13 (1931), pp. 233, 240;
Brunner, *Catalogue of Sasanian Stamp Seals*.

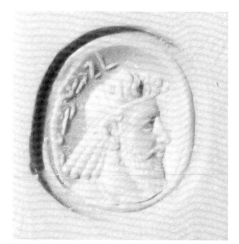

Impression

Profile views of No. 68, No. 69A, and No. 66.

68

Garnet gem with a male head

Inscribed: Narseh-shah
Third or fourth century
Height 1.3 cm., width 1.4 cm.
The British Museum, Department of Western Asiatic
 Antiquities (BM 120210)

The realism of this portrait is characteristic of a few early Sasanian seals that were influenced by the glyptic of the eastern Mediterranean world. The stone has been cut down from its original shape, but even when complete, the image probably included only the head, neck, and part of the chest, rather than the entire bust. This abbreviated type of human bust is characteristic of Imperial Roman portrait seals but not of the Sasanian examples (see Nos. 65, 72). Roman seals were not only copied but also treasured and reused by Sasanian owners,[1] and the adoption of the Western form reflects this appreciation of Roman glyptic styles.

This seal is inscribed with the name of Narseh-shah, a ruler of some part of the early Sasanian Empire but not necessarily a member of the Sasanian royal house. The curls rising up from the forehead are an unusual form of hair style, resembling that on a fragmentary human figure from a hunting plate, once in Berlin.[2] The seal, which has been placed in a modern gold setting, was in the collection of Sir Henry Rawlinson who was, from 1851, in control of the excavations of The British Museum in Mesopotamia.

A comparison between this seal and that of the scribe (No. 66) illustrates the correlation between wealth and quality of workmanship. The fine Sasanian gems are invariably those belonging to members of the royalty or high nobility, such as Narseh-shah.

The portrait of Narseh-shah is indistinguishable, except for hair style and jewelry, from the most perfectly executed seal portraits of Imperial Roman emperors. In this sense it provides a contrast to the equally fine but more typically Iranian seal of Bahram, the Kirmanshah (No. 65).

Selected Bibliography

Pope, *A Survey of Persian Art*, IV, pl. 255 P; Bivar, *Stamp Seals*, II, p. 44, pl. 1, AA3.

Notes

1. G. M. A. Richter, *The Engraved Gems of the Greeks, Etruscans and Romans*, Pt. II: *Engraved Gems of the Romans* (London, 1971), p. 105, fig. 504bis; R. Curiel and H. Seyrig, "Une Intaille iranienne," in *Near Eastern Numismatics, Iconography, Epigraphy and History, Studies in Honor of George C. Miles*, ed. D. K. Kouymjian (Beirut, 1974), pp. 55–59.
2. F. Sarre, *Die Kunst des alten Persien* (Berlin, 1922), fig. 14.

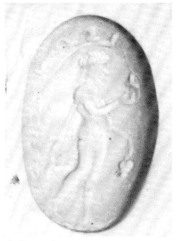

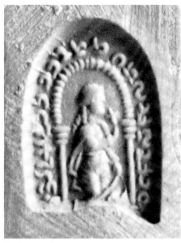

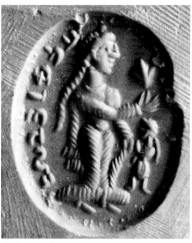

A. Impression　　　　*B. Impression*　　　　*C. Impression*

69
Three seals

A. Almandine seal with a nude female figure
Inscribed: Buxtsapur (male name)
Fourth century
Height 1.5 cm., width 1.0 cm.
The British Museum, Department of Western Asiatic
　Antiquities (BM 119610)

B. Jasper seal with a female figure beneath an arch
Inscribed: Pērōzdukht, Mihr-S . . . (Mihr-Sarēnān-nazd?
　female name)
Fourth century
Height 1.7 cm., width 1.1 cm.
The British Museum, Department of Western Asiatic
　Antiquities (BM 120216)

C. Chalcedony seal with a female and small male figure
Inscribed: Armindukht (female name)
Fourth century
Height 1.7 cm., width 2.2 cm.
The British Museum, Department of Western Asiatic
　Antiquities (BM 119358)

Because dancing female figures are common on Sasanian vases and ewers (No. 18), it is interesting to note the presence of a related theme on Sasanian seal stones. These seals are earlier than any of the silver vessels and indicate that both clothed and nude female forms were represented in Sasanian glyptic by the fourth century. Other illustrations of this type of subject in early Sasanian art are provided by the third-century mosaic panels from Bishapur.

On the first of these three seals, a nude woman holds a flower and a bunch of grapes. On the second, a clothed woman standing under an arch holds a plant and a fold of her garment. The woman on the third seal holds a flower in one hand and her garment in the other. She is accompanied by a small figure, identified as male by his form of dress (see No. 71). He raises his arm, probably in a gesture of respect toward the woman. On Sasanian seals, women are also shown holding other objects, birds, or vessels, but the flower is by far the most common attribute.

These seals offer no solution to the perplexing problem of the significance of the figures. The inscriptions give the names of both females and males so the subject was not associated only with members of one sex. David Bivar identified women of this sort as representations of Anahita, the Zoroastrian goddess of fertility and abundance.[1] Christopher Brunner and David Bivar both note that the arch (as shown on the second seal) appears on seals including fire altars and probably indicates a temple enclosure.[2] Some female figures may, therefore, be priestesses or divinities, but there are others that cannot be definitely connected with a cult. None is unquestionably the goddess Anahita.

Probably the figures on these seals are the prototypes, in form at least, for the motifs on later silver vessels. Whether the meaning remains the same is unclear.

Note on inscription of No. 69B:

The inscription on this seal is carefully written in the glyptic (i.e., inscriptional) form of Middle Persian script used in the fourth century A.D. It indicates the name of the owner, as is common, but contains unusual features. In Sasanian Iran, each individual had at least two names: a personal name and a patronymic. (Nobles might acquire additional, honorific names.) A man's patronymic consisted of his father's name plus the suffix *-an*. A woman's patronymic begins the inscription: pylwcdwḥty, "Pērōz-duxt" (i.e., "Daughter of Pērōz"). The word that follows is not a simple personal name, such as might be expected. It appears to read: mtrs(l)y(n)ʿnzd(y). This could be interpreted as "Mihr-Sarēnān-nazd," which would mean either "relative of the Mihr-Sarēn family" or perhaps "next-of-kin of Mihr, the son of Sarēn." (One is tempted to read "Surēn," for the famous clan name which is properly "Sūrēn.") In this context, which is not paralleled on other published seals, the word *nazd* (*cf.* Persian *nazdik* as "relative") would surely have had a precise legal sense; perhaps it is "near relative, who holds a power of attorney or is acting as executor of a family's estate." If this is so, then the seal would be identifying the owner's special status and authority during a particular period of time, perhaps only a few years; and the absence of parallels would be understandable. *Christopher J. Brunner*

Selected Bibliography
Bivar, *Stamp Seals*, II, p. 61, pl. 7, CA1; p. 62, pl. 7, CB1; p. 63, pl. 7, CC1.

Notes
1. Bivar, *Stamp Seals*, II, p. 25.
2. Brunner, *Catalogue of Sasanian Stamp Seals.*

Profile views of No. 70 and No. 69C.

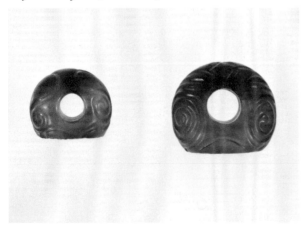

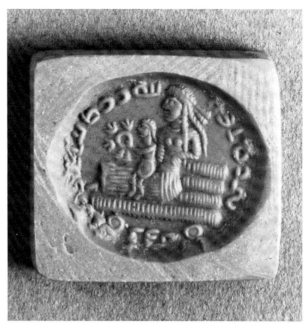

Impression

70

Chalcedony seal with a reclining female figure

Inscribed: Hupand, reliance on the gods
Fourth century
Height 1.6 cm., width 1.9 cm.
The British Museum, Department of Western Asiatic
* Antiquities (BM 119359)*

Although male figures are commonly shown reclining on couches (No. 73), there are few representations of women in this pose. On this seal, the female figure wears a beaded diadem and holds in her lap a small male who grasps a wreath of flowers. A similar wreath appears alone with a hand on some Sasanian seals and David Bivar has suggested that the hand symbolizes a pledge of faith.[1]

There is no way of knowing whether the woman on this seal is a goddess. However, the pose is typical not of Sasanian divinities but rather of human figures. It is possible that the meaning of the scene is connected with the birth of a male child.

Selected Bibliography
Bivar, *Stamp Seals*, II, p. 64, pl. 8, CD1.

Notes
1. Bivar, *Stamp Seals*, II, p. 25.

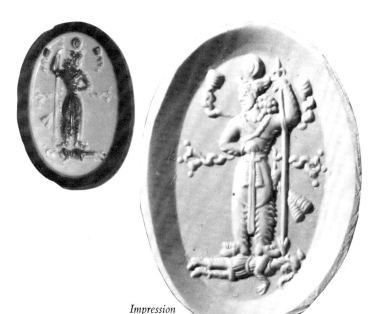

Impression

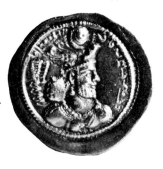

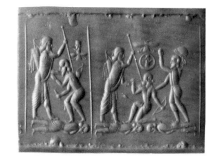

Fig. 71a. Right, top. *Coin of Bahram IV. The American Numismatic Society.*

Fig. 71b. Right, below. *Impression of an Achaemenid cylinder seal. Fifth century B.C. Oxus Treasure. The British Museum (WAA 124015).*

71

Onyx gem with the image of Bahram IV

Fourth century
Height 3.1 cm., width 1.9 cm.
The British Museum, Department of Western Asiatic
Antiquities (BM 119352)

This gem is the only certain example of a seal stone carved by a Sasanian craftsman with the image of a Sasanian king. The crown, decorated with a stepped crenellation and a wing, identifies the monarch as Bahram IV (388–399) (fig. 71a). He stands with one hand resting on his sword and the other holding a spear. The pose is reminiscent of the description of this king given by the tenth-century Arab author, Hamza al-Isfahani, who provides a list of the images of all Sasanian kings.[1] In this largely apocryphal account, Bahram IV is said to appear standing equipped with a lance and a sword. The point of the spear in the seal carving in the British Museum rests on a dead enemy. This method of portraying victory over an enemy is characteristic of the art of the ancient Near East (fig. 71b). The slain figure wears loose trousers and a short tunic, the apparel of eastern subjects of Shapur I (241–272), depicted on one of his reliefs at Bishapur.[2] The fact that General Sir Alexander Cunningham, the original owner of the seal, spent much of his life in India and Afghanistan suggests that the seal was acquired in one of these places. If so, the stone may have belonged to a Sasanian governor of some eastern territory, perhaps to a royal prince. The son of Bahram IV, also named Bahram, is believed by Vladimir Lukonin to have ruled in the East while his father was king of Iran.[3]

The impression of the seal shows the king in left profile, whereas the right profile is the standard form, characteristic of Sasanian coins and the impressed images of the seals. The implication is that this royal stone was primarily a gem, rather than a seal. The appearance of the stone supports this theory: the figures stand out in dark silhouette against the white layer of stone which forms the background. Moreover, it is in the carving, not in the impression, that the preferred right hand holds the most important attribute, the weapon of victory.

This royal gem is a miniature work of art of the same high quality as many of the coins of Bahram IV. The skillful handling of onyx to achieve a deliberate contrast between the dark images and the light background contributes to the beauty of the piece.

Selected Bibliography
Pope, *A Survey of Persian Art*, IV, pl. 255 A; Bivar, *Stamp Seals*, II, p. 56, pl. 4, BC1.

Notes
1. K. Erdmann, "Die Entwicklung der sāsānidischen Krone, *Ars Islamica* 15–16 (1951), p. 101.
2. R. Ghirshman, *Bîchâpour*, I (Paris, 1971), pl. 13.
3. V. G. Lukonin, "Kushano-sasanidskie monety," *Epigraphika Vostoka* 18 (1967), p. 30.

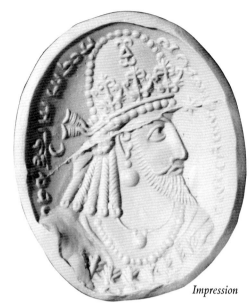

Impression

72

Carnelian seal of Vehdin-Shapur

Inscribed: Vehdīn-Shāpūr, chief storekeeper of Iran
Fifth century
Height 4.6 cm., width 3.8 cm.
The British Museum, Department of Western Asiatic
Antiquities (BM 119994)

Vehdin-Shapur, the man whose image appears on this
seal, has been identified by Ernst Herzfeld as an official
under Yazdegird II (438–457). The elaborate decoration
of the tall cap is a sign of his rank. On the brim, above the
forehead, there is an unusual arrangement of stylized
plants, each of which rises from a pair of upturned wings.
The decorative linear quality of this carved image is par-
ticularly noticeable. In the execution of the ear, the artist
has transformed the natural part into an exceptionally
rich, curvilinear pattern. The details of the representation
on this seal and the form of the letters in the inscription
accord with a date in the fifth century. The leaf border
beneath the bust of Vehdin-Shapur does not occur on
seals before the fourth century, although it exists earlier
on silver vessels (see No. 2) and derives ultimately from
the West. Originally mounted, the seal was probably
worn on a necklet similar to the one depicted in the carv-
ing, or on an armlet, according to a Sasanian custom
described in the *Shah-nameh*.[1]

Few large seals of this excellence have survived (com-
pare No. 65). Two examples comparable to this piece in
size and richness of detail are known only from their
impressions, left on clay sealings excavated at Susa[2] and
Qasr-i Abu Nasr in Iran.[3]

Selected Bibliography
E. Herzfeld, *Paikuli*, I (Berlin, 1924), pp. 79, 167; Pope, *A Survey
of Persian Art*, IV, pl. 255 D; Bivar, *Stamp Seals*, II, p. 49, pl. 3,
ADI.

Notes
1. Bivar, *Stamp Seals*, II, p. 22.
2. *Revue d'assyriologie et d'archéologie orientale* 46 (1952), p. 6, fig. 6.
3. R. N. Frye, ed. *Sasanian Remains from Qasr-i Abu Nasr* (Cam-
 bridge, Mass., 1973), p. 86, impression no. DI.

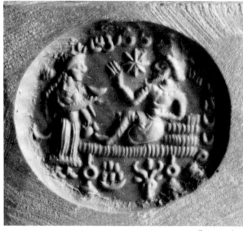

Impression

73

Agate seal with a banqueting scene

Inscribed: Reliance on the gods
Ca. fifth-sixth century
Height 2.2 cm., width 2.4 cm.
The British Museum, Department of Western Asiatic
Antiquities (BM 119703)

The superbly executed scene on this agate seal is compa-
rable to that on a silver bowl in the Sackler collection
(No. 25).[1] A man sitting on a banqueting couch is
approached by a woman carrying a wine jug and a bowl.
They are probably husband and wife, rather than master
and servant, since the man already holds a bowl and
raises his hand to greet the woman rather than to receive
the vessel she holds. Related scenes of marriage in which
a man and a woman sit on a couch and grasp a wreath
between them occur on Sasanian seals and silver vessels.[2]
Because marriage was considered a form of contract, this
subject was appropriate for a seal. Beneath the couch lie
another bowl of food and a saiga antelope head, which
may be a container for wine (see No. 16) or simply an
indication of the man's prowess as a hunter. The latter
interpretation is given to a row of boar's heads, beneath
a banqueter's couch, on a silver vessel in The Walters Art

Gallery in Baltimore.[3] The star directly before the face of the male and the crescent behind the female are symbols commonly placed in the field on Sasanian seals. They also become canonical on the reverse of Sasanian coins from the time of Peroz (459–484) onward, appearing on either side of the fire altar. Later, under Kavad I (499–531), the crescent and star together decorate the border of the coins on the obverse and under Khusrau I (531–579) these popular symbols are customarily placed on the shoulders of the king's garment.[4]

The material, agate, and the detailed execution of the banqueting scene indicate that this seal was owned by a person of rank and wealth, able to afford the services of a skilled artisan.

Selected Bibliography
Bivar, *Stamp Seals*, II, p. 65, pl. 8, CF1.

Notes
1. According to David Bivar, the seal was originally "an ellipsoid, later recut to a bezel shape."
2. Bivar, *Stamp Seals*, II, p. 25; see note 3 below.
3. R. Ghirshman, "Notes iraniennes V: Scènes de banquet sur l'argenterie sassanide," *Artibus Asiae* 16 (1953), pp. 63–65, fig. 14.
4. R. Göbl, *Sasanian Numismatics* (Braunschweig, 1971), pp. 15, 21.

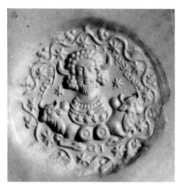

Impression

74
Onyx seal with the figure of a moon god in a chariot

Inscribed: Tahmdēni, witnessed by my person[1]
Ca. fifth–sixth century
Height 2.1 cm., width of seal face 2.6 cm.
Staatliche Münzsammlung, Munich

It is rare that the images of divinities on Sasanian seals can be identified with some certainty. In this instance, the scene appears to represent the Zoroastrian moon god, Mah, riding in a chariot (symbolized by two wheels)

drawn by humped bulls. In the field is a Middle Persian inscription. The ends of the crescent moon emerge from behind the god's head; and a vine scroll, with bunches of grapes and leaves, winds around the border of the seal. In Avestan literature, Mah contains within his being the seed of the bull and is "bright, glorious, water-giving . . . wisdom-giving, wealth-giving . . . prosperity-giving."[2] According to one Pahlavi text, *The Counsels of Adhurbadh, Son of Mahraspand*, the orthodox Zoroastrian was encouraged to take part in certain activities on different days of the month: "On the day of Mah (the Moon) drink wine and hold converse with your friends and ask a boon of King Moon."[3] This may explain the presence of the grape vine surrounding the image.

This scene of a moon god has a close parallel in the depiction of a sun god on a seal once in Berlin and now lost.[4] It showed a male bust with rays around the head, above a pair of wheels and winged horses. Other examples of a sun god with chariot and horses occur in impressions of Sasanian seals and clay sealings, excavated by the Russians at Ak Tepe in Turkmenistan.[5] Better known than these Sasanian representations, however, are the solar images, including a horse-drawn chariot, that are widespread in the art of both the East and West at periods preceding and contemporary with the Sasanian dynasty.[6] Images of a male moon god in a chariot are rarer than those of the sun. No other Sasanian seal has this motif, and there are no other unquestioned representations of Mah in Sasanian art.

The stone used for the seal and the remarkably detailed carving of the scene are indications of its value. The original owner may not have been Tahmdeni since the placement of the letters in the field suggests that the inscription is a later addition.

Selected Bibliography
R. Göbl, *Der sāsānidische Siegelkanon* (Braunschweig, 1973), pl. 6, no. 7d.

Notes
1. Inscription translated by C. J. Brunner.
2. *The Zend-Avesta*, trans. J. Darmesteter, pt. 2 (Oxford, 1883), pp. 88–91.
3. R. C. Zaehner, *The Teachings of the Magi* (New York, 1976), p. 108.
4. E. Herzfeld, "Die sasanidischen Quadrigae Solis et Lunae," *Archaeologische Mitteilungen aus Iran* 2 (1930), pp. 128–131.
5. A. Gubaev and L. A. Lelekov, "Bully sasanidskogo perioda iz Ak-Depe," in *Karakumskie Drevnosti*, III (Ashkhabad, 1970), pp. 105–107; V. G. Lukonin, "Po povodu bull iz Ak-Depe," *Epigraphika Vostoka* 20 (1971), pp. 50–52.
6. J. Rosenfield, *The Dynastic Arts of the Kushans* (Berkeley/Los Angeles, 1967), pp. 189ff.; E. Herzfeld, "Der Thron des Khosrô," *Jahrbuch der Preuszischen Kunstsammlungen* 41 (1920), pp. 105–136.

GLASS

Glass-blowing was invented in the late first century B.C. in the Syro-Palestinian region of the Roman Empire. The resulting mass production of glass led to the export of Roman vessels throughout the ancient world. It is not surprising, therefore, that in the Near East, Sasanian glass vessels reflect the influence of Western prototypes in both their shape and decoration. In some instances, it is difficult to know whether the glasses found in Mesopotamia and Iran are imports, products of Syrian craftsmen, or actually works made by Sasanian artisans.

By the middle of the first millennium A.D., glass-making centers in Mesopotamia were active. Numerous fragments of glass have been found at Sasanian sites such as Kish, Choche, Ctesiphon, and Tell Mahuz.[1] Less is known of the glass from Iran. Although expeditions working in the northwestern part of the country uncovered a few Sasanian graves containing glass vessels,[2] almost none of the glass in public and private collections alleged to have originated in Iran comes from scientifically excavated sites. Because most of this glass is well preserved, it can be assumed that the vessels were found in tombs.

During the Sasanian period, glass served not only as a luxurious form of tableware but also as a rich and colorful architectural decoration. According to ancient sources, Khusrau I (531–579) took glass mosaics from Antioch, presumably to serve as models for the decoration of the ceilings of his palace at Veh-Antioch-i-Khusrau near Ctesiphon. The literary accounts are supported by the discovery of actual fragments of glass mosaics at Ctesiphon during the excavation of the homes of wealthy Sasanian nobles.[3]

Common, mass-produced objects invariably survive in greater quantity than precious works of art. As a result our understanding of the more sophisticated levels of craftsmanship, particularly in a fragile material like glass, is limited. No certain examples of Sasanian gold glass vessels exist to parallel the early Christian and Byzantine production, but the minute gold glass tesserae and beads from Sasanian sites suggest that some gold glass vessels probably were produced in the Sasanian Near East. An elaborate relief-cut bowl in the Museum für Kunst und Gewerbe, Hamburg, and other Sasanian vessels with carved discs and knobs illustrate a type of decoration that was more popular in the early Islamic period.[4] Generally, the relief-cut designs on Sasanian glasses are geometric patterns. An exceptional object is the rock crystal medallion set in a gold bowl in the Bibliothèque Nationale (fig. C, p. 80). The enthroned king carved in relief prefigures the plant and animal motifs which appear on Islamic relief-cut glass and rock crystal vessels.

Other types of decoration on Sasanian glasses are less elaborate. Applied threads, mold-blown ribs, and pinched knobs often enrich the surface. None of these techniques is specifically Sasanian, and Roman glasses provide close parallels for the Sasanian patterns. The quantity of Near Eastern glass vessels and fragments with wheel-cut facets probably indicates a particular Sasanian (perhaps Iranian) preference for a form of decoration that produces an infinite play of light over the surface. At Dura-Europos in eastern Syria, glasses with wheel-cut patterns constitute the largest class of objects in levels of the early third century, the period just before the destruction of the city by the second Sasanian king, Shapur I (241–272).[5] In Iran and Mesopotamia the wheel-cut

designs have less variety than at Dura-Europos. Undoubtedly, the stimulus for the production of vessels decorated with cut facets came to the Orient from the West.

There has been no excavation of a Sasanian city in the Near East comparable to that at Dura-Europos, where a quantity of common and luxury glassware was found. The Near Eastern glasses are largely chance discoveries and, without archaeological evidence, no accurate chronology can be established for the shapes and designs of the Sasanian vessels. Comparisons with Imperial Roman examples and occasional documented discoveries within the Near East offer, at best, general indications of changes in design and decoration over a long period of time. The manufacture of glass vessels was, apparently, a conservative craft. In some instances Sasanian glass is almost indistinguishable from that of the Imperial Roman and early Islamic periods. Nevertheless, certain forms of glass appear to be characteristically Near Eastern (Nos. 76, 77, 78).

Most Near Eastern glass is slightly greenish, the result of iron impurities in the raw material. More unusual are the deep red and violet-hued vessels from Mahuz and Choche (similar to No. 75). Perfectly clear glasses of Near Eastern provenance are rare, and rock crystal must always have been treasured for its colorless translucence. During the Sasanian period rock crystal was used for both vessels (No. 29) and small figurines.[6] Regrettably, nothing comparable to the early Islamic rock crystal vessels with richly carved decoration has survived from Sasanian times.

The Chinese referred to glass as the noble stone of the West, and the export and influence of Roman wares throughout the ancient world is well documented. Less is known of the trade in Sasanian glasses. It is unlikely that they were in great demand in the West, where the markets were already flooded with glass. In the East, one type at least was highly regarded. A Sasanian faceted bowl was found in the tomb of the sixth-century Japanese emperor Ankan. Another, similar piece, retaining its original translucence with no trace of weathering, is among the objects preserved in the eighth-century treasury, the Shoso-in, at Nara, Japan.[7] These late Sasanian glasses were probably carried to the East in the sixth and early seventh centuries, when Persian merchants and embassies traveled widely across Asia. Some may have been taken by the last Sasanian princes, who fled eastward from the Arab invaders and installed themselves in China, hoping to return at some future time to regain the throne of Iran.

Notes

1. O. Puttrich-Reignard, *Die Glasfunde von Ktesiphon* (Kiel, 1934); S. Langdon and D. B. Harden, "Glass from Kish," *Iraq* 1 (1934), pp. 131–136; M. Negro Ponzi, "Sasanian Glassware from Tell Mahuz," *Mesopotamia* 3/4 (1968–69), pp. 293–384; A. von Saldern, "Achaemenid and Sasanian Cut Glass," *Ars Orientalis* 5 (1963), pp. 7–16.
2. T. Sono and S. Fukai, *Dailaman III* (Tokyo, 1968), pl. 41.
3. O. Reuther, "The German Excavations at Ctesiphon," *Antiquity* 3 (1929), pp. 445–446.
4. A. von Saldern, "Sassanidische und islamische Gläser in Düsseldorf und Hamburg," *Jahrbuch der Hamburger Kunstsammlungen* 13 (1968), pp. 33–62.
5. C. W. Clairmont, *The Glass Vessels*, Dura-Europos, Final Report IV, Part V (New Haven, 1963).
6. R. N. Frye, ed., *Sasanian Remains from Qasr-i Abu Nasr* (Cambridge, Mass., 1973), fig. 14.
7. S. Fukai, *Study of Iranian Art and Archaeology* (Tokyo, 1968), pp. 10–11, figs. 1–3.

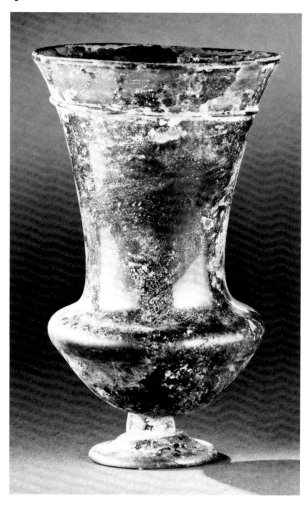

Fig. 75a. *Glass beaker. Late second century A.D. H. 12.5 cm. Kölnisches Stadtmuseum.*

75

Purple glass beaker

Near East; third century
Height 15.3 cm., diameter of rim 10 cm.
The Corning Museum of Glass, Corning, N.Y. (62.1.8)

This translucent purple beaker, an example of fine glassware, rests on a narrow foot attached by a small wad of glass that serves as a stem. Except for a delicate thread in the same purple glass that is attached below the flaring rim, the piece is undecorated. The date of this vessel is difficult to determine. Little is known of the glass production in the Near East during the early Sasanian period, because no corpus of dated material from excavated sites exists.

During the early centuries of the Christian era, Roman glasses were exported throughout the ancient world. They influenced the form and design of vessels in areas as widely separated as western Europe and the Near East.

A close parallel for this beaker is a Roman vessel found in Germany.[1] It dates to the end of the second century A.D. (fig. 75a). Although the silhouette of the Roman piece is less curvilinear and the construction of the foot is different, this beaker from the Corning Museum probably developed from some such late Roman prototype.

The purple color seen here is rarely found among glass objects from Iran. However, fragments of glass discovered in early Sasanian contexts at Tell Mahuz and Choche, in Mesopotamia, exhibit a considerable range of color, including reds and violets.[2] It is probable that there were also richly colored Iranian glasses, at present unknown to us.

Notes

1. F. Fremersdorf, *Römische Gläser mit Fadenauflage in Köln*, Die Denkmäler des römischen Köln V (Cologne, 1959), pls. 66, 67.
2. Negro Ponzi, "Sasanian Glassware from Tell Mahuz," p. 377.

Fig. 76a. *Pierced glass vessel. Ca. fifth century. H. 27.8 cm. Sasanian, Iran. The British Museum (WA 135712).*

76

Pierced glass vessel with two handles

Iran(?); fourth or fifth century
Height 33.1 cm., greatest diameter 11.2 cm.
The Metropolitan Museum of Art; Fletcher Fund (64.60.1)

Made of transparent glass with a greenish tinge, this vessel has handles composed of twisted coils of glass. Wheel-cut facets decorate the narrow tapering body, which is pierced at the base. This glass originally served as a drinking vessel or container from which smaller bowls were filled. The hole drilled in the center of the base allows for the passage of a thin stream of liquid. The piece was allegedly found with an identical vase, now in the Norbert Schimmel collection.[1]

Parallels for the flaring mouth and curved molding beneath the rim can be found on fourth-century glass vessels from Tell Mahuz in northern Mesopotamia.[2] Particularly close in design to this container are two others,

lacking handles, in the Field Museum of Natural History in Chicago[3] and The British Museum (fig. 76a). The vessel in the Field Museum was found during the excavations at Kish in southern Mesopotamia and probably dates to the fifth century.

The almost perfect state of preservation of the vessels in the Metropolitan Museum and Schimmel collections suggests that they were interred in a tomb. A striking contrast is provided by the fragmentary and badly weathered vase of similar shape in the Field Museum discovered in an occupation level at Kish.

Selected Bibliography
"Recent Important Acquisitions," *Journal of Glass Studies* 7 (1965), p. 123, no. 11.

Notes
1. O. W. Muscarella, ed., *Ancient Art, The Norbert Schimmel Collection* (Mainz, 1974), fig. 168.
2. Negro Ponzi, "Sasanian Glassware from Tell Mahuz," pp. 349–350, fig. 156.
3. Field Museum of Natural History, Chicago. Unpublished, Kish no. 157024.

77
Glass bowl with an outward curving rim

Iran(?); late fourth or fifth century
Height 5.5 cm., diameter 16.9 cm.
The Walters Art Gallery, Baltimore (47.431)

Made of slightly greenish glass, this bowl is decorated on the exterior with wheel-cut fluting below the rim and patterns of concentric circles on the body. A number of Sasanian glass vessels of this type are in public and private collections.[1] Their source is allegedly Iran, and the fabric usually has a greenish tinge. Some are deeper than the Walters bowl, but this probably has no chronological significance because the wheel-cut designs are essentially the same on both shallow and deep vessels.

Glass bowls such as this were popular over the millennia in the Near East. The distinctive, everted, flaring rim relates the Sasanian examples to Assyrian and Achaemenid bowls made more than a thousand years earlier in both precious metals and glass. Nor is the decoration of this bowl uniquely Sasanian. The fluted pattern beneath the rim combined with circles on the body occurs on fragments of molded glass bowls of the fourth and fifth centuries from Egypt.[2] Many of the third-century glasses found at Dura-Europos also have circular designs divided by wheel-cut lines.[3]

The use of the Sasanian bowls is unknown. They may have served as conventional receptacles for liquids or foods, or have been used for lamps. An early Islamic bowl, mounted as a lamp, is preserved in the Treasury of St. Mark's Cathedral in Venice.[4]

Selected Bibliography
"Recent Important Acquisitions," *Journal of Glass Studies* 13 (1971), p. 139, no. 29.

Notes
1. von Saldern, "Achaemenid and Sassanian Cut Glass," figs. 4, 5; W. C. Braat, "The Glass Collection of the Rijksmuseum van Oudheden at Leiden," *Oudheidkundige Mededeelingen* 45 (1964), pp. 115–116.
2. D. B. Harden, *Roman Glass from Karanis* (Ann Arbor, 1936), p. 93, fig. 1f, pl. 13.
3. C. W. Clairmont, *The Glass Vessels*, Dura-Europos, Final Report IV, Part V (New Haven, 1963), pl. 26.
4. C. J. Lamm, *Mittelalterliche Gläser und Steinschnittarbeiten aus dem Nahen Osten*, II (Berlin, 1929), pl. 52, no. 9.

78

Glass bowl with wheel-cut facets

Iran(?); fifth century
Height 7.6 cm., diameter 10.7 cm.
The Corning Museum of Glass, Corning, N.Y. (61.1.12)

This deep, steep-sided bowl was made of transparent light green glass, blown into an open mold. The wheel-cut decoration on the vessel's exterior, a geometric pattern of rows of facets, is divided horizontally by lines carved midway up the body. This detail is of interest because the same design occurs on a fifth-century glass excavated at Kish in southern Mesopotamia and now in the Field Museum of Natural History in Chicago.[1] On later Sasanian hemispherical bowls, wheel-cut facets cover the entire surface of the vessel without interruption (see No. 82).

Bowls of this general shape but with circular and oval cut facets were common throughout the late Roman world.[2] The form and design were so popular in the West that the glass vessels were occasionally imitated in silver (fig. 78a).[3] Although this bowl derives from earlier Western prototypes, it differs from these in the thickness of the body and the upright, almost vertical walls. The slight outward flare of the rim suggests a date in the middle rather than late Sasanian period.[4] This feature places the vessel, typologically, between the Imperial Roman examples, which have a somewhat more exaggerated curved profile,[5] and the late Sasanian faceted bowls with simple vertical sides (No. 82).

Notes

1. Field Museum of Natural History, Chicago. Unpublished, Kish no. 157024.
2. The British Museum, *Masterpieces of Glass*, comp. D. B. Harden et al. (London, 1968), p. 80, no. 102.
3. D. E. Strong, *Greek and Roman Gold and Silver Plate* (London, 1966), p. 175, pl. 50B.
4. Negro Ponzi, "Sasanian Glassware from Tell Mahuz," fig. 161, no. 72.
5. C. W. Clairmont, *The Glass Vessels*, Dura-Europos, Final Report IV, Part V (New Haven, 1963), pp. 65–67. Since the drawn profiles are reconstructions from fragments, it is impossible to be certain that the walls of the vessels were originally as vertical as depicted.

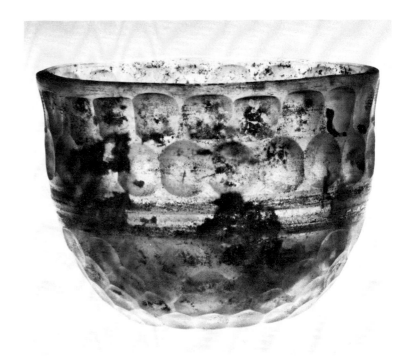

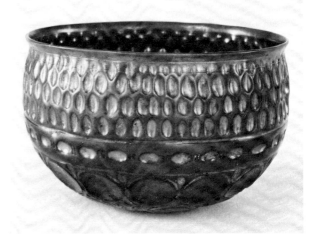

Fig. 78a. *Silver bowl. Late third century A.D. H. 7.8 cm.*
Treasure of Chaource. The British Museum.

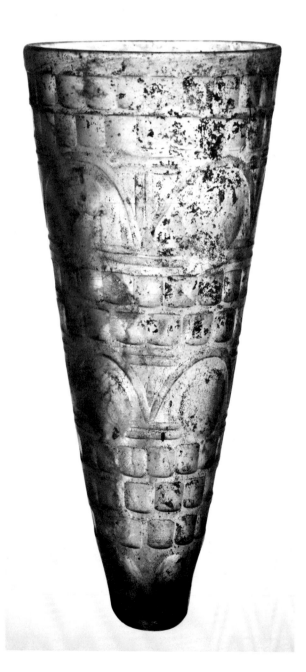

79

Glass lamp or beaker

Iran(?); fifth to seventh century
Height 18.7 cm., diameter of rim 8.4 cm.
The Corning Museum of Glass, Corning, N.Y. (59.1.580)

This conical vessel was made of greenish glass, blown into an open mold and then decorated with wheel-cut and polished geometric patterns. The rim has been rounded off by grinding. Commonly referred to as conical beakers or lamps, vessels such as this undoubtedly served different purposes. Descriptions of conical lamps, mounted on supports, appear in Western literature of the fourth century and later.[1] The decoration is appropriate for a lamp since the wheel-cut facets would have acted as reflectors for the light cast by a burning wick.

This vessel was probably made in the Near East. Two vessels of the same type were found during the excavation of a Sasanian building at Kish in southern Mesopotamia.[2] However, glasses of this shape were widespread in the Roman world. A number of examples made in Roman Syria and exported to Scandinavia are covered with similar (but more delicate) wheel-cut patterns.[3]

The design on the Corning beaker consists not only of facets but also of arching lines. These may be architectural forms (arches of the sort that appear on some mold-blown Jewish glasses) or a purely decorative device (similar to the "pillars" that divide circular patterns on late Roman glasses). The empty arch pattern continued to be popular on ninth and tenth-century Islamic cut-glass vessels and demonstrates the conservative nature of glass design.

Selected Bibliography
von Saldern, "Achaemenid and Sassanian Cut Glass," p. 8, pl. 2, fig. 3; The University of Michigan Museum of Art, *Sasanian Silver* (Ann Arbor, 1967), p. 154, fig. 80; D. Labino, *Visual Art in Glass* (Dubuque, Iowa, 1968), p. 25, fig. 14.

Notes
1. G. M. Crowfoot and D. B. Harden, "Early Byzantine and Later Glass Lamps," *The Journal of Egyptian Archaeology* 17 (1931), pp. 196–208 (refers to publications listing ancient sources).
2. Langdon and Harden, "Glass from Kish," pp. 132–133.
3. G. Ekholm, "Scandinavian Glass Vessels of Oriental Origin from the First to the Sixth Century," *Journal of Glass Studies* 5 (1963), pp. 29ff.

80
Tubular glass vessel

Iran(?); fifth to seventh century
Height 33 cm., diameter 2.5 cm.
The Corning Museum of Glass, Corning, N.Y. (66.1.19)

Wheel-cut lozenges form a network over the surface of this slender green glass container, which was blown and drawn into an elongated shape to achieve its distinctive cylindrical form. Vessels having a similar shape were excavated at Nineveh in northern Mesopotamia[1] and at Qasr-i Abu Nasr in southern Iran.[2] This example has been left smooth at the rim to allow for a close fitting lid, a feature observable on other containers of this type.[3] Regrettably the lid is missing.

The comparable fragmentary glass at Qasr-i Abu Nasr came from a room that contained a large number of stamped clay sealings, originally attached to parcels and documents. This suggests that glass cylinders such as these, hardly practical as receptacles for liquids, may have held writing materials: parchment, brushes, or pens. The containers probably belonged to scribes, who enjoyed a high position in the Sasanian state (see No. 66) and could easily have afforded this type of finely executed glass.

Notes
1. The British Museum, *Masterpieces of Glass*, p. 106, no. 136.
2. Frye, *Sasanian Remains from Qasr-i Abu Nasr*. The glass fragment, F383, is unpublished.
3. *Islamisk Kunst: Davids Samling* (Copenhagen, 1975), p. 11.

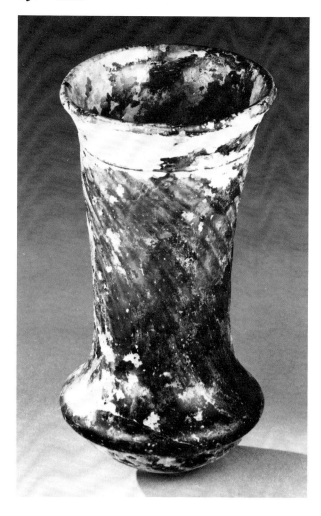

Fig. 81a. *Drawing of a glass vessel. Ca. sixth century. H. 8.6 cm. Sasanian, Iran. Tokyo National Museum.*

81

Glass beaker

Iran(?); ca. sixth century
Height 14.9 cm., diameter 8 cm.
The Corning Museum of Glass, Corning, N.Y. (62.1.7)

The ribbed pattern on this emerald green beaker was formed by blowing into a mold and then twisting the heated glass. An applied trail has been added below the rim. Although there is a well-known class of Frankish vessels of similar shape which were found in the Rhineland,[1] they are almost invariably of a translucent, pale green material and show no traces of the weathering so evident here.

A smaller vessel of this same shape, made of colorless glass, is in the Tokyo National Museum.[2] Allegedly from Iran, it has a stamped or molded figure of a cock in pure Sasanian style (fig. 81a) on the base. It is evident, therefore, that these beakers, commonly associated with the West, were also manufactured in the Near East during the late Sasanian period.

Two dark green beakers of the Corning type are said to have come from North Africa, and it has been suggested that they are products of an east Roman industry.[3] Probably the Frankish and Sasanian glasses both developed from Roman prototypes. In the sixth century, the territorial expansion of the Sasanians into Syria and Egypt led to renewed influences from the West on the arts of the Near East. This emerald green beaker is evidence of the effect of these contacts upon the glass industry of the Sasanian Empire.

Notes

1. F. Rademacher, "Fränkische Gläser aus dem Rheinland," *Bonner Jahrbücher* 147 (1942), pp. 307–311, pls. 60, 61.
2. S. Masuda, "Glass Ware of the Sassanid Age," *Museum* no. 110 (May, 1960), p. 24.
3. R. W. Smith, "New Finds of Ancient Glass in North Africa," *Ars Orientalis* 2 (1957), pp. 91–117, pl. 6, figs. 22, 24.

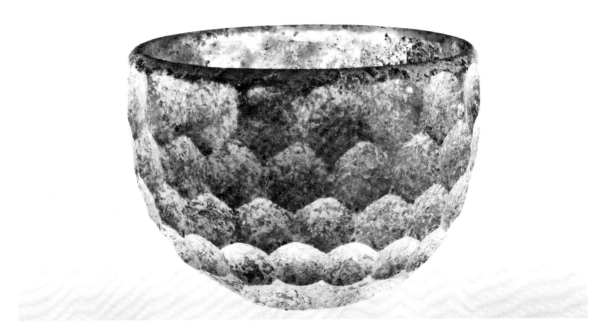

82
Glass bowl with wheel-cut facets

Iran(?); sixth or seventh century
Height 8.9 cm., diameter 13 cm.
The Corning Museum of Glass, Corning, N.Y. (60.1.3)

The most common type of Sasanian glass vessel to have survived is the faceted hemispherical bowl. Characteristically, these late Sasanian glass bowls have fairly thick walls and are entirely covered on the exterior by undifferentiated wheel-cut hexagons. Several examples come from Sasanian levels at sites in Mesopotamia and Iran.[1] Countless others, allegedly from northwestern Iran, are now in the collections of museums in the United States and abroad. The type was not only produced widely in the Near East but also exported, occasionally to the same areas as the Sasanian silver vessels. One Iranian hemispherical bowl was found in the tomb of the Japanese emperor Ankan (d. 535). Another is preserved in the Shoso-in.[2]

Made of glass with a pale yellow tint, this bowl was blown into an open mold. The hexagonal facets that cover the exterior were wheel-cut and then polished. The rim was rounded by reheating. Glasses of this shape are extraordinarily uniform in size and design. Heights vary from 7.6 to 9.7 cm.; diameters from 9.4 to 12.2 cm. The usual pattern consists of four or five rows of wheel-cut facets. Two examples in Japanese collections, allegedly from Gilan in northwestern Iran, have three and six registers respectively, but they are exceptional.[3] This consistency in shape and appearance suggests that the vessels served some special purpose (no longer known) or that the production of this type of glass was, for some reason, carefully regulated.

In the clear transparent glass, wheel-cut facets acted as mirrors, reflecting the hexagonal designs in diminished size. Regrettably, this effect is lost on most of the Iranian examples because weathering has produced an opaque iridescence. To appreciate the beauty of the original piece, one must imagine the almost colorless glass losing its substance as light passed through the walls and transformed the piece into a pattern of reflections.

Selected Bibliography
von Saldern, "Achaemenid and Sassanian Cut Glass," pp. 10ff., fig. 6; Corning Museum of Glass, *A Tribute to Persia: Persian Glass* (Corning, 1972), p. 11, fig. 10.

Notes
1. von Saldern, "Sassanidische und islamische Gläser in Düsseldorf und Hamburg," pp. 36–37; Langdon and Harden, "Glass from Kish," p. 132, figs. 4, 5; Lamm, *Mittelalterliche Gläser*, II, pls. 53, 54.
2. Fukai, *Study of Iranian Art and Archaeology*, figs. 1–3.
3. Ibid., pls. 1, 17.

CERAMICS

To determine the chronological development of the pottery of any culture it is necessary to keep in mind several factors. Forms of vessels change only with the passage of considerable periods of time or with the immigration into an area of new peoples whose traditions differ from those of the local inhabitants. If the population remains stable, it is not easy to detect the passing of a century or even two centuries solely on the basis of the pottery types. Moreover, in lands divided by natural barriers, regional styles develop and sequences established for one area are not necessarily valid for another.

The study of Sasanian pottery is complicated by the absence of examples from controlled excavations at Sasanian sites.[1] Lacking documented sequences of shapes and fabrics, scholars can only tentatively reconstruct the development of the ceramic industry during the Sasanian period. Recent publications of the pottery found by Italian and Japanese expeditions in Mesopotamia and Iran have added to our knowledge, but much still remains to be learned.[2]

In general, it appears that there is no clear dividing line between the pottery of the late Parthian and early Sasanian periods, or, correspondingly, between that of the late Sasanian and early Islamic eras. Ceramics of Sasanian date, glazed in green, blue green, and yellow, are common in Mesopotamia and in the southwest Iranian lands that are a natural extension of Mesopotamia. However, on Sasanian ceramics, in contrast to those of the Islamic period, the glaze covers the vessel uniformly and plant, figural, or geometric designs are not defined through the use of differently colored glazes. Outside of the southwestern region, Sasanian glazed pottery is rare in Iran and a red ware, sometimes decorated with burnished designs, prevails.

The yellow jug in this exhibition (No. 85) illustrates the beauty of a simple glazed surface. The glazed rhyta (Nos. 83, 84), which represent a particular type of luxury ware, are interesting because of their iconography but certainly not common or necessarily characteristic of the whole period. Some of the Sasanian ceramic types, such as the horse-shaped vessel (No. 86), persisted over a long time and had been popular during the millennia preceding the Sasanian era in Iran.

The pottery in this exhibition illustrates a continuity with the past. Innovations and developments that occurred during the Sasanian period remain to be documented by further archaeological excavations at Sasanian sites. Only then will it be possible to give a clear picture of the Near Eastern ceramic industry during the centuries before the Islamic conquest.

Notes

1. D. B. Harden, "Pottery" in S. Langdon and D. B. Harden, "Excavations at Kish and Barghuthiat 1933," *Iraq* 1 (1934), pp. 124–136; J. H. Schmidt, "L'Expédition de Ctésiphon en 1931–32," *Syria* 15 (1934), pp. 1–23; R. Ettinghausen, "Parthian and Sasanian Pottery," in *A Survey of Persian Art*, ed. A. U. Pope (London/New York, 1938), I, pp. 646–680; D.

Oates, *Studies in the Ancient History of Northern Iraq* (London, 1968), Appendix B, pp. 145–160.

2. R. Venco Ricciardi, "Pottery from Choche," *Mesopotamia* 2 (1967), pp. 93–104; R. Venco Ricciardi, "Sasanian Pottery from Tell Mahuz," *Mesopotamia* 5/6 (1970–71), pp. 427–482; N. Egami, S. Fukai, and S. Masuda, *Dailaman* II (Tokyo, 1966); T. Sono and S. Fukai, *Dailaman III* (Tokyo, 1968).

83

Glazed terracotta rhyton with female head

Nippur, southern Mesopotamia; second or third century
Height 24 cm., greatest width 17 cm.
The University Museum, Philadelphia (B9471)

Only the top half remains of this superb terracotta rhyton, found in the excavations at Nippur. The widest section is decorated with a female head, which was molded and inserted into an opening cut into the wheel-turned vase. It is remarkable that the female features are so clearly defined and perfectly preserved. This vessel belongs to a class of rhyton for which there is some evidence in the early Sasanian period. The vase-shaped upper portion, combined with an elongated, curving lower body, ends in a pierced animal-headed spout (see No. 84).

A band of trilobate leaves, applied to the surface of the vase, spreads from either side of the woman's forehead around the circumference of the vessel. Curls of hair rise above the head and fall in two long twisted locks beside the face. A similar hair style appears on early Sasanian seals and silver vessels (fig. 83a). Above the forehead, resting against the hair, is a crescent moon; and beneath the chin is a three-strand necklace, applied to the surface of the neck.

Too little is known of Sasanian glazed ceramics to permit an absolute dating of this rhyton. The deep brown glaze with a yellowish tint that covers both the exterior and interior surfaces is unusual. Blue green, dark green, and yellow are the most common colors of Sasanian glazes (compare Nos. 84, 85) and therefore this beautifully executed vessel may be either late Parthian or early Sasanian in date.

The vessel comes from Nippur, a site in the western portion of the Sasanian Empire, near the great centers of commerce in southern Mesopotamia.[1] In this region, routes from the Mediterranean seacoast joined those from the East. Consequently, in the early first millennium A.D. the art and culture of the area combined both Western and Eastern elements, a fact that accounts for the Greco-Roman rather than Near Eastern appearance of the female head on this piece.

The rhyton was found in a building of Parthian and slightly later date constructed above the temple of the Sumerian god, Enlil. The crescent moon above the forehead of the female indicates that this is probably Nana, a composite nature goddess who was widely revered in Asia in the first millennium A.D. She appears not only in the art of the Parthians and that of the Kushans (who ruled in the area of present-day Afghanistan) but also on

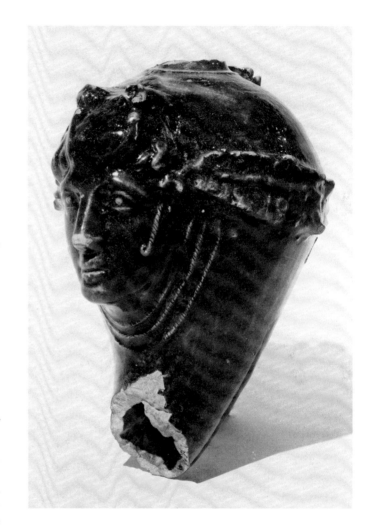

monuments in Transoxiana, farther to the northeast.² In this region, her cult is thought to have been assimilated into that of the Iranian nature goddess Armaiti.³ The crescent is a symbol of the moon-god, the father of Nana; and the plant wreath around the goddess' head signifies natural abundance.

Selected Bibliography

The Babylonian Expedition of the University of Pennsylvania, Series D, ed. H. V. Hilprecht (Philadelphia, 1904), I, p. 331 (described as a lamp with the head of Medusa); Pope, *A Survey of Persian Art*, IV, pl. 185 C.

Notes

1. D. E. McCown and R. C. Haines, *Nippur*, I, *Oriental Institute Publications* 78 (Chicago, 1967), p. 19.
2. J. Rosenfield, *The Dynastic Arts of the Kushans* (Berkeley/Los Angeles, 1967), pp. 83–90.
3. G. Azarpay, "Nanâ, the Sumero-Akkadian Goddess of Transoxiana," *Journal of the American Oriental Society* 96 (1976), pp. 536–542.

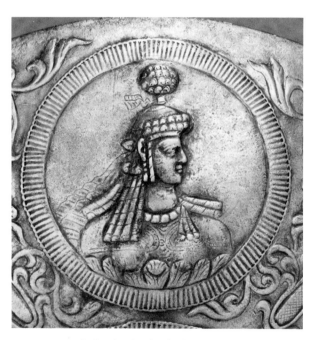

Fig. 83a. *Detail of a silver bowl. Third century A.D. Sasanian, Iran. The Metropolitan Museum of Art; Dick Fund (1970.5).*

84

Glazed terracotta rhyton

Provenance unknown; third century
Length 35.5 cm., greatest diameter 12 cm.
The British Museum, Department of Western Asiatic
 Antiquities (BM 37452)

By fortunate chance this glazed rhyton, decorated with a male bust, a female head, and an animal head spout, has survived almost intact. Only a fragment of the vessel's neck and mouth is lost, and the glaze is preserved over the entire surface. Although iridescence caused by weathering has transformed much of the glaze from dark blue green to a grayish tone, the left side of the female face retains the original color. The fact that the interior was apparently left unglazed is unusual. Glaze commonly covered both surfaces of drinking vessels to prevent the pottery from tainting the flavor of the wine or other beverage.

The rhyton was constructed in a number of parts. The upper section, to a point just beneath the small male bust, was turned on a potter's wheel and then pressed into a mold to produce the figure in relief. The lower portion of the vessel was molded in two halves. Clearly visible seams join the front and back sections. They run from the forehead of the female face to the animal head which was modeled separately in the round. The animal head forming the spout of the vessel has stubby, ribbed horns and a long V-shaped design on the under surface that may represent the bony structure of the jaw. Probably because the clay was pressed unevenly into the mold, the female's features are less finely detailed on the left side than on the right.

The British Museum vessel is one of two pottery rhyta that can, with confidence, be identified as Sasanian. The other, more damaged example, is in the Cincinnati Art Museum.¹ In both instances, three areas are decorated: the body of the wheel-turned vessel, the upper section of the molded curving horn, and the spout.

The small male bust on this rhyton from The British Museum has several interesting details. Although the clay was not pressed sufficiently firmly into the mold to bring out all aspects of the design, certain features are apparent. A necklace rests on the chest, and the beard is gathered into a small ball at the base, a distinctive characteristic of early Sasanian royal representations. Above the head, on either side of a central knob, are small raised dots. Julian Reade, of the Department of Western Asiatic Antiquities in The British Museum, has made the plausible suggestion that these indicate a stepped crenellation. The central

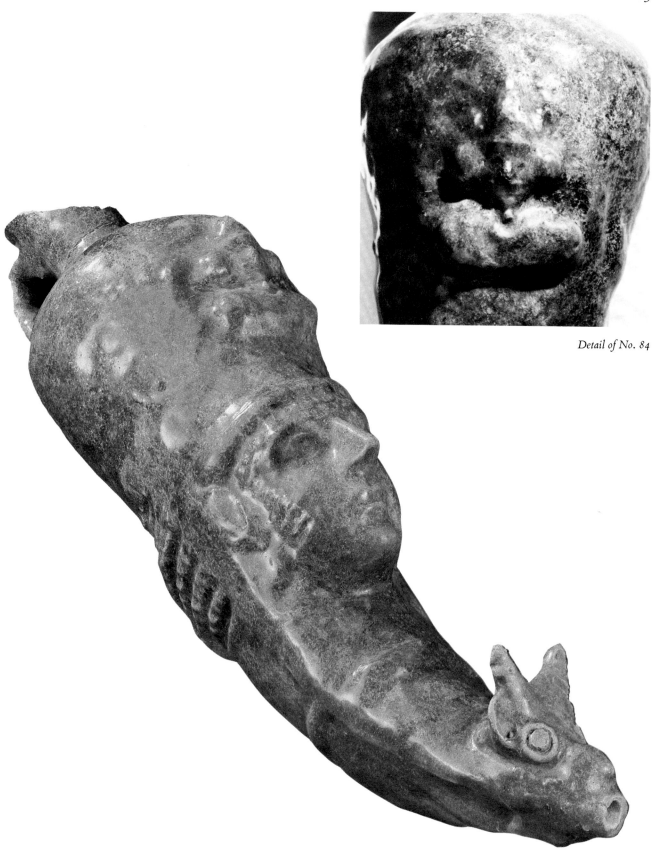

Detail of No. 84

knob represents, in all probability, the ball of hair customarily drawn up above the heads of Sasanian kings and divinities. It too may have been decorated with a beaded stepped crenellation. Regrettably, this part of the design is unclear.

On coins and rock reliefs, Shapur I (241–272) wears a crenellated crown. His hair curls in balls on either side of the head, and his beard is always tied or held by a ring. These similarities suggest that the small male on this rhyton is an image of Shapur, impressed on the surface of the vessel to mark it as an object associated with the royal court. There is no reason to believe, however, that this unpretentious object was a possession of the Sasanian king himself. In antiquity, royal insignia were undoubtedly represented on a wide range of common and luxury wares.

Unfortunately, nothing in the appearance of the female head on the British Museum rhyton suggests the identity of the figure. Except for the wavy locks that fall before the ears, the hair is pulled back and gathered in a bun. The irregular surface of the vessel above the head may be intended to indicate a hair ball rising above the head and signifying royalty or divinity (fig. 83a). On the back of the rhyton, jewels(?) hang from three strands below the hair. A simple band around the neck is perhaps a necklace. The ears are adorned with earrings, each consisting of a small bead and an oval pendant.

Possibly this image and the one on the Cincinnati rhyton are to be associated with the Mesopotamian goddess Nana, who is represented on another ceramic rhyton from the University Museum in Philadelphia (No. 83). This goddess of nature and abundance became identified in the Sasanian period with Iranian divinities having similar functions and qualities.[2] During the first millennium A.D. her cult was widespread throughout much of Asia. Nana is referred to in ancient texts from the Temple of Marduk at Babylon as "the power over princes and the scepter of kings."[3] The presence of a royal image on this rhyton is appropriate, therefore, in conjunction with a representation of the goddess Nana.

Selected Bibliography

K. Erdmann, "Partho-Sassanian Ceramics," *The Burlington Magazine* 67 (1935), pp. 71–77, pl. II, E–G; Pope, *A Survey of Persian Art*, IV, pl. 185 A, D; H. H. von der Osten, *Die Welt der Perser* (Stuttgart, 1956), pl. 84; R. Ghirshman, *Persian Art* (New York, 1962), fig. 132.

Notes

1. Pope, *A Survey of Persian Art*, IV, pl. 185 B. The presumably royal personage on the Cincinnati Art Museum rhyton is in the same location as on the British Museum vessel—high on the vase, above a female head. In this instance, he is mounted on a horse and is approached by a small winged male who bears a diadem. Similar scenes, symbolizing the investiture of the king, occur on the rock reliefs of Shapur I.

2. G. Azarpay, "Nanâ, the Sumero-Akkadian Goddess of Transoxiana," *Journal of the American Oriental Society* 96 (1976), pp. 536–542.

3. J. Rosenfield, *The Dynastic Arts of the Kushans* (Berkeley/Los Angeles, 1967), p. 85.

85
Glazed jug

Allegedly from Susa, Iran; third century
Height 25 cm., diameter 15.1 cm.
Iran Bastan Museum, Tehran (528)

Despite its Iranian provenance, this graceful pitcher with a single handle, round body, and flaring neck is similar in shape to late Parthian and early Sasanian vessels from Mesopotamia. The yellow glaze, which transforms the pitcher into an object of considerable beauty, is also characteristic of Mesopotamian ceramics of Sasanian date.[1] In Iran, the typical Sasanian pottery is the red ware used for the vessel in the shape of a horse (No. 86). The resemblance of this jug to Mesopotamian rather than Iranian wares is understandable, because Khuzistan, the modern province in which Susa lies, is geographically an extension of southern Mesopotamia. Mountain chains and deserts separate it from other parts of Iran.

Shapes of ceramics, glazed and unglazed, remain generally unchanged unless new peoples enter a region or a substantial time passes. The Susa pitcher cannot be dated with precision. It may belong to the first century of Sasanian rule or the last century of the preceding Parthian period. The vessel is therefore a symbol of continuity, of the persistence of the same ceramic traditions in the Parthian and Sasanian periods.

Notes

1. Oates, *Studies in the Ancient History of Northern Iraq,* Appendix B, pp. 145–160; Venco Ricciardi, "Sasanian Pottery from Tell Mahuz," pp. 427–482; S. Langdon and D. B. Harden, "Excavations at Kish and Barghuthiat 1933," *Iraq* 1 (1934), pp. 124–136.

86

Terracotta horse

Allegedly from Susa, Iran; sixth or seventh century
Height 23.5 cm., length 28.5 cm.
Iran Bastan Museum, Tehran (503)

Terracotta pouring vessels modeled in the shape of a horse have survived from many periods in Near Eastern history. This Sasanian example is more elaborate than earlier Iranian ones. The harness and saddle, for example, are modeled in relief rather than simply painted as they were on pieces of the first millennium B.C.[1] In addition, this vessel has punched and incised designs: a chest strap and a beaded necklet with a pendant crescent. In the West, lavish silver-gilt necklets for horses are among the objects found in the fourth-century Esquiline Treasure in Rome.[2] They have pendant crescents hanging from them in a fashion related to the incised necklet on the terracotta horse. The horse wears a bridle (compare No. 1) and a saddle blanket, but no saddle appears because this part of the vessel has been turned into a spout. Regrettably, the ears are broken.

Several details suggest that this is a Sasanian piece, probably dating toward the end of the period. The flaring sides of the saddle blanket are similar to representations on the latest Sasanian and earliest Islamic silver plates. The jeweled necklet worn by the horse appears in a different form on royal Sasanian mounts on the latest rock reliefs, textiles, and other media.[3] The curving lines representing the upper and lower eyelids appear in essentially the same form on a bronze statuette of a horse and rider from Daghestan in the Hermitage Museum, dating to the beginning of the Islamic period.[4] On the basis of the details mentioned above, as well as the crenellated cut of the mane, the bowed tail, and the red pottery itself, the terracotta horse can be assigned to the late Sasanian period.

Selected Bibliography
V. G. Lukonin, *Persia II* (Geneva, 1967), fig. 168.

Notes
1. R. Ghirshman, "La Selle en Iran," *Iranica Antiqua* 10 (1973), pp. 99–107.
2. *Wealth of the Roman World*, ed. J. P. C. Kent and K. S. Painter (London, 1976), p. 49, no. 98.
3. S. Fukai and K. Horiuchi, *Taq-i-Bustan*, I, (Tokyo, 1969), pl. 87; K. Erdmann, *Die Kunst Irans zur Zeit der Sasaniden* (Berlin, 1943), fig. 64.
4. J. Orbeli and C. Trever, *Orfèvrerie sasanide* (Moscow/Leningrad, 1935), pl. 83.

STONE

Large stone sculpture—either in the form of architectural decoration or of statuary in the round—was rarely produced in the pre-Islamic Near East. A few statues of divinities and royal personages exist, but such sculpture is usually on a small scale. There is nothing comparable to the sizable works in stone which abound in the Mediterranean countries and the Far East.

At Sasanian sites the customary mortar and rubble construction was generally masked by molded and painted stucco rather than by elaborately worked stone. An exception is the royal city of Bishapur, in southern Iran, where there are buildings, dating from the time of Shapur I (241–272), made of finished stone masonry and decorated with carved figural friezes.[1] Probably foreign stone masons, captives brought from the West by Shapur I, were responsible for these unusual structures. Stone console blocks at the site are carved in the shape of the foreparts of bulls, an imitation of earlier Achaemenid capitals at Persepolis. They represent a type of ornament which apparently went out of fashion later in the period. Stone was used at Ctesiphon, in southern Mesopotamia, but only sparsely. The German excavators record the presence of variously colored marble plinths and floor slabs in buildings dating to the last century of the Sasanian era.[2]

The monumental stone sculpture of the Sasanians is best represented by the royal rock reliefs carved on the cliff faces in western Iran.[3] Many of these are in low relief and have a pictorial, narrative quality similar to wall paintings. In some cases, however, the royal and divine figures achieve substantial form and resemble statuary in their arrangement as well as in their appearance. This is particularly true of the large-scale images at Taq-i Bostan. The potential contribution of the rock reliefs to the study of Sasanian art is tremendous. The form of the royal crowns provides, in most instances, a secure date for the reliefs. Regrettably, with the passage of time, the reliefs are gradually deteriorating, and the rock carvings are inadequately documented. There are few published photographs of details. Only inaccurate and rough drawings have been made in the past. Fortunately, in recent years, Georgina Herrmann and Rosalind Howell have begun to record the reliefs methodically both in photographs and drawings. In the future it should be possible to study these important works of art in detail and consequently to interpret the scenes with greater confidence.

Apart from the rock reliefs only a few large sculptures in stone are preserved from the Sasanian period. One such major work is a statue of Shapur I (241–272), more than three times life-size, at Bishapur in a huge cave overlooking the river gorge with its celebrated reliefs.[4] At Taq-i Bostan is a second statue, badly weathered and slightly under life-size, which may represent Khusrau II (591–628).[5] A reference to another royal sculpture, that has regrettably not survived, occurs in an inscription carved on a monument at Bishapur. Apasay, the secretary of Shapur I, apparently erected, at his own expense, a statue of the king. He records that "when the king of kings had seen this image, then he has given to Apasay, his secretary, objects of gold and silver, slaves and slave-girls, gardens and estates."[6]

It is probable that the scarcity of minor stone sculptures of Sasanian date is due, in part, to the absence of archaeological excavations at Sasanian sites. The few pieces chosen for this exhibition illustrate a variety of styles, both foreign and Sasanian, as well as the different ways in which this material was used.

The small stone figure of a male (No. 88) is Western in appearance, if not actually in workmanship. Neither his dress nor his hair style is Persian. The piece was allegedly found at Susa and it serves as a reminder of the presence of east Roman stone masons in the Near East. Transported as prisoners of war, these craftsmen undoubtedly executed works of art for the large foreign populace in Mesopotamia and Iran as well as for their new Sasanian masters. Fragments of other figures draped in Western style were found by Roman Ghirshman at Bishapur. In contrast, the small elephant (No. 89) is typically Sasanian and comparable to the elephants on late Sasanian rock reliefs.

Another common use of stone, according to literary sources, was for the manufacture of mosaics. The mosaic floor panels from Bishapur (No. 87), which follow Western models, are a type of decoration that was probably employed in royal and noble buildings throughout the period. Regrettably, only at Bishapur are the mosaics sufficiently undisturbed to permit the reconstruction of scenes. Those found at Ctesiphon were scattered and fragmentary.

It is evident that the Sasanians were impressed by the stone sculpture they saw in the West, and a passage cited in the Introduction mentions the transfer of "marbles" from captured Antioch in Syria to Iran. The historian Ammianus Marcellinus, who accompanied the emperor Julian during his campaigns in the East, comments on the presence near Ctesiphon of a "palace built in Roman style with which we were so pleased that we left it untouched."[7] This site and others of purer Sasanian design are among the archaeological treasures that remain to be uncovered. They may produce, at some future date, examples of Sasanian stone sculpture and architectural decoration to supplement what is already known from the rock reliefs and the works of art in stucco.

Notes

1. R. Ghirshman, *Bîchâpour*, 2 vols. (Paris, 1956–71).
2. O. Reuther, "The German Excavations at Ctesiphon," *Antiquity* 3 (1929), pp. 442–443.
3. E. Herzfeld, "La Sculpture rupestre de la Perse sassanide," *Revue des arts asiatiques* 5 (1928), pp. 129–142; W. Hinz, *Altiranische Funde und Forschungen* (Berlin, 1969); E. F. Schmidt, *Persepolis*, III, Oriental Institute Publications 70 (Chicago, 1970); S. Fukai and K. Horiuchi, *Taq-i-Bustan*, 2 vols. (Tokyo, 1969–72). The *Iranische Denkmäler*, recently revived by the Tehran division of the German Archaeological Institute, has two numbers, issued in 1975, by L. Trümpelmann on the Sasanian reliefs at Sar Mašhad and Dārāb. Future numbers will include the records made by Georgina Herrmann and Rosalind Howell of other Sasanian reliefs.
4. Ghirshman, *Bîchâpour*, I, pls. 28–32.
5. Fukai and Horiuchi, *Taq-i-Bustan*, II, pl. 63.
6. R. Ghirshman, "Inscription des monuments de Châpour Ier à Châpour," *Revue des arts asiatiques* 10 (1936), p. 126; W. B. Henning, "The Great Inscription of Šapur I," *Bulletin of the School of Oriental and African Studies* 9 (1937–39), p. 825.
7. Ammianus Marcellinus, trans. J. C. Rolfe, Loeb Classical Library (Cambridge, Mass./London, 1950), II, pp. 449–451 (Bk. XXIV. 5. 1–3).

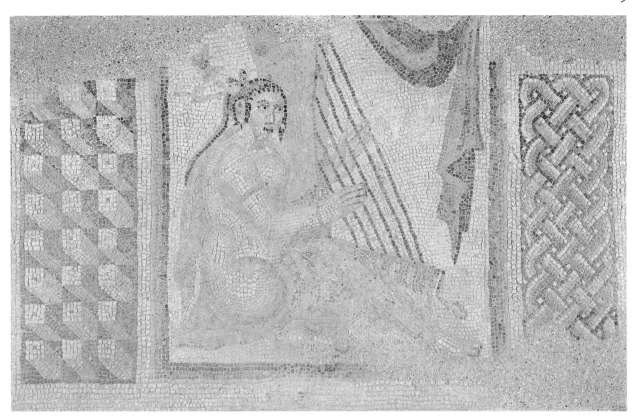

87
Two mosaic floor panels

Bishapur, Iran; third century

A. Seated female harpist
Height 60 cm., width 85 cm.

B. Male head, probably a satyr (*frontispiece*)
Height 38 cm., width 36 cm.

Musée du Louvre, Antiquités Orientales (AO 26169 and AO 26171)

The mosaic floors uncovered during the excavation of the palace of Shapur I (241–272) at Bishapur in southern Iran are rich and varied in design.[1] These two panels in the Louvre formed part of the border of a rectangular floor. Narrow strips with masks of male and female figures alternated with taller panels showing females weaving garlands, holding flowers, playing musical instruments, and dancing. Some of the females are nude, others clothed.

It is generally recognized that these motifs are derived from Western sources. After Shapur I conquered Antioch in Syria, he transported prisoners, including artisans, to Iran. Many of these foreign craftsmen were undoubtedly skilled in the design and laying of mosaic pavements. It is probable that they worked on the mosaic pavements at Bishapur, following patterns adapted by Iranians from Western designs.

The scenes represented in the Bishapur mosaics are clearly derived from Dionysiac imagery. One of the fragmentary panels in this exhibition shows a male head with animal ears—probably a satyr—above a shepherd's crook. On the same panel, there was originally another bearded male with long goat's ears and horns. Beneath that head were pipes, the instrument of Pan. Roman Ghirshman interprets the scenes as festal motifs appropriate to a royal banqueting room. Hubertus von Gall associates the mosaic decoration with a Dionysiac pomp or victory celebration.[2] In his view, they are related to the defeat and capture of the Roman emperor Valerian, commemorated dramatically on the rock reliefs of Shapur I in the nearby river gorge.

The palace buildings at Bishapur were excavated by Roman Ghirshman under extremely difficult conditions just before and during the Second World War. In the last season, 1940–1941, the mission was staffed only by Professor and Madame Ghirshman.[3] During that year, eighteen mosaic panels were excavated, restored, and copied in

color drawings. Before leaving Bishapur, the Ghirshmans meticulously raised the mosaics and removed them for safekeeping to the expedition house. Thanks to these precautions, a few of the mosaics survived the unsettled conditions of the following years. Some are now in the collection of the Iran Bastan Museum in Tehran, and others are in the Louvre.

These unique examples of Sasanian mosaic pavements represent an art that was, according to literary sources, widely used for the decoration of royal and noble residences. Although tesserae have been found at other Sasanian sites, notably Ctesiphon, the scenes cannot be reconstructed from the loose and scattered remains.

The mosaics of the Sasanian period were a costly form of decoration, illustrating the same motifs and designs as the wall paintings. It is regrettable that so few works in either medium have survived.

Selected Bibliography

Ghirshman, *Bîchâpour*, II: *Mosaïques sassanides*, pls. V, 2; IX, 1; pls. A, B; pp. 40, 49; R. Ghirshman, *Persian Art* (New York, 1962), fig. 182.

Notes

1. Ghirshman, *Bîchâpour*, II: *Mosaïques sassanides*, p. 179, pls. 5–15, 17–20; Ghirshman, *Persian Art*, figs. 180–186.
2. H. von Gall, "Die Mosaiken von Bishapur," *Archaeologische Mitteilungen aus Iran* N.F. 4 (1971), pp. 193–205.
3. T. Ghirshman, *Archéologue malgré moi* (Neuchâtel/Paris, 1970), pp. 141ff.

88
White marble bust of a male

Allegedly from Susa, Iran; late third century
Height 19 cm., width 17 cm.
Iran Bastan Museum, Tehran (506)

This fragmentary white marble sculpture is said to have been found in the vicinity of Susa. It represents a short-haired, bearded male wearing a high-necked tunic. The body is broken off at the left shoulder and also at the waist. The right upper arm, left shoulder, and left arm are modern restorations.

All that can be said with any certainty is that the individual represented is portrayed in the style of Roman sculpture of the late third or early fourth centuries.[1] The head strongly resembles portraits of the Tetrarchy (A.D. 293–306, the period during which four emperors jointly ruled the Roman Empire). Here we see the same short military haircut in which the hair is brushed upward into a ridge over a low forehead, the closely trimmed beard hatched with a pattern of parallel incisions and clearly set off from the smooth cheeks, the prominent ears, strongly set mouth, and wide-eyed frozen expression. This sculptural style gained prominence at Alexandria and Antioch during the last decade of the third century. It relied heavily on anti-classical Near Eastern traditions, and can be readily differentiated from Western Roman portrait styles of the same period. The most extreme examples are porphyry Tetrarch groups in Venice and Rome, and a

Fig. 88a. *Coin of Licinius II. The American Numismatic Society.*

porphyry portrait of an unknown Tetrarch in the Cairo Museum. Similar heads have been uncovered in Asia Minor and at Antioch. The massiveness and rigidity of these sculptures also occurs on Tetrarchy coin portraits of the East (fig. 88a), particularly those from Antioch.

No long-haired, long-bearded Persian of any consequence would have allowed himself to be shown in this manner. Furthermore, there are almost no stone sculptures in the round from the Sasanian period in Iran. If the piece was made in Iran it must have been commissioned by a person who wished to have a portrait sculpture in Roman style. Since the work is small, it may have been brought to Iran from some location in the east Roman Empire, such as Syria. Possibly it arrived during the war between the Romans and the Sasanians in the late third century A.D. At the outset of this war, in 296, the Sasanian king Narseh (293–302) took the offensive against Diocletian, conquering Armenia, invading Mesopotamia, and threatening to cross the Euphrates to strike at Syria. Diocletian sent his son-in-law, the Caesar Galerius, to stop the Persians, but he was severely defeated in a battle in Mesopotamia. He managed to escape with his life while the bulk of his army was either killed or captured. Subsequently, Galerius regrouped his army at Antioch and attacked Armenia where he successfully routed Narseh and destroyed the Sasanian forces. Diocletian then advanced to Nisibis in Mesopotamia where terms of a humiliating peace were forced on the defeated Narseh.

If this sculpture is an east Roman work of the late third century, it was probably at the time of Narseh's defeat of Galerius' army in Mesopotamia that the piece came to Iran as booty. Alternatively, it could have been made by a Roman prisoner in exile.

As to the identity of the person portrayed, we are again beset with uncertainties. Although the portrait could easily be that of Galerius, the Roman emperor who defeated the Sasanian king Narseh, it has no imperial insignia. The simple dress appears to be a high-necked tunic gathered at the waist by a belt. It is neither a Roman toga, nor the full military regalia of the period preferred in imperial representations. This included body armor and a long cloak fastened with a brooch at the right shoulder. Nevertheless, sleeved, belted tunics reaching to the knee were the common attire of the late third century worn under armor. This costume is also illustrated on the rock relief of Shapur I (241–272) where it is the garment of Roman emperors. On these occasions, however, the Roman cloak and brooch were also reproduced by Persian sculptors.

The real identity of this portrait in Roman Tetrarchic style remains unknown as do the precise circumstances leading to its discovery in Iran. *Martha L. Carter*

Notes

1. R. Delbrück, *Antike Porphyrwerke* (Berlin, 1932); H. P. L'Orange, *Studien zur Geschichte des spätantiken Porträts* (Oslo, 1933); G. von Kaschnitz-Weinberg, "Spätrömische Porträts," in *Die Antike* 2 (1936), pp. 36ff.; O. Pelikán, *Vom antiken Realismus zur spätantiken Expressivität* (Prague, 1965).

89
Stone elephant

Iraq(?); sixth or seventh century
Height 7.3 cm. Stone: Ferroan-Dolomite
Ex coll. E. Herzfeld (purchased Baghdad)
The Metropolitan Museum of Art; Gift of Alastair B. Martin
(48.154.8)

Western literary sources refer to the troops of elephants in the Sasanian army in the fourth century. Ammianus Marcellinus writes, "their awful figures and savage gaping mouths could scarcely be endured by the faint-hearted."[1] This is hardly the impression given by this elephant from The Metropolitan Museum. Although he strides purposely forward, his tusks, which were inlaid in another material, are missing, and his appearance is not ferocious. A small circular socket is cut in the center of the back to hold some object in place, probably an armed rider. Around the neck is a beaded band, possibly symbolizing royal ownership. It is held at the top of the neck by a square clasp.

When this elephant was first published, by Ernst Herzfeld, it was assigned to the end of the Sasanian period.[2] Herzfeld compared the animal to the elephants depicted with considerable realism on the rock reliefs of Khusrau II (591–628) at Taq-i Bostan. In contrast, earlier representations of elephants at Bishapur are clumsy and unnatural.

Herzfeld originally considered this elephant to be a chessman but then rejected the theory because the most ancient chess pieces known, from various regions, are entirely abstract in form. The size of the Metropolitan Museum elephant, however, argues in favor of Herzfeld's original interpretation. This may be the earliest evidence of a game that the Sasanians allegedly adopted from India.[3]

Because the exact date at which chess was transmitted to Iran is not recorded, the precise form of the Indian game which the Sasanians first played is unknown. In the fifth century in India, *chaturanga*, the forerunner of chess, was played by four teams. Yellow and green were allied on one side against red and black on the other. Each team included a king, horse, elephant, boat or chariot, and four footmen. Because this was a war game, the pieces corresponded to divisions in the army: horsemen, elephant corps, naval fleet or chariot corps, and foot soldiers.[4] This form of the game brings to mind the images on two late Sasanian monuments—one at Taq-i Bostan and the other, destroyed in ancient times, at Ctesiphon.

The reliefs on the rectangular panels of the side walls at Taq-i Bostan are hunting scenes.[5] Kings, horsemen, elephants, boats, and attendants appear in the carvings on these walls. Only the left wall is substantially complete (fig. I, p. 121). There, the relief panel is framed by a hunting net, the sides of which are divided into eight and nine segments respectively, recalling the divisions of a gameboard. In the center of the scene are two figures of a king. On the right wall there are three kings, but the lowest one is set apart and may be an addition in an area that was never finished in the original plan.

These scenes include all the elements of the four-team *chaturanga* game. As described in the *Shah-nameh*, the chess board was a "battlefield in the midst of which the king takes up his position."[6] Both the chess game and the hunt were allegories for war and the defeat of human enemies. Although it is uncertain whether the Sasanian artist who planned the unusual hunting scenes at Taq-i Bostan deliberately followed the model of the royal war game, there is no question that the reliefs present, in pictorial fashion, the same subject as *chaturanga*.

The second Sasanian monument that may relate to *chaturanga* is a painting that once decorated the wall of the throne hall of Khusrau I (531–579) at Ctesiphon.[7] Known only from later Islamic literature, this painting showed the defeat of the Roman army at Antioch. The Sasanian king was clothed in green and mounted on a yellow horse, a combination of colors without particular meaning in the Iranian world.[8] One possible explanation for the use of these two colors in the scene is that they were known to the Sasanians as those of two allied teams in *chaturanga* and therefore believed to be appropriate. Regrettably the literary source does not record whether the colors of the opposing Roman army were red and black.

The *Shah-nameh* recounts at length the adoption, supposedly by Khusrau I, of the game of chess. It came with gifts from India but was as much a challenge as a gift. If the Persian king, Khusrau, could explain the moves of the pieces and the purpose of the game, the Indian ruler agreed to continue to pay him the customary tribute. If Khusrau failed, the Indians would stop their payments.

Khusrau not only succeeded, he returned the challenge by sending the game of backgammon to India (see No. 25). The Indians were unable to work out the moves and purpose of the game. Thus the Persians retained a position of dominance in an apocryphal contest which may reflect some territorial or economic conflict in the history of the two nations.

Selected Bibliography

E. Herzfeld, "Ein sasanidischer Elefant," *Archaeologische Mitteilungen aus Iran* 3 (1931), pp. 26–28; A. U. Pope, ed., *A Survey of Persian Art* (London/New York, 1938), IV, pl. 169 B; K. Erdmann, *Die Kunst Irans zur Zeit der Sasaniden* (Berlin, 1943), fig. 88.

Notes

1. Ammianus Marcellinus, trans. J. C. Rolfe, Loeb Classical Library (Cambridge, Mass./London, 1950), II, p. 481 (Bk. XXV. 1. 14).
2. Herzfeld, "Ein sasanidischer Elefant," pp. 26–28.
3. The Metropolitan Museum of Art, *Chess: East and West, Past and Present* (New York, 1968), pp. xii–xiii, no. 1.
4. *Encyclopaedia Britannica*, 15th ed. (Chicago, 1974), Macropaedia 2, p. 1151.
5. Fukai and Horiuchi, *Taq-i-Bustan*, I, pls. 32, 81.
6. *The Epic of the Kings*, *Shāh-nāma*, trans. R. Levy (London, 1967), pp. 327–328.
7. F. Sarre and E. Herzfeld, *Archäologische Reise im Euphrat- und Tigris-Gebiet*, 4 vols. (Berlin, 1911–1920), II, p. 70.
8. Another reference to these colors occurs in a fanciful account written by the tenth-century Arab author, Hamza al-Isfahani. He describes the crowns of Ardeshir I and Hormizd I as being green and gold in color: H. H. Schaeder, "Über das 'Bilderbuch des Sasaniden-Könige'," *Jahrbuch der Preuszischen Kunstsammlungen* 57 (1936), p. 232; K. Erdmann, "Die Entwicklung der sāsānidischen Krone," *Ars Islamica* 15–16 (1951), p. 96.

Bibliography

General

al-Thaʿalabi. *Histoire des rois de Perse.* Edited and translated by H. Zotenberg. Paris, 1900.

Altheim, F., and Stiehl, R. *Ein asiatischer Staat.* Wiesbaden, 1954.

Boyce, M. *The History of Zoroastrianism.* Leiden/Cologne, 1975. Has selected bibliography.

Christensen, A. *L'Iran sous les Sassanides.* 2nd ed. rev. Copenhagen, 1944; reprinted Osnabrück, 1971. (This is a comprehensive history of the Sasanian Empire including material on literary sources, religion, and society.)

Erdmann, K. *Die Kunst Irans zur Zeit der Sasaniden.* Berlin, 1943; reprinted Mainz, 1969.

Frye, R. N. *The Heritage of Persia.* Cleveland/New York, 1963. pp. 198–223.

Gagé, J. *La Montée des Sassanides.* Paris, 1964.

Ghirshman, R. *Persian Art: The Parthian and Sassanian Dynasties.* New York, 1962.

Lukonin, V. G. *Iran v epokhu pervykh sasanidov.* Leningrad: Gosudarstvennogo Ermitazha, 1961.

———. *Kultura sasanidskogo Irana.* Moscow: Otdeleniye istorii institut narodov Azii, Gosudarstvennyi Ermitazh, 1969.

———. *Persia II.* Cleveland/New York, 1967.

Nöldeke, T. *Geschichte der Perser und Araber zur Zeit der Sasaniden aus der arabischen Chronik des Tabari.* Leiden, 1879.

Pigulevskaja, N. *Les Villes de l'état iranien aux époques parthe et sassanide.* Paris/The Hague: Ecole pratique des hautes études —Sorbonne VIe section, 1963.

Pope, A. U., ed. *A Survey of Persian Art.* London/New York, 1938; reprinted Tokyo, 1964. Vols. I, IV; pp. 493–819, pls. 146–257.

Porada, E. *The Art of Ancient Iran.* New York, 1965. pp. 192–225.

The Shahnameh of Firdausi. Translated by A. G. Warner and E. Warner. London, 1915.

Zaehner, R. C. *The Teachings of the Magi.* New York, 1976.

The Zend-Avesta. Pt. 1, 2. Translated by J. Darmesteter. Oxford, 1883–95. (Müller, F. M., ed. *The Sacred Books of the East.* Vols. IV, XXIII.)

Silver

Amiet, P. "Nouvelles acquisitions: Antiquités parthes et sassanides." *La Revue du Louvre* 17 (1967), nos. 4–5, pp. 273–282.

———. "Orfèvrerie sassanide au Musée du Louvre." *Syria* 47 (1970), pp. 51–64.

Dalton, O. M. *The Treasure of the Oxus.* 3rd ed. London, 1964. Pls. 36–39.

Erdmann, K. "Die Entwicklung der sāsānidischen Krone." *Ars Islamica* 15–16 (1951), pp. 87–123.

———. *Die Kunst Irans zur Zeit der Sasaniden.* Berlin, 1943. pp. 84–102, pls. 59–80.

———. "Die sasanidischen Jagdschalen," *Jahrbuch der Preuszischen Kunstsammlungen* 57 (1936), pp. 192–232.

———. "Zur Chronologie der sassanidischen 'Jagdschalen'." *Zeitschrift der Deutschen Morgenländischen Gesellschaft* 97 (1943), pp. 239–283.

Harper, P. O. "Royal Imagery on Sasanian Silver Vessels." Ph.D. dissertation, Columbia University, 1977.

Herzfeld, E. "Khusrau Parwēz und der Tāq i Vastān." *Archaeologische Mitteilungen aus Iran* 9 (1938), pp. 91–158.

Lukonin, V. G. *Persia II.* Cleveland/New York, 1967.

Marshak, B. I. and Krikis, Ya. K. "Chilekskie Chashi," *Trudy Gosudarstvennogo Ermitazha* 10 (1969), pp. 55–80.

Orbeli, J. "Sasanian and Early Islamic Metalwork." In *A Survey of Persian Art*, edited by A. U. Pope. London/New York, 1938. Vol. I, pp. 716–770.

Orbeli, J., and Trever, C. *Orfèvrerie sasanide.* Moscow/Leningrad, 1935.

The University of Michigan Museum of Art. *Sasanian Silver: Late Antique and Early Medieval Arts of Luxury from Iran.* Introduction by O. Grabar. Ann Arbor, 1967.

Bronze

Melikian-Chirvani, A. S. "The White Bronzes of Early Islamic Iran." *Metropolitan Museum Journal* 9 (1974), pp. 123–152.

Negro Ponzi, M. "Some Sasanian Moulds." *Mesopotamia* 2 (1967), pp. 57–92.

Stucco

Baltrusaitis, J. "Sāsānian Stucco, A. Ornamental." In *A Survey of Persian Art*, edited by A. U. Pope. London/New York, 1938. Vol. I, pp. 601–630.

Erdmann, K. *Die Kunst Irans zur Zeit der Sasaniden.* Berlin, 1943. pp. 76–89.

Kröger, J. "Sasanidischer Stuckdekor. Ein Beitrag zum Reliefdekor aus Stuck in sasanidischer und frühislamischer Zeit nach den Ausgrabungen von 1928/9 und 1931/2 in der sasanidischen Metropole Ktesiphon (Iraq) und unter besonderer Berücksichtigung der Stuckfunde vom Taḫt-i Sulaimān (Iran), aus Niẓāmābād (Iran) sowie zahlreicher anderer Fundorte." Ph.D. dissertation, Freie Universität Berlin, 1977.

Kühnel, E., and Wachtsmuth, F. *Die Ausgrabungen der zweiten Ktesiphon-Expedition (Winter 1931/2).* Berlin: Islamische Kunstabteilung der Staatlichen Museen, 1933.

Moorey, P. R. S. *The Oxford-Chicago Excavations at Kish (1923–33): The Objects in Oxford.* Forthcoming.

Pope, A. U. "Sāsānian Stucco, B. Figural." In *A Survey of Persian Art*, edited by A. U. Pope. London/New York, 1938. Vol. I, pp. 631–645.

Schmidt, E. F. *Excavations at Tepe Hissar, Damghan.* Publications of the Iranian Section of the University Museum. Philadelphia, 1937.

Schmidt, J. H. "L'Expédition de Ctésiphon en 1931–1932." *Syria* 15 (1934), pp. 1–23.

Thompson, D. *Stucco from Chal Tarkhan-Eshqabad near Rayy.* Warminster, 1976.

Watelin, L. C. "Sāsānian Architecture, C. The Sāsānian Buildings near Kish." In *A Survey of Persian Art,* edited by A. U. Pope. London/New York, 1938. Vol. I, pp. 584–592.

Textiles

Boulnois, C. L. *The Silk Road.* New York, 1966.

Fukai, S., and Horiuchi, K. *Taq-i-Bustan.* 2 vols. Tokyo, 1969–1972.

Geijer, A. "A Silk from Antinoë and the Sasanian Textile Art." *Orientalia Suecana* 12 (1963), pp. 3–36.

Ghirshman, R. *Persian Art: The Parthian and Sassanian Dynasties.* New York, 1962. pp. 226–237.

Meister, M. "The Pearl Roundel in Chinese Textiles," *Ars Orientalis* 8 (1970), pp. 255–267.

Peck, E. H. "The Representation of Costumes in the Reliefs of Taq-i Bustan." *Artibus Asiae* 31 (1969), pp. 101–146.

Seals

Ackerman, P. "Sāsānian Seals." In *A Survey of Persian Art,* edited by A. U. Pope. London/New York, 1938. Vol. I, pp. 784–815.

Bivar, A. D. H. *Catalogue of the Western Asiatic Seals in the British Museum, Stamp Seals* II: *The Sassanian Dynasty.* London, 1969.

Borisov, A. Ia., and Lukonin, V. G. *Sasanidskie Gemmy.* Leningrad, 1962.

Brunner, C. J. *Catalogue of Sasanian Stamp Seals in The Metropolitan Museum of Art.* New York: The Metropolitan Museum of Art, forthcoming.

Frye, R. N., ed. *Sasanian Remains from Qasr-i Abu Nasr.* Cambridge, Mass., 1973.

Göbl, R. *Der sāsānidische Siegelkanon.* Braunschweig, 1973.

———. *Die Tonbullen vom Tacht-e Suleiman.* Berlin: Deutsches Archäologisches Institut, Abteilung Teheran, 1976.

Horn, P., and Steindorff, G. *Sassanidische Siegelsteine.* Berlin, 1891.

Glass

The British Museum. *Masterpieces of Glass.* Compiled by D. B. Harden et al. London, 1968.

Fukai, S. *Study of Iranian Art and Archaeology.* Tokyo, 1968.

Lamm, C. J. *Mittelalterliche Gläser und Steinschnittarbeiten aus dem Nahen Osten.* Berlin, 1929.

Langdon, S., and Harden, D. B. "Glass from Kish." *Iraq* 1 (1934), pp. 131–136.

Negro Ponzi, M. "Sasanian Glassware from Tell Mahuz." *Mesopotamia* 3/4 (1968–69), pp. 293–384.

Puttrich-Reignard, O. *Die Glasfunde von Ktesiphon.* Kiel, 1934.

Sono, T., and Fukai, S. *Dailaman III.* Tokyo, 1968.

von Saldern, A. "Achaemenid and Sassanian Cut Glass." *Ars Orientalis* 5 (1963), pp. 7–16.

———. "Sassanidische und islamische Gläser in Düsseldorf und Hamburg." *Jahrbuch der Hamburger Kunstsammlungen* 13 (1968), pp. 32–62.

Ceramics

Egami, N.; Fukai, S.; and Masuda, S. *Dailaman II.* Tokyo, 1966.

Erdmann, K. "Partho-Sassanian Ceramics." *The Burlington Magazine* 67 (1935), pp. 71–77.

Ettinghausen, R. "Parthian and Sāsānian Pottery." In *A Survey of Persian Art,* edited by A. U. Pope. London/New York, 1938. Vol. I, pp. 646–680.

Harden, D. B. "Pottery." In S. Langdon and D. B. Harden, "Excavations at Kish and Barghuthiat 1933." *Iraq* 1 (1934), pp. 124–136.

Oates, D. *Studies in the Ancient History of Northern Iraq.* London, 1968. Appendix B, pp. 145–160.

Rosen-Ayalon, M. *La Poterie islamique.* Mémoires de la délégation archéologique en Iran, L, Mission de Susiane. Paris, 1974.

Schmidt, J. H. "L'Expédition de Ctésiphon en 1931–1932." *Syria* 15 (1934), pp. 1–23.

Sono, T., and Fukai, S. *Dailaman III.* Tokyo, 1968.

Venco Ricciardi, R. "Pottery from Choche." *Mesopotamia* 2 (1967), pp. 93–104.

———. "Sasanian Pottery from Tell Mahuz." *Mesopotamia* 5/6 (1970–71), pp. 427–482.

Stone

Fukai, S., and Horiuchi, K. *Taq-i-Bustan.* 2 vols. Tokyo, 1969–72.

Ghirshman, R. *Bîchâpour.* 2 vols. Paris, 1956–71.

Herzfeld, E. "La Sculpture rupestre de la Perse sassanide." *Revue des arts asiatiques* 5 (1928), pp. 129–142.

Hinz, W. *Altiranische Funde und Forschungen.* Berlin, 1969.

Reuther, O. "The German Excavations at Ctesiphon." *Antiquity* 3 (1929), pp. 442–443.

Schmidt, E. F. *Persepolis.* Vol. III. Oriental Institute Publications 70. Chicago, 1970.

Trümpelmann, L. "Das Sasanidische Felsrelief von Sar Mašhad." *Iranische Denkmäler,* Lieferung 5. Berlin: Deutsches Archäologisches Institut, Abteilung Teheran, 1975.

———. "Das Sasanidische Felsrelief von Dārāb." *Iranische Denkmäler,* Lieferung 6. Berlin: Deutsches Archäologisches Institut, Abteilung Teheran, 1975.

Color photographs 5, 8, 12 by Otto E. Nelson; 87A, 87B by Maurice Chuzeville; 65 by courtesy of the Trustees of the Chatsworth Settlement; 84 by courtesy of the Trustees of the British Museum; 1, 53, 55 by courtesy of the lenders.

fig. 1a from B. N. Arakelyan, "Klad serebryanykh izdeliy iz Erebuni," *Sovetskaya Arkheologiya* (1971), no. 1, p. 146.

fig. 2a by courtesy of the Iran Bastan Museum, Tehran.

fig. 5a from *Cultural Relics Unearthed in China* (Peking: Wen Wu Press, 1972), pl. 70.

fig. 31a from S. Fukai and K. Horiuchi, *Taq-i-Bustan*, II (Tokyo, 1972), pl. XXXVII.

fig. 31b from A. Belenitskiy and B. Marshak, "Stennye rospisi, obnaruzhennye v 1970 godu na gorodishche drevnego Pendzhikenta," *Soobshcheniya Gosudarstvennogo Ermitazha* 35 (1973), p. 59.

fig. 81a from S. Masuda, "Glassware of the Sasanid Age," *Museum* no. 110 (May, 1960), p. 24.

fig. I from S. Fukai and K. Horiuchi, *Taq-i-Bustan*, I (Tokyo, 1969), pl. XXXII.

figs. 21a, 34a, 34b, B, J, K, L, M, N by Carol and Lionel Bier.

figs. 4b, 42a by Prudence O. Harper.

All photographs of objects in the British Museum are reproduced by courtesy of the Trustees of the British Museum.

Map by Joseph P. Ascherl

The Royal Hunter has been designed by Roberta Savage and printed at the Press of A. Colish in Mount Vernon, New York.

First printing, 1978: 3500 copies

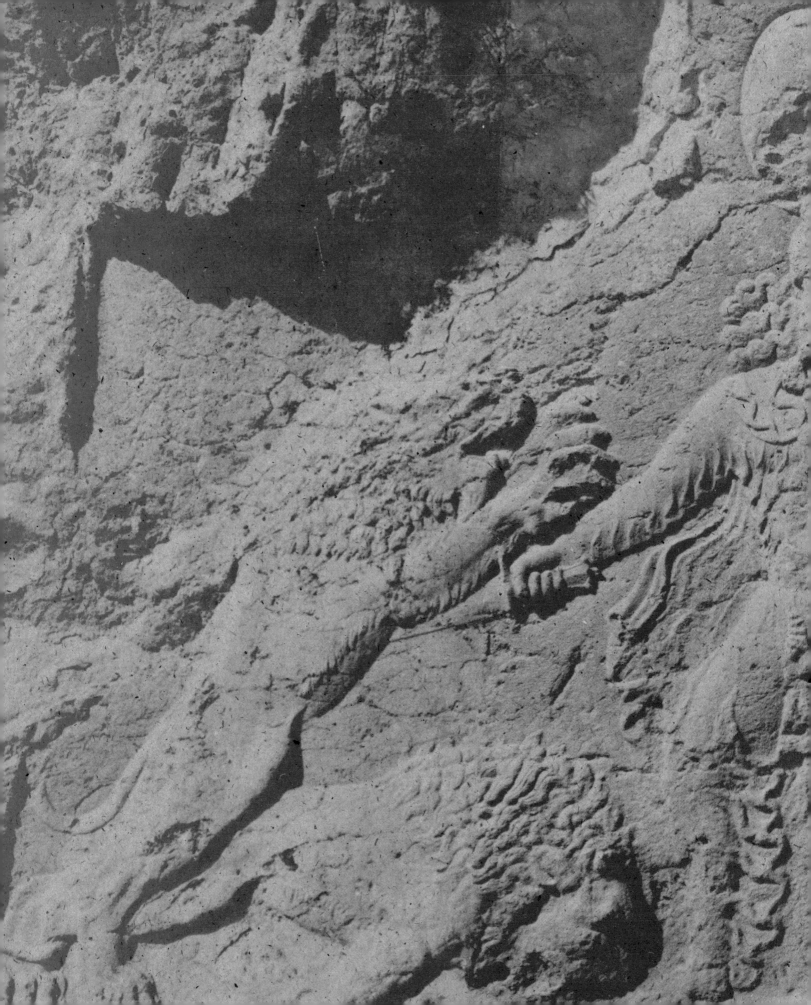